PAINTED
BOOKS FROM
MEXICO

PAINTED BOOKS FROM MEXICO

GORDON BROTHERSTON

CODICES IN
UK COLLECTIONS
AND THE WORLD
THEY REPRESENT

PUBLISHED FOR THE
TRUSTEES OF THE BRITISH MUSEUM
BY BRITISH MUSEUM PRESS

For Jack and Billy
and George

© 1995 Trustees of the British Museum

Published by British Museum Press
A division of The British Museum Company Ltd
46 Bloomsbury Street, London WC1B 3QQ

A catalogue record for this book is available
from the British Library

ISBN 0 7141 2519 9

Designed by Harry Green
Typeset by Southern Positives and Negatives (SPAN),
Lingfield, Surrey
Origination by Colourscan, Singapore
Printed in Italy by Grafiche Milan

CONTENTS

ILLUSTRATIONS

ABBREVIATIONS

ADEVA	Akademisches Druck und Verlag Anstalt, Graz
AGN	Archivo General de la Nación, Mexico
BO	Bodleian Library, Oxford
BM	British Museum
CONACYT	Consejo Nacional de Ciencias y Tecnología
ECN	Estudios de cultura náhuatl (Mexico)
FCE	Fondo de Cultura Económica, Mexico
HMAI	Handbook of Middle American Indians, usually with Census numbers (Glass 1975, 1975a, Gibson & Glass 1975, Robertson 1975)
INAH	Instituto Nacional de Antropología e Historia
ITC	Instituto Tlaxcalteca de Cultura
RG	Relaciones geográficas. Produced by towns in Mexico in 1580–81 in response to a standard questionnaire (Acuña 1982–8).
UAT	Universidad Autónoma de Tlaxcala
UNAM	Universidad Nacional Autónoma de Mexico

ACKNOWLEDGEMENTS

Acknowledgement is due to the following for permission to reproduce photographs:

Archer M. Huntington Art Gallery, University of Texas, Austin

The Bodleian Library, Oxford (for 5 scenes from MS. Arch. Selden A.72 (3); MS Arch. Selden A.1, fol, 37r; MS. Arch. Selden A.1, fol. 57r)

Cambridge University Press (for three maps from Brotherston, Book of the Fourth World, 1984)

Fondo de Cultura Económica, Mexico (publishers of a recent facsimile of the Laud Codex)

Fonds Mexicains, Bibliothèque Nationale, Paris

The John Rylands Library, Manchester

The Board of the Trustees of the National Museum and Galleries on Merseyside

By courtesy of the Trustees of the British Museum

By kind permission of the Trustees of the Ulster Museum, Belfast

The University Library, Glasgow

PREFACE

The painted books of ancient Mexico constitute a precious and little known chapter of world literature. The work of the *tlacuilo* (scribe) whose art goes back thousands of years before the conquistadors reached America, they are exquisite manuscripts written and drawn on native paper or skin, and later, on European paper. Twenty or so of the finest have ended up in the United Kingdom, where they have long been a source of interest. Samuel Purchas included woodcuts of pages from the Mendoza Codex in his *Pilgrimes* (1625); William Robertson, a star of the Scottish enlightenment, drew on them in his pioneering *History of America* (1778); William Bullock displayed them at a major exhibition in London in 1823; the Anglo-Irish Lord Kingsborough published many of them for the first time in his *Antiquities of Ancient Mexico* (1831–48); and in this century, James Cooper Clark, followed by Cottie Burland, have led the way to adequate readings of Mendoza, Zouche and other texts. In 1992, Elizabeth Carmichael organised a quincentenary exhibition in London under the title 'Mexican Painted Books'.

The 1992 exhibition was accompanied by a 1000-copy edition of a small book (Brotherston 1992a), which sold out immediately. Part of it has been incorporated now into the present volume, the first to deal with the subject at length. It introduces each of the UK texts, analysing most of them in considerable depth. At the same time, it draws on them extensively in order to build up a framework that may serve for the study of ancient Mexican books more generally, showing the kind of script they use, the way they depicted the European invasion from the 'other' side, the main points of historical origin which they establish, and their representation of ritual and economics.

There is a growing fascination with these books and several important advances have been made even in the short intervening period since the exhibition. First, a whole new codex has been found among the Additional Manuscripts of the British Library, the eight-folio Landbook of the town Calacoayan, just northwest of Mexico City. Then, major commentaries have accompanied facsimile editions of Zouche (Jansen 1992) and Mendoza (Berdan & Anawalt 1992), while the Mexican scholars Perla Valle and Luis Reyes have respectively published indispensable analyses of the Tepetlaoztoc Codex (1992) and the Tamazolco Map (1993). Other significant work has emerged from papers presented at the Codices symposia held in New Orleans (1991) and Taxco, Mexico (1994), and from the doctoral dissertation of Philip

Stokes. The last few years have also witnessed an astonishing series of archaeological discoveries in Mexico, at Teotihuacan, Cacaxtla, Cantona, Cuajilote and other sites, which impinge directly on our reading of the manuscripts.

For help in countless ways, my thanks are due to my wife Ana, Luis Reyes, Margo Glantz, Miguel León-Portilla and Johanna Broda in Mexico, Tim Laughton and Barry Woodcock of the University of Essex, the late William Fellowes, Stephanie Wood, Elizabeth Carmichael and John Mack of the British Museum, Alan Donnithorne formerly of the British Museum Conservation Department, David Weston of Glasgow University Library, Winifred Glover of the Ulster Museum, Belfast, Wm. T. Reilly of Austin and the curators and librarians of the other institutions where these manuscripts are housed. A fellowship from the John Simon Guggenheim Foundation for 1993–4 was of great assistance, as was a visiting professorship financed by CONACYT of Mexico which enabled me to work during the summer of that year with scholars and graduates at the Escuela Nacional de Antropología e Historia. Finally, in making this book possible, my editor Carolyn Jones has been a model of patience and intelligence.

WIVENHOE–TEPOZTLAN
June 1994

NOTE ON ORTHOGRAPHY

The spelling of native names has been generally standardised, though not in first-time transcriptions and rarely with proper names (in Nahuatl o=u, i=y, qua=cua). Accents on Nahuatl words are not marked; stress characteristically falls on the penult, rather than the final syllable preferred by Spanish-speakers (e.g. Tenochtitlan, not Tenochtitlán). With calendar names comprising a number and a sign, the numbers are written out for persons (e.g. One Reed of Tula) and concepts (e.g. the Era Four Movement) but not otherwise (e.g. year 1 Reed). In this respect the fuller than usual detail given in the Index is to help it serve as a glossary. In referring to native texts known under several names I have generally chosen one and have preferred not to italicise except when there is a clear bibliographical obligation to do so: details are given in Bibliography A and the Notes. Cases of difficult pagination and reading order are treated in Appendix 1: the general rule has been to adapt the former to the latter. Years BC are dated according to the astronomers' count, which includes a year 0, rather than that of the historians, which does not. Throughout, the term Mexica is preferred to the commoner Aztec.

CHAPTER ONE

THE BOOKS OF
MESOAMERICA

Before Columbus dreamed of sailing west, the peoples of America were already writing and recording their world. To the north they used such devices as the birchbark scrolls of the Great Lakes and the tanned deerskins of the Mississippi; to the south, the knotted strings which under the Inca acquired the sophistication of a computer programme. In Mesoamerica (the middle part of the continent: that territory which stretches from Nicaragua in the east to Mexico and Michoacan in the west; Map 1) books were a speciality. Carefully prepared surfaces of deerskin or native paper (fig.1) served as

1 Native paper (8000 reams). Mendoza f.25

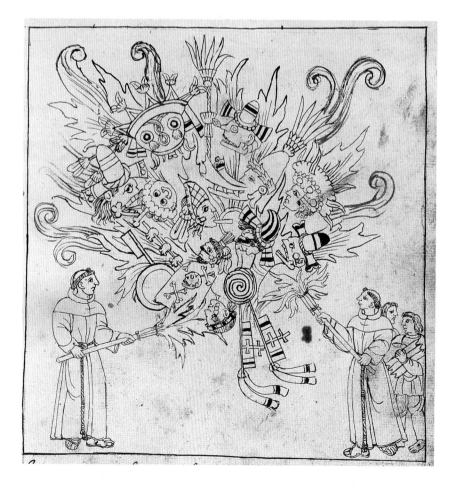

2 Burning books (lower right) and pagan paraphernalia. Tlaxcala Codex 13

maps, scrolls or books whose pages were folded together like a screen or accordion. Archaeology, especially in the land of the lowland Maya, assures us that the practice of book-making was at least 1000 years old by the time Columbus arrived. Texts were written and painted, usually in a variety of colours, with brushes so fine that their line is difficult to emulate with a pen even today. Only now are we beginning to intuit the knowledge they record.[1]

When the Franciscans arrived in Mexico in 1524 they appealed to their book, the Bible, as justification for their need to proselytise. In their reply, the Aztecs (or Mexica as they called themselves) noted that they too had their scriptures and precious books, which told another, longer story of genesis and human culture, and which boasted a political tradition that stretched far beyond the great city of Teotihuacan (flourished AD 250). A pioneer in his day, the native historian Chimalpahin used this tradition to point out flaws in the medieval European account of Jerusalem, implicitly asking the question: Who entered whose history? Everything that the Christian invaders sought to impose was threatened by the existence of these native books, and consequently they burned them by the hundred (fig.2), ransacking library after library, often burning their owners as well. As many of the native historians pointed out, the actions of the Christian invaders destroyed not only pagan belief but also the historical detail of a major civilization. Most of the few texts that survived this purge eventually succumbed to the ravages of time, so that only a score or so of those extant may be considered wholly pre-Cortesian in style. With the exception of four screenfold books written in the hieroglyphic script of the lowland Maya area, all of these 'classics' stem from within a few hundred miles of the Mexica capital Tenochtitlan. No less than seven are now to be found in the United Kingdom. Texts in the native tradition produced after Cortes, many of them on European paper and with alphabetic glosses, run to several hundred,[2] making the painted books of Mexico in all a chapter of world literature that is both abundant and precious.

Means of representation

The books that have survived from the pre-Cortesian era are written in two kinds of script. Four, all native-paper screenfolds, are written in the hieroglyphic system peculiar to the lowland Maya (fig.3). (They are now held in Dresden, Paris, Madrid and Mexico City.) All the rest, of paper and of skin, use a type of writing sometimes called 'Mixtec–Aztec', which has no necessary connection with any one spoken language; it is referred to here as iconic script.

Maya hieroglyphic script, now being deciphered apace, is found predominantly not in books but in inscriptions in stone and wood that were carved during the Classic Period (AD 300–900) in the great cities of the Maya lowlands, such as Palenque, Yaxchilan, Calakmul, Tikal and Copan. Its origins may be traced directly back to the far older inscriptions of the neighbouring Olmec, on the coast of the Gulf of Mexico (hereinafter referred to as

the Gulf Coast), who are now known to have spoken Zoque, a language closely linked by some to both Maya and Totonac.[3] Texts in Maya hieroglyphic script form a corpus in their own right which is represented in the United Kingdom by numerous inscriptions brought back in the late nineteenth century, and by important early copies of the screenfold books.

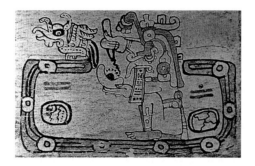

3 Maya scribe (right-handed) in cave with hieroglyphs and date. Madrid p.72

4 Toltec scribe Nine Wind (left-handed). Tepexic Annals p.4

Not tied to any single phonetic system, the iconic script used in all the non-hieroglyphic books was sensitive to the phonetics and syntax of the speech of those who used it – Nahuatl or Mexica, Otomi, Tlapanec, Cuicatec, Mixtec, Zapotec, highland Maya, and the original Toltecs (fig.4). Above all, this kind of writing exulted in the capacity to fuse into one visual statement what for us are the separate concepts of letter, art and mathematics. For that reason it has no close parallel anywhere and has posed serious problems for historians and theorists of script. In Nahuatl it is called *tlacuilolli*, that which is painted or written. Archaeologically, it has widespread antecedents in Classic and pre-Classic inscriptions and paintings at Teotihuacan in the Highland Basin, Cacaxtla and Cholula, Xochicalco, the Totonac and Olmec centres on the Gulf Coast and the Zapotec and Mixtec centres in Oaxaca.

Common to these and even other types of script used in Mesoamerica is a factor which has been recognised as diagnostic of its culture as a whole. This is the calendar, or rather the apparatus of sign sets and numbers which served to articulate time throughout the region. As the codices themselves show, there were two main complementary cycles, identified respectively with the year and with human pregnancy.

The yearly cycle involves 18 scores or 'feasts' (*ilhuitl* in Nahuatl) each of 20 days, and each with its own patron, customs, harvests and offerings; to these were added five epagonal or 'useless' days (*nemontemi*), making 365 in all. The symbols used to designate the 20-day feasts often allude to seasonal or social practices, like the mummy bundle of Miccailhuitl, the Feast of the Dead in August, or the migrant bird of Quecholli, the Feast of the Birds in November. In some post-Cortesian sources, these feasts are arranged as a wheel (fig.5), which helps us to appreciate their inner structure, paired as several are, lesser and greater, between the hinges of the equinoxes.

The other cycle, known in Nahuatl as the *tonalamatl*, book of fates or days,

relates to pregnancy and the practice of midwifery – a fact only recently acknowledged by scholars.[4] A measure of the nine moons of human gestation, the cycle comprises 260 nights and days, that is, 9 moons of 29 nights named by the 9 Night Lords, and 13 lots of 20 days named by the Thirteen Numbers and the Twenty Signs (Tables 1–3). The combination of number and sign

5 Tlaxcala Calendar Wheel: the eighteen 20-day feasts

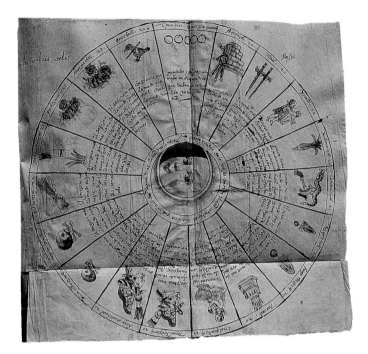

which served to name days could also name a person after her or his day of birth, for example as 'Six Monkey' or 'One Reed'; or again it could name a year. In this latter case, for arithmetical reasons the Thirteen Numbers could combine with only four of the Twenty Signs, each five places distant from the previous one, to produce the cycle of 52 years (i.e. 13×4), a Round or 'year-binding' (*xiuhmolpilli*). For their part, the Mexica named their years after the Signs House, Rabbit, Reed and Flint, that is III, VIII, XIII, and XVIII in the set of twenty.

The semantic details of these cycles, especially that of the yearly feasts, varied regionally; and so did the way in which they intermeshed, for example, in producing the count of nine nights, or the 52-year cycle. Yet throughout Mesoamerica there is no doubt about their identity as such, or about their role in the development of writing itself.

Knowing the norms and conventions of iconic script or *tlacuilolli* enables us to identify texts in which the native tradition is still in full flower, untouched by European influence. Several texts that self-date as post-Cortesian – the Selden screenfold for example – belong entirely to that older tradition. Others may include actual details of the encounter with Europe, such as the hogs,

hens and doubloons in the Tepotzotlan Codex; yet native scribes fully adapt these new phenomena to previous norms.

In the iconic tradition, the internal reading sequence of the screenfold books is determined by one or other of only two principles. That is, either it moves forward year by year and belongs (like Zouche and Bodley) to the genre of annals, years being named by *tonalamatl* numbers and signs as, for example, '1 Reed' or '13 House'. Or it is divided up into chapters and belongs, like Féjérváry and Laud, to the 'ritual' genre, the internal reading sequence of each chapter being determined by the sign and number sets of the year and the *tonalamatl*.

A richly represented genre termed *xiuhtlapoualli* (year count), annals in

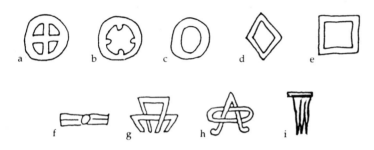

6 Year markers: a) Monte Alban b) Metlatoyuca Lienzo c) Féjérváry; Tepechpan Annals d) Tepetlaoztoc [Fig.179] e) Borbonicus; Aubin; Huichapan Annals (Otomi); Tochpan Lienzos; Itzcuintepec Annals; Tlapa Annals f) Mixcoatl inscription [Fig.60]; Miltepec Roll; Tulancingo Lienzo g) Xochicalco h) Borgia; Coixtlahuaca Lienzo; Tlahuixtlahuaca Roll; Cuicatlan Annals; Tepexic Annals; Tilantongo Annals i) Chiepetlan Lienzo

Mesoamerica reach back to year dates inscribed on stelae already in the first millenium BC; and they carry forward into histories written alphabetically in native and European languages. The basic principle they share, simply of moving forward from one year date to the next within the 52-year 'binding' or Round, was variously expressed over time and by region. Hence the set of four *tonalamatl* Signs that names years varies: it was House–Rabbit–Reed–Flint in Tenochtitlan, Tlaxcala, Itzcuintepec, Tepetlaoztoc, Coixtlahuaca and Tilantongo, while elsewhere it was Wind–Deer–Tooth–Movement, the set that accompanies annual maize plantings in Féjérváry (pp.33–4). And not only did the Sign vary: so did the qualifying number, so that AD 1519, the year of Cortes's arrival shown in Aubin, was 1 Reed in Tenochtitlan and 13 Reed in Tilantongo. Again, the markers used to distinguish these year names from other days in the *tonalamatl* count could be a box (Tenochtitlan, Itzcuintepec), a diamond (Tepetlaoztoc), a circle (Metlatoyuca), or the looped 'A' or solar ray typical of Coixtlahuaca and Mixteca texts (Selden Roll, Zouche etc.) (fig.6). The solar-ray annals are usually (though not always) accompanied by dependent days in the year, and intervals of more than one year are common between two consecutive dates. Hence, at the start of Eight Deer's biography in Zouche we move direct from his birth in year 12 Reed (AD 1011) to his activities in the year 7 Reed (AD 1019), when he was eight. By contrast, the Highland Basin norm was to record year names, in their square markers, without dependent days, and to proceed one year at a time. A classic example here is the Aubin

Codex which spells out every year of Mexica life from 1 Flint (AD 1168), the departure from the island Aztlan, to the beginning of the seventeenth century.[5]

Within this genre of annals, there are also marked differences of format (fig.7), and of emphasis and mode. Year narratives may concentrate on migration, military conquest and tribute rights, genealogy, or the kind of biography so luminously represented by Zouche's story of Eight Deer, from his father's first marriage to his own, at the age of 40. Indeed, the variations between the many annals in the native tradition are great, yet they all adhere to the same reading principle, in representing the passage of time. After Cortes, this corpus of annals was transcribed in part into alphabetic histories written in

7 Boustrophedon reading streams (after Stokes 1994) a) Tilantongo Annals obverse b) Tilantongo Annals reverse c) Xaltepec Annals d) Tepexic Annals, Teozacoalco Annals

Nahuatl, and in Spanish, such as the *Historia de Tlaxcala* by Diego Muñoz Camargo, who complains more than once about the terrible consequences that Spanish book-burning had for native historians. The few texts that have survived allow us at least to glimpse the historiography of ancient Mesoamerica, and to trace four main traditions from their respective starting points in the island Aztlan, the seven caves of Chicomoztoc, the tree of Apoala and the bullrushes of Tula (see Chapters 3–6). Archetypes of these traditions are far from forgotten in Mexico today.

In the other main pre-Cortesian genre, here called 'ritual', just nine texts have survived, all of them magnificent. They are from the Highland Basin (Borbonicus), Tlaxcala (Tonalamatl Aubin), Cholula (Borgia, Cospi, Vaticanus) and the upper Papaloapan (Porfirio Díaz, Aubin Ms 20, Laud and possibly Féjérváry) (Table 4). Here, the sign and number sets of the *tonalamatl* and the year are all-important and, rather than the year dates of the annals genre, determine the reading order of every page and chapter.[6] In their day, baffled and suspicious, European missionaries perceived chiefly in this type of book a threat to the Christian message they strove to implant. Hence in the book-burning scene in the Tlaxcala Codex, we see the destruction of the old gods whose masks correspond to the Twenty Signs as Wind, Rain and Death: these are precisely the deities we see celebrated in page-icons in the ritual texts (fig.2). At the same time, in the effort to understand this pagan world, a few partial transcriptions were made of the classic ritual texts. As a result,

although much in them remains obscure, we can be sure that they invoke the story of genesis and evolution recounted at length in the 'Bible of America', the *Popol Vuh* of highland Guatemala, and other core beliefs of Mesoamerican culture. In so doing, they in fact supply a cosmogonical base for the economics of day-to-day life, both the labour tribute regulated by the *tonalamatl*, and the commodity tribute or 'offerings' made over the cycle of annual feasts.[7] Geographically, the story of creation and world ages was even reflected in the cosmic maps found in the Féjérváry and other ritual texts, which were imposed on actual landscapes for the purposes of tribute collection.

Through comparing texts in this ritual genre we may begin to identify topics and chapter-themes common to them. Focused on human life and labour, the *tonalamatl* chapters celebrate the nine Night Lords and explain the combinations of Number and Sign which affected people's fates through birthday names such as Two Dog, Eight Deer, Nine Wind and so on. And they deal with such themes as birth, behaviour, marriage, maize-planting, travel, fire-kindling and burial. Superlative examples of the genre, Laud and Féjérváry have in common the Birth chapter, which typically highlights two paired acts and states – of begetting and bearing, severing the umbilical cord and suckling. Again common to both Laud and Féjérváry, the Behaviour chapter rests on the contrast between useful citizens, and their useless counterparts who gamble, thieve, drink and otherwise misbehave.[8] Formally, the ritual texts may be approached as the masterworks of *tlacuilolli*, which, like classic Nahuatl poetry, presuppose much ingenuity in their reader and invite multiple decipherment.

In addition to these two genres, annal and ritual, that are so well repre-

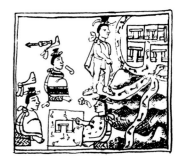

8 Planning strategy, with the help of a cotton lienzo map. Florentine Codex Book 8, f.33v

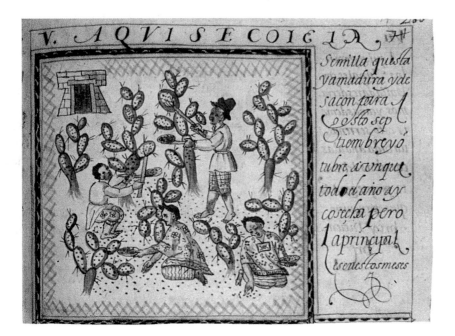

9 Harvest. Cochineal Treatise, scene 5

sented in the paginated screenfold books, other types of text in the pre-Cortesian tradition survive. These include the scroll or strip, usually of paper, which traces the footprints of migration, notably in the case of the Chichimecs who travelled to such places as Itzcuintepec, Huamantla, Miltepec and Tlahuixtlahuaca; the cotton lienzo or sheet that maps extensive territories and once served for planning military strategy, as the Florentine Codex shows (fig.8); and the smaller sheet, usually of paper and often reused, that records contracts, agreements and administrative data of all kinds. Moreover, after the European invasion and the emergence of the Spanish viceroyalty in Mexico, iconic script was adapted to a whole series of new needs, principally in the defence of local rights. Since Spanish colonial law courts admitted evidence in native writing, scribes went on to produce a mass of new documents, adapting these older forms. Also, local life was illustrated, as in the case of the Cochineal Treatise, which details the continuing production of cochineal dye under Spanish rule (fig.9). In the Highland Basin of Mexico there is, however, a shift or decay in style after the 1560s, with the death and disappearance of scribes who had been trained before the destruction of Tenochtitlan.

While the Europeanisation in these later texts cannot be doubted – both in the need they respond to and in the details of their format, script and perspective – they nonetheless continue and develop older conventions more often than has been generally realised. An intriguing case of such continuity is provided by the Mendoza Codex of the 1530s, which in detailing Mexica tribute practice distinguishes clearly between the commodity tribute brought in from the provinces and the labour tribute of its citizens. In other words, it continues to respect the traditional distinction made between these two types of tribute, which in ritual screenfolds such as Féjérváry correspond respectively to the year cycle and the *tonalamatl*. All this indicates in turn how significant economics were to ritual and, conversely, how tribute systems were organised along 'ritual' lines.

The texts considered so far, pre- and post-Cortesian, either exemplify or grow directly out of the native script tradition. Later in the Spanish colonial period, other subgroups emerged. One such subgroup consists of the Landbooks, often referred to as 'Techialoyan' (figs 190, 192–4); made of coarse native paper, these served to defend communities against changes in colonial law until as late as the nineteenth century, as the Calacoayan Landbook reveals. Appropriately, the finest example comes from Azcapotzalco, capital of the former Tepanec domain northwest of Tenochtitlan from which the genre stems.[9] Another group consists of the Catechisms or 'Testerian' manuscripts (fig.195) whose main purpose was Christian instruction. Even here there is still an echo of the old conventions, in the Landbooks and the Catechisms alike. The former, notably the Azcapotzalco book, with its broad political scope, appeal to the models of Mesoamerican history previously recorded in the annals, and place glyphs and the pre-Cortesian year calendar continue

to signify. The latter carry forward symbols and principles of organisation that characterise the ritual genre.

Names, titles and provenance

Over half the Mexican manuscripts in the United Kingdom are customarily known by names that say nothing about their local origins but refer rather to subsequent European owners. This is especially true of the six skin screen-folds most firmly in the pre-Cortesian tradition, that is the two ritual texts (Laud and Féjérváry) and the four Mixtec annals (Selden, Bodley, Zouche and Egerton) – for which, moreover, the description 'codex' is a misnomer, since these are true books, complete and coherent in their own right. This fact was recognised already in the early seventeenth century by the collectors William Laud (archbishop under Charles I), Thomas Bodley and John Selden, who contributed the screenfolds that bear their names to the Bodleian (after Bodley) Library of Oxford University. This remarkable trio were among the first to regard the screenfolds as literary texts in their own right, not mere exotica, and respected them accordingly. Two centuries later, the screenfolds named after the collectors Baron Zouche (Robert Curzon), Egerton and the Hungarian Féjérváry found their way into libraries in London and Liverpool, on a wave of civic pride.[10] In telling the dynastic stories of the Mixteca, each of these annals promotes the interests of a particular town, most likely its provenance: namely Xaltepec (Selden), Tilantongo (Bodley) and Teozacoalco (Zouche).

The Kingsborough Codex in the British Museum contained both the Tepe-tlaoztoc and Cochineal texts, which now exist separately after the recent dis-binding of the codex volume; here, each is given its own title, to avoid the confusion of the single Kingsborough label. This document takes its name from the Anglo-Irish aristocrat Edward King, who spent his entire fortune producing colour facsimiles of Mexican painted books in the nine folio volumes of his *Antiquities of Mexico* (1838–48), the first publication of its kind; a statue to him can be seen in the main square at Tepetlaoztoc. Finally, the French ethnographer Joseph Marius Alexis Aubin imposed his surname on the *Anales mexicanos no.1* manuscript, upon producing a lithograph edition around 1850.

The Mendoza Codex, that magnificent account of the Mexica empire, also commemorates a European name, but this time the circumstances are differ-ent, since the manuscript in question was actually prepared for that person – Antonio de Mendoza. As the first viceroy of New Spain, Mendoza sent this document to the emperor Charles V, only to have it intercepted by pirates. On its way to the Bodleian Library, where it is now kept, the Mendoza Codex passed through the hands of the French cosmographer André Thevet, who penned his name on the title page, Richard Hakluyt, Samuel Purchas (who in 1625 reproduced several pages as woodblocks in his *Purchas his Pilgrimes*) and, eventually, John Selden.

All the other texts derive their titles from their provenance in Mesoamerica.

In the simplest cases, this is self-evident or established by a place sign suitably glossed or explained in an accompanying alphabetic text. Such are the stone-mat cave (*te-petla-oztoc*) of Tepetlaoztoc, a glyph also prominently featured in the Xolotl Maps of Texcoco; the half-open door or 'house entrance' (*calaquia*) of the Calacoayan Landbook; and the toad (*tamazolin*) of Tamazolco, a provenance that has now become quite explicit thanks to the transcription of the Nahuatl glosses made by the Mexican scholar Luis Reyes García. As for the Tlaxcala texts, Calendar and Codex, they are bound with the 1580 manuscript of Diego Muñoz Camargo's *Historia de Tlaxcala*, a major work in Spanish in the Hunterian collection in Glasgow, recently rediscovered by scholars. Here, the problem is not at all provenance but authorship, insofar as the editor of the facsimile edition has insinuated that the Codex may have been the work of Muñoz Camargo himself, the mestizo son of a conquistador.[11] In fact, like the Calendar, it derives from earlier, entirely native Tlaxcalan sources.

Studies by Cottie Burland, Alfonso Caso, Ross Parmenter and others, show that the native-paper Roll named after John Selden (*not* to be confused with the Mixtec skin screenfold which also bears his name) can be fully identified with a group of texts from the Coixtlahuaca Valley. These texts characteristically feature the multiple place sign which appears towards the end of the Selden Roll and which includes the snake of Coixtlahuaca itself, as well as the knot and the feather of nearby Tlapiltepec and Ihuitlan, each place highlighting the element which corresponds to it. In the case of the Selden Roll, the dominant element is the head, whose eyes emerge as if from night, which the Ihuitlan Lienzo glosses as Tlahuixtlahuaca – the place of dawn. Accordingly, we shall refer to the Selden Roll as the Tlahuixtlahuaca Roll, to avoid the risk of confusion with the Selden Codex.

Discovering where the remaining texts come from is more complicated. In the manuscript now in Belfast, which we have named the Tepotzotlan Codex, the sign for that place, the 'hunchback' (*tepotzotl*), is not actually given, and those signs that are present at first offered no clue as to provenance. Happily, however, we were able to match this original with a copy on European paper which is still in Mexico and which makes clear that both texts originated in a dispute between Tepotzotlan and three tributaries, whose place glyphs are in the Belfast original: Xoloc, Cuauhtlapan and Tepoxaco. Having possibly arrived in Ireland via the auction of Lord Kingsborough's papers in Dublin in 1842, this text languished nameless in a drawer in the Ulster Museum until a few years ago, when Winifred Glover came across it.[12]

For their part, defined on internal evidence as a geographical subgroup, the Roll and Codex of Itzcuintepec and the Metlatoyuca Lienzo likewise required detective work before their provenance could be firmly established. Indeed, the fragments of the two Itzcuintepec texts had first to be physically sorted and reassembled before they were legible at all.[13] The place sign for Itzcuinte-pec – a black-and-white dog's head – clear enough in both texts, is ubiquitous in Mesoamerica yet today no town of that name appears in maps of the Metla-

toyuca area; conversely, the place sign for Metlatoyuca, whose location is known, is absent in all three texts. The uncertainty, which at one point put Cottie Burland off the track, was resolved through reference to other native maps of the surrounding area, saliently, the Xolotl Maps of Texcoco and the Tochpan Lienzos of Veracruz.[14]

The Xolotl Maps, the chief source of the sixteenth-century Texcoco historian Ixtlilxochitl, depict the *chichimeca-tlalli* or Chichimec domain around the Basin of Mexico; the Tochpan or Tuxpan Lienzos, brought to light as a result of the Mexican national oil company's interest in Indian lands in that area, mark out

10 Figures from the codices.
Top: Eight Deer, Nezahualcoyotl;
below: Cuauhtemoc, scribe.
Mexican postage stamps

the western end of ancient Tula's domain on the Gulf Coast and feature both Itzcuintepec and Metlatoyuca. As it happens, the respective northeastern and southwestern landmarks on these two sets of maps coincide in the cases of the 'wood fort' of Cuauhchinanco (Huachinango), the bird of Tototepec, and the 'stone enclosure' of Tenanitec – today Cerco de Piedra, near the ruins of Metlatoyuca, in northernmost Puebla. Of these, Tototepec and Tenanitec reappear in the Itzcuintepec and Metlatoyuca texts, along with several other places, not least Itzcuintepec itself, which in the Tochpan Lienzos form part of the same cluster.[15] This general borderland area includes the upper reaches of the Pantepec Valley and was known to the Mexica as Atlan, after the garrison and tribute centre they placed there. In the Tochpan Lienzos, it is shaded in as a special enclave.

Brought together in this book, the Mexican pictorial manuscripts that have found their way to the United Kingdom can now be better understood and interpreted. Together, and cross-referring as they do, they offer a coherent and particular insight into the great civilisation of Mesoamerica (fig.10).

CHAPTER TWO

RESPONSES TO INVASION

What is called the invasion of America was not a single event, nor did it end with the deeds of conquistadors. Rather it is a complex phenomenon that has been going on for five centuries. Begun by Columbus at the end of the fifteenth century, in recent times it has been concentrated in the last native redoubts of the continent, such as the Amazon forest and the highlands of Mesoamerica.

It is true that in the case of the Mexica capital Tenochtitlan, the dominant power in Mesoamerica in the early sixteenth century, the main confrontation between Old World and New, highly dramatic, was confined to the years 1519, 1520 and 1521. Yet there, too, the cultural upheaval and the military activities did not equal a near-sudden and total catastrophe. Apart from the massive testimony to the survival of intellectual activity in the Highland Basin itself, in the Oaxacan mountains scribes continued to produce annals entirely within the native tradition for four decades after Cortes entered Tenochtitlan, as the Selden Codex confirms. Indeed, as late as 1691, the fateful year of eclipse and native revolution, the scribes of Quetzalcoatl were still keeping up their books in Chiapas; and today, the Otomi of Pahuatlan continue to produce *amate*-paper images which directly recall the screenfolds, as do the altar layouts used in the ceremonies of the Tlapanec and the Mixe. In addition to all this, the Maya of eastern Mexico were still using their hieroglyphic screenfold books at Tayasal as late as 1697; and at such towns as Chumayel, Mani and Tizimin they comprehensively transcribed them into alphabetic Maya in their Books of Chilam Balam – a source of native resilience even in this century.

There can be no doubt that for the Mexica and most Mesoamericans, the European invasion was traumatic, something so violent and horrific as to exceed previous norms. The technology used by the invaders – ships, steel, gunpowder, horses, mastiffs – their style of diplomacy and their greed, and the devastating diseases they brought with them, all amounted to a shaking up of the world as it had been. In the annals of Tlatelolco, the sister city just north of Tenochtitlan, the entry for 1521 gives a searing account of the agonies suffered by the defenders of the capital during Cortes's siege of that year. The total lack of food and other supplies effaced good manners and social distinction, and brought about a collapse of the economy more drastic than in the worst famines of the past.[1]

And all this happened among us. We saw it. We lived through it with an
astonishment worthy of tears and of pity for the pain we suffered.
On the roads lie broken shafts and torn hair,
houses are roofless, homes are stained red,
worms swarm in the streets, walls are spattered with brains.
The water is reddish, like dyed water;
we drink it so, we even drink brine;
the water we drink is full of saltpetre.
The wells are crammed with adobe bricks.

Whatever was still alive was kept between shields, like precious treasure,
between shields, until it was eaten.

We chewed on hard tzompantli wood, brackish *zacate* fodder, chunks of adobe,
lizards, vermin, dust and worms.

We eat what was on the fire, as soon as it is done we eat it together right by the
fire.

We had a single price; there was a standard price for a youth, a priest, a boy and a
young girl. The maximum price for a slave amounted to only two handfuls of
maize, to only ten tortillas. Only twenty bundles of brackish fodder was the price
of gold, jade, mantles, quetzal plumes; all valuables fetched the same low price.

For all that, the shock did not extinguish native capacity to observe, record
and assess, as this Nahuatl text from Tlatelolco testifies. In the tradition of
annals to which it belongs, the foreign assault for all its trauma was formally
another event in a story that had been going on for a long time: novel as he
was, Cortes was entering a history already thousands of years old by the time
he arrived. In native-script annals such as those in the Rios, Aubin, Azcatitlan
codices, whose starting points often go back several centuries – as in the illus-
trated Nahuatl narrative in the Florentine Codex (Book 12) elicited by Frair
Bernardino de Sahagún – native American authors treated the conquest in
their own terms, noting details only as they become significant in their eyes.

This other perspective on events is also found in the host of documents
produced to defend rights and title before the three arms of Spanish colonial
power.[2] These were the encomenderos, many of them former conquistadors
like Cortes, who laid claim to vast estates, that is, lands plus their native in-
habitants; the Church, whose mission began in earnest with the arrival of the
Twelve Apostles in 1524; and the Crown, which began to assert its own rights
through the first of the viceroys, Antonio de Mendoza 11 years later, and through
the system of crown courts or Real Audiencias, for which indeed many of the
surviving native documents had initially been produced as evidence (fig.11).

For those who have had to face it, the invasion of the New World has
usually brought wholesale loss of goods and territory, 'removal', forced
labour and even total extermination. The momentum of these processes has
meant that over the centuries few of its victims have had the opportunity to

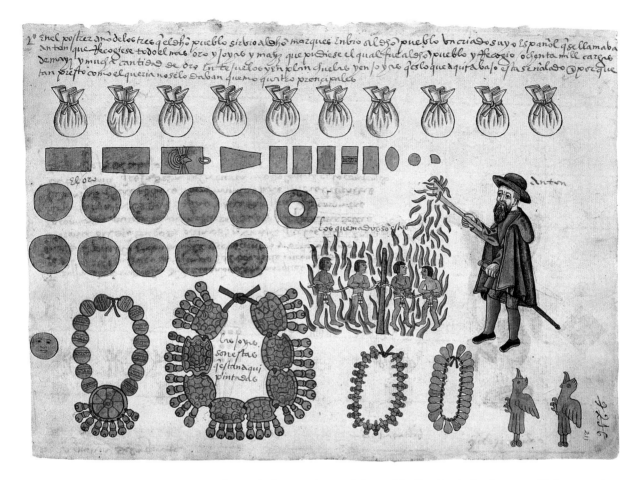

11 Anton burns people. Cloth and gold tribute. Tepetlaoztoc f.9

evaluate their experience philosophically. Again in the case of Mesoamerica, however, native authors not only recorded events but pondered their wider implications. The poets, priests and historians who survived the siege of Tenochtitlan reflected on the momentous changes around them, ever proposing the question of who had entered whose history. The lowland Maya of Yucatan made a similar response, with emphases of their own, in their Books of Chilam Balam. As might be expected, these native accounts generally have a perspective quite different from such European sources as Cortes's letters to Charles v or the famous 'true' history of Bernal Díaz.

Assault on Tenochtitlan

Native and European accounts alike concur in distinguishing the following main phases of action in the assault on Tenochtitlan. First, Cortes and his interpreter Malintzin land at Chalchicueycan/Veracruz and travel through Tlaxcala to Tenochtitlan, which they enter as Moctezuma's guests (April to November 1519). The Spaniards then stay in Tenochtitlan, still as guests, until they are expelled, in the so-called Noche triste (30 June), having massacred citizens during the feast of Toxcatl and brought about Moctezuma's death

(November 1519 to July 1520). Next, with enormous assistance from their Tlaxcalan allies, the Spaniards regroup and besiege Tenochtitlan; Cuauhtemoc, Moctezuma's successor, surrenders (July 1520 to August 1521). Finally, the aftermath brought the Christian mission (1524), the death of Cuauhtemoc (1525), and campaigns in provinces beyond Tenochtitlan's empire (August 1521 onwards).

In narrating these events, the native as opposed to the European historians assert their position through what they choose to record and not record, through their emphasis and their attitudes to the principal characters, and through their basic loyalty to Mesoamerica as a place and to the archival and cultural wealth they saw being destroyed by the invaders. In observing these details, we become aware in turn of the internal differences which separate writers in the Mexica tradition from their rivals the Tlaxcalans, whose dislike for Tenochtitlan led them to side with Cortes. For their part, the Mexica attached particular importance to the process and stages of European intrusion, to technology, to due succession in rulership and in calendric matters, and to the role of Malintzin.

Cortes did not land at Veracruz out of nowhere – some white god mysteriously descended from the heavens. From the garrisons they had established in Cuba, in the wake of Columbus, the Spaniards had been surveying and even attacking Mexico's Gulf and Caribbean coasts for decades before April 1519; and Cortes himself had landed at Cozumel. This activity did not go unnoticed and the intelligence Moctezuma had of it was expressed in the form of omens, threatening disaster: the comet whose flaming, headlong approach

12 Years 1 Reed and 2 Flint (1519–20): first arrival; bodies dismembered by the Spaniards at the Great Pyramid. The *ilhuitl* or 20-day count runs along lower edge, from Quecholli (November) to Tecuilhuitl (July). Rios f.87

to the sun eccentrically contrasts with the steady course of the planets; the Cuatezcatl bird whose head mirrors events to come, in an augury whose periphery uncannily exceeds known bounds.[3] In its account of the reign begun by Moctezuma in 10 Rabbit (1502), the Aubin Codex inserts signs of the new arrivals into the 52-year pattern of fire kindlings and the continuing story of

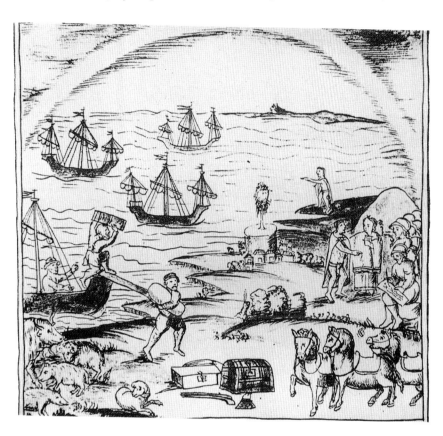

13 Landing at Veracruz. Florentine Codex Book 12, preface

Mexica conquests. After the sightings of 'flying creatures' (*tlacahuillome*) and great-sailed ships in 3 Flint (1508), invitations are actually sent out to the foreigners the following year, to come to Tenochtitlan (fig.14).

When it comes, the landing in Tenochtitlan's territory in Veracruz, April 1519, is marked by the appearance of a huge galleon offshore, complete with its rigging, and by Moctezuma's defenceless envoy bearing gifts and a renewed invitation to the newcomers: these are typified in the pale, bearded warrior on his rearing steed, heavily clad in mail, with lengthy steel-blue sword in hand (fig.12). Meanwhile, weapons are brought ashore, and Malintzin as interpreter controls the lines of communication (fig.13). These initial vignettes list the technological and other advantages which will prove decisive, including the alliance with Malintzin, as we shall see.

Unlike the indigenous swords, manufactured from obsidian blades inset into wood, the Europeans' steel swords could dismember at a single stroke.

14 Years 1 Rabbit to 10 Reed (1506–15). Aubin ff.40v–41

This deadly capacity is the motif of several subsequent massacres, such as those perpetrated inside the holy temple at Cholula, Mesoamerica's Rome, and before the Main Temple at Tenochtitlan during the feast of Toxcatl in 2 Flint (1520) (fig.12). Both occasions generated literally heaps of severed arms, legs and heads. The cannon came into their own chiefly in the siege of 1521, mounted on brigantines in what was predominantly a naval battle on the lake round Tenochtitlan, of which the Florentine Codex gives a compelling panorama (fig.15). 'Giving off smoke' (*yalpopocaya*) is how the conquistador enters Water's Midst (*atliyaitic*) or Tenochtitlan, in the words of 'Atequiliz-cuicatl' ('Water-pouring song'), from the collection of Nahuatl poetry known as the *Cantares mexicanos*.[4] Lines from the 'Tlaxcalan song', another poem in the same collection, trenchantly sum up the impact of metal technology on Tenochtitlan:

> armed with metal
> they wreck the city
> they wreck the Mexica nation
>
> [tepoztlahuiceque
> quixixinia atlon yan tepetl
> quixixinia Mexicayotl]

As for the horse, the Spaniards perceived its effect to be critical even at the pure psychological level; once in power, they confined Indians to foot. The

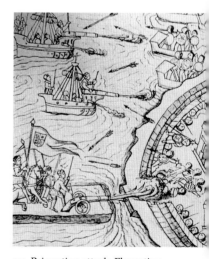

15 Brigantine attack. Florentine Codex Book 12, f.56

16 Years 11 Flint to 1 Reed (1516–19). Left, Spanish galleon, Moctezuma's mummy bundle. Right, musicians (drum, rattle) approached by Spaniard before the temples of Tlaloc and Huitzilopochtli. Aubin ff.41v–42

story of the dog is similar, as the Cuauhquechollan Lienzo and other documents testify, savaging Indians with mastiffs having been a form of intimidation practised by the Spaniards already in Cuba and the Caribbean islands. Las Casas recalled hearing one Spaniard saying to another: 'Lend me a quarter of a Villaine [an Indian], to give my Dogs some meat, until I kill one next.'[5] Above all, the Spaniards were enormously helped in their enterprise by the devastating effect of smallpox and other diseases they imported. With pitiful precision native annals report disease as the single factor that worked most to European advantage, eliminating whole populations and their leaders on a scale never known before.

In detailing in this way the technical and psychological impact of the invasion, the Mexica sources take care to show how political power continued to be transmitted through rulership and the calendar, with its system of 52 named years and of eighteen 20-day feasts within each year. In the heightened times of these first encounters, local annals affirm the rhythm of their own days and years, against the quite different ways of measuring and conceiving time inherent in the Christian calendar imported at Veracruz.

As the threat to Tenochtitlan's rule, Cortes enters local annals at a highly significant moment, in the feast of Quecholli of the year 1 Reed (November 1519). The year name was also that of a monarch of highland Tula, who had been driven to exile and death in the east in the ninth century, where in some accounts his heart fused with the planet Venus and hence with a cycle of recur-

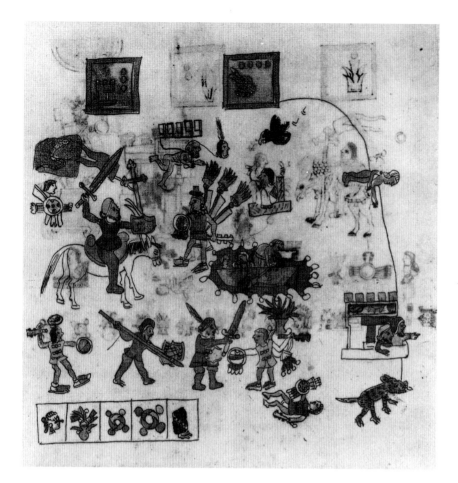

17 Years 3 House and 4 Rabbit (1521–2): siege from Toxcatl (May) to Miccailhuitl (August), with 100 Spaniards and 400 Tlaxcalans killed; Cuauhtemoc installed and Spaniards in Coyoacan (lower right). Rios f.87v

rence that hinges calendrically on the date name One Reed. This pattern of recurrence should not, by the way, be confused with the legends of Cortes as the returning white god put about by the Spaniards and their supporters.[6] As for the feast of Quecholli, this was and is when migrating birds flock to the highland lakes, an apt emblem for Cortes and one foreseen in the 1508 mention of the 'flying' strangers, and in the augury of the Cuatezcatl bird.

Cortes's presence in Tenochtitlan is then spelt out feast for feast, each with its emblem, through the winter solstice in Panquetzaliztli, the spring equinox in Tlacaxipehualiztli, and the celebrations of Toxcatl, up to the expulsion in Greater Tecuililhuitl, by now in the following year 2 Flint (1520) (fig.12). The emblem for Toxcatl, Tezcatlipoca's sacrificial victim, acquires particular resonance, in view of the Spaniards' role as the enthusiastic sacrificers on that occasion, who are portrayed in full swing over a whole page in Rios and Aubin (fig.16); so does the emblem for Tecuililhuitl, the feast of the great lords, and now in fact the time of the torture and murder of the greatest of them, Moctezuma. Moreover, the period of Spanish presence in the capital, thirteen 20-day feasts or 260 days that extend from Quecholli to Tecuililhuitl, is itself

significant, in equalling the ritual *tonalamatl* or gestation period, the 'birth' here being that of the first mestizos and the expulsion of their alien fathers.[7]

From Tenochtitlan's point of view, legitimate rulership did not end with Moctezuma's death, cataclysmic as this was. The line continued with his successor Cuitlahuac, who however was very quickly killed by smallpox, a reminder of the deadly impact of European diseases. Nonetheless, Cuitlahuac's reign was duly measured in the annals as four feasts or 80 days, and his successor Cuauhtemoc duly named. It should also be noted that despite the huge disruption caused by Cortes, the tribute empire of Tenochtitlan went on functioning during these calendric periods, just as it had done before he appeared.

The final siege of 3 House (1521) is shown in the annals to have lasted 100 days or five feasts, from Toxcatl to Lesser Micailhuitl. Indeed the precise moment of Cuauhtemoc's surrender is explicitly said in the Tlatelolco Annals to have been determined by the calendar and the fact that Micailhuitl was the feast of the dead. Its emblem is the corpse wrapped in black that features as the last native feast in several annals (fig.17).[8] The military defeat is typically noted in Nahuatl phrases like *inic poliuhque mexicayotl* ('here the Mexica world was destroyed'). Nevertheless, the line of rulership was continued, by Cuauhtemoc until he was hung by Cortes far off to the east of the Usumacinta river (fig.19), and then by Tlacotzin and Motelchiuh. The latter had greeted the Spaniards at Veracruz, fought them valiantly during the siege, been tortured by them over fire in Coyoacan, and ended his days on an expedition to Colhuacan, near the old Mexica homeland Aztlan, far to the northwest (fig.58).[9] By 5 Flint (1536) the twelfth emperor Panitzin finds himself sharing power with the first of the viceroys, Antonio de Mendoza (fig.18).

18 Panitzin (note the name glyph *pantli* or banner) enthroned as 12th Mexica *tlatoani* in the year 5 Flint (1536); opposite are the first viceroy Mendoza and newly introduced coinage. Aubin f.46v

Defence of an ideal

In the wake of their military victory, the Europeans began a campaign of ideological persuasion, through the church and then the viceroyalty, all of this being registered in annals which, like Aubin, carry on through into the seventeenth century. The Christian initiative, which began in 1524 with the arrival of the Twelve Apostles – Franciscan friars sent to Mexico by Pope Hadrian VI and Emperor Charles V – provoked major responses from the Mexica side, among them the *Cantares mexicanos* manuscript and the Priests' Speech. In their struggle against mindless disintegration, the *Cantares* invoke the heroes and events of the national past, like an earlier water-borne battle at Xochimilco or the founding of Tenochtitlan; and they ingeniously juxtapose the more brutal facts of the invasion – murder, pillage, rape, the siege and razing of the island city – with the finer tenets of Christian doctrine, like the transubstantiation of the flesh and the entry to paradise. A masterpiece of intellectual self-defence, the Speech explicitly contrasts the old pagan order with that then being imposed on Mesoamerica.[10]

The Speech opens on a note of great humility and courtesy, with a welcome

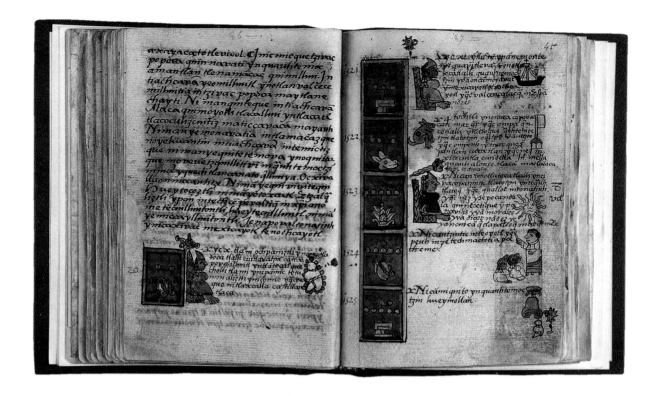

19 Years 2 Flint to 7 House (1520–25). Left, Cuitlahuac dies of smallpox (1520). Right, Cuauhtemoc installed as ruler (1521) and killed (1525). Aubin ff.44v–45

much like that offered to Cortes by Moctezuma when they first met: 'Take rest from the toil of the road, you are now in your house and in your nature.' The claims made by the Christians on their own behalf are then rehearsed, which gives them an ironic air, especially insofar their validation is scripture and holy books: after all, Mesoamerica was itself the home of books which explained the creation and age of the world, in terms, moreover, which have stood up better to scientific research than has Genesis. Reminding the Twelve Apostles that they have been allowed in under sufferance by Cortes, 'our sovereign here' (who gave them his stables as living quarters), the Mexica priests appeal to them as professionals with a vulnerable role in society, warning them: 'If you want peace, do not force the people to see that we are put aside.'

The Christians are then allowed to glimpse something of this native knowledge, like jewels in a half-opened casket, which are three gifts which correspond to the priests themselves and to the complementary professions of the planter and hunter-warrior. From the third the story of empire derives, one which begins in the remote past at Tula and Teotihuacan, cities about which the Europeans are presumed, correctly, to know nothing ('Do you know when the emplacement of Tula was, of Uapalcalco . . .?'), and ends in Tenochtitlan itself. Those who created this tradition are the 'world makers', authors of a harmony and intelligence implicit in the very mechanism and disposition of the Mexica tribute system and the systems that preceded it. This

is quite explicit in the phrases which identify the flow of cosmology with the calendric course of time (the 'usages' of the Chichimec etc) and the ordering of precious tribute items such as quetzal feathers and gold.

> Do you know
> when the emplacement of Tula was, of Uapalcalco,
> of Xuchatlappan, of Tamoanchan,
> of Yoalli ichan, of Teotihuacan?
> They were the world-makers who founded
> the mat of power, the seat of rule.
> They gave
> authority and entity,
> fame and honour.
> And should we now destroy the old law,
> the Chichimec law,
> the Toltec law,
> the Colhua law,
> the Tepanec law,
> on which the heart of being flows,
> from which we animate ourselves,
> through which we pass to adulthood,
> from which flows our cosmology
> and the manner of our prayer?

The *Cantares* and the Speech defend not just the system ravaged by the invaders but the idea of it, its logic and its harmonies. These are manifest in the Mendoza Codex (prepared for the viceroy of that name) even at the basic level of economics and political management, and to a degree that makes all too apparent the failure of the new arrivals to understand the local order of things, let alone match it in their own attempts to set up a colonial administration.

Discernible still in certain of the state borders of modern Mexico, the Mexica tribute system operated according to the model displayed on the title page of the Mendoza Codex: that is, a metropolitan centre surrounded by four provinces to the west, south, east and north, each with its typical products and culture (Map 2). The overall number of towns subject to the capitals of these five areas was made to equal the days in the year, just as the total number of head towns in the quarters equalled the number of nights of the moon (fig.20).[11]

20 Mexica tribute towns arranged according to the ciphers of sun (365) and moon (9,29); products typical of each quarter (beams and planks, west; seashells, south; bags of cochineal, east; loads of chilli, north)

Gobernadores		Head towns		All towns										
Petlacalcatl	+123	centre	9	13	10	26	16	26	7	10	7	9		= 124
Atotonilco	+46	west	7	6	7	13	12	6	2	1				= 47
Tlachco	+69	south	7	10	14	12	14	8	6	6				= 70
Chalco	+82	east	7	6	22	11	11	3	22	8				= 83
Cuauhtochco	+45	north	8	7	6	7	11	7	2	5	1			= 46
	365		29											246

Thickly studded with places which today have become suburbs of the mega-lopolis Mexico City, the central tribute area took in towns around the lakes, such as the former Tepanec capital Azcapotzalco to the west, Xochimilco to the south, Tepetlaoztoc and Texcoco on the east bank, and Cuauhtitlan and Tepoxaco to the northwest. Beyond here, the western quarter, uppermost in the title-page map of Mendoza, ran towards the frontier with Michoacan which the Mexica never succeeded in overcoming. Heavily wooded and largely Otomi-speaking, it provided wild eagles and massive beams of timber. With its provincial capital in the ball-court town Tlachco (today Taxco in Guerrero) the southern quarter furnished such distinctive goods as naturally coloured cotton, and crimson spondylus shells from Acapulco – cult objects treasured along the Pacific Coast as far as Peru.

By far the richest, the eastern tribute quarter stretched from Chalco, on the lake of its name within the Basin, to the far-flung enclave of Xoconochco on the Quiche border (now that of Mexico with Guatemala), the source of exotic jaguar pelts and quetzal feathers. Along the way travellers passed through the Cholula Plain guarded by its four snow-capped volcanoes; Coixtlahuaca, the strategic bastion along the road conquered by the Mexica in 1467, and Mixtec centres such as Nochistlan, a source of cochineal; and Tochtepec, a lure for Cortes after only days in Tenochtitlan and renowned as a source of cacao, exquisitely wrought blankets, jade necklaces, gold tiaras, and the rubber (*ollin*) after which the builders of Mexico's most ancient cities, the Olmec, took their name. Finally, the northern quarter comprised the hot plains and low hills of the Gulf Coast, including the river system of Tochpan, today the port of Tuxpan. A land of Nahua, Totonac and Huaxtec people, its distinctive con-tribution was loads of red chilli peppers, then as now a symbol of spicy sexuality.

Finally, to this geographical model, according to which commodity tribute was delivered to the capital, the Mendoza text adds an account of labour trib-ute, specifying the roles and duties of citizens. In all, the viceroy and through him the emperor Charles v were presented with a harmonious whole which both appeals to the ciphers of ritual and functions as a working arrangement, a cosmogram that integrates the ideal and the material, sky and earth. As a model, the text was aimed from crown to crown, and argued particularly against encomenderos, such as Cortes, who had done much deliberately to wreck the older economic and social structures.

Even after the military defeat of the Mexica, the economic arrangement detailed in Mendoza continued largely to function, though now devoid of its powerful ritual logic, and with a loss of colour and brilliance succinctly recorded at the death of Moctezuma, when the count of years pales from its normal turquoise to black and white. This suppressed world of the Mexica began to be reinvoked in the nineteenth century Wars of Mexican Independ-ence and, above all, in the Revolution of 1910. Then, Indian and mestizo majorities came into their own and the Spanish imposition was reviled: to its

credit Mexico still has no room for monuments to Cortes. According to Hugh Thomas's recent history of the Conquest, the 'magic' in this subsequent story began in the very moment of military defeat in 1521, when carousing through the night Cortes and his fellows could not escape the sense that the greater victory was not theirs: for 'in the end, to be honest, it had been the Mexica who had fought like gods'.[12] This same point is made by the Mexica themselves in the *Cantares mexicanos*, in a sarcastic eulogy of Tlaxcalan and Spanish prowess in destroying Tenochtitlan, a place whose greatness they say will always make it the heart of the nation (*Cantares mexicanos*, Song no.66).

Malintzin

The whole process of the Spanish invasion and takeover is epitomised in the particular story of Cortes's dealings with the person who helped him consistently throughout, that is his ally and interpreter Malintzin or La Malinche, today a major symbol in Mexican consciousness.[13] There has been much debate about Malintzin's origins as one successively 'sold' by family and merchants, before Cortes fell in with her on the Tabasco coast. Native accounts tend to support Bernal Díaz, for whom she was the high-born Doña Marina, against Cortes, in whose letters to Charles v she figures as little more than a 'tongue' or interpreter (both being *lengua* in Spanish). More than that, in the early stages of their joint adventure, she is portrayed as Cortes's equal in every way, one who in addition talked more and actually received better hospital-

21 Malintzin and Cortes each receiving tributes of 80 turkeys, jewellery, and (her additional item) a blanket. Tepetlan Codex

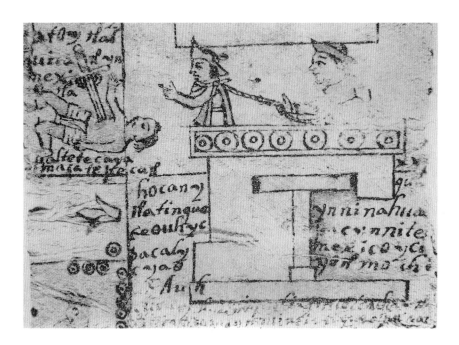

22 Moctezuma as puppet controlled by Cortes. Moctezuma Codex

ity and tribute than he did. Evidence for this comes in texts from Tepetlan (fig.21), which they visited when at Quiahuiztlan, the alternative Veracruz, in June 1519; and from Tizatlan, the first of the Tlaxcalan head towns they encountered on their journey west from the Gulf Coast.[14]

From here on, Malintzin is always present at decisive moments. She negotiates between Moctezuma and Cortes at their first meeting and talks to the former about preparations for the ill-fated Toxcatl ceremony. Fleeing from Tenochtitlan after the Noche triste she gathers intelligence and alerts Cortes to the feelings towards the Mexica harboured by their hosts at Teocalhueyacan. She actually gives a military order prior to the brigantine attack,[15] and stands beside Cortes when Cuauhtemoc formally surrenders, another epochal moment.

The Mexica sources make clear Malintzin's importance not just as an ally of Cortes but as an actor in her own right, whose ambitions provoked particular disgust. After all, had not Moctezuma, himself portrayed as a collaborator and Spanish puppet in the native annals (fig.22), asked how could she behave as she did, being 'a woman among us here' (*ce ciuatl nican titlaca*).[16] In the tense atmosphere before the Noche triste, she hails citizens from a rooftop, with Cortes looking meek and diminished beside her, and demands water and supplies for the Spaniards (fig.23): this shocking breach of etiquette led to skirmishing and several deaths and becomes a motif of the 'Waterpouring song' ('The lady Maria comes shouting, Maria comes saying, "O Mexicans, your water jars go here! Let all the lords come carrying"'). Again, the first thing she and captain Cortes think of doing immediately after Cuauhtemoc's surrender, amid the heaps of carnage, is to recover the gold they had had to leave behind during the Noche triste. Hence the exchange,

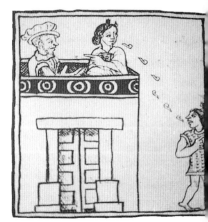

23 Malintzin shouting from roof. Florentine Codex Book 12, f.29

relished by the Mexica historian, between her and the local citizens:

> Then Malintzin spoke again: 'The captain says: "You will produce two hundred gold pieces this size",' and she showed the size rounding her hands. The answer came: 'Maybe some woman or other (*ciuatzintli*) put them up her skirt. They'll be looked for, he'll find them.'

After the Mexica defeat, Malintzin went on to establish a joint power base with Cortes in Coyoacan, where they set up house and had their son Martin, and where such atrocities as the roasting of Motelchiuh were committed, again in the hunt for gold. The eloquently entitled 'Manuscrito del aperreamiento' ('Savaging-dog manuscript') indicts her and Cortes for the murder of several local leaders in Coyoacan: their chief victim, hands tied and held on a chain, is being savaged by a mastiff (fig.24).[17] Cortes is making the word 'to meet' in sign language while behind him Malintzin is carrying a rosary in her hand: this suggests that the leaders were summoned to Coyoacan for Christian instruction – that is, under false pretences, to say the very least. These Mexica insights into Malintzin as a major actor in the conquest help us to form a better idea of that historical event as a whole.

24 Mastiffs savaging leaders summoned to Coyoacan by Cortes and Malintzin (top). Coyoacan Codex (Aperreamiento MS)

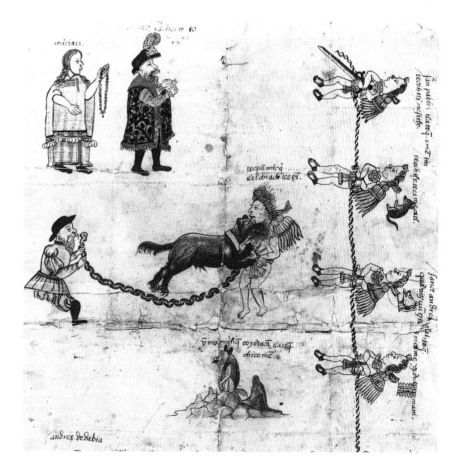

The Tlaxcalan version

The story told in these Mexica documents is repeated over much of Meso-america – Tlaxcala, Coixtlahuaca, the Mixteca, highland Guatemala, Yucatan, Michoacan – with shifts of emphasis according to region and date of impact. In texts from all these places, we find the same consciousness of Mesoamerica as a world entered into by people from afar, the same defence of local causes and rights, and the same recognition of Malintzin's leading role, power and skill. Formally, this is complemented by the same recourse to patterns of knowledge and perception: for example, in the ritual maps found alike in the Mendoza Codex and the Tlaxcala Lienzo, and in the use of calendric signs such as that of the momentous feast of Toxcatl.

One version, however, stands out from all the rest: that of the Tlaxcalans who, like Malintzin, helped Cortes. Here events are seen from quite another angle. Unlike those of the Mexica, the Tlaxcalan texts say little or nothing about what was going on before Cortes arrived and hence about the history the Spaniards entered. As narratives they decline to count or articulate time in the years and cycles of the pre-Hispanic calendar. By the same token they steer clear of the facts of military and ideological conflict and do not register the invasion as a process, or resistance to it in the name of the prior order. Much attention is paid to the first meetings with Malintzin and Cortes en route from Veracruz to Tenochtitlan, which the Mexica could observe only patchily, through emissaries. These meetings are always depicted as friendly, even though in fact they were not, bloody battles having been fought at first on Tlaxcala's eastern frontier, according to the Huamantla Codex, for example, which is from that area (fig.25). And the 'traitor' Malintzin is always shown in a favourable light: she is exemplary as the converted noblewoman who, by

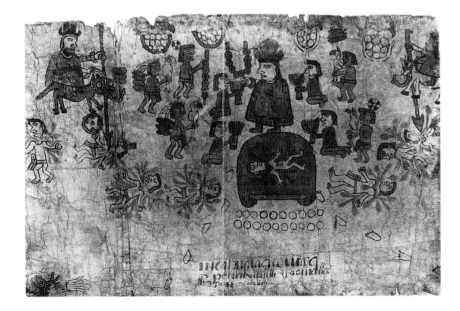

25 Arrival in Tlaxcala. Huamantla Roll

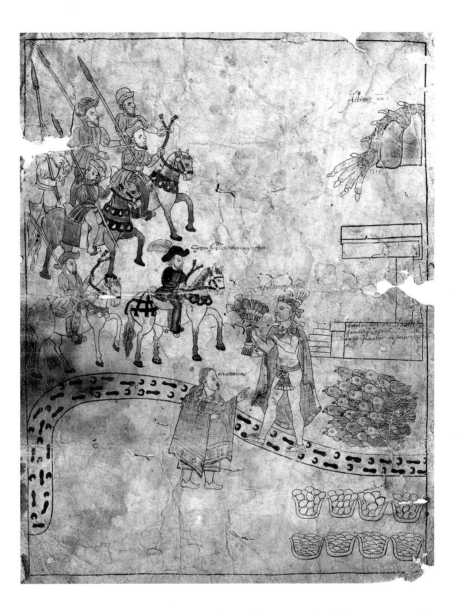

26 Arrival in Tlaxcala. Tizatlan
Codex

her very presence, confirms the viability of the new rules of the game. For the
Tlaxcalan historian Muñoz Camargo she was nothing less than a goddess
through whom true knowledge of the Catholic faith first came to Mexico,
although ideologically her power was with time displaced in part by that of
the Cross itself.

The main Tlaxcalan record is preserved in a series of texts which over time
reflect Tlaxcala's own political ambitions in the two centuries after Cortes.[18]
The oldest in the series, the four-page Tizatlan Codex (or 'Texas Fragment'),
shows the hospitality given to Malintzin and Cortes upon arriving in Tizatlan,
the first of the four Tlaxcalan head towns they encountered on the road from
the coast (fig.26). The first two pages concern their arrival at the waterfall of

Atlihuetzian, where she is greeted by Tepeloatecutli, and then at Tizatlan itself, where he is greeted by Xicotencatl; the second two pages concern the tribute given to the visitors, according to the traditional categories of food and durable goods. For Malintzin these last include precious textiles, and the daughters of nobles who, in the Spanish sources, become 'slaves' that are distributed direct to the thirsty army. Throughout, this Tizatlan Codex adheres closely to pre-Cortesian norms, especially in the way it represents space in plan and in profile, and in the way it sets out the items of tribute according to category and quantity. Further, a strong counterpoint is set up between Malintzin and Cortes as recipients of the tribute, between the red of her clothes and the black of his. For all these reasons, the Tizatlan text, like the Tepetlan Codex noted above and indeed like dozens of documents prepared as evidence for the Real Audiencia, may be placed firmly in the native literary tradition as a statement of account, of debts incurred by the new arrivals, that being the main objective of Tlaxcalan policy at this early stage.

With time, the four pages of the Tizatlan Codex were incorporated into the far longer and much celebrated Lienzo of Tlaxcala, which is known in turn in several successive versions (those of Cahuantzin, Chavero, Yllañes) (fig.27).

	I arrival		II reception	
	a	b	a	b
Tizatlan Codex	1	2	3	4
Tlaxcala Lienzo:				
Cahuatzin/Chavero	4	5	6	7
Yllañes	D	E	F	G
Tlaxcala Codex	31	32	35	34
Entrada Codex		[3	4]	

27 Arrival in Tlaxcala: textual relationships

The objective of the Lienzo was rather to argue for tax exemption and other privileges under Spanish rule, and to urge that, as early converts to Christianity, the Tlaxcalans should be considered conquistadors in their own right in the campaigns that they waged from one end of Mesoamerica to the other – from Nicaragua in the east to California in the west. Here, the account of arrival and sojourn at Tizatlan are subsumed as early events in a much grander story told in 87 scenes, which begins with the supposedly peaceful – as we saw it was not – crossing over the border into Tlaxcala, and goes on to record the whole assault on Tenochtitlan and then, after the Mexica defeat, the wide-ranging campaigns beyond the old empire. In all it is a magnificent text, which describes in great detail the debacle of Toxcatl (duly marked by its pictograph) and the subsequent street fighting in Tenochtitlan. It is prefaced by a fine ritual map, a quincunx of the four head towns of Tlaxcala that centre on the sacred volcano Matlalcueye, the 'blue skirt' which later was significantly christened Malintzin or La Malinche.

True to its purpose, the Lienzo puts much emphasis on the skill and expertise of the Tlaxcalans and on Spanish dependency. During the first approach to Tenochtitlan, the Spaniards are encouraged to strike terror into the hearts of Tenochtitlan by massacring worshippers at Quetzalcoatl's great shrine at Cholula. The choice of this route furthered an old territorial claim to the south, which the modern state of Tlaxcala still nurtures; it also enabled the Spaniards to make their entry into the Basin via the 'route of Cortes', that is, through the imposing portal of the twin snow-covered volcanoes Popocatepetl and Iztac-

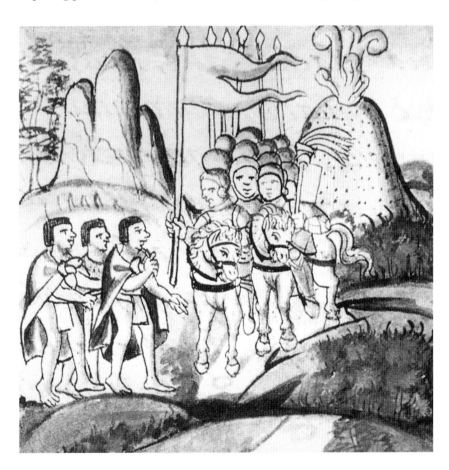

28 Between the volcanoes, on the road to Tenochtitlan. Florentine Codex Book 12, f.18

cihautl, which we see depicted from the Mexica side in the Florentine Codex (fig.28). Then, after the Noche triste, the Spaniards are shown to be very much at a loss, stumbling through unknown and hostile countryside to the northwest of the capital (fig.29), until at last they find a haven – back, of course, in Tlaxcala, which this time they approach via the western head towns Quiahuiztlan and Ocotelolco. Thanks in part to the good offices of Malintzin, the Tlaxcalans agree to help them again, despite their sorry and humiliated state. In this spirit, the Tlaxcalans enable Cortes to regroup, transporting arms and supplies up from Veracruz (fig.30) and planning the new assault on

30 Regrouping at Chalchicueycan, the necklace-place (Veracruz). Tlaxcala Lienzo 30

Tenochtitlan. The strategy followed here, a hard attack on the garrison of Tepeaca and the towns of its tribute district,[19] could have stemmed only from native knowledge; and in the Lienzo it is enhanced as a subset of 11 battles, eleven being the 'military' cipher that determines the total of Tenochtitlan's garrisons in the Mendoza Codex. These battles then culminate in the even more ritualised plan of the siege of Tenochtitlan, a quincunx which this time pits the defenders of that island city at the centre against the Tlaxcalans and Spaniards who occupy the causeways and access routes from Coyoacan, Tlacopan, Tecpatepec (where today the shrine of Guadalupe stands) and Xochimilco (fig.31).

With the defeat of the Mexica, confirmed in the curt Nahuatl gloss *yc poli-*

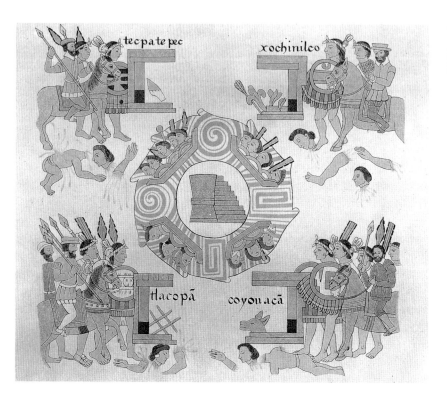

29 Spaniards attack (Cholula) and retreat (Tepotzotlan). Tlaxcala Lienzo 9, 22

31 Siege of Tenochtitlan. Tlaxcala Lienzo 42

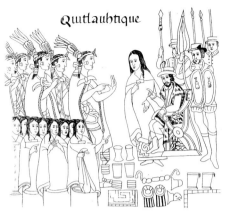

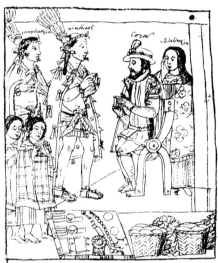

32 Perspectives on tribute: a precise list of gold and jade items and woven blankets blends increasingly into the surrounding scenery. Left: Tizatlan Codex; top right: Tlaxcala Lienzo; below right: Tlaxcala Codex

uhque mexica, the Lienzo goes on, without so much pausing for breath, to record the Tlaxcalan campaigns beyond Tenochtitlan's boundaries, to the northwest in Panuco and the Huaxteca, to the west in Michoacan, Jalisco and California, to the east in the Mixtec, Zapotec and Mixe regions of Oaxaca and in the Maya regions of Guatemala. A key part of the argument in this long last section of the text is that the constant or principle of continuity throughout was given by the Tlaxcalans themselves, who in practice worked with a number of quite different Spanish conquistadors, among them Alvarado, Nuño de Guzmán and Cortes.

Prepared for the visit of the Tlaxcalan delegation to Philip II's court in Madrid in 1585, the Tlaxcala Codex is the next in the series of texts which give the anti-Mexica version of the Conquest. A far longer work and formally now much affected by European perspective (fig.32), the Codex both amplifies and modifies the narrative of the Lienzo; it adds important opening sections on early evangelisation in Tlaxcala and on the glories of the Spanish monarchy,

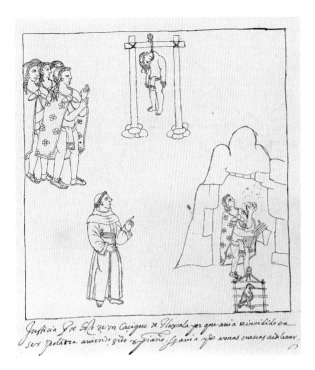

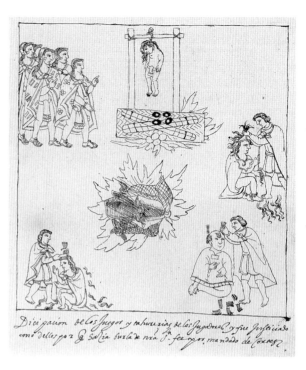

and at the end much extends the account of the campaigns waged to the east and west. These additions have the purpose of making even clearer the Tlaxcalan claim to political power as conquistadors in their own right and in practice directly anticipated the movement of 400 Tlaxcalan families into Chichimec territory in northern Mexico in 1591.

The account of evangelisation shows Christians burned books, burned and hanged people, baptised, cut hair short and introduced more modest dress. One page tells of the misfortune of a nobleman who stayed true to his religion, going to a cave to do penance and sacrifice a quail, which led to his being hanged the very next day (*quipilloque mostlauhqui*) (fig.33). Another tells of the man who played the traditional board game *patolli*, and who was likewise hanged as a result (fig.34). We even see Spaniards denounced for participating in pagan ritual and making offerings of decapitated quails (fig.35). Though brutal, this repression is shown to be all in an ideological cause ultimately espoused by the authors of the text, who having suffered it declare themselves at least as good Christians as the invaders. The section ends by indicating how the system of bishoprics introduced by the Spaniards into Mesoamerica relied territorially on the prior Tlaxcalan conquest of nine of its provinces: Guatemala, Chiapas, Cuixco and Oaxaca to the east, Michoacan, Xalixco, Colhuacan, Panuco and Totonacapan to the west (fig.36).[20]

At the end of the text as a whole, 23 further scenes of conquest appear, which flesh out the panorama of the nine provinces. We go beyond the limits established in the Lienzo to reach eastern Guatemala and Nicaragua, before

33 Hanging a pagan. Tlaxcala Codex 12

34 Hanging a gambler; his patolli board burns below him. Meanwhile friars cut natives' hair. Tlaxcala Codex 11

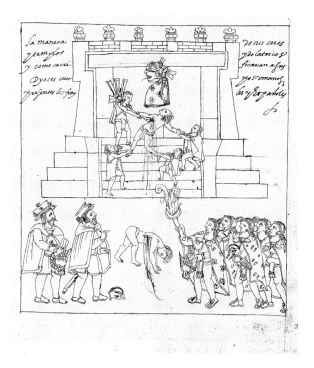

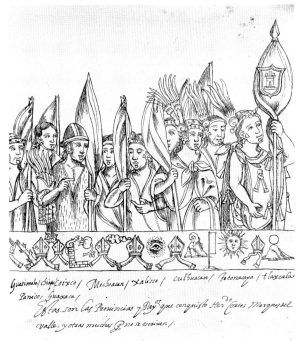

35 Heart-sacrifice ceremony attracts Spaniards who hold decapitated quails, a pagan offering. Tlaxcala Codex 7

37 Right: Cipollan or Zuni, with seven gates (four plus three). Tlaxcala Codex 156

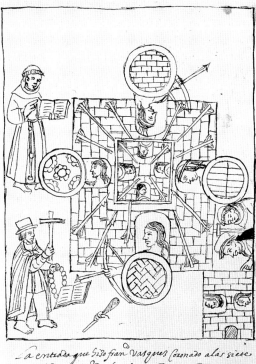

36 Above: The nine provinces. Tlaxcala Codex 19. Left to right: Guatemala/Cuauhtemallan as tree-trunk (*cuauhitl*); Chiapas as *chia* river; Cuixco as snake (*coa*-); Oaxaca as *guaje* plant; Michoacan as cloud (*mix*-); Jalisco/Xalixco as sand-eye (*xal-ix*); Colhuacan as a crooked peak (*col-*); Panuco as banner (*pantli*); Totonacapan as sun (*tonatiuh*); and Tlaxcala as a round tortilla (*tlaxcalli*)

returning to unsubdued areas in Oaxaca. The final page shows the Tlaxcalans entering their plus ultra, the seven towns of Cibola, today Zuni in New Mexico, USA (fig.37). In all, many of the toponyms are unknown or less clear in any other source, which in itself lends the Codex great literary value. Examples are the seven gateways of Zuni, which recall the Seven Caves of Chichimec history; the snake enclosure of Coatzacoalco; the precious waters of lake Atitlan, the sacred focus of many Guatemalan texts; the rainbow of Cozamaloapan, a major archaeological site on Guatemala's Pacific coast; and the water and smoke of Atlpopocayan, 'that is, the volcano of Masaya', which has been a shrine in Nicaragua for thousands of years, as superb but little-known stelae from the region confirm (fig.38).[21]

By the eighteenth century, yet another text had been added to this Tlaxcalan version of the Conquest, the Entrada Codex. Following the later colonial taste of its times, this text concentrates entirely on the glorious deeds of the Spaniards, for whom the Tlaxcalans are now mere allies, giving yet another version of their entry (whence 'Entrada') and of the military defeat of Tenochtitlan. It is far more European in style and composition, making a unified statement out of several of the scenes represented in the Tizatlan Codex and in the Lienzo and the Codex of Tlaxcala; and it adds to these a view of the ship-building operations that preceded the assault from the lake and which were surely due more to Spanish than to Tlaxcalan initiative.

And in all this, what of Malintzin, 'our mother' as she is sarcastically called in the 'Tlaxcalan song' in the *Cantares mexicanos*? As we pass from the Tizatlan Codex to the Lienzo, and from the theme of tribute to that of prior evangelisation, she is literally displaced by the Cross itself. In what had been the second greeting along the road to Tizatlan, Cortes and Xicotencatl embrace a huge Cross, forgetting Malintzin: for all her technical skills and her significance as the mother of Cortes's child, she begins to be ideologically dispensable as a pioneer Christian noble, which confirms, by negative definition, the reading made above of her role in the tradition of anti-Mexica texts. Altogether less crucial to the argument in general, she slips even more into the background with the later Yllañes version of the Lienzo. Here, our view of her figure is interrupted by more dominant masculine elements; her body is rounded out according to the aesthetics of the 'feminine' imported from Europe and as such implicitly becomes the property of the new owners of history.

By the time we reach the Entrada Codex scarcely a trace is left of her autonomy or of the intelligent counterpoint which had linked her with Cortes. Ever the 'doña', she is incorporated into social groups whose disposition and movement match the flagrant machismo of the Colony; and as European perspective is introduced she gracefully slides back along with her indigenous world, anti-Mexica and good hearted, pathetically anxious to gratify the invaders' whim. In other words, this line of Tlaxcalan texts ends by accepting the premise which was always taken as basic by European historians.

38 Distant conquests: a) Tonatiuh Ihuecotian (setting sun), California b) Tecpan Atitlan (lake palace), Guatemala c) Cozcatlan (necklace place), El Salvador d) Cozamaloapan (rainbow river), Sta Lucia Cozumalhuapa, Guatemala e) Atlpopocayan (smoking water), Masaya, Nicaragua. Tlaxcala Codex 100, 105, 121, 134, 139

THE ISLAND AZTLAN

The story of the Mexica and their dramatic rise to power is told in a large number of texts from the Highland Basin, among them the Aubin and Mendoza codices. In these narratives the earliest starting point is specified as Aztlan, the place of the white-feathered heron (*aztatl*). Knowing only a humble life on the island, the Azteca – as the Mexica were initially called – decide to cross to the mainland, and reach a cave in Colhuacan, the crook-top (*col-*) mountain of the ancestors (*te-colli*). In the years of the native calendar this is shown to have happened in the year 1 Flint which, working back from Cortes's arrival in 1 Reed (1519) corresponds to the Christian year 1168 (or possibly 1116, one calendar round earlier). Confirmed now as Mexica, they have as their guide the 'humming-bird' (*huitzilin*) patron Huitzilopochtli and,

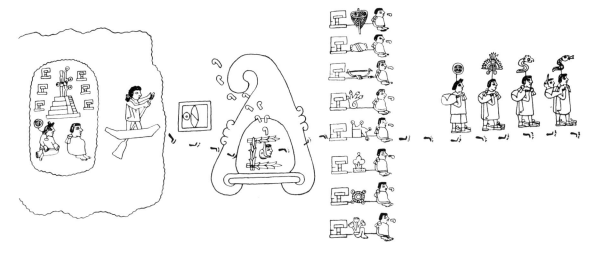

39 Mexica migration: the six clans leave Aztlan and encounter Huitzilopochtli in Colhuacan. Aztlan Annals pp.1–2

receiving the promise of future glory, espouse the calling of warrior hunters. After journeying for many years through harsh terrain, they finally arrive at the Highland Basin. At first they survive only as subjects of powers long established on the lake shore but eventually in 2 House (1325) found their own town Tenochtitlan on an island, the centre of their future empire. Its name derives from the stone-cactus (*te-noch-*), the perch of the eagle that typifies their war-like destiny. There follows a sequence of nine emperors who extend Mexica power to the limits recognised by Cortes when he encountered Moctezuma II in 1519.[1]

Simple enough in itself, this story exists in many versions in native-script texts carved in stone as well as penned on paper and in alphabetic narratives in Nahuatl and in Spanish; and there are many discrepancies between them. These relate chiefly to the particular places visited by the migrant Mexica, and to the role of their patron deity Huitzilopochtli (fig.39). At the same time, we can sense how the facts of history are given ritual shape: the story begins and ends on an island; and in each case this island lies across from Colhuacan, an image synonymous with great age and the name both of the ancestral mountain near Aztlan, and of the lakeside power in the Basin ruled by Coxcox, to which the Mexica were subject just before founding Tenochtitlan.

The discrepancies and this ritual mirroring of events have together led some to dismiss the whole Aztlan story as bogus – either a mere back projection from the position of imperial strength later enjoyed by the Mexica, or the invention of a past by a tribal group that had none, no adventure to speak of prior to their rise to power.[2] It is true that Tenochtitlan, like Rome and other imperial centres, invented and adjusted its history. This was especially so when it came to enhancing the image of the patron deity Huitzilopochtli, whose Aztlan origins appear to have been humble or even plebeian: the fourth emperor Itzcoatl (1428–40) is explicitly said to have burned older histories just because they exposed these origins, which were felt to be no longer fitting for an imperial power.

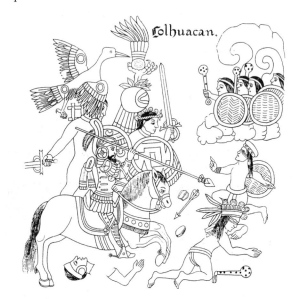

40 Colhuacan, with its crooked peak. Tlaxcala Lienzo 71

For all that, there is a strong consistency in these texts and to deny their historicity altogether must imply a certain arrogance towards the Aztlan tradition, and towards the worth of native histories generally. The sequence of main events noted in the summary above, falling as it does between the twelfth and fourteenth centuries, finds important cross-references in other highland texts: though the dates that plot the migration itself show a certain

slippage, the Cuauhtitlan Annals and Chimalpahin support the Mexica texts with respect to the departure from Aztlan and the start of the imperial reigns. The overall direction of the journey, from northwest to southeast, is similarly consistent and can be plotted on a modern map. Working back from the sure locations in and near the Basin, we may even identify the initial Colhuacan with the mountain of that name depicted in the Tlaxcala Lienzo and Codex (figs 39, 40), which lay in Nueva Galicia, near the home of the Huichol, linguistic relatives of the Mexica. Aztlan, with its herons, must therefore have been an island along that part of the Pacific coast and has indeed been identified with the island-town Mexcaltitlan, Nayarit, which has a similar six-part internal structure and where herons abound.

By far the most authoritative version of the Aztlan story is the one told in the magnificent native-paper screenfold named after the Italian Boturini and here called the Aztlan Annals. As a classic example of the *xiuhtlapoualli* or annals genre, this text attaches events to year dates, from 1 Flint to 6 Reed (AD 1168–1355), at the same time as interweaving them into the places named along the migrants' trail of footprints. Although the fact has been questioned,[3] the style is pre-Cortesian and the outline of glyphs confident and firm. As a native text, its qualities are such as to make it a yardstick by which to gauge all the other versions of the Aztlan story that have survived in iconic script.

In the first instance, these include the Sigüenza or Aztlan Map, also on native paper and more geographical in emphasis, and the Aubin Codex, which combines features of both the Annals and the Map of Aztlan, adding in large passages of alphabetic text in Nahuatl. Then there is a second group

41 Mexica migration, years 1 Flint to 9 Flint (1168–76). Mexicanus pp.18–19

consisting of the annals in the Mexicanus Codex (fig.41), and those known by the name of Azcatitlan, the town of the ant (*azcatl*) inset as a glyph into Aztlan. Here, while Aztlan remains the formal starting point, attention is also given to the grander Chichimec tribal home of Seven Caves, and the migrants pass by more places. Finally, a yet grander version is offered in the Huitzilopochtli manuscripts (Rios and Telleriano), and in those reproduced by Friar Diego Durán, which elide Aztlan entirely into Seven Caves and, like the Mendoza

Codex, extend its political geography to the limits of Mesoamerica itself. Making the comparison between these works helps us to glimpse the historical experience that underlies the journey from Aztlan and to understand the native theme of migration.

Arrival on the mainland

On the opening page of the Aztlan Annals, the crossing from the island to the mainland is made by canoe; in the year 1 Flint the journey continues as a footprint trail which leads in the first instance to a cave in Colhuacan, where Huitzilopochtli issues his promise of future glory, as a stream of nine breath scrolls. Huiztilopochtli's 'disclosure' is the more potent since it emerges through successive mouths: his own which is set in the beak of a humming-bird, which in turn is set into a leaf bower opening inside the cave inside the mountain (fig.39). From here on, four bearers carry him in his beak wrapped in a sacred mummy bundle similar to those used by more northern tribes. As a bird, Huitzilopochtli is a shaman augur; as a humming-bird he is the soul of the warrior who travels huge distances and who belongs to the family of 13 sacred Quecholli or fliers honoured in ritual. His promise is recorded at length by the Nahuatl historian Cristóbal de Castillo, who also brings out the hardships in Aztlan that drove the Mexica to migrate to the southeast:[4]

> You will go to those peoples who have not known combat, who are unpractised in war and unskilled, those who have settled together on the land, those who have dwelt a long time in one place where things are flourishing and organized, places in flower, where want has been banished and everything can be had for the taking by those who work at war.

In the Aztlan Map great emphasis is put on the departure from the island, the beginning of an elaborate double-scrolled progress through the landscape that ends with the arrival at the other island, Tenochtitlan. Here, however, Huitzilopochtli stays bound up in his bundle and the promise of glory is made by another bird, the heron of Aztlan (the Annals show only its feathers, plus the 'a-' sound of *atl*, water). The footprint trail is now our only guide since year dates, starting with 1 Flint, are omitted and instead we are shown the passage of years as dots, again in the style used still by the Huichol and other more northern groups. The Mesoamerican calendar is, however, implicitly invoked in the signs for year multiples also placed along the roadside, 'great ages' (*huehuetiliztli*) of 104 years or two calendar rounds. In the Azcatitlan version, Huitzilopochtli appears from the very start as an august public figure in a white heron-feather cape (again an allusion to Aztlan as heron island), posing atop a mountain already on the island, before his appearance at Colhuacan, where again he is on top of rather than inside the mountain.

The next event in the story occupies pp.2–4 of the Aztlan Annals and it concerns how the Mexica defined themselves in relation to future neighbours in and near the Basin, and how they discover their calling as hunter-warriors.

The neighbours are first listed vertically as eight, the *chicue calpoltin* as Aubin puts it, which can be read as two groups of four. First, from bottom up, we have Huexotzinca, Chalca, Xochimilca and Cuitlahuaca, all inhabitants of Nahuatl-speaking towns which lay to the east of Tenochtitlan and which long before the Mexica arrived were well settled in the agricultural way of life suggested by their very name glyphs, notably the flowering fields of Xochimilco and the manure water of Cuitlahuac. The second four are listed as Malinalca, Tlahuica, Tepaneca and Matlatzinca, not so much inhabitants of towns as tribes active into the west of Tenochtitlan who are linguistically quite diverse and whose preference for hunting is likewise indicated in their name glyphs, especially the bow and arrow of the Tlahuica and the net of the Matlatzinca (figs 42, 48).

42 The eight clans separate at night, four to the east (left) and four to the west (right). Aztlan Annals p.3

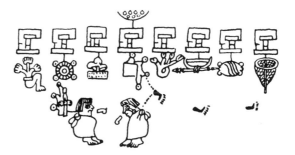

Clearly stated only in the Aztlan Annals, this symbolic distinction between the callings of planter and hunter recurs in the Priests' Speech; it has enormous significance in Mesoamerican culture and in the Classic period affects even the architecture of cities such as Palenque.[5] Here, it comes into full force as the Mexica make their own beginning, at the sign of the severed tree trunk of Tamoanchan, and then under the night sky witness the actual separation of the planters and the hunters whose paths now divide to the east and west. Ever guided by Huitzilopochtli's words they then find their own name – Mexica and no longer Azteca – and their destiny as hunter-warriors by performing the ceremonial acts of capturing in their hunting bag (*huacal*) an eagle shot from the sky, and of sacrificing three *mimixcoa* – 'cloud-snake' hunters – stretched out over cactus and mesquite bushes.

This critical experience is generally lost or blurred in all other accounts, where, for example, the tree of Tamoanchan, no longer felled, is emptied of meaning. In the Aztlan Map the night sky that had marked the separation of planters and hunters becomes the simple place name Ilhuicatepec. In the Azcatitlan Annals the eight planters and hunters lose their cultural value on being reduced to the seven who emerged from Seven Caves, and the night sky becomes an echo of the prolonged eclipse featured in the cosmic scheme of world ages.[6] This latter source does, however, echo the planter-hunter divide in separating off maize-tending women from the male hunters, who continue

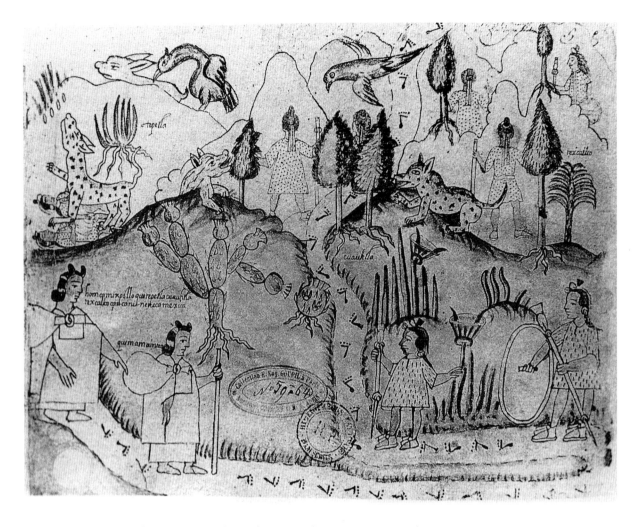

43 Through the wilds. Azcatitlan
Annals p.9

along the main road of migration; and in referring to the Mexica start as their
'flood', which again echoes the world-age scheme, it alerts us to the deep
connection that exists in American cosmogony between the felled tree
Tamoanchan and the tumultuous birth of rivers that drowned the world. As
for the eagle shot by the Mexica, in the Azcatitlan and the Mexicanus texts it
appears paired with the jaguar, simply as a stereotype indication of the wild
hazardous country through which the migrants were passing (fig.43).

Towards the highland lakes

After these complex beginnings, of arrival and initiation on the mainland, the
Aztlan Annals follow a more straightforward course, signposted by a series
of toponyms that interweaves with a boustrophedon count of years. The first
pair of toponyms, Cuextecatlichocayan (where the Huaxtecs weep) and
Coatlicamac (snake maw) (fig.45),[7] leads them to Tollan or Tula, the place of
rushes which dominated the Basin and highland Mexico in the tenth and

eleventh centuries AD (pp.5–7) and which was by then abandoned. This route towards the Basin – one previously used by the Chichimecs who followed Xolotl (as we shall see on p.63) – skirts what was once the domain of the Huaxtecs of the Gulf Coast, who are here identified by the perforated nose and swept up hair characteristic of them. The former military strife between Tula and the Huaxtec was ritualised in arrow shooting instituted by the witch-like 'cotton mothers' known as Ichcuinanme, the cause of the Huaxtecs' tears.[8] In the Huitzilopochtli version, the Huaxtecs are given new reason for weeping, since here a division of the Mexica invades their territory, later incorporated in fact into Tenochtitlan's tribute system, attacking towns such as Tetepanco (also in the Aztlan Map) and Pantepec. Just before they reach Tula, the Mexica kindle New Fire in 2 Reed (1195), the first of the seven kindlings they performed before Cortes arrived in 1519; the sign 2 Reed bears the knot of the year binding (*xiuhmolpilli*), that is, the calendar round of 52 years.

A further run of four towns of water and fire – Atlitlalacyan (sink hole), Tlemaco (brazier), Atotonilco (hot water), Apazco (water basin) – brings us firmly into the Basin, to Huitzcol, where the Mexica perform their next kindling (1247) and nearby Tzonpanco, the skull-rack place, today Zumpango of the northern lake. Their arrival at Tzonpanco was bloody and it was the skulls of the local inhabitants that led to a change of name, from Atenco.[9] From here they pass through another series of places before reaching the extra large glyph of Chapultepec, the grass-hopper mountain that marks a major halt in all the main versions. Winding north to south, the list that culminates in Chapultepec anticipates the line of 11 garrisons later set up to guard Tenochtitlan's tribute empire, several of them reappearing in that capacity (fig.161), namely, Tzonpanco, Xaltocan, Acalhuacan, Coatitlan (here they bring the maguey plant from Chalco and for the first time make the alcoholic drink pulque), Acolnahuac and Popotlan. The list also includes Huizachtepec, the

44 Pantitlan ('place of banners'): offerings at the whirlpool shrine. Florentine Codex Book 1, f.23

45 Cuextecatlichocayan ('weeping Huaxtec') and Coatlicamac ('snake maw'): a) Aztlan Annals p.5 b) Aubin f.6 c) Mexicanus p.20

site of the grand kindling of 1507, the last before Cortes, along with places that became major shrines around Tenochtitlan, such as the whirlpool at Pantitlan (banner or flag) (fig.44), and Tecpayocan (abundant flint), the site of the kindling of 1299, and the antecedent of what is today the most visited shrine in Latin America, that of Guadalupe, at Tepeaca.

Having brought us to Chapultepec, depicted as a major water-source, the

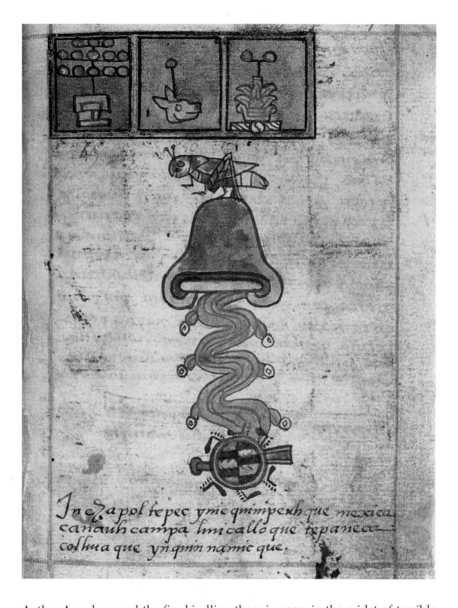

In cçapol tepec ymc qmmperh que mexica
canauh campa hmi callo que tepaneca
colhua que ynqmn namic que.

46 Battle at the water-source Chapultepec in the kindling year 2 Reed (1351). Aubin f.19

48 Opposite, Aztlan. Aubin f.3

Aztlan Annals record the fire-kindling there in 1351, in the midst of terrible defeat at the hands of the Colhua and the Tepanec. Driven ignominiously from the high ground, they flee on rafts through the marshes, arrows flying past their heads (figs 46, 47). The Aztlan Annals then come to an end, showing how the Mexica had to work as mercenaries for Coxcox of Colhuacan, in his wars with Xochimilco. The very last moves made by the Mexica, before

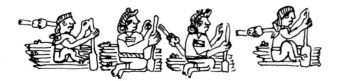

47 Left, Mexica fleeing in the year 6 Reed (1355): two men and two women paddle rush and reed rafts (*acatlacuextica, tolmatlapa*). Aubin f.22

52

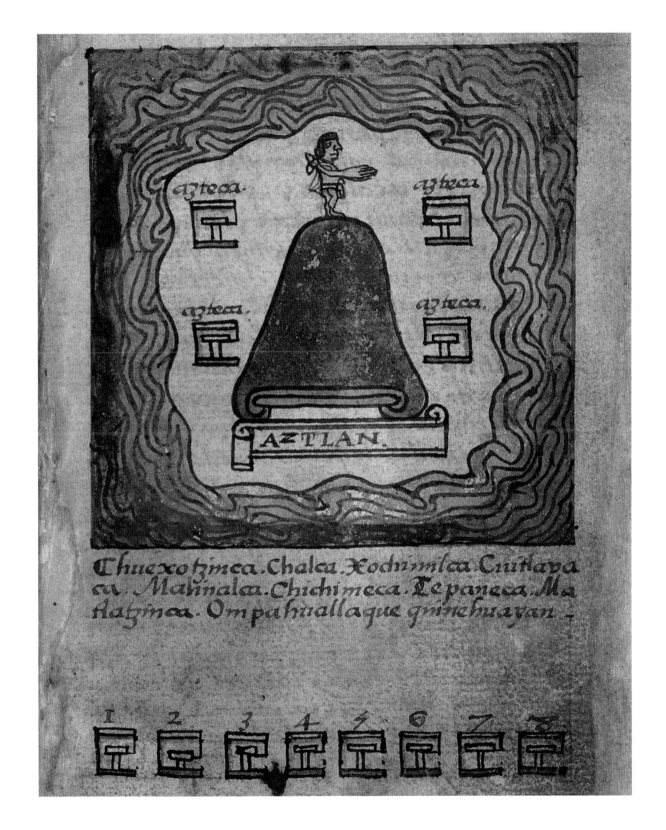

they emancipated themselves and founded their own centre at Tenochtitlan in 1363–4, are depicted in the other versions and they include visits to the places of dark ash (Nexticpac) and white saltcake (Iztaccalco), of child-bearing (Mixiuhcan) (fig.49) and the midwives' steambath (Temazcaltitlan). This last pair of places leads us directly to the 'birth' and imperial ascent of Tenochtitlan.

Over the course of the migration, the Aubin Codex follows the Aztlan Annals quite closely (fig.50). True, in Aubin much of the information conveyed entirely in iconic script in the Aztlan Annals is transcribed alphabetically into Nahuatl, and the glyphs that remain are not always drawn with precision or understanding. Cases in point are the 'weeping Huaxtec' of Cuextecatlichocayan (fig.45), which gets all but swallowed by the snake maw of Coatlicamac; and the four bearers of Huitzilopochtli's bundle whose names are blurred, Cuauhcoatl (eagle-snake) losing his distinctive bird-like head and fork-feathered tail. Similarly, as in other later sources, toponyms and events are interchanged, so that the place Mixiuhcan is read as Mexica women giving birth at a particular moment in time (fig.49).[10] Yet now and again Aubin actually surpasses the Aztlan Annals in precision, for instance, in outlining the 'bent awl' of the mountain Huitzcol.

In matching the Aztlan Annals place for place, Aubin makes, however, one significant addition. The first kindling, performed just prior to arrival at Tula and unlocated in the Aztlan Annals, is assigned to a specific place in Aubin, as it is in the other later texts (Azcatitlan, Mexicanus, Huitzilopochtli), namely the snake mountain Coatepec, close by but not the same as Coatlicamac (fig.50).[11] Later reflected in the architecture of Tenochtitlan's main pyramid, Coatepec was celebrated as the place of Huitzilopochtli's celestial birth, as the sun who put to flight the stars of the southern sky. It bears all the marks of a place and concept inserted into the migration story in the interests of an already imperial Tenochtitlan.

In the Sacred Hymns of Tenochtitlan, composed to match the grander architecture of its power, Huitzilopochtli is the 'one born on his shield' at Coatepec. Miraculously conceived, he executes those who had spoken of his illegitimacy even as he leaps from his mother's womb, fully armed.[12] This is a most suggestive development of the parthenogenesis motif widespread in stories of American epic heroes, where the problem of the absent father is usually resolved by quite other means. The point here is that Huitzilopochtli's illegitimacy is never denied, rather it becomes the source of his energy and his prompt action. In ignoring Coatepec, the Aztlan Annals remain true to a less exalted account of early Mexica history, which also takes care not to omit their years of servitude to Coxcox. At the other extreme, the Huitzilopochtli manuscripts play down this degrading experience, while making much of the godly birth at Coatepec and even insinuating that the Mexica were conquerors before their time, for example in the Huaxteca. Between the two, Aubin admits the notion of Coatepec, though without the showier imperial trappings.

49 Mixiuhcan, the child-bearing place, with midwife, blanket and cradle. Azcatitlan Annals p.22

Founding Tenochtitlan

The founding of Tenochtitlan, which occurs after the Aztlan Annals come to an end, is a major event in the other Mexica histories. It is the culminating moment in the Aztlan Map, while in the Mendoza Codex it occupies the title page, and in each case the future capital Tenochtitlan is shown at the centre of its four quarters (fig.51). The site is marked by the eagle perching on the stone cactus (*te-noch-*); in later texts such as Aubin the eagle is shown eating a snake, a celebrated image which today officially designates Mexico on its flag and its banknotes. Some scholars have explained the dietary addition, that is the snake, as a misreading of the seething stream of water-and-fire (*atl-tlachi-nolli*) that symbolises war and which issues from the beak of this same eagle in Mexica sculpture. This may be, yet it should not be forgotten that according to the Aztlan Annals one of the four bearers who carried Huitzilopochtli during the migration was called Cuauhcoatl, a name which contains the concepts of both eagle (*cuauhtli*) and snake (*coatl*).

In depicting the foundation of Tenochtitlan, Mendoza ingeniously indicates how the plan of the city prefigures that of the empire. Around the eagle and stone cactus spreads territory separated into four quarters by turquoise streams. At the most local level, the streams evoke the canals cut to drain the lake marshland, with its reeds and bullrushes; on the grander scale, they suggest the inflow from the four provinces of the tribute empire. By means of the same spatial shift, the skull rack to the right could denote the architectural

50 Coatepec, the snake hill; years 1 House to 2 Reed (1181–95). Aubin f.6v–7

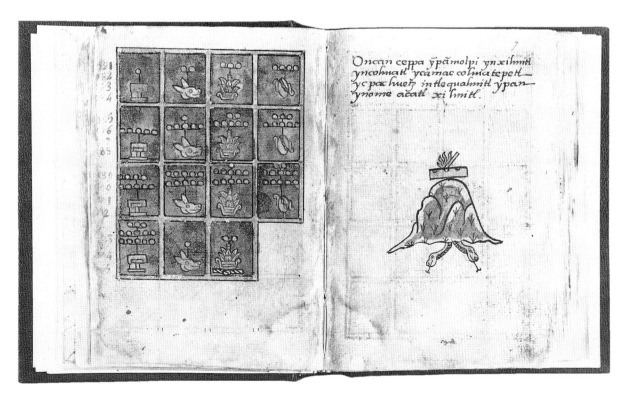

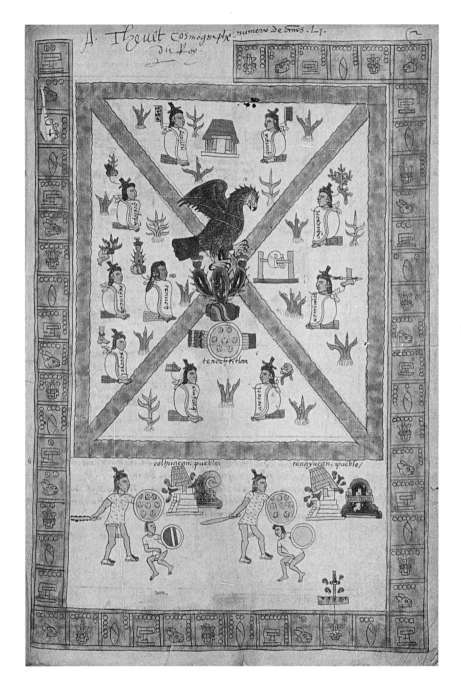

51 Title-page map: the four quarters of Tenochtitlan. Mendoza f.2

feature that stood to the north in the precinct of the main pyramid, dedicated to Tlaloc and Huitzilopochtli; or it could refer to the town Tzonpanco, the site of the Mexica conquest on the northern shore of the northern lake. Again, opposite the skull rack, the inaugural and eponymous ruler Tenoch sits on his wickerwork seat: he is surrounded by his council of nine on lesser seats whose total anticipates the nine tribute districts of the metropolitan area.

The years of Tenoch's reign, from 2 House (1325) to 13 Reed (1375), provide a frame for the foundation scene, while two of the four year names, House and Reed, reappear as a paired motif in the remaining quarters. Above, to the west, a thatched rustic hut recalls the Mexica's migration from Aztlan, and asserts their role as the western bastion of the Mesoamerica of their day – the lake map authored by neighbouring Tlatelolco similarly puts west uppermost; the Mexica even punned their name with the crescent new moon that appears in the west and which today is the emblem of the Virgin Guadalupe.[13] Below to the east, reed-arrows plus shield emblemise the warfare they prosecuted chiefly in that direction, east having been easily the richest tribute quarter.

Events said by Mendoza to have occurred during Tenoch's inaugural reign include the conquests of Colhuacan and Tenayuca, and the fire kindling of 2 Reed (1351). The Aztlan Annals and the Aubin Codex alike give a less than triumphal version of this kindling, which took place at Chapultepec; indeed the Mexica are said to have been routed on that occasion by precisely the polities Mendoza claims they conquered. Yet more telling, the Aztlan Annals

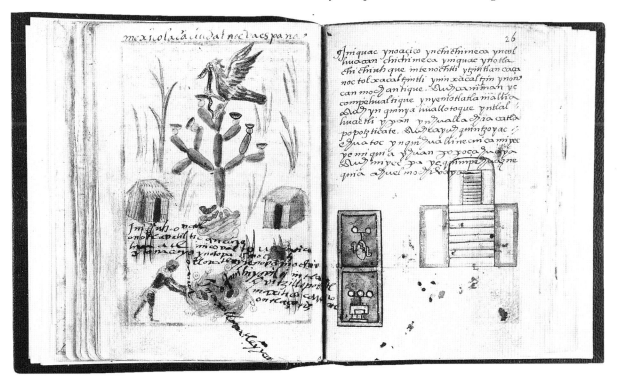

52 Founding Tenochtitlan; Years 2 Flint to 3 House (1364–5). Aubin f.25v–26

make no mention at all of Tenoch, even at the moment of his supposed accession in 1325, and in Aubin as in Mendoza he is distinguished from his successors by having a seat rather than a full throne (*icpalli*). In all, this confirms Mendoza as a high imperial account of Tenochtitlan and its people, in which awkward or unworthy details are suppressed, in the name of established models and ciphers such as the four world quarters and the ninefold council.[14]

Later versions of the founding of the city go yet further; Tezozomoc, for example, tells how Huitzilopochtli hallowed the site by planting there the heart of his nephew Copil, in a sequel to his own alleged divine birth at Coatepec.

Aubin gives its own intriguing version of the founding of Tenochtitlan (fig.52). Here, the pair named Cuauhcoatl and Axolohua recognise the centre of the future town and empire in the eagle's nest that is built of iridescent feathers on the stone cactus, beside gourd-green water. As we saw, Cuauhcoatl is the name of the bearer of Huitzilopochtli's bundle which anticipates the image of the snake-devouring eagle atop the cactus. Axolohua is drowned in the water of the lake, only to revive and tell of his vision of the ancient rain-god Tlaloc, who announces that he welcomes Huitzilopochtli as his future companion and neighbour. With the construction of the main pyramid, just this welcome was consecrated in the pair of temples atop it, dedicated respectively to each of them, farmer and hunter-warrior. Axolohua's name indicates he is a relative of the *a-xolotl*, 'water dogs' or amphibians native to the highland lakes: *axolotl* and *xolotl* dogs have, in common with humans, the unique neothenic property of having tender naked skin. As amphibians, they also waver between being larvae and fully-developed: as the *Cantares mexicanos* tell us, this is an apt condition from which to reveal the vision of Tlaloc and to anticipate future metamorphoses.

The Mexica rise to power was presided over by a series of rulers whose sequence, names, dates, and areas of activity are generally agreed, that is, after the dubious initial case of Tenoch (fig.53). In Mendoza, as in Azcatitlan and

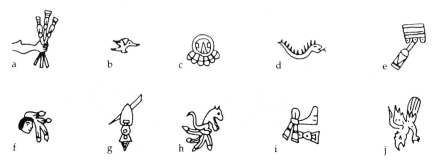

53 Mexica emperors:
a) Acamapichtli 1376–95
b) Huitzilihuitl 1395–1414
c) Chimalpopoca 1414–28
d) Itzcoatl 1428–40 e) Moctezuma I
1440–69 f) Axayacatl 1469–83
g) Tizoc 1483–6 h) Ahuizotl
1486–1502 i) Moctezuma II
1502–20 j) Cuauhtemoc 1520–4

Mexicanus, these accounts are arranged as nine reigns which ritually echo the inaugural council of nine, while Aubin formally continues to adhere to the genre of annals and to narrate events year by year. In each case we witness how, having secured shoreline strongholds to the south and east in Colhuacan and to the north and west in Tenayuca, the Mexica under their first three emperors took over the Basin and what became the metropolitan area. This included Xaltocan, Cuauhtitlan and the northern lake; Otumba, Texcoco and the east bank of the central lake; Xochimilco, Mizquic and the southern lake (neighbouring Chalco always remained a special case); and Cuauhnahuac, today Cuernavaca, Morelos, over the southern mountain rim. With the defeat of Azcapotzalco and the Tepanec domain to the west, the Triple Alliance was

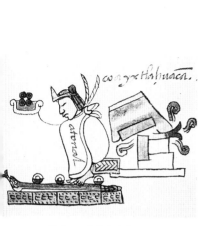

54 Defeat of Coixtlahuaca ('snake-plain', from *coa-*, snake, and- *ix-* star-eye) and its ruler Atonal (*a-tl*, water or river; *tonal*, sun or fate). Mendoza f.7v

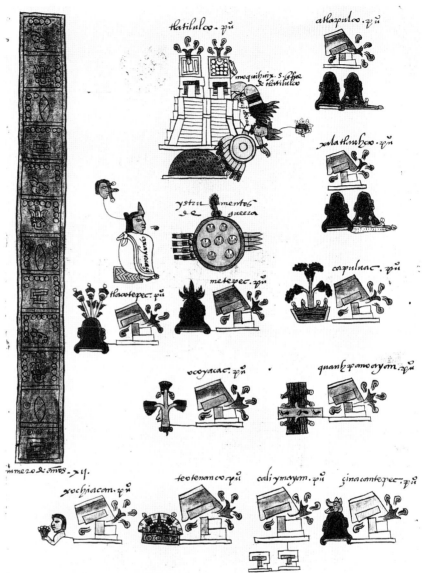

55 Reign of Axayacatl, Years 4 Rabbit to 2 House (1470–81); defeat of Tlatelolco and its ruler Moquihuix. Mendoza f.10

forged between Tenochtitlan, Texcoco and Tlacopan and a big expansion occurred under Itzcoatl (1428–40). This emperor began the push southwards beyond Cuauhnahuac to Tepecuacuilco and what became the southern province, today the state of Guerrero, a source of cotton and spondylus shells from the coast of the Pacific or 'southern sea'. The prime feat of Moctezuma I (1440–69) was to take Coixtlahuaca, the key to the Papaloapan valley and therefore to the immensely rich eastern tribute province; in Mendoza, Coixtlahuaca is the only town apart from Tlatelolco to be honoured with the naming of its ruler (figs 54, 55). Moctezuma also pressed towards the Gulf Coast and the 'northern sea', laying the foundations of what became the north-

ern province, known for its variety of hot chilli peppers. For his part, Axayacatl (1469–83) pressed towards the Huaxteca, completing the northern province; and he battled hard against Toluca to the west, the source of timber and wild animals and always the least tractable of the four provinces. The reign of Tizoc (1483–6) was proverbial for its brevity and lack of lustre; as if to compensate, two huge *cuauhxicalli* or stone altars attribute to him two ritual series of 11 and 15 conquests, albeit of places previously subjected. Conquests under the remaining two emperors, Ahuizotl and Moctezuma II, were much more numerous and reached further afield, Moctezuma having driven as far east as Xoconochco and the border with the Quiche kingdoms of Guatemala. At the same time, these emperors consolidated the system of four provinces encountered by Cortes and celebrated to such effect in the codex prepared for the viceroy Mendoza.

At the centre of the system and the metropolitan area, Tenochtitlan thereby vastly enhanced its own architecture and self-image, notably in 1487 when inaugurating the main temple, constructed with the labour of the 'four towns' of Morelos (Cuauhnahuac, Tepoztlan, Huaxtepec, Yauhtepec) (fig.56); and in 1507, the last kindling before Cortes, held at Tlaloc's new temple atop Huizachtepec near Colhuacan, a scene gloriously represented in the Borbonicus screenfold (fig.162).

Several of the histories in the Aztlan tradition end with Cortes's invasion or soon after it. In the Azcatitlan Annals Mexica princesses stare enigmatically

56 The great pyramid and the four towns (*naualtepetl*): Cuauhnahuac (speaking tree), Tepoztlan (axe place), Huaxtepec (hill of the *guaje* plant) and Yauhtepec (hill of the *yauhtli* herb). Aubin f.38v

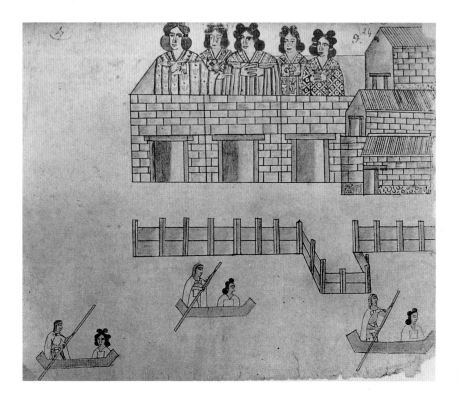

57 The princesses ferried away. Azcatitlan Annals p.47

over the walls of their city, before these are razed and the serious business of conversion begins (fig.57); in Mendoza, colour drains dramatically from the two years that follow Moctezuma's death. Aubin, however, carries on right through to the following century, in all completing a span of 440 years. Registering the destruction caused by the conquistadors and the imposition of new Christian rituals, it shows notable continuity and narrative evenness of its

58 Years 8 Rabbit to 4 Reed (1526–35). Aubin ff.45v–46

own. Thanks to Vollmer's meticulous edition, it also emerges as the yardstick for a whole cluster of subsidiary Mexica annals, several of them now in Paris. The details Aubin offers of events after Cortes's arrival are particularly valuable for understanding the echoes and hidden coherences found by the Mexica in their longer history, in the fashion most fully developed in the *Cantares mexicanos*. Hence, the brigantine attacks of 1521 recall the flight in rafts from Chapultepec in 1351; Motelchiuh's return in 1528 to the Colhuacan that lay across from Aztlan recalls the Mexica's departure from that place, along an inverted footprint trail (fig.58); and the final kindling of new fire, still recorded for the year 2 Reed (1559) and noted as the eighth since the departure from Aztlan, is preceded by a locust, both a symbol of a voracity, well exemplified now by the new invaders, and the sign for Chapultepec, the site of the fateful kindling of 1351.

SEVEN CAVES AND THE CHICHIMEC

Historically, the Mexica arrived in Mesoamerica as the most recent of many waves of intruders from the northwest. These predecessors are generally known as the Chichimec, a name which denotes both canine qualities and the propensity to suckle, proper to non-agriculturalists who live off the breast of nature. Superb archers and desert dwellers, the Chichimec entered Mesoamerica proper by force, or were invited in as allies by ailing governments, or were placated by being made trustees of high-ranking hostages. Having themselves gained power, they then recorded their own ancestral histories as a means of defending it, not least against fellow Chichimec. According to the *Relaciones geográficas*, the title *chichimeca-tecutli* or Chichimec Lord came to typify the notion of independence, specifically in polities such as Tlaxcala, Tochimilco and Texcoco which resisted the Mexica tribute system or entered it on privileged terms.

59 Seven Caves as eyes and the other head orifices. Laud p.22

These people acknowledged a common origin in Chicomoztoc, the place of Seven Caves. Like Aztlan, this homeland was perceived to lie far off in difficult terrain near the ancient crook-tip mountain Colhuacan. Indeed, as we have seen, in some Mexica accounts of the migration from Aztlan, Seven Caves is actually fused with Colhuacan, which is also what happens in certain of the Chichimec texts. Insofar as Seven Caves can be assigned to a geographical spot of its own, a good candidate would be the mountain and archaeological site called Chicomoztoc that lies just south of Zacatecas, near the tropical line: this place is known for its seven caves and for its massive dry-stone walls and temples, which are thought to have been built as early as the second to the sixth centuries AD.[1]

The story of the southeastward migration from Seven Caves is told in a great array of texts, among them several characteristic *tiras*, long unfolded strips or rolls of native paper or skin, read left to right and top to bottom. In consistently identifying Chicomoztoc as the point of departure, these sources represent it as a literal birthplace, its caves serving as a womb, or as a mouth, the largest of the head's seven orifices (fig.59).[2] As such, the number seven commonly defines places of origin in Mesoamerica and beyond, for example in the fabled city of Cibola, today Zuni in New Mexico, depicted at the end of the Tlaxcala Codex.

Beginning as early as the seventh century AD, Chichimec intrusion was a long and complicated affair. Those who had first left Chicomoztoc were iden-

tified as patron ancestors, of whom over 100 were identified by name, among them Tonatiuh (Sun), Ocotochtli (Pine Rabbit), Mixcoatl (Cloud Snake), Nopal (Cactus), Cuauhtzin (Little Eagle), Tecpatzin (Little Flint) and Tzitzitl (Little One); or they elaborated on the dog-like qualities of the Chichimec, as Itzcuintli (Black-and-White Dog), Ome-Itzcuintli (Two-Dog), Ahuizotl (Water Hound) or Xolotl (Dog, usually with Ruff).[3] Xolotl was also recognised as the name of the epic deity, Quetzalcoatl's double, who had brought about the settlement at Seven Caves in the first place. Mixcoatl was pursued by the fearsome (and calendrically symbolic) Itzpapalotl, Obsidian Butterfly (fig.60). As a principle, the lives of these august inaugural figures are not limited to normal human spans but serve rather to link departure from Chicomoztoc with arrival at the new homeland.

In the larger perspective, the Chichimec come to represent a whole historical phase, not unlike the Middle Ages in Europe. Most likely Otomi-speakers in the first instance,[4] they adopted the languages (chiefly Nahuatl), dress and customs of the different arenas they entered and came to dominate. The records they left, very numerous and diverse, adhere to different local styles when, for example, naming people or counting calendar years. For all that, the point of departure is always Seven Caves. And the destination is always the *chichimeca-tlalli* or Chichimec domain, a series of clearly marked and overlapping arenas, of which five are especially well represented in native texts: the Highland Basin, the Cholula Plain, Tlaxcala, Coixtlahuaca and Cuextlan.[5]

The Highland Basin

The most celebrated account of the Chichimec arrival in the Basin is the set of maps from Texcoco named after the leader Xolotl, which has the three lakes as its constant focus, with Texcoco and the east bank uppermost. Moreover, these maps were an immediate and constant source for one of the most able native historians of post-Cortesian times, Ixtlilxochitl (Obsidian Flower) – also the name of an ancestor who once ruled Texcoco. According to these documents, at the time when the Mexica were setting off from Aztlan, Xolotl and his son Nopal had already followed the path through Cuextecatlichocayan, Coatlicamac and Tula to the Basin, with which Map 1 opens (fig.61, bottom left). Here, Tula features as the smallest and most recent of four ancient sites visited by the pair, the other three being the vast city of Cahuac to the northeast, a temple near Tepetlaoztoc, and the Pyramids of the Sun and the Moon at Teotihuacan. Easily the largest, Cahuac is identified by a frog, and in Nahuatl the name means 'abandoned': shown on Spanish colonial maps as 'Caguala', its ruins lie near present-day Ixhuatlan de Madero and have been described as Huaxtec.[6] The reverence felt for these places, already then partly in ruins and overgrown with *zacate* grass, is expressed by the fact that they are designated as 'Toltec', that is, proper to the ancestors who first brought urban skills to Mesoamerica and who founded a whole line of cities that stretched up from the Gulf Coast to the highland Tula recorded in the Xolotl Map. The

60 Mixcoatl (left) and Itzpapalotl (right) in the year 4 Flint (upper right). Stone inscription from south of Tepexic (after Seler 1915)

61 The highland lakes. Xolotl Map 1

term Toltec is also applied to the older inhabitants of the Basin shown in the Map, whose civilised cotton clothes contrast exemplarily with the rough animal skins that still cover Xolotl and his band.

Having further surveyed the new territory from look-outs thereafter named in his honour, Xolotl installs himself at Tenayuca, the centre which preceded the founding of Azcapotzalco on the west bank (the Tepanec capital whose Landbook is inaugurated by Xolotl, fig.62) and of Texcoco on the east bank. From here he ceremonially marks out boundaries to the four sides of the page, taking in the snow volcanoes Chiuhnautecatl (Nevado de Toluca, southwest) and Poyauhtecatl (Orizaba, southeast), along with the strongholds of Tenanitec (northeast), Metztitlan and greater Atotonilco (northwest). Reaching far eastwards as it does – beyond Popocatepetl, Iztaccihuatl, Tlaloc and the mountainous rim of the Basin – this ambitious claim never actually

fell under the single control of Texcoco. The Xolotl Maps serve, however, as an excellent reference for the larger corpus of Chichimec texts, since they encompass the arenas of Cholula and Tlaxcala, and set up boundary marks such as Tenanitec, Tototepec and Cuauhchinanco (Huachinango) that are held in common with the Cuextlan texts further to the northeast.

62 Xolotl as dynastic forebear. Azcapotzalco Landbook

Xolotl Map 1 lays the foundation for Texcoco's rise to power, as the first in the series of ten maps. The last of these pay particular attention to the life of Nezahualcoyotl who when young had to flee the Tepanec tyrants Tezozomoc and Maxtla, and who eventually collaborated with the Mexica emperor Itzcoatl in building up the Triple Alliance, after the defeat of the Tepanec: this golden moment, the year 4 Reed (1431), stands as the starting point for a whole body of other Texcocan histories. As such, this Texcocan version of Chichimec history has its own emphases, ones we find either confirmed or modified in other Basin texts. In presenting their case against Tepotzotlan to the Real Audiencia in 1556, San Mateo Xoloc and its allies made much of this same pedigree, evident in the very name of the town in question – once a look-out used by Xolotl himself. On the other hand, Chichimec centres such as Chalco, Tlatelolco, Cuauhtitlan and Tepetlaoztoc diminish or remove Xolotl from the

65

story altogether, proposing instead heroes of their own, such as Cuauhtzin, Mixcoatl and Tonatiuh.

Surveying the Basin from one of his lookouts on the northern rim of the northern lake (San Lucas Xoloc near Xaltocan), Xolotl in the Tlatelolco Map is quite outdone by Cuauhtzin, who stares back from the southern rim of the southern lake, larger, and with the memory of the migration from Seven Caves to nearby Chalco inset into his mountain as seven dots (fig.63).[7] The annals of Cuauhtitlan to the northwest, rightly admired as a generally metic-

63 Cuauhtzin ('little eagle', left) and the canine Xolotl (right). Tlatelolco Map

ulous compilation of a wide range of native sources, offer a much longer and unbroken year-by-year narrative that stretches from the emergence from Seven Caves in the seventh century (or yet earlier) up to the arrival of Cortes, in all a span of nearly 900 years, in which the name Xolotl shines by its absence. Here, initiated by Itzpapalotl the Obsidian Butterfly, in company with Mixcoatl and the Cloud Snakes, the Chichimec shoot their arrows far in four directions and set off on the long journey to Cuauhtitlan. This source is especially important for detailing the rise of highland Tula in the ninth century, that is, after rather than before the first Chichimec foundation at Cuauhtitlan. Indeed, as Ixtlilxochitl tells us, it was in this context that the Toltecs who had arrived from Tollantzinco and the Gulf Coast bargained with the ever more threatening Chichimec, offering them hostages in return for peace on their northwest frontier. Facing increasing pressure, the last of the Toltec line to rule in highland Tula, One Reed Topiltzin, was eventually driven from the city, announcing the diaspora of 1064 which took his subjects, now often referred to as the 'Chichimec Toltecs', far afield.

On the east bank of the main lake, the 'stone-mat cave' Tepetlaoztoc cast back to its own version of the Chichimec arrival in the Basin when presenting evidence to the Real Audiencia in its Codex. In so doing it disclosed a partic-ular rivalry with neighbouring Texcoco, which had gone on to become a member of Tenochtitlan's Triple Alliance. As Texcoco's own histories admit, Tepetlaoztoc was the older of the two towns, and it makes its appearance before Texcoco does in the series of Xolotl Maps. The Tepetlaoztoc Codex develops the point, showing how the Chichimec patron of that town, Tonatiuh (or Huey Tonatiuh), had arrived from Chicomoztoc at the very start of the twelfth century ('440 years ago', as the text puts it): that is, earlier than Xolotl. And these Chichimec came via a different route, turning away from Coatlica-

mac, highland Tula and the altiplano and heading closer to the Gulf Coast, whose influence is evident in their styles of dress and face adornment, such as the pierced nose, skin fret and saw-tooth crown seen in Tohueyo's name glyph (figs 64, 65). The last stage of this migration from Chicomoztoc to Tepetlaoztoc, cave to cave, is detailed in the first of the Codex's two opening maps

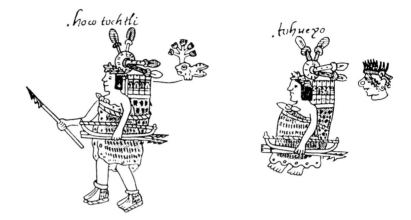

64 Typical Huaxtec. Florentine Codex Book 9, f.50v

65 Above right: Ocotochtli, the 'pine rabbit', and Tohueyo, the 'neighbour' from the Gulf Coast. Tepetlaoztoc (after Seler 1915)

(figs 66, 67), in place names which wind in southwestwards from Tlaxcala, and which in part prefigure Nezahualcoyotl's flight, in the opposite direction, from the Tepanec centuries later.[8] Among them we may note Tlaxcala itself, rendered here as the rocky place Texcala; the encircled Yahualiuhcan; and Zoltepec, the westernmost of three 'quail mountains' in Tlaxcala, which is further alluded to in the Tlaxcala Codex as the place where, later again, the skulls of both Spaniards and their horses were put on display (the skull racks have been recently excavated). More critically, Zoltepec here appears together with the Deer river Mazaapan and the Eagle and Jaguar mountains Cuauhtepec and Ocelotepec, all of them places named as a set trail in the Chichimec texts of the Cholula Plain and Coixtlahuaca (fig.79); reciprocally, Tepetlaoztoc is named as a stopping place in migrations from Seven Caves to Cuauhtinchan, on the Cholula Plain. For its part, the second of two opening maps in the Codex ingeniously recalls Seven Caves as an origin and first homeland by incorporating seven cave-like hollows into the hills that surround Tepetlaoztoc.

With the migration completed, surrounding subject towns are listed and Huey Tonatiuh installs Tepetlaoztoc's first ruler, a certain Ocotochtli, or Pine Rabbit (figs 68, 69). Both characters appear face-to-face, clad in their heavy skins, at the start of the dynastic section of the Codex. Friction with Texcoco began when Xolotl and his descendants, having now founded their own town, decided to enclose a large piece of land as a hunting reserve, and appointed Ocotochtli as a guardian. Claiming prior rights, Ocotochtli resisted and as a result was immediately branded by Texcoco as a 'rebel', in a political movement which also involved Yacanex (a fellow 'rebel' from Tepetlaoztoc), and

67

66 Map 1. Top
and top left:
eagle, jaguar
and quail
mountains;
deer river.
Tepetlaoztoc f.1

67 Map 2.
Place sign for
Tepetlaoztoc
in third
promontory
down.
Tepetlaoztoc f.2

68 Rulers.
Tepetlaoztoc f.3v

69 Rulers. Note
thrones and
cotton clothes.
Tepetlaoztoc f.4

the ruler of Tepotzotlan, and which culminated in a full-scale Chichimec war (*chichimecayaotl*) between the two groups: the Acolhua Chichimec of Texcoco who by now speak Nahuatl and the older neighbours who understand only the Chichimec tongue (denoted by the speech glyph affixed with the phonetic element *chi-a* or amaranth). Xolotl Maps 2 and 3 (fig.70) show Ocotochtli battling with Quinatzin near the latter's home town Texcoco, while below Yacanex engages with Huetzin, near Chiautla.[9] Although Texcoco is supposed

70 Ocotochtli driven back towards Teotihuacan (pyramids left or north) by lance-bearing Chichimec of Acolhuacan (from *a-tl*, water, and *-col-* bend or elbow); Yacanex ('nose ash') is seen below near Tepetlaoztoc and one of Texcoco's land enclosures. Xolotl Map 3

technically to have won this dispute, the Tepetlaoztoc Codex offers clear evidence of the fact only later, when Cocopin comes to power in the early fifteenth century (fig.71). Cocopin is the first to exchange the animal skins worn by his predecessors for cotton clothes, and the evidence suggests that he was actually installed by his father-in-law Nezahualcoyotl, beginning his reign in 4 Reed (1431), the Texcocan annus mirabilis celebrated in the Quinatzin Codex. The same contrast between skin-clad Chichimec and cotton-clad Acolhua appears in the *RG* Map of Cempoala, at the northeastern

71 Below right: Cocopin ('pierced with barb' in penance) and Tlilpotonqui ('daubed with black'). Tepetlaoztoc

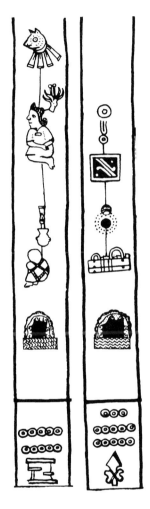

corner of the Basin, where, however, the two parties appear to co-exist peacefully with each other and with the Otomi of the region.

Another angle on the dealings between these two Chichimec towns, Tepetlaoztoc and Texcoco, is provided by the native-paper annals of Chiautla, known as the 'Codex en croix' on account of its remarkable page format of four radial arms each of 13 years. Exquisitely detailed, this Chiautla text exactly dates the reigns of Tepetlaoztoc's rulers and offers its own insights into

Chichimec life in the Highland Basin, especially on the east bank of the lakes (fig.72).

The Cholula Plain

Cholula, Quetzalcoatl's shrine, was in its day one of the most revered cities in the New World. The first stages of its huge pyramid, which the Spaniards tried to demolish but could not, date back well into the first millenium BC. The grand temples and palaces of the place, displaced after Cortes by the cathedral and many churches of Puebla, are a constant reference point for the Cholula Maps, which fit Xolotl into the story of the world ages, as well as for texts from the surrounding area (Map 3), notably the annals and the five maps of Cuauhtinchan. Along with the pair of maps from nearby Nepopoalco (also known as the 'Maps of Chichimec History') and the maps of Tecamachalco and San Juan Cuauhtla further to the east, the Cuauhtinchan texts are also our prime source of evidence on the Chichimec who migrated there from Seven Caves.

Consisting of 52 folios, the Cuauhtinchan Annals are most profuse in their account of the more than 100 Chichimec leaders at Seven Caves, of two separate exoduses, and of how Chichimec rulership was eventually established in AD 1176 in the Cholula arena, where the old homeland was again recalled in the sevenfold structures of towns settled around Cuauhtinchan itself.[10] With their more geographical emphasis, these Cuauhtinchan maps centre on the hills in the middle of the Plain and vividly depict the four snow-capped volcanoes that are visible from Cholula's pyramid and guard its arena: Poyauhtecatl (Orizaba) and Matlalcueye (Malinche) to the east, and Popocatepetl and Iztaccihuatl to the west (fig.73). In the wall of mountains to the north, always to the top of the page, we find Tlaloc-faced Napatecutli (Cofre de Perote);

72 Cocopin dies (mummy bundle, left) and Tlilpotonqui is born (cradle, right), at Tepetlaoztoc (place sign lowermost). Above Cocopin sits his widow Iztacxochitl ('white flower'), who ruled during the ensuing interregnum; she was the daughter of the 'fasting coyote' Nezahualcoyotl, whose name glyph is shown above her. The day of Tlilpotonqui's birth is given as 1 Rain. Chiautla Annals, years 10 House and 13 Flint (1489 and 1492)

73 The four snow-capped volcanoes around Cholula: white Poyauhtecatl and blue Matlalcueye below, fiery Popocatepetl and Iztaccihuatl above. Tepexic Annals p.14

Tepeyahualco, magnificent as the heir to the vast lava city of Cantona (fig.74); the star mountain Citlaltepec; Tlaxcala's Deer river Mazapan, Eagle and Jaguar mountains Cuauhtepec and Ocelotepec, and its southern Zoltepec; and Tlaxcala itself, again depicted as the rocky Texcala. To the south stand the Tentzon ridge and the gateway for the south-flowing Atoyac river; and the split mountain Tepexic. As in the case of the Xolotl Maps, we are taken beyond the eastern edge of the main arena, in this case passing from the Plain down towards such Gulf Coast towns as Matlatlan (the place of nets, now Maltrata) (fig.75), and the 'mouse' town Quimichtlan. Cuauhtinchan Map 1 extends

74 Northern locations:
a) Napatecutli, 'four-times lord'
b) Tepeyahualco. Cuauhtinchan Maps 1 & 2

75 Matlatlan, 'place of nets':
a) Mendoza b) Cuauhtinchan
Map 2 c) Cuauhtinchan Map 1
(net as roots of the six-branch tree
glyph that gives this town's
alternative name) d) Tlapiltepec
Lienzo (both net and tree)
e) Tequixtepec Lienzo 1
f) Miltepec Roll (net on tree trunk)
g) Coixtlahuaca Lienzo 1
The pair of Twelve Flints shown
in e) are also present in d) and g)

southeast to the upper Papaloapan drainage, to the necklace town Cozcatlan and to Tzoncoliuhcan (Zongolica), while Map 2 depicts links with the Chichimec who went off in that same direction, to establish themselves in the neighbouring arena of Coixtlahuaca.

Cuauhtinchan produced this copious documentation of annals and maps because of two sixteenth-century disputes. The first was with Tepeaca, the 'nose' face town just to the east which literally faces out the eagle of Cuauhtinchan, having been preferred as an administrative centre by the Mexica, and then by the Spanish. The second was internal and broadly speaking involved two groups of Chichimecs who had reached Cuauhtinchan by different routes and who felt different affinities, with Nahuatl-speaking Cholula and with Coixtlahuaca respectively. Despite differences arising from the second dispute, all these texts share the grand historical perspective of 'Toltec–Chichimec History' or *Historia tolteca–chichimeca*, a phrase which indeed serves as an alternative title for the Cuauhtinchan Annals. Having left 'Colhuacatepec', the first band of Chichimec settle in highland Tula which, as in the Xolotl Maps, is located in the tradition of the 'Great Tula' that long ago flourished on the Gulf Coast. Now called Toltec Chichimec, the band moves on to Cholula, in the diaspora dated to 1064 in the Cuauhtitlan Annals. At that

time Cholula was still cruelly dominated by the Xicalanca Olmec, so that the Toltec Chichimec return to Seven Caves to implore their younger Chichimec brothers to become their allies, and hence win autonomy. Their common Chichimec identity and speech are indicated by the same phonetic glyph (*chi-a*) that is used in the Xolotl Maps (fig.76).

Going through their initiation rites, the Chichimec at Seven Caves accept, and sing a song in Otomi. With their deep native-American roots, the rites – shooting arrows in four directions, being succoured by creatures from the wild – are depicted in the Annals in a way which specifically recalls the central section of the Borgia screenfold, a text thought to be from Cholula.[12] The journey back from Seven Caves to Cholula and Cuauhtinchan is recorded in great detail in the Annals and in Map 2. The Annals are notable for tracing out a route that goes down to the Gulf Coast, passing through towns such as Cuetlaxtla, before turning back up through the Papaloapan Valley, to pass Cozcatlan and Tehuacan. The Map sets out a different route, which in fact divides: here the Chichimecs separate in order either to enter the Highland Basin and go round its lakes, or to pass it by on the longer Gulf Coast route that takes them past Tochpan and the ancient ruin of Cahuac. In this Map, the migrations to and from Seven Caves are most ingeniously recorded as a sinuous, event-filled road which then opens out in the main arena of the Cholula Plain. Finally, military victory over the Xicalanca Olmec at Cholula leads to a fire kindling at the centre of the arena, Cuauhtinchan, and the start of the official year count, in 9 Flint (1176).

76 Chichimec speech and the *chia* glyph. Cuauhtinchan Annals f.14

Tlaxcala

The Chichimec origins of the Tlaxcalans, Cortes's allies, are reflected in the boundaries of the modern state of Tlaxcala, and are copiously described by the local mestizo historian Diego Muñoz Camargo (Map 3).[13] Yet little internal evidence has survived in native script. There are simply no matching accounts of the events assigned to Tlaxcala by Chichimec texts from the Basin to the west and from Cuauhtinchan to the south. It is as if, with Christianity, history had begun anew.

True, some echoes can be heard. The opening of the Tlaxcala Lienzo features the 'blue skirt' Matlalcueye sacred to the Chichimec as to those before them, a huge blue mountain around which the four head towns of Tlaxala are ritually arranged in a quincunx, Quiahuiztlan and Ocotelolco above, the lesser Tepeticpac and Tizatlan below. Similarly, the genealogies boasted by these four head towns make much of the autonomous lordly title *chichimeca-tecutli* and depict the founders armed with bow and arrows and clothed in skin. Their names correspond directly with those of the Chichimec forefathers who came from Chicomoztoc, as is the case with the Mixcoatl and Cuauhiztac of the Tamazolco Map (fig.78). For their part, in ending the account of the Tlaxcalan drive back north at the seven gates of Zuni, the authors of the Tlaxcala Codex no doubt echoed the emergence from Seven Caves centuries before

77 Popocatepetl (smoking) and
Iztaccihuatl. Huamantla Roll

(fig.37). The one native-script history of the migration as such which appears
to have survived from the whole area is the Huamantla Roll; its interest is
heightened by its uniqueness and by other factors as well. It is on native paper,
and has only recently been re-assembled from nine fragments. It also sheds
light on the otherwise forgotten southeastern corner of Tlaxcala, being the
work of Otomi-speakers from Huamantla, or Cuauhmantla, the chief town of
that area.

In a rough and powerful style and without recourse to year dates, the Roll
takes us, left to right and west to east, along the footprint trail that begins in
'the cave of our departure' (*nican toquiyahn oztoc*) and traverses the Basin north
of Tenochtitlan and its lake, then to pass the pyramids of Teotihuacan and the
great Otomi centre of Otumba. Finally the Tlaxcalan arena is marked out in
relation to its northern and southern Zoltepecs and to landmarks already
viewed, as it were, from the other side, along the eastern rim of the Basin
(Popocatepetl, Iztaccihuatl, Tlaloc) (fig.77) which here appears to the west,
and the northern wall of the Cholula Plain which here appears to the south
and features the blue-green Matlalcueye and the star mountain Citlaltepec.
Inset into the slopes of Popocatepetl, Huexotzinco has the same thatched coni-
cal roof that identified this town in Cuauhtinchan Map 2. In contrast to the
Xolotl and Cuauhtinchan Maps, the Huamantla text does not at all extend its
eastern boundary; rather the row of toponyms amassed along its right-hand
edge suggests the defensive wall built by Tlaxcala on its frontier with the Gulf
Coast area and anticipates the vividly portrayed and terrible slaughter
brought from the east by Cortes (fig.25). In all, a direct reminder of the Otomi
factor in Chichimec history, this text intermeshes significantly with those from
neighbouring arenas.

78 Overleaf: Tamazolco Map

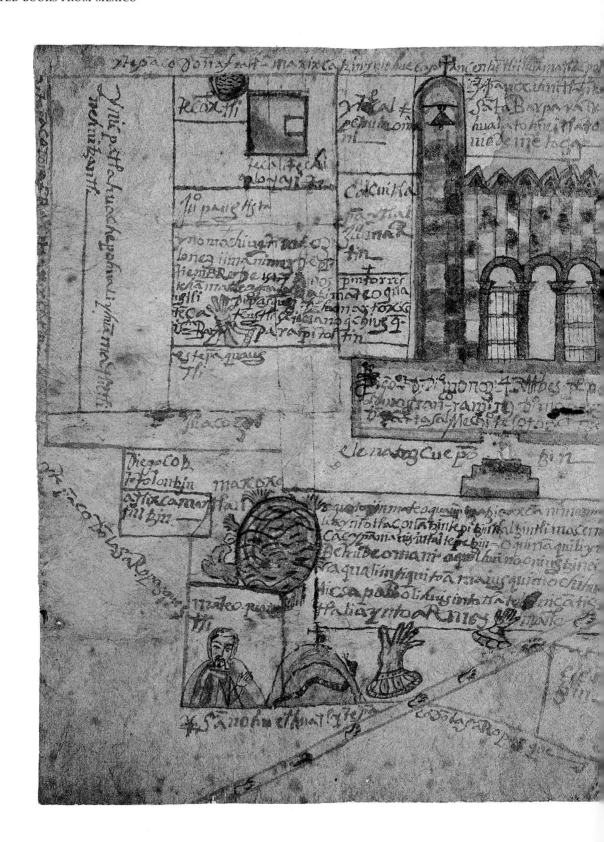

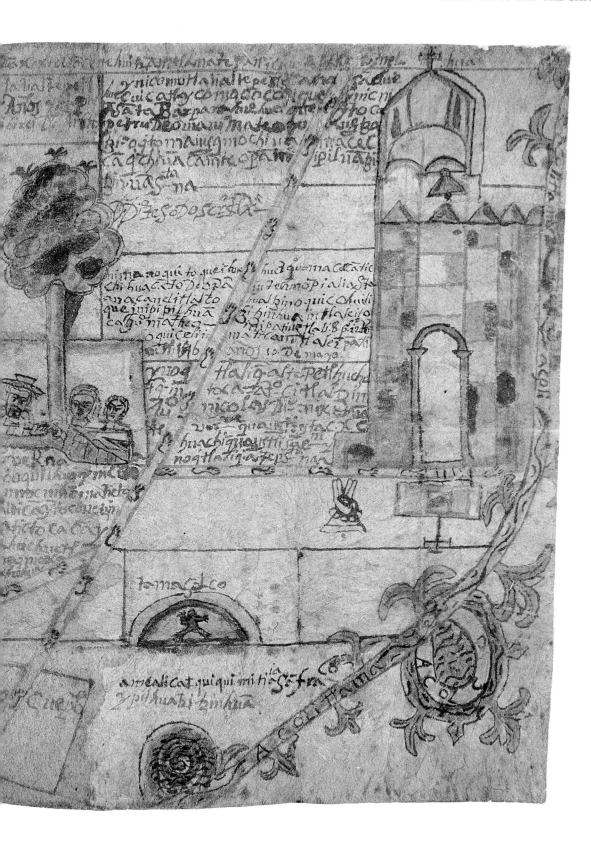

Coixtlahuaca

As the Mendoza Codex unambiguously confirms, Coixtlahuaca was the key to the great eastern tribute road that ran from the highlands down through the Papaloapan Valley, the Butterfly River, to the riches of the tropical lowlands and its supplies of quetzal feathers, jaguar skins, rubber and gold jewellery. Situated just north of the continental divide and itself part of the Papaloapan river system, Coixtlahuaca belonged to an area with an extremely long cultural history, which saw very early developments in ceramics, agriculture and irrigation, and which linguistically brought together Chocho, Cuicatec and Mixtec, as well as Nahua: enormous platforms and other architectural remains testify to its erstwhile power (Map 4). In recent years its political identity has been decisively revealed through a body of nine closely interrelated lienzos, all originally from towns in the vicinity and in the valley of Coixtlahuaca, among them Tlapiltepec, Tequixtepec, Tizaltepec, Tulancingo, Ihuitlan and Coixtlahuaca itself. Indeed, with their high degree of consistency and cross referring, these texts have vindicated the notion of Coixtlahuaca arena in the first place, and they enable us to assign the same provenance – specifically the towns of Tlahuixtlahuaca and Miltepec – to the two rolls named after Selden and Baranda, as well as to establish links with the Gómez de Orozco fragment.[14]

The Chichimec history of these places is again shown to begin at Seven Caves, whose glyph appears at or near the start of most of the dozen or so surviving Coixtlahuaca Valley accounts, albeit in a form sometimes squatter than that preferred by Cuauhtinchan, a mean saurian mouth displacing the full flower design of wombs in plan (Table 5A). The Tlahuixtlahuaca Roll is unique in showing an ancestor actually emerging from the cave; he is One Jaguar, clad in a carapace and bearing the many flints which possibly indicate his identity as Tecpactzin. The migrations depart successively from Seven Caves and then subdivide, as in the Cuauhtinchan texts, but now range more widely in time and space. The various routes take in the already familiar highland Tula, the source of the diaspora in 1064, and the Deer river plus Eagle and Jaguar mountains sequence associated with eastern Tlaxcala in the Cuauhtinchan Maps. Landmarks of two further routes are the 'star' river of the Gulf Coast and the Quetzal and Jade rivers (fig.79) that lead to Matlatlan, the frontier town south of Orizaba which the Tlapiltepec and Coixtlahuaca Lienzos define by a combination of net (*matla-tl*) and six-branched tree, the exact glyph used in Cuauhtinchan Map 1 (fig.75). The key role of Matlatlan is discussed at length by Muñoz Camargo, and from it a secondary route leads across to Colhuacan and other towns in the Basin, passing Cuauhtinchan and Cholula on the way. In all, this account further details the system of overlapping arenas that we noted in texts from the Basin and the Cholula Plain.

Arrival at Coixtlahuaca inspires a fire kindling presided over by Two Dog or other Chichimec leaders, and carried out by the pilgrim bearers of Quetzalcoatl's and Tlaloc's sacred bundles. In every sense a culmination, the

kindling occurs only after the pilgrim bundle-bearers emerge from a fort and dismember a monster reptile whose gaping maw requires incessant feeding, a known motif (as at Xochicalco) for political powers who demand excessive tribute.[15] The pilgrims number four, wear the saw-tooth crowns characteristic of the Gulf Coast and include the characters Thirteen Lizard and Ten House. The location is determined by a complex federal emblem which combines flints and turtles with known toponymic features of the various allied towns, such as the singer of Cuicatlan (Table 5B), the snake of Coixtlahuaca (fig.54), the knot of Tlapiltepec, the feathers of Ihuitlan, the shell of Tequixtepec

79 Landmarks en route from Chicomoztoc: a) Quetzal and Jade rivers, Tlapiltepec Lienzo b) Jaguar, Eagle and Macaw mountains, Tlahuixtlahuaca Roll

(Table 5B, C), the head of Tlahuixtlahuaca, the pot of Tepenene, the arrows of Miltepec and the butterfly of Papalo and Papaloapan (fig.80). Indeed, in the absence of other information, it is the prominence of one or other of these features which may suggest the provenance of a given text. At the kindling in the Selden Roll, as we noted earlier, the major element in the federal emblem is the head whose eyes emerge as if from darkness; a feature glossed Tlahuix-tlahuaca in the Ihuitlan Lienzo, this name invokes the lord of the house of dawn Tlahuizcalpantecutli, whose eyes characterisitically emerge from the

80 Upper Papaloapan towns: Papalo (butterfly, a–b), Tlahuixtlahuaca (dawn, c), and Miltepec (arrows, d–g). a), d) Tlapiltepec Lienzo; b) Quiotepec Annals; c), e) Ihuitlan Lienzo; f) Coixtlahuaca Lienzo; g) Tepexic Annals

night. At the same moment in Baranda, Miltepec, with its three arrows, easily exceeds the other toponyms in size and importance (fig.81).[16]

In its turn, the kindling leads to expansion along the chevron trails of war, to a set of places that lie at some distance, two to the north and two to the south of Coixtlahuaca, Cuicatlan and the Upper Papaloapan, in a quincunx reminiscent of that which inaugurates the Tlaxcala Lienzo. In the standard pattern, the two towns to the south towards the Mixteca, are Mictlan, the place of the dead (southeast), and Nexapa, the river of ash (southwest); to the north lie Tepexic (northwest), the split mountain with its characteristic black and white chequer, and Teotlillan (northeast), the place of solar eclipse or 'divine blackness' noted as a destination for the Toltec Chichimec in the Cuauhtitlan Annals. Justifiably thought of as the lost core of ancient Mesoamerican literature, straddling as it does the continental divide and the Puebla Oaxaca

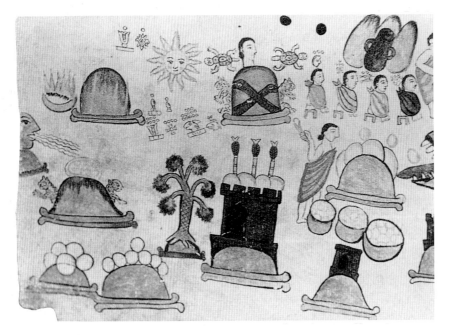

81 Migration from Seven Caves. Miltepec (Baranda) Roll

82 Emblem names and places: Two Dog 'Gourd' of Tepexic and Lady One Eagle of Nexapa above, Lady Nine Tooth of Mictlan and One Death 'Sun' of Teotlillan below. Cuicatlan screenfold p.10

border, this model (Table 5D) reappears in the several classic pre-Cortesian texts.[17] These include the magnificent annals of Tepexic which, giving their own version of events, make only passing reference to Seven Caves and transfer the kindling to Tepexic, placing it under the auspices of Two Dog, the patron name of that place according to Cuicatlan (Porfirio Díaz Ms) (figs 82, 83); Mixtec annals such as those of Tilantongo (Bodley), where it occurs several centuries earlier; and august maps in ritual screenfolds from Cuicatlan (Porfirio Díaz Ms), Teotlillan (Laud), and Coixtlahuaca (Map), which invoke the world ages and layers of history which surely antedate the Chichimec. In applying this received geographical model to the inaugural kindling shown in their lienzos, the Chichimec were possibly appealing more to an

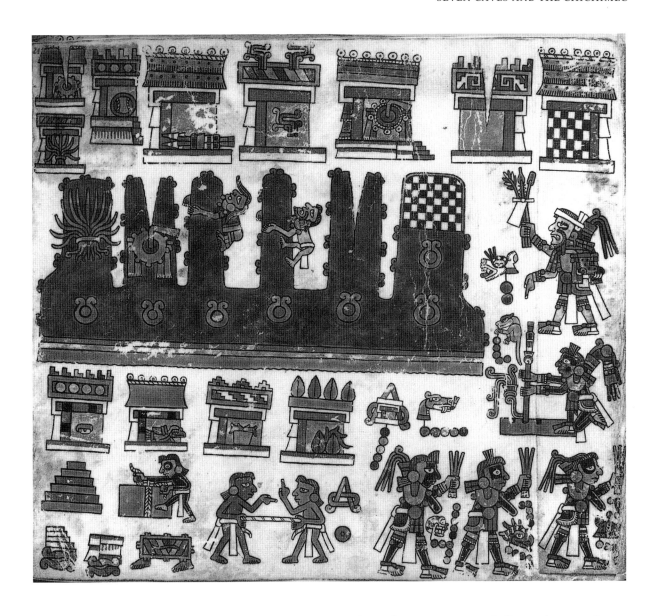

83 Kindling at Tepexic in the year 5 House, Two Dog presiding. Place signs on raised base, right to left: Tliltepexic (black chequer), Tepexic (ravine), Huehuetlan (old man), Huehuetlan (old woman), ? (gourd), ? Tentzon (maguey). Tepexic Annals p.32

idea than representing military fact since, as we shall see, the genealogies that succeed it spring exclusively from territory closer by. By the time Tenochtitlan drew its tribute map, only Mictlan remained subject to Coixtlahuaca, Tepexic being assigned to Tepeaca and Teotlillan to Tochtepec.

In the next phase of the Chichimec story that began in Seven Caves, dynasties of notable length extend vertically up the page, a major origin being Yucucuy, Mixtec for the 'green hill' Monte Verde on the watershed that dominates the Coixtlahuaca Valley and its intermittent north-flowing rivers. Rivalries and alliances abound although certain founder-conquerors are mentioned repeatedly, such as the line of Four Jaguars, and Lady Thirteen Caiman. Common to all these texts, the convention of naming the

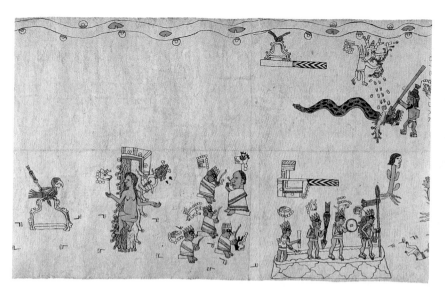

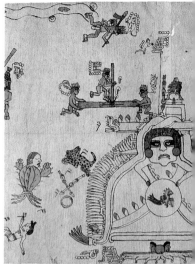

people by their birthday number and sign differs from that used in the previous arenas and suggests Chichimec adaptation to local norms, as does the firm emphasis on female as well as male ancestry, and the twinning of dynasties.

Finally, in these Coixtlahuaca texts, again as in those of Cuauhtinchan, the stream of time opens out spatially, into an arena where the main towns cluster, some boasting Christian churches. The southern edge is consistently identified with Yucucuy and the continental divide, while the limit to the north is fuzzier. Ihuitlan and Tlapiltepec spread up to Cozcatlan and Tehuacan, the necklace and beast towns of the Toltec Chichimec listed in the Cuauhtitlan Annals that likewise belong to the Upper Papaloapan river system. Tlapiltepec reaches up further still, to Tecamachalco and the Cholula Plain, and offers us a neat vignette of the rivalry there between Tepeaca and Cuauhtinchan, where the 'nose' face of the former, flushed with success under the Mexica and the Christians, glares at the paler 'eagle' face of the latter (fig.87).

Of these Chichimec histories from the Coixtlahuaca Valley, it is the Tlapiltepec Lienzo which is richest in sheer information and the most ecumenical, the details it provides often being critical for understanding less explicit or damaged versions. The Ihuitlan Lienzo is succinct to the point of ellipsis yet gives us an invaluable set of glosses. Generally, the preference for or exclusion of certain details may indicate varying internal loyalties, just as in the Cuauhtinchan case. Of the two lienzos of Tequixtepec, the first celebrates Seven Reed and the other ancestors who made Maltrata into the springboard for the incursion into the Basin; at Coixtlahuaca, it celebrates Four Jaguar and dynasts known to have had close links with the Mixteca. Lienzo 2, on the other hand, omits these references and tends rather towards the pilgrim and black monster version told most fully in the Tlahuixtlahuaca Roll.

87 Cuauhtinchan ('eagle house') and Tepeaca ('nose hill'):
a) Mendoza b) Tlapiltepec Lienzo

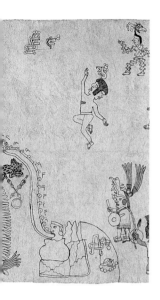

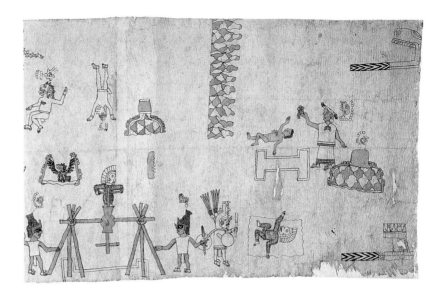

84–86 Fire kindling. Tlahuixtlahuaca (Selden) Roll

Over its length as a strip or roll, the Tlahuixtlahuaca text traces the migration from Seven Caves to the Coixtlahuaca Valley in some detail, focusing on the four pilgrims who wear saw-tooth crowns and who appear four times (figs 84–6). Here their chief role is to bear the sacred bundle of Quetzalcoatl, the Toltec patron deity with Gulf Coast antecedents, who has been seen with his mask of wind (*ehecatl*) already at the start of the text, enthroned in the sky. After Seven Caves, Quetzalcoatl reappears and is revered by the pilgrims near the start of the migration trail, in a commanding aspect which directly recalls the glyph of the Gulf Coast city Quetzalcoatlan (fig.88, Table 6B), today named Ecatlan after his wind mask and celebrated in local Chichimec histories from the Cuextlan arena. On being carried across Deer river, Quetzalcoatl all but drowns, only to swing his head back up out of the water; here the river is actu-

88 Quetzalcoatl receiving homage. Tlahuixtlahuaca Roll

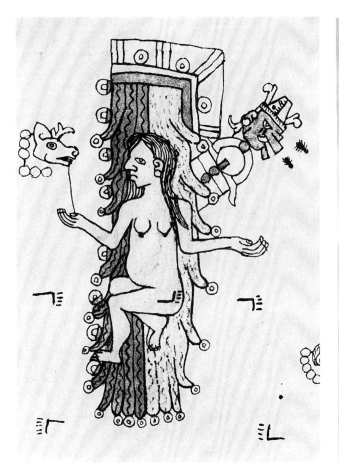

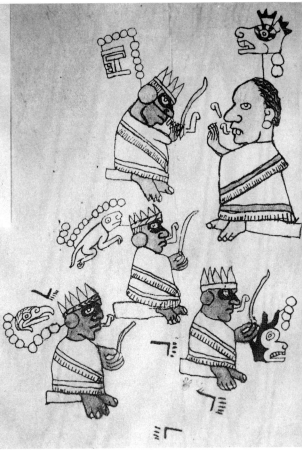

ally identified with a woman named Six Deer (fig.89), whose naked thighs recall the plump haunch of the Cuauhtinchan Map 2 version of this place name. The image as a whole suggests both the precariousness of Quetzalcoatl's cult and the particular problem posed to it by lust, Quetzalcoatl himself not having always succeeded in practising the sexual restraint he preached. Under the eyes of Two Dog (fig.90), the pilgrims then declare themselves, coming out of their stronghold to pose their political challenge. Upon the defeat of the black monster they take possession in the grand fire kindling, at which the image of Quetzalcoatl is revered atop the main altar, a position it enjoys, named Nine Wind, in the Ihuitlan Lienzo, at Coixtlahuaca.[18] In the military campaigns that follow, however, the saw-tooth crowns and their deity fare less well. In his last appearance towards the end of the Roll, where he is given the particular name Nine Wind, Quetzalcoatl is lying inverted and flat out and this time apparently unable to get up again (fig.91). A similar fate befalls Lord Monkey, who is also seen flat out after the axis that supports him revolves. Indeed, the notion of general upheaval is expressed through the inversion of the whole landscape towards the end of the Roll at Yucucuy

89 Quetzalcoatl rising from river. Tlahuixtlahuaca Roll

90 Two Dog orders the kindling. Tlahuixtlahuaca Roll

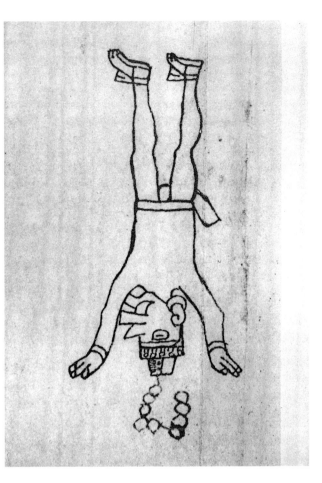

91 Quetzalcoatl Nine Wind flat out (his name Sign Wind is the mask he wears). Tlahuixtlahuaca Roll

92 Lady Thirteen Caiman of Tlachixtlahuaca ('ballcourt plain') victorious at Yucucuy. Tlahuixtlahuaca Roll

which puts the final toponyms into the opposite of their normal positions, with the underworld Mictlan above and the sun town Teotlillan below. Again, a woman is present at the occasion, the powerful Lady Thirteen Caiman of the ball-court town Tlachixtlahuaca, who bloodily indulges in heart sacrifice, another practice supposedly resisted by Quetzalcoatl (fig.92).

As typal experience of pilgrimage, the main moments of the Chichimec migration to the Coixtlahuaca area find quite direct echoes in its ritual literature. The dangers of wild beasts are echoed in the Hazards chapter in the Cuicatlan screenfold (cf. fig.43), while the Nine Wind sequence of river crossing, challenge, kindling and prone submission in the Tlahuixtlahuaca Roll resembles the Amazons chapter in the Laud screenfold of Teotlillan, where at each moment the male is outmatched by a mostly bare-breasted woman endowed with enormous physical and mental power who encroaches on the male preserves of the ball-court and fire kindling (fig.93). At the same time, the particular historical relationship between the Toltec Quetzalcoatl Nine Wind brought in by the pilgrims and the leader Two Dog is strongly corroborated in the pre-Cortesian annals of Tepexic, where we find fire kindlings

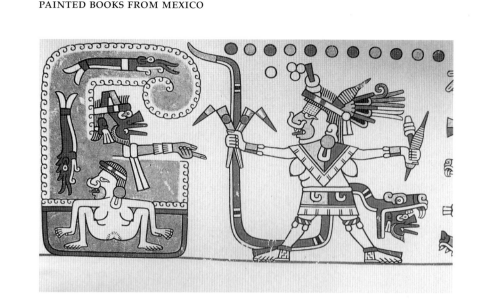

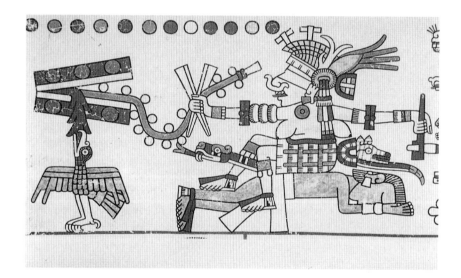

93 Amazons; the first (top) and the last of four scenes of female domination. Laud pp.15, 18

inset into the landmarks of this same arena, though of course with Tepexic at the centre (fig.83). The prestige of this town was confirmed at the time of the Tlaxcalan–Spanish attacks in 1521 by the fact that its ruler, Moctezuma Mazatzin, had the authority to bargain with Cortes in the name of 20 towns in the Upper Papaloapan area, including Tehuacan, Cozcatlan and Teotitlan. At the time of Two Dog it was confirmed in the Coixtlahuaca ritual map where chevron warpaths lead out in four directions from the kindling, with one variation: instead of going towards Tepexic, the warpath in the northwest leads out from that place, suggesting the status less of defeated subject than of conqueror (fig.163). Along the way we find not temples ablaze but the northern fortifications also shown in the Miltepec Roll and still visible in the area. In the Tlahuixtlahuaca Roll, precisely this respect or even affinity for Tepexic

is reflected in the fact that the defeated subject in the northwest, normally Tepexic, is replaced by another (Tlapiltepec), at the height of Quetzalcoatl's political prestige in the area.

Cuextlan

Cuextlan, or the Huaxteca, is the last of the five major arenas defined by surviving Chichimec texts which trace their origin back to Seven Caves (Map 3). It corresponds to the northern coast of Veracruz and the adjacent stretches of altiplano, and culturally has long been the home of Totonac, Huaxtec, Nahua and even Otomi. Tenochtitlan established its presence there in the garrison and tribute district of Atlan (Table 6A), the 'water place' which aptly alludes to the rivers that cascade from the altiplano down through lush forests to the coastal lowlands. Unlike the preceding four arenas, however, Cuextlan has gone almost entirely unrecognised in scholarship as a literary focus of any kind. This is because the texts which represent it are so little known: the three Tochpan Lienzos were first edited as late as 1970; the Metla-toyuca Lienzo is first published adequately in this volume; and only in 1992 were the sundry *amate* fragments, catalogued as the Itzcuintepec Papers, physically assembled into meaningful texts – the Roll, and the Codex comprising map, annals and genealogy. In these circumstances, a fuller than usual introduction is needed to the arena in question.[19]

In this, our readiest guide is the set of three Tochpan Lienzos, which correspond to three historical phases in Cuextlan history: Chichimec, Mexica and Christian. As maps, all three texts along with their variants and copies focus on the 'rabbit' town Tochpan (figs 94–7), on the Gulf Coast, a calling place in the Chichimec migration detailed in such sources as the Cuauhtitlan Annals and the Cuauhtinchan Maps. All three lienzos prefer the orientation which places west uppermost, and they highlight the hydraulic system of the Cazones and Pantepec–Tochpan rivers, which flow down from south and west to the brilliant foaming sea off the coast of Veracruz, in the region of Tuxpan (the modern version of Tochpan). In each, the rabbit of Tochpan appears in large humanoid form towards the north or right as the chief glyph, at the end or the beginning of a north–south footprint road that links it with Tuzapan, the place of the 'mole' (*tuza-tl*). This deliberate pairing of fellow rodents, rabbit and mole, occurs in other sources, in a four-part model which also includes the poisonous western pair Xiuhcoac (fire-snake) and Xicotepec (bee) (fig. 94).[20]

At the centre of the first Tochpan Lienzo (fig. 95), we see a large emblem – a shield plus four west-pointing arrows – which denotes the Chichimec conquest of the year 13 Flint. The four arrows recall the four Chichimec conquerors reported in the *Relaciones geográficas* of this coastal region, as well as the shooting in four directions upon emergence from Seven Caves.[21] Clad in no more than cotton loin-cloths, four pairs of local male inhabitants, one pair per arrow of conquest, sit beside trees, to the east (the coast), north, west

and south. Their hairstyle corresponds to that of the Gulf Coast people depicted in the Aztlan Annals and other Mexica texts. They are the Totonac, whose language is thought to have been close to that of the Olmec (Mixe–Zoque) when Teotihuacan flourished, and which is related in turn to the Huaxtec branch of Maya. Such affinity would help to explain the high

west

east

94 Stinger and rodent towns: Xicotepec (bee) and Xiuhcoac (fire snake) to west (above), Tuzapan (mole) and Tochpan (rabbit) to east (below). Tochpan Lienzo 2

proportion of place names in Lienzo 1 that embody number, such as Thirteen and Seven, or numbers and signs, such as Three Dog, Two Monkey and Four Deer. It may also explain the local tendency to convert the *c* and *x* of Nahuatl (pronounced s and sh) into *t*, as in Tihuatlan (the 'woman' town Cihuatlan), and *tz*, as in Tepetzintla (the maize mountain Tepecintla) and Tziuhcoac (the fire-snake Xiuhcoac). The whole is subtly cast into the model of the four quarters to which are allotted nine figures (the four pairs plus the humanoid rabbit), and in which east matches west as north does south. A similar ritual significance attaches to the overall total of twice 11 place glyphs. Less fixed, the sequence of place names to the south suggests movement in from the north and west, starting appropriately with the footstep of Tlapa and passing through the places Four Deer and Thirteen, on the way to the 'owl' seaport of Tecolotlan.

Linked to the year 1499, the second Tochpan Lienzo greatly increases the number of towns and roads shown in the first, in outlining the situation provoked by the Mexica invasions of the area begun by emperor Axayacatl. Aligning frontier towns, 14 to the west and 10 to the south, it also demarcates the enclave of Atlan–Tetzapotitlan, between the roads that branch out to Acuetzpanoayan (near Huachinango) and Metlatoyuca. In the Mendoza Codex, this enclave corresponds to the sixth tribute district of the northern province, Tochpan being the fifth and Xiuhcoac the seventh. Consisting of only two towns, the Atlan–Tetzapotitlan district was unique in the whole Tenochtitlan system, insofar as each of the two towns was obliged to double

as a garrison, to defend the frontiers of the enclave. As for the fifth tribute district Tochpan, six of its seven towns appear in Tochpan Lienzo 2, in central positions, while several listed in the seventh district Xiuhcoac also appear, this time ranged along the western frontier. Among these last are Molanco and Xiuhcoac itself, and certain which stand out on linguistic grounds, since being Huaxtec they find only rough equivalents in Nahua-sounded glyphs, such as Tamapachco (-*ma-itl* 'hand' + *pach-tli* 'seashell' in Mendoza; simply 'hand' in Tochpan Lienzo 2; Table 6A).

At the same time, given the fuller detail of the second Tochpan map, we can make a more precise correlation between its outline of the Cuextlan Chichimec arena and that set out in the Xolotl Maps from their standpoint in the Basin. Places which serve as common boundary marks for the two sets of texts, to southwest (Tochpan) and northeast (Xolotl) respectively (figs 96–8), include Cuauhchinanco (the wood enclosure Huachinango), the 'bird' town Tototepec in Hidalgo, the four-stone enclosure of Tenanitec, and the nearby abandoned house of Cahuac (phonetically reduced to the 'cocoa house' Cacahualco in the variant of Tochpan Lienzo 2, fig.106). Further cross-references can be made with the Gulf Coast *Relaciones geográficas* of 1581 that report on Chichimec movements in this area, notably with respect to the city of Quetzalcoatlan (Table 6B) set into the southern boundary, a prime halt for the migrants in the Tlahuixtlahuaca Roll (fig.88).

Much later in style, the third and final Tochpan Lienzo dates to around 1700 and replaces the Mexica control strategy with that of the Spanish. The Atlan enclave disappears, though in fact it can still be discerned today in the northernmost projection of the state of Puebla. The abandoned city of Cahuac/Cacahuatenco is replaced by the palm tree of Ixhuatlan de Madero, the modern town near which the ruins lie. In all, the threefold series of Toch-

95 Tochpan Lienzo 1

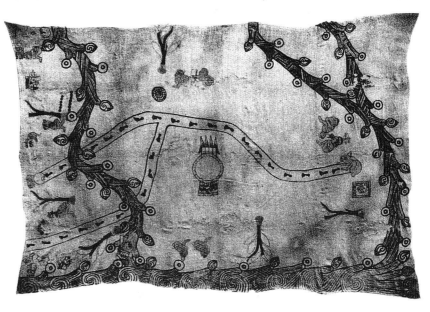

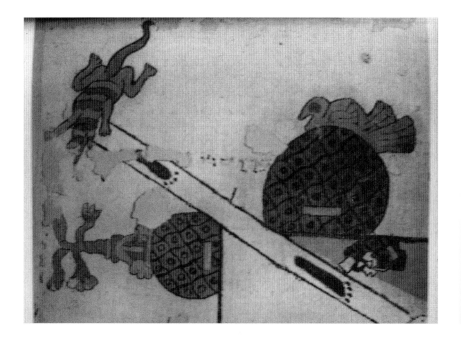

96 Cuauchinanco (wood fort) and Tototepec (bird hill). Tochpan Lienzo 3, southwest corner

97 The southwestern corner of the enclave (detail), Tochpan Lienzo 2. Above: Tenanitec (stone enclosure), Metlatoyuca (*metate* grindstone); below: Cozcacuauhtenco (yellow eagle), Itzcuintepec (dog), Atlan (water)

98 The northeast, with Tenanitec (corner), Cuauhchinanco, Tototepec (below), and the ruined pyramids of Cahuac. Xolotl Map 1

99 Opposite: Metlatoyuca Lienzo

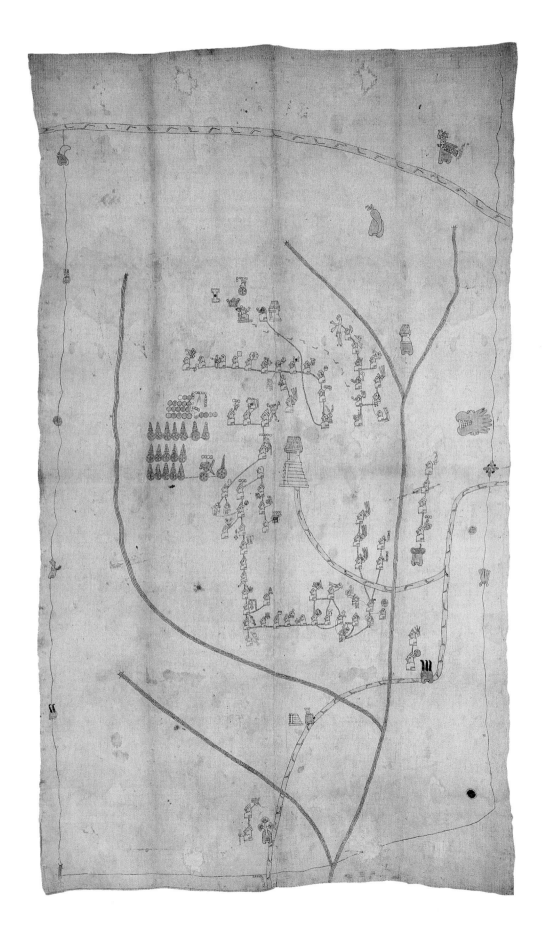

91

pan Lienzos evinces the continuity and capacity for political resistance for which this region as a whole is justly renowned.[22]

Once the Cuextlan arena is established with the help of these Tochpan Lienzos, it becomes much easier to locate and describe the British Museum texts associated with Itzcuintepec and Metlatoyuca. The town of the dog, on the southeastern border of the Atlan enclave, Itzcuintepec imprints on all the texts traditionally assigned to it a magnificent version of the head of the black and white Chichimec canine after which it is named. Most often, this Itzcuintepec glyph is paired with that of the stone enclosure Tenanitec that serves as a landmark in both the Tochpan Lienzos (on the western border of the enclave) and the Xolotl Maps. In the Lienzo of Metlatoyuca (fig.99), the *metate* or 'grindstone' town featured at the end of the uppermost or western road in the Tochpan Lienzos (fig.97), the glyph for that place is not recorded, although the glyphs and the rivers which are present leave no doubt about an overall location to the west of the enclave.

A Chichimec strip fully comparable to those of Huamantla, Tlahuixtlahuaca and Miltepec, the Itzcuintepec Roll (fig.102) reads downwards from its badly damaged upper left-hand corner, along a migratory route which includes several of the places named in the Tochpan Lienzos, such as Thirteen (Matlacomeitlan), Molanco, Tamapachco, Four Deer and the shoreline of the Gulf Coast, and highlights as major points of arrival the twin towns of Itzcuintepec and Tenanitec. The starting point of the migration is confirmed as Seven Caves by the presence of the ancestor Huey Tonatiuh (Great Sun), and by a

a b

highly significant Nahuatl gloss, which likewise identifies the leaders of the migration as Tzitziquiltzin (Little One) and Ahuizotl (Water Hound, a shamanic name still used today); painted black, they wear the saw-tooth crowns of the Gulf-Coast Chichimec and Ahuizotl stands under a darkened sun with black vomit issuing from his mouth (figs 100, 101).[23] Having taken possession, the Chichimec stage a ritual shooting match and inaugurate the dynasties said to control more than 50 towns.

In characteristic fashion, the Itzcuintepec Roll sets the stage for the more detailed Map, Annals and Genealogies that comprise the Codex. Adhering to the same model of nine units set into four quarters which introduces the Tochpan Lienzos and the Mendoza Codex, the Map (fig.103) is oriented to east, the quarter also privileged with three rather than two toponyms. From the centre, Itzcuintepec and Tenanitec lay claim to four and five subjects respectively. These include, to the east, the cutting-axe place Teximalpa,[24] the roadside stone of Tetzapotitlan and Quetzalcoatlan (here identified specifi-

102 Right: Itzcuintepec Roll

103 Far right: Itzcuintepec Map

100 Ahuizotl: inscription in Tepoztlan pyramid (after Seler)

101 Ahuizotl the water-beast (vomiting) and the 'little one' Tzitziquiltzin: Itzcuintepec Roll

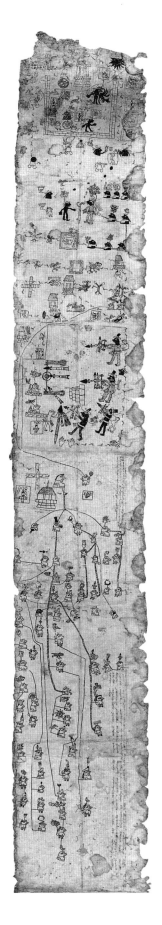

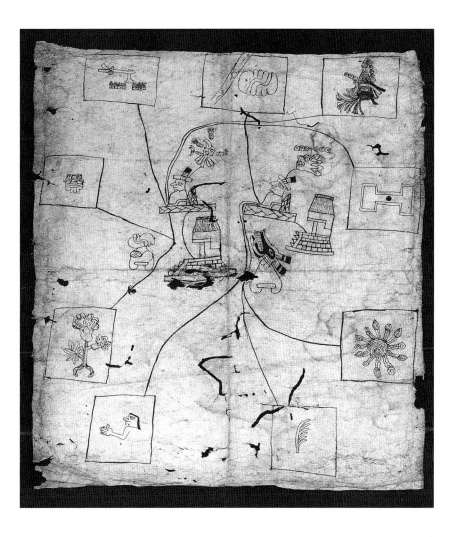

cally with Nine Wind); to the south, Tlachco and Atlan; to the west, Topilte-pec and Tamapachco (also neighbours along the western horizon in the Toch-pan Maps); and finally, to the north, Ichcatlan and a cave toponym also present in the Tochpan Lienzos that remains unidentified. The arena thus defined in the Map then serves as the setting for the events narrated in the Annals, which feature the inaugural year 13 Flint in a square marker (the same year and the same marker as in Tochpan Lienzo 1) (figs 95, 104),[25] and for the dynastic relationships traced in the Genealogies (fig.105). Here, further place glyphs appear which are familiar from the Tochpan Lienzos, the Xolotl Maps and the Mendoza Codex, such as the new moon of Metztitlan further to the west, the rushes of Tulapan, the fire-snake of Xiuhcoac, the maize cob of Tepecintla, and the frog which denotes the abandoned Cahuac or Cacahualco (Table 6B, fig.106). Throughout, the twin towns of Itzcuintepec and Tenanitec remain the constant central reference.

Though the Metlatoyuca Lienzo diverges in certain respects from the

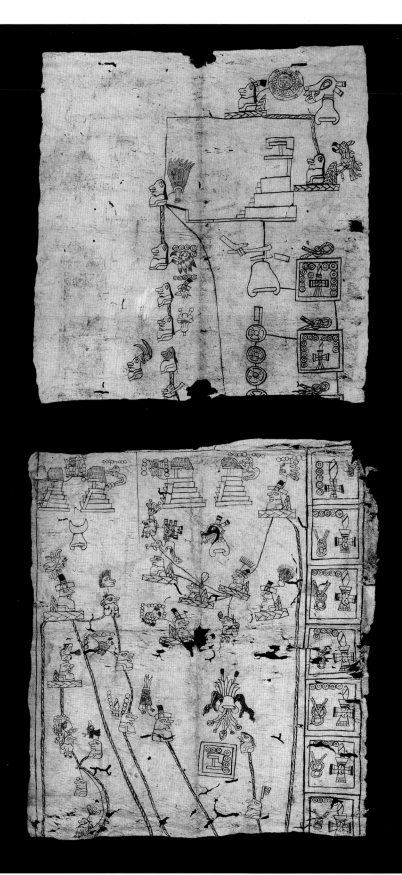

105 Itzcuintepec Genealogy

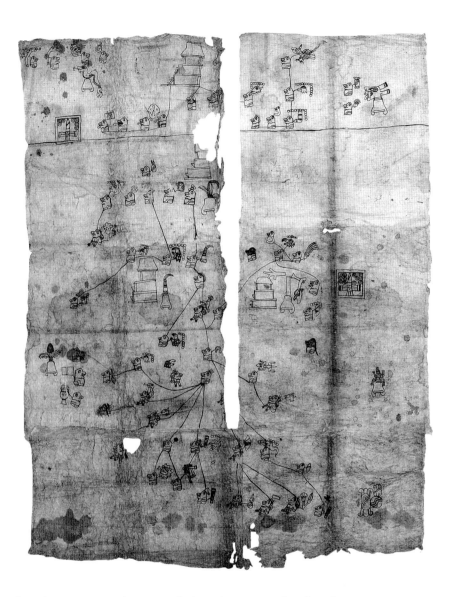

104 Opposite: Itzcuintepec Annals

Itzcuintepec texts, for example in using a round rather than a square year marker, it depicts human figures in the same squat forms and similarly distinguishes types of temple step as saw-tooth or right-angled (this distinction is also present in ritual texts like Laud). It names the same Chichimec ancestor, Huey Tonatiuh, and among the toponyms in both sources is found a diagnostic pair of gaming glyhs, those of the ball-court *tlachtli* (Tlachco) and the ludo board *patolli* (Patoltetitlan, north of Huachinango, fig.107), as well as the banner of Pantepec and the water glyph of Atlan itself.[26] Down its length, the Metlatoyuca Lienzo likewise recalls the Tochpan Lienzos in prominently featuring the Pantepec–Tochpan rivers, seen here further upstream and to the southwest in the drainage system.

This survey of five Chichimec arenas – the Highland Basin, the Cholula

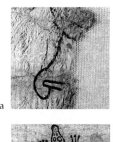

a b c

d e f

106 Metztitlan (crescent moon) and Cahuac (frog): a), d) Itzcuintepec Genealogy; b), e) Xolotl Maps; c) Tlaxcala Lienzo; f) Tochpan Lienzo

Plain, Tlaxcala, Coixtlahuaca and Cuextlan – far from exhausts the store of places these people inhabited or passed through. There are clear signs of their presence in many other texts from the Basin and surrounding areas, and their characteristic weaponry of bow and arrow even appears in Mixtec annals (fig.113) otherwise quite devoted to polities and dynasties which have nothing at all to do with cultures from so far to the north and west. It does, however, provide a framework, the *chichimecatlalli*, in which to place a good proportion of texts now in the UK, namely the codices of Tepetlaoztoc and Tepotzotlan from the Basin, the Tlahuixtlahuaca Roll from Coixtlahuaca, and the Itzcuintepec texts and the Metlatoyuca Lienzo from Cuextlan; and it gives us a clue to the story of itself that Tlaxcala silenced. It also helps to show how interrelated the five main Chichimec arenas were, over the whole span of the Mesoamerican 'Middle Ages', and hence to contrast the various norms and conventions that they adopted from the local populations they encountered. Over the whole area we find as many as five different types of year marker – square, round, diamond, solar ray (A-O) and knotted band (fig.6) – lesser or greater emphasis on dynastic succession, greater or lesser preference for royal pairs over single male rulers, different images of Chicomoztoc itself. Yet this place is constantly identified as the beginning of the larger Chichimec story, which in all cases features migration, a formative experience in its own right, typically represented by footprint trails through palpable landscapes.

The fact that all these Chichimec texts recount a common experience leads us in turn to broach the delicate question of chronology, comparing the time-depths they establish. An anchor here has to be the Cuauhtitlan Annals, which work their way forward from year to year, over nine centuries from 1 Reed (AD 635), successively recounting the deeds of the Chichimec who first emerged from Chicomoztoc, the rise of highland Tula and the great diaspora of 1064, the arrival of the Mexica in the Basin (the dates are admittedly a bit difficult here), and finally Moctezuma II's encounter with Cortes in 1519. Often disregarded or disbelieved, the overall scheme proposed by these

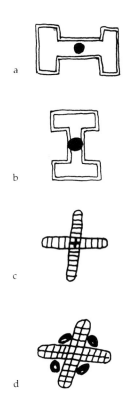

a

b

c

d

107 Gaming glyphs Tlachco (ball game) and Patoltetitlan (board game): a), c), Itzcuintepec Codex; b), d), Metlatoyuca Lienzo

annals from Cuauhtitlan can now be seen to be supported by other Chichimec texts at every stage. The 1064 date given for the diaspora from Tula fits well with reports from precisely the places which the migrant Toltec Chichimec are said to have reached, notably Cholula and Coixtlahuaca. In starting their year count proper in 9 Flint (AD 1176), just over a century later, the Cuauhtinchan Annals leave an appropriate space for the migrations to Cholula, back to Chicomoztoc and then again to Cholula. Similarly, in depicting the dynastic lines of Coixtlahuaca, the lienzos of that area count 20 or more generations between the Chichimec arrival and the encounter with Cortes (whose troops actually appear in several cases). Hence they effectively push the arrival and the great kindling back towards the tenth century, though it should not be forgotten that some of the Chichimec who reached Coixtlahuaca did so by other routes which bypassed and had no necessary connection with highland Tula.

Going further back, which most analysts of the Cuauhtitlan Annals have been reluctant to do, corroboration from Coixtlahuaca and other areas can be found in turn for the yet earlier dates specified for the first emergence from Seven Caves, four or five centuries before the Mexica left Aztlan. In the first instance, the main evidence here is provided by the Cuextlan texts, which corroborate each other in confirming the seventh-century beginnings spelt out by Cuauhtitlan. The Nahuatl gloss on the Itzcuintepec Roll unequivocally states that the migration from Seven Caves began 'eight hundred and sixty years' prior to the sixteenth-century date at which it was written: this order of time is confirmed in the Metlatoyuca Lienzo both by a further calendric count, of 763 years that includes a hair-feather (400) plus 17 units of 20 (a flag or banner); and by a genealogy which extends forward to around AD 1500 over no less than 26 generations. As for Coixtlahuaca, the longer dynastic lines there extend to as many as 31 generations. This repeated placement of Chichimec beginnings in the seventh century finds an echo in the work of Chimalpahin, Motilinía and other historians who transcribed data from annals written in native script. And it is supported by the more recondite time-counts of the kind found in the Nepopoalco Maps, which begin with a reminder of Seven Caves as a base date and thread year multiples (two hair-feathers or twice 400, plus sundry smaller units) into a border that ends at the year '1466'.[27]

In sum, our indispensable source for learning about Chichimec history is the considerable body of texts which, though otherwise often quite diverse, acknowledge a common origin in Seven Caves. These reconstruct for us the *chichimecatlalli*, the vast network of arenas that lay between Michoacan and Oaxaca, and record a history of migration and settlement which, beginning before highland Tula flourished, spread over seven or more centuries.

THE MIXTEC LINEAGE TREE

That a dynasty arises as if born from a tree is a widespread conceit in Mesoamerica. It is found in the lowland Maya city of Palenque, in the seventh-century panel that celebrates Pacal and his son Chan Bahlum; and it recurs 1000 years later far to the west in the Landbook of Tepotzotlan (fig.108). In the Mixteca region of western Oaxaca it has a particular currency in the impressive body of screenfold annals which were produced in the fifteenth and sixteenth centuries in order to justify family claims to power in such towns as Teozacoalco, Tilantongo, Xaltepec, Tlaxiaco and Tututepec. Tracing genealogical threads through nine or more centuries, these histories highlight the tree sources of favoured lineages in such places as Apoala, the white tree, on the continental divide (Yuta tnoho or lineage river in Mixtec) (fig.109), and the 'burned town' Achiotlan further to the west (Nuu dna in Mixtec).[1]

While the Mexica and the Chichimec recorded their beginnings as migration from distant landmarks, island and cave, the Mixtec ruling class identified theirs with emergence from trees that stood closer to home. And rather

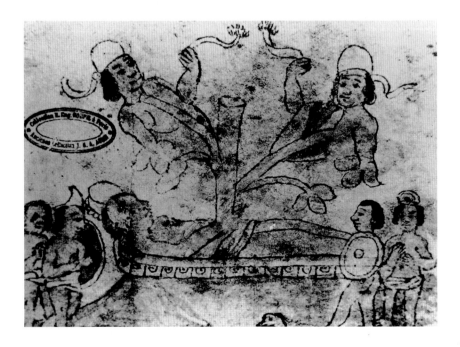

108 Family tree. Tepotzotlan Landbook

than feature journeying male heroes who pioneer the roads of conquest, the Mixtec texts invoke ancestors who appear as royal pairs from the start, women and men who initiate immensely complex webs of intermarriage and family intrigue. The power enjoyed by Mixtec women – recognised political fact – positively leaps out from the pages of these annals.

Like their eastern neighbours the Zapotec, the Mixtec 'cloud people' were heirs to the great Oaxacan civilisation epitomised by Monte Alban, a city whose power reached back in time to the early first millenium BC and which

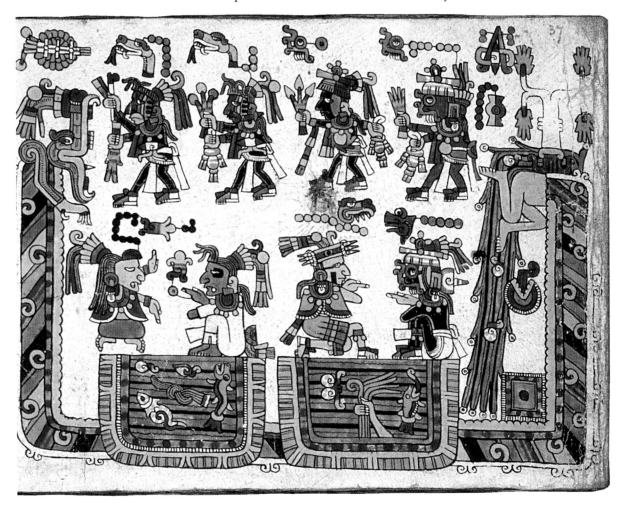

109 Apoala as river source. Teozacoalco Annals (Zouche), p.37

flourished as an ally of the highland metropolis of Teotihuacan.[2] With the demise of this old order, the Mixtec began to establish claims of their own, developing their own style of calendar and script within the broader Mesoamerican tradition. Having language and these cultural traits in common, the Mixtec nevertheless struggled between themselves, in a series of close-knit rivalries. First, the tree-born lineages sought for one and a half centuries or so to impose themselves on an older earth-born aristocracy, and

finally succeeded in doing so by the early tenth century. Second, the tree-born rulers incessantly disputed each other's rights to accession, especially insofar as these were affected by the notorious eleventh century tyrant Eight Deer Jaguar Claw (AD 1011–1063), whose life and times are a main focus for post-Classic Mixtec history.

So intense and self-absorbing were these dynastic debates that they could become the very stuff of history, beside which all else diminishes into insignificance. A fine example of this tendency comes in the annals of Xaltepec (Selden Codex), which covering nearly 1000 years of dynastic succession continue to set out rights of the local lineage, in perfectly pre-Cortesian fashion, until as late as the 1550s. It is as if the Spanish invasion, which goes entirely unmentioned, had never happened. The town Teozacoalco acted in similar vein, with regard to its lineage, whose pre-Cortesian history is recorded in the Zouche–Nuttall screenfold. When replying to the standard questionaire of 1580 which the Spanish sent out to native towns in order to elicit the reports known as the *Relaciones geográficas*, Teozacoalco distinguished itself not just by dealing with the usual facts of geographical environment but by rehearsing the whole centuries-long story of its tree-born dynasty, in a native-style genealogical map that runs through to contemporary times. (The fact it did so gave invaluable clues to the Mexican scholar Alfonso Caso, in his epic task of deciphering and correlating this Mixtec corpus.) In Tututepec, on the Pacific Coast, these same dynastic concerns surfaced again as late as the nineteenth century, when part of the Colombino–Becker screenfold – annals that included a biography of Eight Deer and his special links with that southern area – was produced as evidence in a legal dispute.

Like Eight Deer Jaguar Claw, the characters in this royal Mixtec saga are normally named by their birth-date in the *tonalamatl* (Eight Deer), plus an epithet (Jaguar Claw) that serves to distinguish them from others with the same *tonalamatl* name, their year of birth being punctiliously noted in the 52-year calendar (Eight Deer was born and died in years with the same name, 12 Reed, 52 years apart – 1011 and 1063). Much of the keener infighting between rival lineages centres on precisely this order of calendric detail, facts being massaged to suit the argument being advanced: dates are doctored or removed so that second husbands and wives displace first, and younger half sisters and brothers usurp elder siblings. Indeed, the evidence produced by Tututepec in the court case just mentioned (the Colombino–Becker screenfold) is severely marred in its own terms by the fact that dates and day names have been erased from a text otherwise left intact. Needless to say, this sort of creative approach to dynastic links that are dauntingly intricate in any case has done little to help those seeking to establish a general framework for Mixtec history. There is nonetheless broad agreement about the succession of dynasties and the fact that rulers emerged from the trees of origin not all at once but over time, just as the Chichimec emerged from Chicomoztoc.

A dozen or so Mixtec dynastic narratives have survived in screenfolds now for the most part in English libraries, and they can be usefully approached according to the usual criteria of date and provenance, as well as the ideological line each defends. Touchstones in this exercise are Nine Wind, patron of the Apoala tree-born elite; Lady Nine Tooth of Mictlan–Chalcatongo (Dzandaya), matron of the earth-born; Eight Deer of Tilantongo; and Eight Deer's distant aunt and rival to the throne of Tilantongo, Lady Six Monkey of Xaltepec.[3]

The heartland: Tilantongo, Teozacoalco and Xaltepec

As the Apoala tree-born began early to consolidate their power in the Mixteca, the 'black' town Tilantongo (Nuu tnoo) at the heart of the region had effectively become its capital by the early tenth century (fig.110). A century later, this position was reinforced by Eight Deer, who made it the centre of an empire that emulated that of Monte Alban, reaching from the Pacific coast in

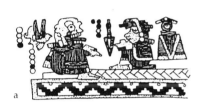

a b c d

110 Tilantongo (small black chequers): a) Tilantongo Annals b) Teozacoalco Annals c) Teozacoalco Map d) Tepexic Annals

the south up to and beyond the continental divide in the north. History from Apoala up to the 1490s is recounted from the viewpoint of this town in the Bodley codex. The main narrative on the obverse gives due attention to Eight Deer, respectfully tracing his rights back through his father Five Caiman to the tree-born Eight Wind. Indeed, though his birth date remains the same as in other accounts, Eight Deer is even credited here with being the son not of Five Caiman's second wife Lady Eleven Water but of the woman who is otherwise recognised as his first, Lady Five Eagle. And the grand design of his empire is anticipated in a geographical prologue not found elsewhere, which straddles the continental divide in the fashion of the Coixtlahuaca and Tepexic texts.

On the reverse of the Bodley screenfold we find a series of genealogies from other places which are made to feed into the principal story, that of Tilantongo, told on the obverse. Among these places is Tlaxiaco or Tlachquiauco, a town to the northwest embroiled in the Mexica defeat of Coixtlahuaca in the 1460s and then invaded by Moctezuma II in 1511–12 (fig.115d). Dating to the 1490s, the Bodley legitimation of Tilantongo was made between these two Mexica invasions, and can be interpreted as a response to the threat posed by the first (fig.111).

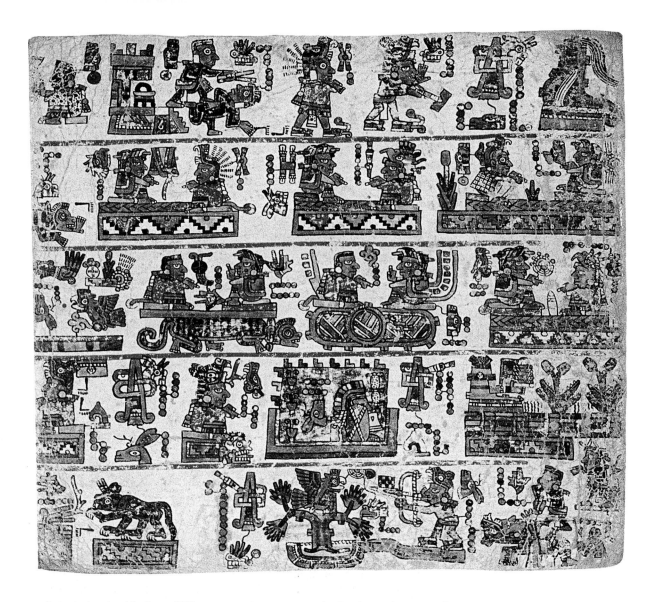

Intertwined with that of Tilantongo at every stage is the dynastic story of Teozacoalco, the 'great temple enclosure' (Chiyo cane in Mixtec) and major political centre situated to the southeast, close to Monte Alban and the Zapotec centre Zaachila (fig.112).[4] Teozacoalco's principal text is the Zouche–Nuttall screenfold: the obverse gives an overall history, in which the tree-born of Apoala are not always preferred to their earth-born predecessors; the reverse is a biography of Eight Deer up to the age of 40, the eve of his first marriage. A masterpiece of literary diplomacy, the biography treads a narrow line between celebrating Eight Deer's grandeur, on the one hand, and denouncing his psychopathic greed and many atrocities on the other. Most delicate is the treatment of the blood-drenched rivalry between him and his aunt Lady Six Monkey of Xaltepec, protégé of Lady Nine Tooth.

In general, the two Teozacoalco narratives are notable for their broad perspective. Early historical and dynastic links are established with areas

111 Eight Deer's death and burial in 12 Reed (1063) (two lowest registers); rulers of Tilantongo's second dynasty are shown up to the seventh generation. Tilantongo Annals (Bodley) p.14

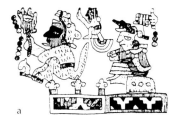

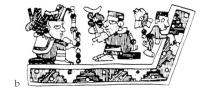

112 Teozacoalco (sacred enclosure): a) Tilantongo Annals b) Teozacoalco Annals c) Teozacoalco Map

beyond the Mixteca heartland, especially with the Zapotecs of Zaachila, and with the Cholula Plain to the north, where we are shown the familiar snow-capped volcanoes and the presence of the bow-and-arrow bearing Chichimec (fig.113), whose weapons contrast with the locally-used spear-thrower (*atlatl*). With regard to the figure of Nine Wind, whose authority is not accepted uncritically, there are even suggestive echoes of the sacred bundle and migration story told in detail in the Coixtlahuaca Valley texts (fig.114). Similarly, in Eight Deer's biography, much is made of that hero's involvement

113 Chichimec bowmen from the north: a) Teozacoalco Map, receiving tribute from Mixtecs Twelve Dog and Eight Rain; b) Teozacoalco Annals p.11

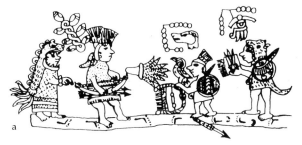

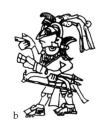

114 Nine Wind, in his sacred bundle, revered in the temple of the Plumed Serpent Quetzalcoatl. Teozacoalco Annals p.15

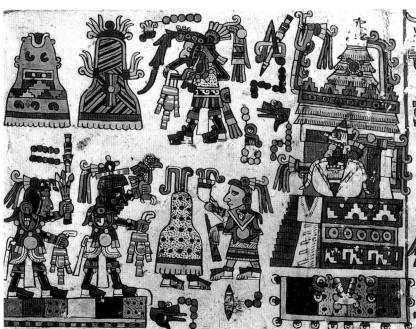

with the Coixtlahuaca patron Four Jaguar, and with One Death Sun, a friend of his enemies identified earlier (p.80) with Teotlillan and the Cuicatec area into which the Mixtec began to intrude precisely at this time (eleventh century).

The third of the three towns on which known Mixtec genealogies primarily concentrate is Xaltepec, the 'sand' town (Añute in Mixtec) set slightly apart to the east and listed as a subject of Coixtlahuaca in Mendoza (fig.115), along

a b c d

115 Mexica tributaries:
a) Xaltepec (sand); b) Tochpan (rabbit); c) Tepoxaco (volcanic stone); d) Tlachquiauco (ball court rain). Mendoza ff.43, 52, 26, 45

with its neighbour Mictlan. Xaltepec makes its statement in the Selden Codex of the 1550s, a 20-page screenfold painted on one side only and read from bottom to top (rather than the usual Mixtec direction of right to left). Although Xaltepec coincides with Tilantongo and Teozacoalco in recognising founding fathers in such figures as Ten House and Lady One Tooth, it locates the source of its tree-born lineage not in Apoala but Achiotla and traces quite different lines of descent (fig.116). Its modest domain of yesteryear is shown to have reached north to Nochistlan and south to Teozacoalco, with which it shows a special affinity on the subject of Eight Deer. There is less apparent affinity with Tilantongo, not least since five centuries previously Eight Deer had brutally murdered the ruler of Xaltepec, Lady Six Monkey, along with her children. However, in the name of a common Mixtec interest in the face of Mexica and then Spanish intrusion, the annals pass over these unpleasant moments in

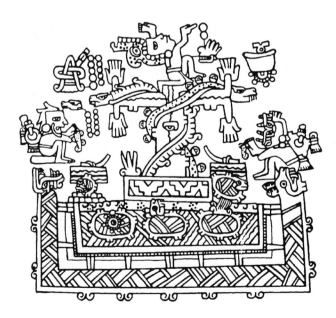

116 Tree birth. Xaltepec Annals p.2

silence, when presenting what is otherwise a most vivid account of Lady Six Monkey's life and times.

Outposts to south and north: Tututepec and Tepexic

While these annals from the core triad of Tilantongo (Bodley), Teozacoalco (Zouche) and Xaltepec (Selden) give a version of Mixtec history that is dense and enjoys a very high degree of cross reference, texts from other centres further afield offer interesting angles of their own. In its screenfold (Colombino–Becker), the southern polity of Tututepec (bird hill, Yucusaa in Mixtec, fig.117) concentrates on the lives of Eight Deer and his local successor Four Wind. It is overtly triumphalist, celebrating successful Mixtec intrusion into that rich coastal region. An ethnically complex mix of Chatino–Zapotec and Toltec–Nahua culture, with effective economic links (copper axe-money) over thousands of miles of the Pacific Coast,[5] Tututepec had in its day been incorporated into Monte Alban's empire and was later visited by the last monarch of highland Tula. In its annals, Tututepec powerfully inserts Mixtec presence into this southern province through the much vaunted figure of Eight Deer. His grand fire kindling of AD 1047, gingerly handled in Zouche and even Bodley, is here given a firm architectural setting. At the same time, Tututepec dispenses with the internecine quarrels between the metropolitan dynasts that were irrelevant down here; hence it has no qualms in celebrating Eight Deer's military victory over Lady Six Monkey and his subsequent murder of her and her children.

At the other geographical extreme from Tututepec a no less intriguing angle on Mixtec history is provided by the northern bastion of Tepexic, the 'ravine' (the Mixtec is Cavua) (figs 118, 82, 83, Map 3). An archaeological site of major proportions, whose origins are being pushed back to ever earlier

117 Tututepec ('bird hill'). Tututepec Annals

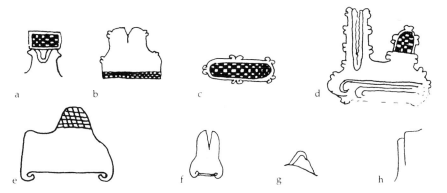

118 Tepexic ('ravine') Tliltepexic ('black ravine'): a) Tilantongo Annals (Bodley) p.4 b) Nochistlan Fragment c) Coatepec Lienzo d) Tututepec Annals p.3–4 e) Dehesa p.18 f) Heye Lienzo g) Cuauhtinchan Map 2 h) Tlaxcala Lienzo

a b c d

e f g h

dates, Tepexic with its split mountain and chequer board customarily figured, as we saw, to the northwest in the ritual quincunx map that centres on Coixtlahuaca and the upper Papaloapan, in texts from that region. In the Mixtec tradition Tepexic has a similar directional significance as the northernmost of the four quarters assigned to Tilantongo both during the first dynasty (Tilantongo

Annals) and at the time of Eight Deer's kindling (Tututepec Annals). Appropriately, the same town also plays a key role in a northern subgroup of Mixtec texts, whose formats differ from the norms of centre and south, and which favour ancestral births from mountains rather than trees. These are the Nochistlan Fragment where, as a dynastic seat to the west of the cochineal or 'cactus blood' place Nochistlan, Tepexic (lower register) matches Apoala to the east (upper register); the Egerton screenfold, possibly from Tehuacan,

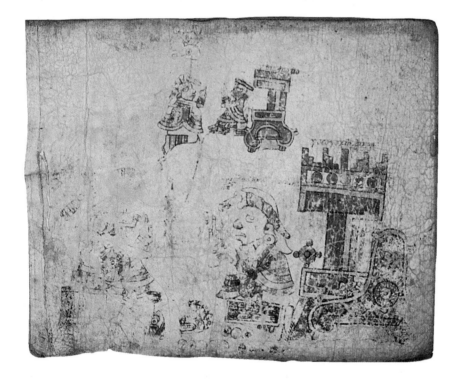

119 Jewel town. Egerton p.20

where in a similar division of registers it appears along with other northern centres such as Cholula and Tequixtepec, as well as with Tilantongo (fig.119); and the Tulane Codex of Huamelulpan, whose ancestors Nine Movement and Seven Deer (this time tree-born) were specially acknowledged by Tepexic, despite their limited power.[6]

The text which gives most prominence to Tepexic is the obverse of the Vienna screenfold, also the grandest surviving account of the tree-birth at Apoala under the auspices of Nine Wind. The longest screenfold annals extant, this text offers an impressively broad view of Mixtec history and falls into ten chapters, each of which culminates in a fire kindling. Five of these kindlings are placed on the map by bands of toponyms that are joined at the base, according to the ritual scheme of the centre that is surrounded by four horizons or quarters. Of these, east with the tree of Apoala (fig.177) and south with the skull of Mictlan are readily identifiable; north and west are less easy to read not least because of the fact that the Rain God (? north) denotes several

different locations, including the general concept of the Mixteca itself. In any case, these four horizons, whose bases all rest on the lower edge of the screen-fold page, are preceded by the band that includes Tepexic, Huehuetlan and other close neighbours, and which is uniquely privileged by resting on a base raised to the middle of the page (fig.83). Quite clear-cut, this formal arrangement in itself strongly points to Tepexic as the main focus of the narrative and hence its provenance. Such a provenance fits well with the northern traits otherwise evident in the narrative, not least the continuous and very close parallels with the Tlahuixtlahuaca Roll of Coixtlahuaca, noted earlier, on the subject of Nine Wind's links with Two Dog who presides over the kindling at Tepexic and who is the patron name of Tepexic in the Cuicatlan screenfold (Porfirio Díaz), as Caso has shown (fig.82). And it is not incompatible with the genealogy painted in a different hand on the reverse of the same screenfold, which unlike all those considered so far takes a general view of the Mixteca, its opening glyph, and evinces no particular loyalty to one or other dynasty or town.

In these Tepexic Annals (Vienna obverse), over the five pages that follow the tree birth at Apoala (pp.16–20) Nine Wind consecrates the founder couple of that place, One Flower and Lady Thirteen Flower, whose daughter Lady Nine Caiman married Five Wind and distinguished herself as a dread warrior. And he ratifies ancestors from several other places, such as Seven Flower and Lady Nine Reed, honoured by Teozacoalco and commemorated in an inscribed bone from Monte Alban; Lady Nine Tooth of Mictlan and Lady One Eagle of Nexapa, twinned matrons of the rivers that lie to the southeast and southwest in the Coixtlahuaca quincunx; Two Dog, the name later deeply tied up with Chichimec history; and Eight Wind of Xochixtlan, the ancestor invoked by Teozacoalco, Tilantongo and Xaltepec alike and held in common by Eight Deer and Lady Six Monkey.

In the Tepexic account of the Apoala birth, Seven Flower and Eight Wind appear amongst those nearest to the tree, along with half a dozen other named characters plus an unnamed yet distinctive naked couple (fig.120); and all of them can likewise be seen together, under the command of Nine Wind, in the Teozacoalco Annals. In this latter source, however, the tree as such is absent, and Nine Wind is portrayed more as a military oppressor than a benign patron. Ideological differences here, pro and contra the emblematic Toltec figure of Nine Wind Quetzalcoatl, intervene to the extent of making the Apoala birth scarcely recognisable as the same event. Treated with less enthusiasm by Teozalcoalco than by Tepexic, Nine Wind is ignored more or less entirely elsewhere in the Mixtec corpus, even at the climatic moment of the Apoala tree birth.

A similar difference of view occurs with respect to the main progenitor of Tilantongo's second dynasty Eight Deer, so widely invoked in the Mixtec corpus. For in the later stages of the story told in the Tepexic Annals, this figure is conspicuous by his absence, even though he appears on the reverse

of the same Vienna screenfold. As we saw, Teozacoalco gives a far less glowing account of his life than does Tututepec; yet not to mention him at all is still more negative, even when we admit that the overall thematic concern of the Tepexic Annals is less genealogical, especially in the later chapters. This must be read as a further ideological statement by Tepexic, one again proper to its northern perspective on events, to judge by apparent unflattering allusions to Eight Deer in ritual texts from Coixtlahuaca and Teotlillan.[7]

A notable feature of the Mixtec annals in general is the capacity of the scribes who wrote them to urge a particular version of history, not just through the kind of emphasis or omission we have been referring to but also

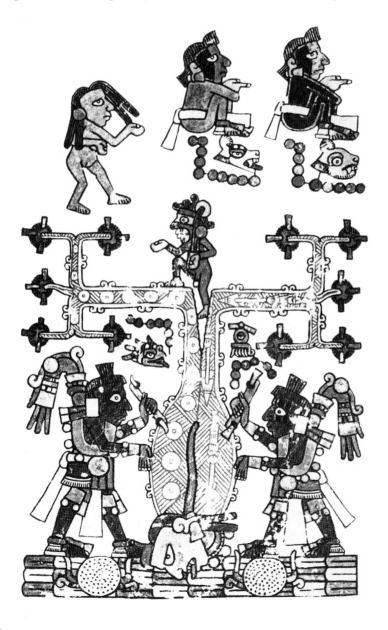

120 Tree birth. Tepexic Annals p.16

through subtler means of representation. This whole question is well illustrated in the subgenre of biography, where the focus on a single character is closer and more prolonged. Two examples immediately present themselves, Lady Six Monkey Kerchief and Eight Deer Jaguar Claw.

Famous lives

The abiding problem of Lady Six Monkey's early life, as the Xaltepec Annals tell us (p.6), stemmed from the fact that her elder brothers were killed in the year 9 House (AD 1021), leaving her torn over whether to further the dynastic claims of her family. That same year she took advice from her mentor Ten Lizard, which led to a period of retreat and meditation in a cave. She then paid her respects to Nine Tooth, the great matriarch of Mictlan, effectively advancing her claims over those of her young and already ambitious relative Eight Deer.

Her ensuing involvement with her future husband Eleven Wind is graphically narrated on page 7 of the Xaltepec Annals (fig.121). Reading from bottom to top, we see a dance held in their honour in the year 10 Reed (1035), at which old men and women move around a *teponaztli* drum with heart and flower rattles in their hands. Two years later, in 12 House, they bathe ceremonially together, naked in cascades of water. In the next register up, sits her mentor Ten Lizard, who has behind him a consignment of mantles and other clothing, quetzal plumes, jade and gold. The year is now 13 Rabbit (1038), and Ten Lizard is engaging two emissaries, Two Flower and Three Caiman, to carry Lady Six Monkey to her husband's town. This they do, along a road clearly marked in the next register, only to be insulted by Six Lizard and Two Caiman, whose cutting words are shown by flints set into their speech scrolls. In the top register Lady Six Monkey is seen in the 'skull' town Mictlan sitting face to face with the matriarch Nine Tooth, whose help she is seeking in order to avenge the insults she received. This is forthcoming in the form of the two warriors behind Nine Tooth, who with wood and obsidian swords in hand will capture the two offenders. One is sacrificed there and then, while the other is first taken to the town of Eleven Wind.

The marriage to Eleven Wind, who had previously been the husband of Eight Deer's half-sister, is then duly enacted in the same year 1038 (Xaltepec Annals p.8); seated on her throne she receives gifts from One House. The births of her sons Four Wind and Four Caiman follow in 2 Flint (1040) and 4 Rabbit (1042). It is the death of her husband Eleven Wind in 9 Reed (1047), which precipitates another dynastic crisis. Taking advantage of it, Eight Deer invades, kills most of the male heirs and, according to the Tututepec Annals, Six Monkey herself. This gruesome end to her 40 or so years of life is, as we noted above, diplomatically overlooked in the Xaltepec narrative, which quickly passes on to the fortunes of those who succeeded her. Her son Four Wind, who married Eight Deer's daughter Ten Flower in 1059, is the subject of the second half of the Tututepec Annals.

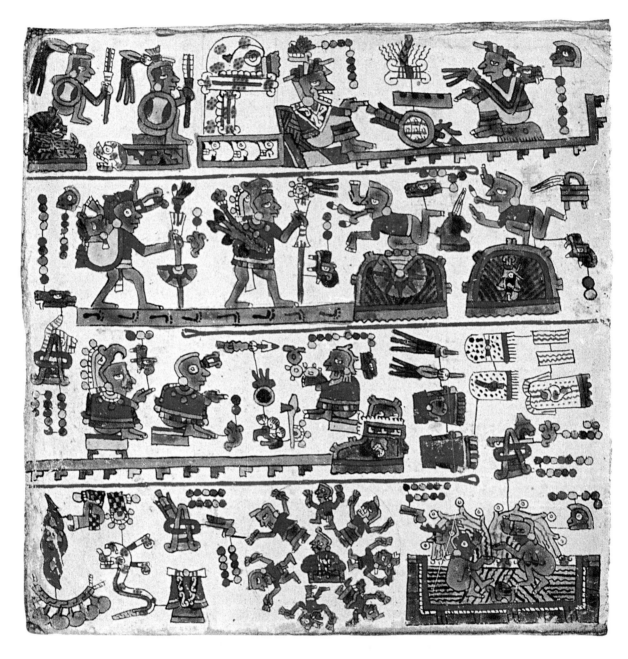

The main accounts of Eight Deer Jaguar Claw are those given in the first half of the Tututepec Annals and on the reverse of the Teozacoalco or Zouche screenfold. This latter source runs to over 40 pages and covers the 39 years of his bachelorhood. At the start he is identified among his siblings as the first child of his father's second marriage, being born in the year 12 Reed (1011) (fig.122). Already as a child of eight and an adolescent of 16 he launches into conquest, Herculean episodes marked by the places that were penetrated by spears thrown from his *atlatl* (fig.123). This activity precedes and sets the tone

121 Lady Six Monkey's life story. Xaltepec Annals (Selden) p.7

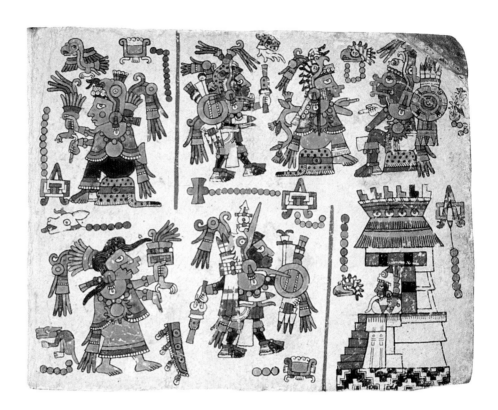

122 Eight Deer's father Five Caiman, ruler at Tilantongo

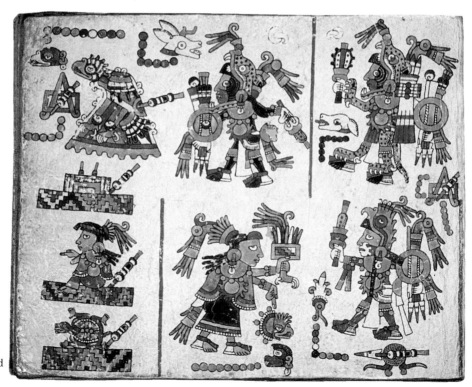

123 Eight Deer, first child of his father's second marriage, as child conqueror

for his attempts to be recognised at the age of 20 as a future ruler; sitting behind Lady Six Monkey he pays his respects to the matriarch Nine Tooth at Mictlan (fig.124). This episode has been interpreted as a bargain made by both Eight Deer and Six Monkey, whereby they traded their souls for the infernal power controlled by the skeletal Nine Tooth. Four years later, in a more contemplative mood, he offers incense eastwards at dawn, as the sun rises through the branches of a tree. Then at 32 he ceremoniously sacrifices a deer and a dog with his older half-brother Eleven Ollin and he receives a call from the sky; unlike that of his brother, his ear reddens to the voice from above, and the net of inheritance attaches to his foot.

After this succinct start, where we cover 32 years in three pages, great attention is paid to the remaining seven years of Eight Deer's political career as a bachelor. In this same year 5 Reed (1043) his energy attracts the interest of emissaries from highland Tula, with whose knowledge he begins his campaign against the rich southern province of Tututepec (fig.125). Its coveted cacao beans with their luxurious aroma figure among three paired gifts, the others being gold artefacts and a jaguar and eagle both newborn (fig.127), as in the offerings depicted at Teotihuacan. From the south coast he turns his military gaze to Mictlan, despite its sacred nature, and moving further north comes face to face with Four Jaguar, the grand patron name of Coixtlahuaca (fig.128). Under Four Jaguar's auspices he receives the honour of having his nose pierced and thereafter is seen wearing an elaborate jade ornament.

Over the following 16 pages of the Teozacoalco narrative (pp.53–68), Eight Deer achieves his maximum recognition. With his older half-brother kneeling before him he receives homage from a contingent of 100 lords who represent 29 towns in the four quarters around Tilantongo and Mictlan; this is a ritual arrangement which in the Yucusaa version is given far more cosmic resonance. The sequence of place signs and the names and attributes of their lords indicate a domain that faced the Zapotecs to the east, extended north over the continental divide to Coixtlahuaca and the Cholula Plain, was firmly hemmed in to the west by Tlapa and Tlachinollan, and found particular military glory in subduing the heavily armed rulers of cacao-producing Tututepec to the south.[8]

His aspect ever more ferocious, Eight Deer sets off again from Tilantongo in 8 Rabbit (1046), conquering and instigating scenes of sacrifice which now involve not just dogs but humans and messengers from above who snatch up hearts. He also enters into dispute with Four Jaguar, invading territory which now includes the 'singer' town Cuicatlan and the Upper Papaloapan, and then embarks on the first of two water-borne attacks, to which a whole page is dedicated, taking the town of 'breeches' (perhaps the Maxtlatlan shown in the Xalapa *RG* Map). In the Tututepec version, the following year 9 Reed (1047) – his most glorious – is consecrated by a fire kindling which quite dominates the text, being enhanced by celestial motifs and images of wordly might. The Teozacoalco story, however, is different, despite the reference in the gloss *nauh*

124 Visit, with Lady Six Monkey, to Mictlan; penance and sacrifice

125 The bargain made with the Toltecs over Tututepec

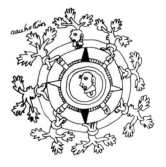

126 'Nauh ollin' or Four Movement, the name of this Era, as gloss on a place-name that shows 52 of the 80 'degrees' that make up the Mesoamerican circle. Teozacoalco Annals p.76

127 Gifts, in three pairs, from Tututepec. Teozacoalco Annals p.47

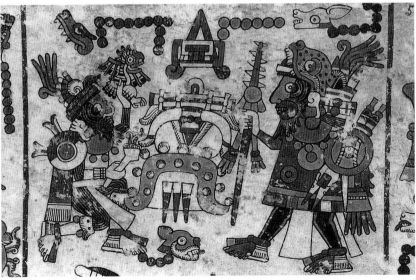

128 Eight Deer with Four Jaguar. Teozacoalco Annals p.52

129 Water-borne attacks, by night
(top) and day (below).
Teozacoalco Annals pp.75, 80

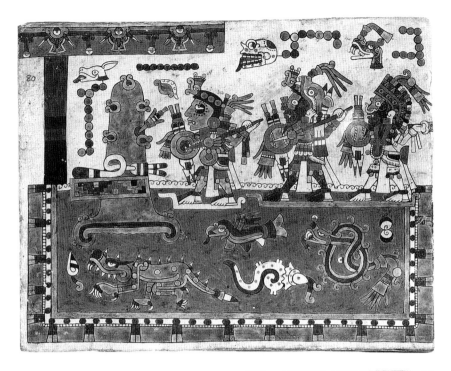

ollin to the year 9 Reed's great significance in the Era (fig.126). The year begins
and ends badly, and the kindling itself, performed with a drill which is out of
kilter, is squeezed in as just another event in the boustrophedon reading
stream. Beforehand, having witnessed the death of one who bears the name
of his younger brother Nine Flower, Eight Deer abuses a contingent of 14 lords
who carry the flag of the sacrificial victim. Afterwards, having further con-
sulted with Four Jaguar, he engages in the second water-borne attack, which
ends in disaster. As in the case of other paired events in this biography, such
as the animal and then the human sacrifices or the two successive contingents

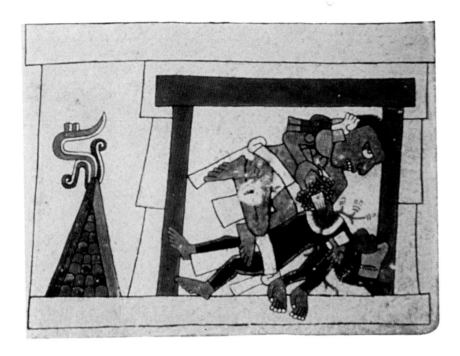

130 Murder in the sauna. Teozacoalco Annals p.81

of subject lords, the meaning of each becomes clearer through comparison. The first attack was by night, on calm water, and the aquatic creatures below swim in sympathy in the direction of the attack. The second is by day, on rough water which causes the boats to sink, and there is little support from the creatures below (fig.129).

Occupying the final four pages, the closing years 10 Flint to 12 Rabbit (1048–1050) are saturated with death and destruction, and the savagery indicated in Eight Deer's second name Jaguar Claw. First, his elder half-brother is murdered in his sauna or *temazcal*: breaking all the rules, the assassin hides the knife in the branches used to beat the skin during the sauna (fig.130). Eight Deer's part in the affair is not clear, but he goes through with the funeral rites, receiving gifts; yet this time these do not quite equal the three pairs once received at Tututepec and do include the fermented pulque which as a motif threatens disintegration.[9] Next (fig.131) we see the aftermath of his invasion of Lady Six Monkey's domain, and his capture of her son Four Wind, a mere lad of nine (the usual version is he escaped by hiding in a cave). Finally he indulges personally in a gladiatorial event, tearing with his jaguar claw at the flesh of the victim, who is tied by the waist to a heavy stone; further bloodletting follows when another victim, tied to the *tlacaxipectli* frame, is shot through with spears. Blood red having become the dominant colour, the narrative then discreetly fades out, leaving the rest of Eight Deer's ever more murderous career to the imagination (fig.132). The obverse, however, does record the end of his bachelorhood and the first of his several marriages, in the year 13 Reed (1051).

131, 132 Opposite: Sacrifice in the closing scenes. Teozacoalco Annals pp.83–4

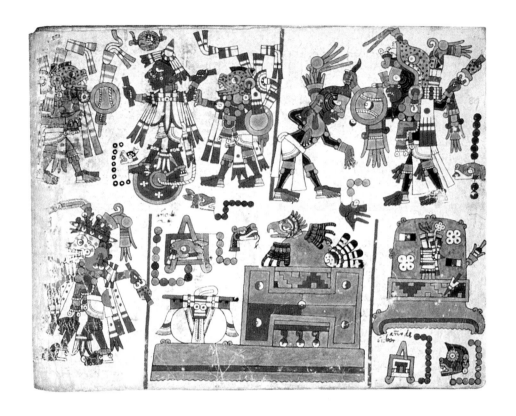

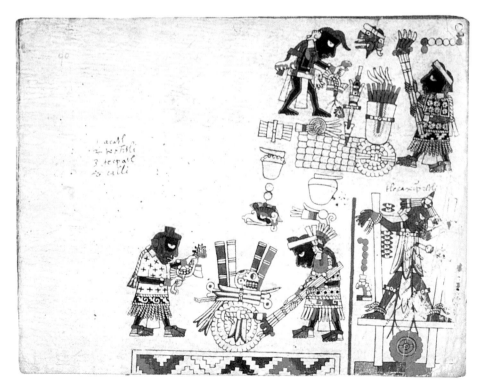

CHAPTER SIX

QUETZALCOATL'S TULA

Each of the three traditions we have now considered, Mexica, Chichimec and Mixtec, identifies its starting point with a natural landmark, island, cave and tree, which is fundamental to the history that then unfolds. Yet on occasion, the very texts which specify these starting points cast back earlier still, to more distant epochs of Mesoamerican experience. In doing so, they concur in invoking Tollan or Tula, the Toltec 'bullrush place', as the prior beginning of things. In the Cuauhtinchan Annals this place is called the 'great Tula', Huey Tollan; the *Cantares mexicanos* (Song 69) call it eastern Tula, Tollan Tlapallan. In the Tepexic Annals and the Tlahuixtlahuaca Roll, it is the home of the plumed serpent Quetzalcoatl.[1]

Tula remains a major problem for scholars, its identity, its location, its antiquity. As the home of Quetzalcoatl, Tula is widely celebrated, in the larger scheme of world ages, as the first city of this Era, the cradle of calendar and script, of civilisation itself: yet it is hard to know where this ancient and splendid place lay, or indeed whether it ever existed. The *Cakchiquel Annals* of Solola (highland Guatemala) coincide with the *Popol Vuh* of the neighbouring Quiche Maya in identifying it in these terms, yet speak of it as not one place but four, ritually patterned to the east, west, north and south. Elsewhere the fourfold model determines the multiple not of towns but of provinces subject to Tula, as in the Cuauhtinchan account of these subjects as the digits of two hands and two feet; yet again, four is the number of beamed temples built at Tula by Quetzalcoatl. Then, the very prestige of Tula's bullrush sign caused it to be consciously adopted as a place name, by the Tulas known historically in Mesoamerica, which are ubiquitous and include Tula in the modern state of Hidalgo, as well as Tollantzinco (with a diminutive, known in Coixtlahuaca and northeast of the Basin), and Tulapan (known on the Gulf Coast to the east and west in Tabasco and Tochpan). It also became an epithet for urban greatness as such, in the cases of Cholula (Tollan-Chololan), site of an ancient 'Toltec' pyramid and Quetzalcoatl's main shrine in the centuries before Cortes, Tenochtitlan, the Mexica capital, and even lesser centres such as Tlapiltepec which boasts the bullrush emblem in its Lienzo (figs 133, 29).

To compound the difficulty comes the question of sources. Many a native historian complained that in giving a full account of Tula and the longer Toltec tradition he was at a disadvantage since the relevant texts in native script had been burned out of existence, in the bonfires of the Mexica emperor Itzcoatl,

and then of the zealous archbishop Zumárraga. Worse, in attempting to fill the resultant gap at the start of Mesoamerican history, certain of these historians inserted tales of settlers arriving on the Atlantic and Pacific coasts, which have an unmistakable Christian-colonial flavour.

In this situation, many scholars have been content to recognise only one Tula, the highland Tula of Hidalgo. This is obviously the place referred to in the great majority of texts, not least the Mexica and Chichimec accounts of migration to the Highland Basin; and archaeological research at the site has

133 The ancient adobe-brick pyramid (*tlachiualtepetl*) at Cholula: a) Cuauhtinchan Map 1; b) identified with the Toltecs ('Toltecatl'), Cholula Map 2; c) identified with Tula ('Tollan') and the rushes (*tule*) of the Atoyac river, Cholula *RG*

confirmed the statement in the Cuauhtitlan Annals that it flourished between the ninth and the eleventh centuries AD, before the diaspora that spread even to Campeche and Yucatan (its distinctive 'snake' columns have counterparts at Chichen Itza). In this reading, however, the term Toltec becomes identified exclusively with this late horizon and references to other Tulas, in particular the great eastern Tula that may have antedated Apoala or Seven Caves, are dispatched to the realm of 'myth'. It is alleged that descriptions of this other place are clearly hyperbolic; that we know of no archaeological site with which it could be identified, or of any specific language or culture; that its dates where legible are hopelessly vague; that its ruler Quetzalcoatl is a mere archetype; and so on.

Climate and produce

At first sight, this approach seems to be encouraged by the accounts of Tula that are given in the Florentine Codex. There, Quetzalcoatl belongs to Nahuatl culture through the very syllables of his name; yet the Toltecs are identified at another point with the Olmec, the 'rubber people' of the Gulf Coast, who certainly spoke quite another language. And the economy of Quetzalcoatl's domain Tula appears indeed to be that of an other-wordly Golden Age:[2]

> The Toltecs were certainly rich
> food was not scarce enough to sell
> their vegetables were large
> gourds for example mostly too fat to get your arms round
> maize ears millstone size
> and they actually *climbed*
> their amaranth plants
> cotton came ready dyed

in colours like crimson saffron pink violet leaf-green
 azure verdigris orange umbra grey rose-red and coyote yellow
it all just grew that way.

They had all kinds of valuable birds
blue cotingas quetzals turpials red-spoonbills
which could talk and sang in tune
jade and gold were low-priced popular possessions
they had chocolate too, fine cocoa flowers everywhere.

The Toltecs did not in fact lack anything
no one was poor or had a shabby house
and the smaller maize ears they used as fuel
to heat their steambaths with.

Yet passages such as these are not enough to justify our thinking of the early 'great' Tula as entirely fictitious. To begin with, for all its bravura this Nahuatl paragraph need not be construed as hyperbolic. Indeed, comparing the details given here with other descriptions of the 'mythical' Tula points us in quite specific directions, historically and geographically. The products attributed to the place are far from random or randomly arranged: they fall into just the two main categories imposed on commodity tribute in the Mesoamerican system, as such documents as the Tizatlan and Mendoza codices remind us. There are first, everyday food, and second, more durable and luxury items.

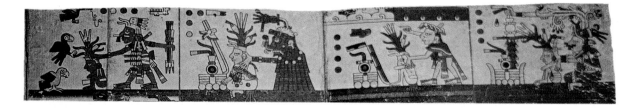

For its part, the food is both staple and the trophy of the adventure in plant genetics for which tropical America is renowned, one which culminated in the development of maize, whose size – a critical point in the story – is mentioned twice here. The doctrine according to which human flesh itself was made of maize, enabling the civilisation of this Era to begin, is a constant in Meso-american texts, from the Trilogy of panels at Palenque and the *Popol Vuh* to Féjérváry (fig.134) and the *Cantares mexicanos* of Tenochtitlan. In this last source, the maize emblem is fully identified with Tula, as it is in the Rios Codex, also of Tenochtitlan. A late copy of a pre-Cortesian original, enhanced by copious glosses in Italian, Rios traces advances in agriculture in a world-age context, showing how maize came to characterise this Era and how it was improved as a staple thanks to the efforts of Quetzalcoatl and his capacity to control the work force through the four temples he built at Tula (fig.135).

134 Maize planting. Féjérváry PP.33–4

The other products attributed to Tula in the Florentine Codex define space both through the environment they grow in – cotton, rubber, cacao – and through traditions of manufacture – objects worked from gold, jade and the plumage of tropical birds. Consulting the tribute lists in Mendoza we find the

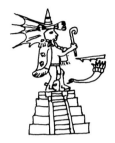

135 Quetzalcoatl at Tula; his four temples or ministries are ranged below the symbols of the recalcitrant work force (deer and stone) that is converted to productivity (lizard and plant, both green). Rios f.9

plants confined to the hot lowlands, including the naturally dyed cotton (far from being a phantasma, this Mexican product is today again being commercially developed).[3] The products manufactured from gold, jade and plumage are also all listed, though these are now mainly confined, like the balls of processed rubber, to the eastern tribute road opened for Tenochtitlan by the capture of Coixtlahuaca, signally Tochtepec on the lower Papaloapan, whose wealth outdid that of all the other districts combined. Learning of Tochtepec's wealth within a matter of days of arriving in Tenochtitlan, Cortes decided to capture it, as was his wont, though as it turned out he met with little military success in this case. The same route had been taken centuries previously by Quetzalcoatl One Reed or Topiltzin of highland Tula, who at the end of his days journeyed eastwards to Zacanco, Xicalanco, Acallan and Tlapallan. As a Toltec heir, Topiltzin chose this destination because, in the words of the 'Toltec Elegy' in the *Cantares mexicanos* (ff.26v–27), he was expected there, because 'his house is already there'. Reviewing this question, Nigel Davies acutely remarked that 'such reports reinforce the tentative suggestion that some kind of Toltec colony had existed on that [Gulf] coast, which could later have become a receiving area for Toltec fugitives [like Topiltzin], though archaeological confirmation is scanty'.[4]

Downstream from Tehuacan, Coixtlahuaca, Apoala, Cuicatlan and Teotlillan, the district of Tochtepec lay and lies on the edge of the lowlands that stretch to the coast of Veracruz and Tabasco. Precisely this area is identified with Tula and the Toltec on two occasions in the Cuauhtinchan Annals. The first of these is the prologue, where the stage is set for the wide-reaching action of the main narrative, which as we have seen takes in the thousand miles or more that stretch between Chicomoztoc, highland Tula, Cholula, Tzoncoliuhcan and the Papaloapan Valley. The second is when the Toltec Chichimec are returning to Cholula via the Gulf Coast route that takes in Cuetlaxtlan, Tula, Teotitlan, Cozcatlan and Tehuacan: that is to say, this Tula lies somewhere on or near the lower Papaloapan River.

Twenty fingers and toes

The prologue to the Cuauhtinchan Annals confirms this location in detail, in presenting a diagrammatic list of place names transcribed from a native map, now lost, of the original great metropolis Huey Tollan. Here, the 20 subjects of Tula, in the form of personal possessives, are imaged as its 'fingers and toes' and are set out in four groups, hands and feet to the right and left on the page,

each of which corresponds to provinces to the east and west of the metropolitan area (fig.136):

Pantecatli	Nonohualca
Ytzcuitzoncatli	Cuitlapiltzinca
Tlematepeua	Aztateca
Tlecuaztepeua	Tzanatepeua
Tezcatepeua	Tetetzincatli
Tecollotepeua	Teuhxilcatli
Tochpaneca	Zacanca
Cenpoualteca	Cuixcoca
Cuetlaxteca	Cuauhchichinolca
Cozcateca	Chiuhnauhteca

136 Huey Tollan's fingers and toes. Cuauhtinchan Annals f.1v

To the left, the two western provinces are Pantepec and Tecolotlan and their subjects are all ports on the coast (Tochpan, Tecolotlan, Cempoala) or lie on the rivers that drain towards it (Pantepec, Itzcuintepec, Tlemaco, Tezcatepec, Tlecuaztepec all on the Pantepec–Tuxpan system, plus Cuetlaxtlan, and Cozcatlan, far up the Papaloapan and one of the earliest homes of maize in Mesoamerica). They can all be identified with towns named on later maps; indeed, the border between the Pantepec and Tecolotlan groups can be seen as a remote antecedent of the Atlan enclave defined in the Tochpan Lienzos. The ten subjects of the eastern provinces, by contrast, have largely disappeared, although certain of them are named if not located in other texts, such as the Zacanco of Topiltzin's eastward destination, and the Chiuhnautlan and the Nonohualco of the Matichu Chronicle, in the Books of Chilam Balam, which recount how settlers moved from Tabasco to Campeche and Yucatan.[5] It is worth noting that native towns have not only disappeared in these eastern provinces, they have also left no codices at all in native script.

Absolutely unambiguous in its hand-plus-feet analogy and in its sheer layout on the page, the model of lowland Tula's four provinces each with five subjects is unfortunately not respected in the chief edition of the Cuauhtinchan Annals, that of Paul Kirchhoff, who recast the whole set as five provinces of four subjects each, because he was convinced that the Tula at stake was not the lowland Huey Tollan – which name is ignored – but Tula Hidalgo and this was the only way the geography could be made to fit. Even so, the landscape had to be scoured at parish level before matching place names could be found. In short, the native geographical model of Huey Tollan is quite dismembered.

The lowland location suggested for Huey Tollan on the strength of the native evidence presented so far is corroborated by what we are told about the migrations that spread out from it. The eastward movement recorded in the Matichu Chronicle of the Maya has already been noted, and dates to the time of Christ in the count of Maya *katuns*; for its part the *Popol Vuh* of the high-

land Maya records the journey of those who brought script from Tula (*u tzibal tulan*). A matching westward movement towards Tochpan and then up past Tollantzinco to highland Tula is detailed by Ixtlilxochitl, for around AD 400 (see p.63). This route is likewise alluded to in the Cholula *RG* (fig.33), where Tollantzinco and highland Tula are said to have taken their names from a far older and greater counterpart, precise memory of which was now lost, but which undoubtedly had existed as the prototype for Cholula as well (Tollan–Chololan).

> And the Indians also say that the founders of this city came from a place called Tullan, about which, since it is far away and much time has passed, there is no information; and that on the way here they founded the Tullan which is twelve leagues from Mexico City, and Tullantzinco, also near Mexico City; and that they ended up in this place and called it Tullan too.[6]

By the same logic, highland Cempoala, in its own *Relación geográfica*, is defined as an outgrowth of the lowland predecessor of the same name, the subject of Huey Tollan.[7] Recognising these westward Gulf Coast extensions of Huey Tollan is essential to understanding how Toltec cults epitomised in the very place name Quetzalcoatlan were encountered and adopted there by immigrants from Seven Caves, to Coixtlahuaca, Cholula and the Basin alike, along a route which bypassed highland Tula entirely. It also underpins the series of ancient towns listed by the priests of Tenochtitlan when defending the antiquity of their civilisation before the Franciscan missionaries. Starting off from Tula and the beamed temple Huapalcalco, we pass through Yoali-chan on the border between the coastal plain and the altiplano (the site of so many huge cities little-known today) and end in the Highland Basin at Teotihuacan – as recorded in the Priests' Speech:

> do you know when the emplacement was
> of Tula of Uapalcalco
> of Xuchatlappan of Tamoanchan
> of Yoali ichan of Teotihuacan?

A further route left southwards from Huey Tollan, and eventually led to Cholula, as is shown in the Rios Codex, which also mentions reasons for the diaspora. Places along the way, such as the 'shouting mountain' Tzatzitepec (in Tzoncoliuhcan), and the symplegades, or crusher mountain, can also be detected in the parallel but far fuller version of this experience reported in the Tepexic Annals (fig.137), which takes us further south to the Coixtlahuaca Valley, and to the Mixteca, the ancient fief of Monte Alban.

Indeed, defined in these ways by native texts, the domain of Huey Tollan is comparable with that of Monte Alban, in extent and on other counts. Reconstructing it similarly relies on the notion that toponyms may be remembered, even in the same glyphic form, over thousands of years if necessary: Joyce Marcus has shown, for example, how the sign for Cuicatlan, the place of the

singer, remained visually constant from inscriptions at Monte Alban, dating to the sixth century BC or earlier, up to the Mendoza Codex of the sixteenth century AD (Table 6B). Marcus also showed how this particular place, Cuicatlan, marked for Monte Alban a frontier to the north, right on the tribute road which passed down the Papaloapan Valley to, we now suggest, Huey Tollan.[8]

137 The route from Tula: a) Tzatzitepec b) symplegades. Rios ff.10, 12 (right); Tepexic Annals pp.8, 9 (left)

The Olmec and the Mesoamerican Era

Archaeologically, the Huey Tollan area is densely identified, through monuments and entire cities, with the rubber people, the Olmec. As the 'mother culture' of Mesoamerica, the Olmec are known as pioneers of urbanism by the start of the first millenium BC, who took an early interest in calendrics and script, elaborated the plumed serpent image and the fourfold cosmic model, built beamed temples, and made courts for the game played with the rubber ball of their name (*olli*, Olmec) – all prime Toltec attributes. And they had established a political network in Mesoamerica comparable if not identical in extent with what we have learned about that of Huey Tollan. Following the Florentine Codex, Nigel Davies points to the Olmec as 'the true Toltec', in the larger Mesoamerican framework. Of course, it is not a question of having to identify Huey Tollan exclusively or even largely with that culture, given differences, for example, between Olmec and later script types and given what we now know about the internationalism of the major Mesoamerican cities, but of saying that the link is likely more than geographical coincidence.[9]

In very recent times, the first decipherments have been made of extensive Olmec texts, inscribed in the first centuries of the Christian Era on stelae at sites now known by Spanish names on and near the lower Papaloapan (for example, La Mojarra and Tres Zapotes). These confirm that at least the elite among the Olmec spoke Zoque, a tongue close to Totonac until just before the first westward exodus reported by Ixtlilxochitl, and to Maya until the eastward exodus a century or two earlier reported in the Matichu Chronicle, the Maya having gone on to distinguish their speech phonetically in their own hieroglyphic script from AD 292 onwards.[10]

These decipherments leave no doubt that the Olmec viewed their history, already 1000 years old by the time they wrote the texts in question, in the

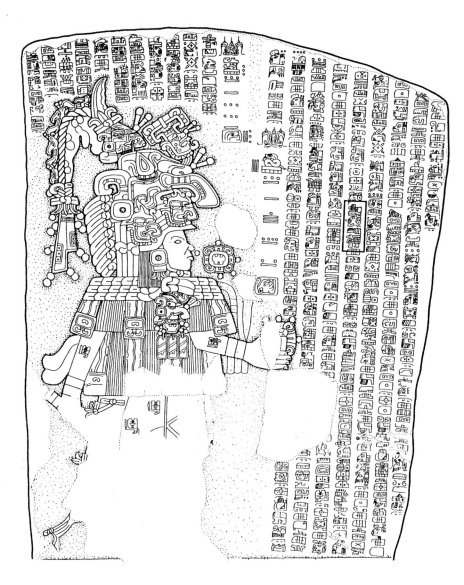

138 Olmec Stela, La Mojarra (after National Geographic). The two bar and dot dates, top centre, are 21 May 143 AD and 13 July 156 AD

grand perspective of the Era, which began in 3113 BC and which chronologically forms part of the even grander scheme of the world ages (fig.138). When setting up their own hieroglyphic system, the lowland Maya adopted this chronology too, to the extent that scholars most often refer to the 3113 date as that of the Maya Era, with fine disregard for what is solid Olmec precedent. Those who built Palenque, the western bastion of the Maya and the city of theirs that lies closest to the Olmec, also told stories of events early in the Era, in which a participant was the figure Nine Wind, the *tonalamatl* name by which Quetzalcoatl was widely known.[11]

Putting things in this Olmec perspective is important for our reading of similar calendric usages in the iconic script tradition, which have usually been dismissed out of hand, along with the idea that Huey Tollan ever actually

existed. The clearest example is again the Rios Codex which, in showing how this Era emerged at Quetzalcoatl's Tula from the story of human agriculture and the broader world-age scheme, measures its length in years. It is 13 lots of 400, or 5200 years, structurally the exact equivalent of the Olmec and Maya measures (fig.139). Another Mexica text which deals, magnificently, with the world ages is the celebrated Sunstone of Tenochtitlan (fig.140), where the same span can be read from the numerals embedded in the cloud snakes (*mixcoa*) that rim its disk, this time as 100 (ten by ten) Rounds each of 52 years. The name which the Sunstone gives to the Era, Four Ollin, incidentally coincides with the spring equinox of 3113 BC, in the Mesoamerican international day count. Other examples of such Era arithmetic, all of them in a world-age context, could be found in such Nahuatl texts as the Cuauhtitlan Annals and the Legend of the Suns, as well as in certain of the Mixtec annals, but the decoding is too complex to go into here.[12]

A major testimony to the Era begun in Tula is the Tepexic Annals which, as we have seen, are dedicated to Nine Wind Quetzalcoatl. At the start, this figure is born from the earth, the protégé of the creator pair One Deer (p.2) and the instructor in writing and rhetoric (p.4; fig.4), and then from the sky (p.5; fig.141), where he is seen with his Gulf Coast attire, shell pectoral and conical hat, and the four temples he built at Tula, the stars there recalling the Florentine image of the Gulf Coast as the land where the stars loom closest to earth. The cosmogonic nature of this beginning is confirmed in Gregorio García's eighteenth-century commentaries, with specific reference to this Quetzalcoatl, who later officiated at Apoala. Having established this august beginning, the Tepexic text goes on to celebrate its kindlings and the quarters, and in doing so not only invokes the Era span but actually counts it out from year to year, over 52 pages and four millennia.

Because of the enormous length of time covered by the Tepexic text, few have been prepared to believe that these are true annals, and various ways have been found of drastically pruning them. It has been alleged, for example, that most of the dates are just 'symbolic' and have no time value; or that the much of the first chapter, the longest by far, includes a subsection (Nowotny calls it 'Unterabschnitt', pp.4–16) that really consists of explanatory notes. There is no formal justification for treating the text in this way. The first chapter reads as a continuous, uninterrupted sequence and throughout the narrative follows the usual conventions of the annals or *xiuhtlapoualli* genre, according to which year dates are placed in a boustrophedon format, a reading stream that moves necessarily forwards. (Why bother using this format if the dates are not to be read as successive? How is it decided that some dates are just 'symbolic' and others are not when they all look exactly the same?) Indeed, not to read the Tepexic Annals in orthodox fashion calls into question norms otherwise applied automatically to the genre to which they belong. True, this history, like the others in the Mixtec corpus – or for that matter like histories anywhere – has ritual traits; yet even these in turn may confirm that

139 The Era's 5200 years as thirteen lots of four hundred (hair-feathers). Rios f.8

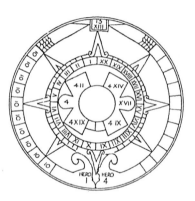

140 Diagram of the Sunstone, with encircling cloud snakes that each carry the sum of 10 × 10, and the Era name Nauh Ollin or Four Movement

the text is meant to be read as a sequence, for example when 2 Reed and other key year names are repeated exclusively at significant intervals, creating a rhythmic effect that cannot be ascribed to coincidence.[13]

At the very least, the Tepexic Annals deserve to be acknowledged as the kind of grand self-imaging in time for which Olmec and Maya Era inscriptions are noted, a structuring of the past designed to enhance the present of its

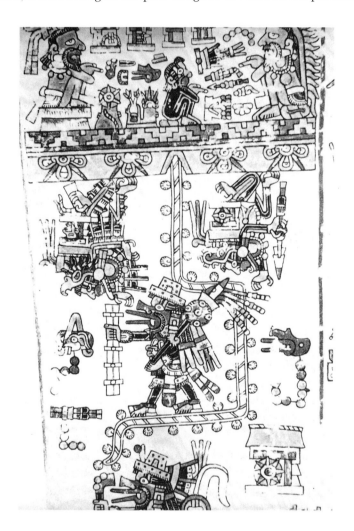

141 Nine Wind's sky birth. Tepexic Annals p.5

authors. What relation the self-imaging bears to material history is another, and a different, question. To pronounce on the matter negatively would seem premature given how little we know about Mesoamerica's past and how much of our reading of Era texts has been radically changed by archaeological advances and decipherments even in the last few years. At any event, after his sky birth Quetzalcoatl prompts movement through recognisable landscapes on the Gulf Coast, the Papaloapan region, the Mixteca, the Cholula Plain and the Highland Basin, at dates not incompatible with what is known about

127

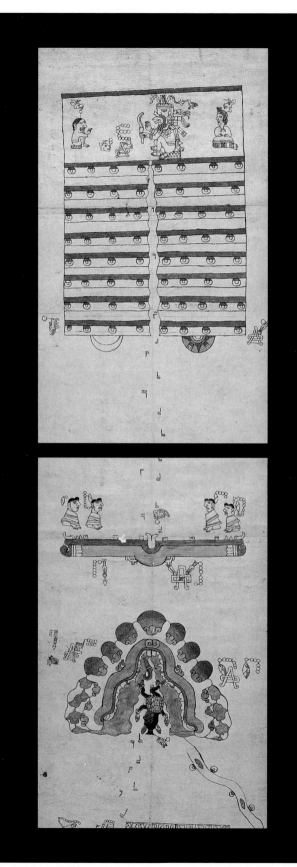

142 Sky to Seven Caves.
Tlahuixtlahuaca Roll

settlement in those areas, plus the rise of agriculture (depicted in Olmec carvings at Chalcatzingo), irrigation and ceramics; and he ends by authorising dynastic figures in the domain around Tepexic at dates which, despite the intervening thousands of years, coincide with those given in the Coixtlahuaca and Mixtec annals.[14]

It would be hard to overestimate the significance of the Tepexic Annals as a native guide to the past of Tula and Mesoamerica, and to the Era framework in which that past is ritually set. Implicit in many other native sources, this framework remains in urgent need of scholarly attention.

In featuring the birth of Quetzalcoatl Nine Wind from the womb of the sky down through the stars, the subsequent journey from Chicomoztoc and the deeds of Two Dog, the Tepexic Annals runs parallel to the Tlahuixtlahuaca Roll, as we have noted before. Nine Wind Quetzalcoatl enthroned in the sky is guarded by the same creator pair One Deer and wears the same attire (fig.142). In other words, the Roll tells the same story, much abbreviated. Calendrically, the abbreviation corresponds to the each of 52-year Rounds spelt out in the Annals (92 in all) being reduced to a star-eye in the Roll (65 + 10 + 17): for date to date, the two texts register exactly the same time periods, on the basis of this equivalence. This means that Quetzalcoatl's birth from the womb of the sky, down through ranks of stars, like the subsequent journey along the star-studded road from Chicomoztoc to Coixtlahuaca Valley, can be read simultaneously as a chronological statement. A similar claim can be made for star bands in other texts in the same Quetzalcoatl tradition as the Tepexic Annals and the Tlahuixtlahuaca Roll, the Gómez de Orozco fragment for example, as well as Mixtec annals such as those of Xaltepec.[15]

Discussion of these matters rapidly becomes too technical for a general account of texts in the Huey Tollan tradition, and this is not the place to develop complex arguments for and against positions taken by other scholars. Suffice it to say that in telling the story of Quetzalcoatl of Tula, the Tepexic Annals and the Roll formally appeal an Era framework comparable to that in Olmec and Maya texts and likewise implicit in certain of the histories written in the same iconic scripts as themselves, which otherwise focus on later points of origin, in Apoala, Chicomoztoc or Aztlan.

In general, much of the confusion that has arisen with respect to Tula and the Toltec and their role in Mesoamerican history has stemmed from a lack of respect for native testimony, and for its literary sophistication. The 'Toltec Elegy' (*Cantares mexicanos*), a true poem of the mind, leaves no doubt that Toltec history was thought and even made to repeat itself over the centuries. Thus the career of the lord of the last city in the direct Toltec line, One Reed Quetzalcoatl of highland Tula, was consciously modelled on that of forebears in the same cultural and political tradition. The Elegy characterises his final journey to the east as the return to true and ancient Toltec origins, to the grave that is also the cradle of maize, architecture, calendar and script alike, this last being the medium to which the poem itself most appeals.

RITUAL SYNTHESIS

S o far, in identifying major starting points in Mesoamerican history – Mexica, Chichimec, Mixtec and Toltec – we have been dealing chiefly with the kind of narrative known as *xiuhtlapoualli* in Nahuatl, that is the 'year count' that moves steadily forward in time, from one date to the next. As we saw, the other main genre of Mesoamerican literature known from pre-Cortesian times comprises ritual texts, nine of which have survived: these are read according to quite different principles, consisting of separate chapters, each with its own internal reading order and theme (Table 4). As a genre, they make full use of the semantic capacities of iconic script or *tlacuilolli* and are highly ingenious and sophisticated, to the extent that to transcribe even a short chapter may require many pages of ordinary prose, diagrams and arithmetical notation. Our ability to read their often impenetrable pages is much helped by copies and partial transcriptions made after Cortes, such as the Magliabechiano, Rios and Mendoza codices, and by the extensive reports on ritual life included in the Florentine Codex.

Without exception, the reading order of every chapter in these ritual texts is determined by one or more of the number and sign systems that belong to the *tonalamatl* and the year cycles, a fact that places enormous weight on these last as classifiers of reality. Many of the *tonalamatl* chapters remind us that one of the prime functions of this cycle was divinatory or mantic: the Florentine Codex confirms that ritual books were used to decide the fates of the nights and days on which people were born or wished to embark on some major enterprise.

The *tonalamatl's* nights and days

The nine Night Lords or Yoallitecutin (Table 1) count out the 260 nights of the *tonalamatl*, from conception to birth, as nine moons of 29 nights, and in so doing they bestow fates by threes – good, bad and indifferent. Ranged in four pairs around the first of their number, Xiuhtecutli, the Fire Lord literally of 'kindling', they spell out the sequence of gestation: Itztli the hard Obsidian of possible miscarriage and Piltzintecutli the budding Precious Child of the visible embryo (2, 3); Cinteotl the Maize Lord who fattens the flesh and Mictlantecutli the Hell Lord who builds the skeleton (4, 5); the females Chalchiuhtlicue Jade Skirt and Tlazoteotl the Weaving Woman who may determine the earliest possible births (6, 7); and finally Tepeyolotli Hill Heart with his wild breech baby and Tlaloc the Rain God with his amniotic waters

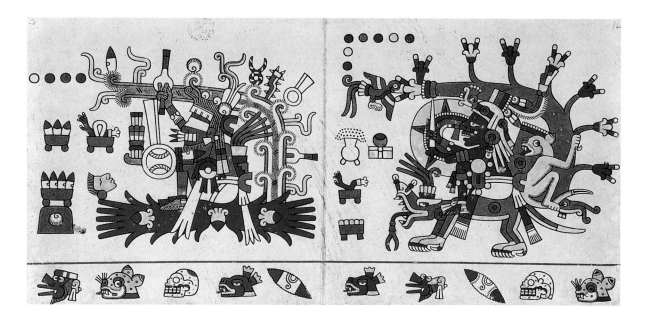

143 Night Lords (right to left):
Piltzintecutli (3), Xiuhtecutli (1).
Laud pp.33–4

(8, 9).[1] Prominent in the ancient calendars of the Mixe and the southern Zapotec, the Night Lords are celebrated in every one of the ritual books; and their force is still felt today in native calendars and customs, such as 'soothing of the child' (*arrullar al niño*) over nine nights that symbolically rehearse the nine-moon gestation and birth of Christ, that is Huitzilopochtli, at midwinter. With cradling arms they shield the years; and as agents of transformation, they themselves metamorphose in the chapter dedicated to them in Féjérváry (pp.2–4) and Laud (pp.31–8) (fig.143). As the powers invoked by the midwives, they correspond numerically to the orifices of the human body.

144 Straying husband. Borgia
p.59

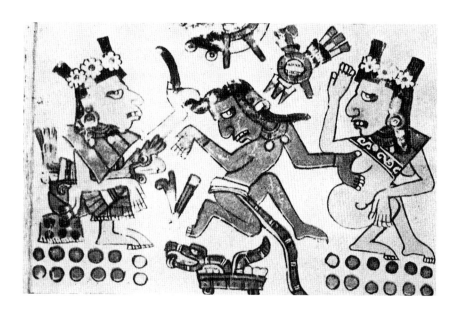

While the Yoallitecutin count and allot the night fates of the *tonalamatl*, its days are allotted by the Thirteen Numbers and Twenty Signs. As an element in a person's birthday name, any one of the Thirteen Numbers could be added to that of a prospective partner, in order to decide the type of marriage that would result between them. The total 24, for example, points to a wayward husband and a retentive wife (fig.144). As bearers of fate, the Thirteen manifest themselves more vividly as the Quecholli, the airborne creatures of augury defined by such concepts as habitat, diet, song, type and time of flight, plumage, whether edible or not, or domestic (Table 2). The very concept of 'day fate' or *tonalli* could be expressed graphically as the utterance of a bird (fig.145).[2]

The three precious-feathered members of the set, Macaw (*alotl* 11), Quetzal (12), and Parrot (*toznene* 13), epitomise the tropical plumage so prized as tribute and even as currency. Eagle (*cuauhtli* 5), a higher flier than fellow predators Hawk (*uactli* 3) and striped Eagle (8), is everywhere the paragon of military virtue; Owl (10), Eagle's double, is the night seizer with second sight who bodes ill: the numerical relation between the two birds is caught in the visual pun that equates two facing Eagle profiles with the full face of the Owl (namely 5+5=10) (fig.146). With their amazing metabolism the two Humming-birds, white and green (*huitzilin* 1, 2), supremely exemplify the principle of transformation through flight, as does Butterfly (*papalotl* 7). As edible and wholesome day birds, Quail (*zolin* 4) and Turkey (*huexolotl* 9) could oppose the ill-omened night birds plain Owl (*chicuatli* 6) and eared Owl (*tecolotl* 10). Turkey is the domesticated companion who when abused or forgotten recovers its own voice and the fierce revolutionary quality celebrated in the *Popol Vuh* account of the world ages. Through being decapitated, Quail atoned for having baulked Quetzalcoatl on his return from the underworld (fig.35; Table 2). Defining character in these ways, the Thirteen impinged especially on the subject's own coupling and reproduction. Always identifiable with and as their individual numbers, they could function arithmetically in tribute systems, representing totals of towns or coefficients of year Signs, and could even be substituted by normal numbers in place glyphs: the eagle element in Cuauhquechollan, for example, is stated effectively by five dots in Xolotl Map 3.

A thesaurus of significant images, the set of Twenty Signs (Table 3) incorporates the face-masks of certain of the Night Lords and the heads of certain of the Quecholli, and denotes ingenuity as much as fate, like musical and other skills. Distributed over the body they indicates nodes; and as the attribute of deities in the page-icons typical of ritual genre, the complete set defines total power. Hence the Signs articulate the figure of the warlike Tezcatlipoca: Deer (*mazatl* Sign VII) and Wind (*ehecatl* II) placed at his extremities suggest speed and his single foot makes Caiman (*cipactli* I) the earth-beast tremble; his back protects the House (*calli* III) of settlement. In the Laud icon of the rain god Tlaloc (fig.148), four of the Signs recur, much enlarged, as special attributes

145 Tonalli as birdsong in the place sign Tonala. Ihuitlan Lienzo

146 Quecholli arithmetic: two Eagles (5) as one Owl (10). Teozacoalco Annals p.16

and helpers: Lizard (*cuetzpalin* IV) sings to bring down the waters from above;[3] Jaguar (XIV) roaring open-mouthed in the headdress, and Snake (V) held vertically as a sceptre, denote the thunder and lightning of Tlaloc with his Rain-mask (XIX). The last three elements explain the cryptic phrase in the sacred Hymn to Tlaloc which refers to his Rain as 'Jaguar-Snake' (*ocelo-coatl*), that is, the result of thunder and lightning. Very much in the mode of the *tonalamatl*, this equation is arithmetical too, since the sum of Jaguar (Sign XIV) and Snake (V) is Rain (XIX).

The Number plus the Sign of a given day and hence its fates is a topic much elaborated in the *tonalamatl* chapters of the ritual books, where yet more correlative sets are introduced. Prominent among them is that of the Thirteen Heroes who helped to create the Mesoamerican world and who include Quetzalcoatl, Tezcatlipoca, as well as Mictlantecutli, Tlaloc and others of the Night Lords now in more active guise. Indeed, the carefully defined logic of these many sets alerts us to the danger of assigning single a priori identities to Mesoamerica's 'gods': identity here derives rather from position and function within particular sets, which relate to such diverse concepts as gestation, augury or world building. The need for arithmetical clarity in correlating these sets may even demand a grid format, for example when calculating the nights of the *tonalamatl* not just as nine moons of 29 but in the 'orifice' formula of twice 9×9 plus twice 7×7 (the footprint sequence in Cospi pp.1–8), or when matching the Numbers plus Signs of days with those of years. The Round of 52 years, that is the four year Signs multiplied by the Thirteen Numbers, can be set out in rounds or squares; alternatively, the halves, quarters and fifths of the *tonalamatl* or the Twenty Signs are laid out spatially in map-like designs.

Typically, the fate of a day or night is related to a specific activity, in chapters that develop clear thematic concepts out of the very Numbers and Signs according to which they are read, celebrating their intrinsic powers or weaving them through into patterns of human experience.[4] The most highly articulated and eloquent are:

PLANTING – anthropomorphic maize is set into the caiman earth and its yield is announced over the four-year harvest span;

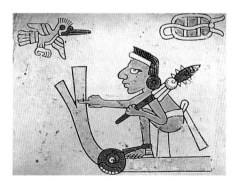

147 *Pochteca* in canoe, with trader's backpack and bird. Féjérváry p.39

TRAVEL – the *pochteca* and other bearers of goods and information, with their *tameme* backpack and frame (*cacaxtli*), staff and fan, move along the footprint trail on land or the water-route of the canoe, or emulate sun, moon and planets along the zodiac road (fig.147);

VENUS – rising heliacally (just before the sun) in the east, five times over eight
 years and 99 moons, the planet hurls its arrows into respective victims, like
 potentates or water-sources;

BURIAL – objects that the soul needs on the journey beyond death accompany
 patterned mummy bundles;

MARTIAL ARTS – postures and devices of warriors typified by the marsupial
 tlacuache;

HAZARDS – bat, caiman, eagle and jaguar ambush the roads of the would-be
 conqueror;

148 Flood and Eclipse (right to
left): Tlaloc bringing together the
waters above and below; Sun
obscured on journey between
eastern and western horizons,
Mictlantecutli below, blood-
sipping eagle above. Laud
pp.45–6

WORKERS – females and males are each five in number like the digits of their hands, five being their number in the set of thirteen Heroes (Table 2);

KINDLING – the new calendric cycle, typically of 52 years, is begun when flame is engendered by the fire-drill and carried to the quarters;

TRIBUTE-TREES – the four quarters of tribute that surround the capital are typified by the trees and vegetation and the birds that respectively thrive in them;

DRINKERS – flaunting the privilege of the aristocrat and the aged, occupants of thrones and power have brought to them cups of foaming pulque or cacao.

The gamut of these topics, which in a given chapter may appear alone or in combination, includes such other matters as Judges, Partners, Marriage, Amazons, and Roof-beams. Especially brilliant and instructive are those topic-chapters which, like Birth and Behaviour, dispose of whole subsets of acts and events.

Birth and Behaviour

The Birth chapter covers the longer story of gestation which corresponds to the very logic of the *tonalamatl*, and thematically highlights two paired acts and states. After impregnation or creation, coded as the bone gimlet that pierces an eye or cell, the child is carried, literally on the palm of a hand; after the severing of the umbilical cord, which reaches down from the sky (*temo* means both to descend and to be born), the baby suckles on the breast and its ideally black nipple – as thirsty as a fish or in vain, to quote the detail in Féjérváry (fig.149). The opening chapter in Laud (pp.1–8) (figs 151, 152) presents two versions of the sequence, one 'bad' and one 'good'. The 'bad'

149 Birth: impregnation and pregnancy, cutting the umbilical cord and breast feeding. Féjérváry pp.23–9

sequence is dominated by Mictlantecutli whose power, necessary for the formation of good bones and blood, can be deadly in excess. The impregnating bone fails to feel its way through to the dark cell or prison (*cuauhcalli*) in which the unborn child sits, owl-like; and the foetus, miscarried, is equipped with the paper passport of the unborn (*tetehuitl*). The cutting of the plaited umbilical cord is watched by a grey bird of bad omen; and the would-be suckling mother is as dry as a stick. In the 'good' sequence, Mictlantecutli's power is tempered by that of Tlazoteotl, the Weaving Woman, who holds the thread of life (respectively 5 and 7 of the Night Lords, these two figures are both invoked in the Florentine Codex account of birth). Here the woman comes instantly to bear the child and, her belly round, she is kissed by the golden *huitzilin* or humming-bird that eases labour pains. The umbilical cord is straight and the placenta is properly buried. Her suckling does not preclude her husband's sexual excitement (a red-tipped penis). In these details, there is a hint of natal practices still observed in rural Mesoamerica, for example the choice of the mother's food as 'hot' or 'cold', the wicker mat that keeps her from touching the ground, and the proper burial of the placenta in the maw

150 Birth: mother with cradle, midwife with mat and symbols of male and female callings. Mendoza f.57

of the earth-beast. This last notion, along with that of conception as a piercing or carving of the face of new life, recurs in the language of shamanic cures which, in affirming the health of the body, intimately allude to its gestation, and to the story of the world ages.[5] Highly defined, the images of these paired acts plus states – beget and bear, sever and suckle –, are also recognisable in *xiuhtlapoualli* narratives, as in the Tepexic Annals account (pp.4–5) of Nine Wind's earthly gestation, and then of his descent plus umbilical cord from the womb of the sky (fig.141).

Once born and suckled, the subject faces service, contract, rank, concepts whose Nahuatl phraseology has been extensively preserved in the Huehue-

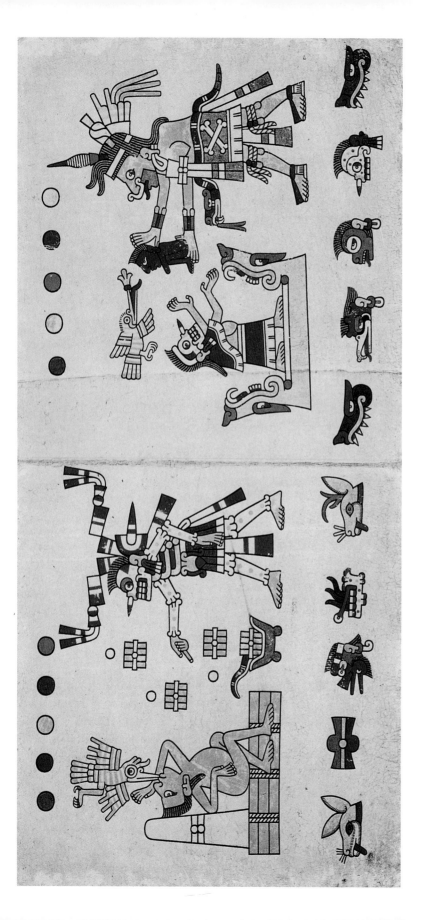

151, 152 Birth, the 'good'
sequence. Laud pp.5–8

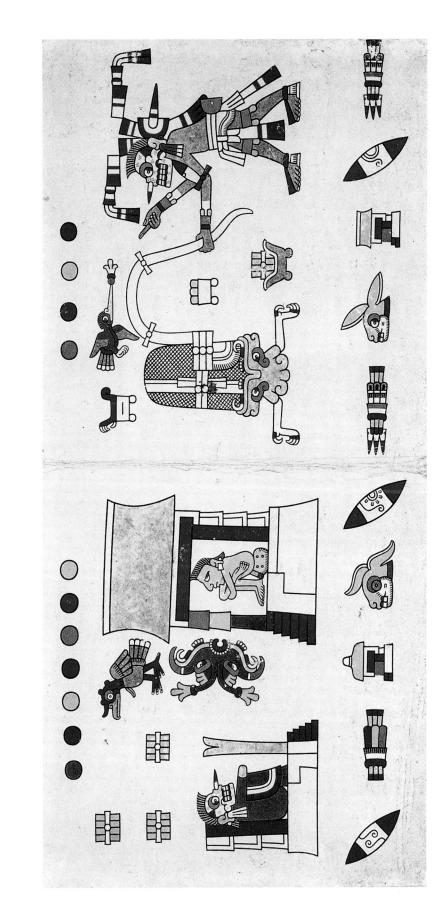

tlatolli texts of the sixteenth century.[6] The topics in question are legible in the subsequent chapters in Féjérváry, and in the corresponding section of Mendoza, which having likewise begun with its Birth chapter (fig.150) overtly deals with marriage, labour tribute, warrior rank and *pochteca* cults among Tenochtitlan's citizenry ('from the grave of the womb to the womb of the grave', as Samuel Purchas put it). The particular parallel between Féjérváry and Mendoza, anticipated in their respective title-page maps (figs 50, 164), helps us to interpret the remarkable Behaviour chapter about work in general,

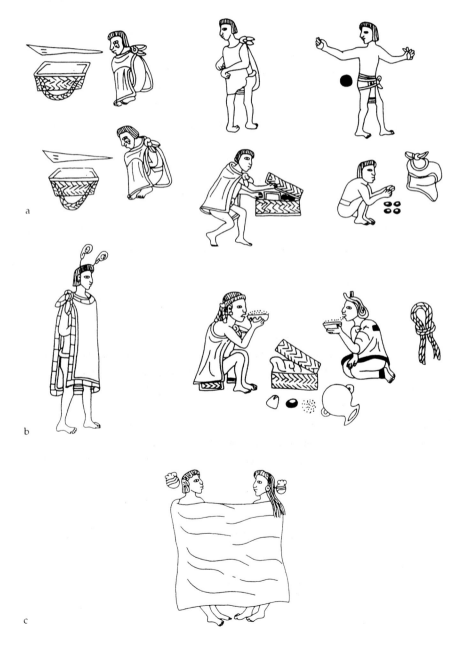

153 Behaviour: a) *coa* planting stick and carrier's tumpline, emblems of useful work (left); idling, playing ball, thieving from casket, gambling at *patolli* with four black bean tokens and the shirt lost by the player (right) b) two-faced gossip, pulque drinkers c) adulterers under blanket and stoned. Mendoza ff.70–71 (after Berdan and Anawalt)

which is common to both texts and to Borgia. It is legible thanks mainly to the Mendoza version of it (pp.70–1) which, devoid of the *tonalamatl*, has Spanish glosses that go some way to explaining the ingenious logic and metaphor of the iconic-script original (fig.153).

Generalising the question of work and training, this Behaviour chapter rests basically on a contrast between useful citizens, who carry the hod (*huacal*) and the planting stick or hoe (*coa*) of the public worker, and their useless counterparts who loiter, gamble on the ball-game, thieve, gossip, drink pulque and fornicate. The *huacal*, with its tump-line, indicates all forms of transport and travel; the *coa* and its twin tool, the wood-cutter's axe, denotes sedentary agriculture (whence the binary Nahuatl expression *ti milla chiazque / ti cuahcuahuizque*: 'we'll prepare the milpa' / 'we'll clear the trees'). On the negative side, the thief lifts the lid of the 'treasure casket' (*petlacalli*); the gossip, double in tongue and listening ears, is the poisonous *maquizcoatl*, which means both gossip and double-headed coral snake; the drunk consumes with the thirst of a deer; and the snake-like penis fornicates 'under the blanket'.[7]

In the Borgia version (pp.18–21), these notions of civic duty and misdemeanour are established first through the four basic urban or masonic forms of temple, pyramid, waterway and ball-court together with the cults proper to them, plus the four social conditions defined by back-pack, hoe, axe and pulque pot. Privileged role models, representatives of the Thirteen Heroes preside over each so that, for example, the Sun guards the temple against theft, Jade Skirt (phallic snake in her water jar) epitomises lust, Tezcatlipoca indulges in the ball-game yet also bears his *pochteca* load, Tlaloc wields the *coa* just as Tlahuizcalpantecutli (Lord of the House of Dawn) wields the axe, and the Hell Lords exult in the waste occasioned by pulque. The scenes of felled forests and blooming milpas of maize are especially graphic.

Like Borgia, yet concentrating on only a few multivalent Signs (Jaguar XIV, Deer VII, Lizard IV and above Snake or Coatl V), Féjérváry also proposes an internal structure of four-plus-four moments or images, chapter halves which reflect each other in terms of bad and good (figs 154–7).

IN THE FIRST HALF

The drinker thirsty as a deer for foaming pulque is admonished by Tlaloc.

The thief, idle like the jaguar, steals food from the temple.

The hissing, two-tongued gossip becomes the two-headed coral or *maquizcoatl* snake which sets ablaze, with the fire offering made to it, the temple it inhabits.

The adulterer's companion, on her bent waterway, shows her complicity by carrying a phallic snake in her water jar.

THEN, THANKS TO WORK

The two-headed snake becomes two snakes, one of which tamely licks the carrier's hand, as he sweats blood under his load.

The jaguar is driven back to the forest which it endeavours to defend from the wood-cutter's axe.

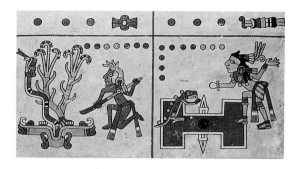
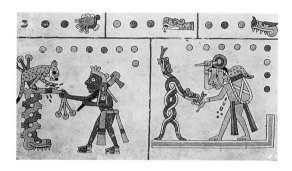

154–7 Behaviour, Féjérváry pp.26–9 (lower register)

Little excitement is generated in the ball-court by players that are, respectively, one-handed and a lizard.

Through the hoe, the phallic snake (*coa-tl*) becomes the community work (*coa-*) that produces maize.

Year cycles

The great majority of chapters found in the ritual texts are concerned with and regulated by the *tonalamatl*, in the ways indicated above. Those that are not deal with the yearly cycle of eighteen 20-day feasts, and with a little-studied complementary night cycle of eleven. This type of chapter tends to deal directly with these year cycles as such, detailing payments or 'offerings' of commodity tribute items, paraphernalia and choreography, and undergoes less thematic development than is the case with the *tonalamatl* chapters.

In the Feasts chapter, though many of the details specified show marked regional variation, there is the same structure of paired lesser and greater feasts and a recurrence of key symbols, especially at the equinoxes and solstices. These include Tonantzin's spindle and thread and her broom at Ochpaniztli (September), Xipe's cap and stripped-off skin at Tlacaxipe-hualiztli (March), the flag (*pantli*) of Huiztilopochtli's or another's victim in Panquetzaliztli (December), and Tlaloc's bubbling pot that marks the onset of the rains in Etzalqualiztli (June) (fig 158). Similarly transparent are the water-pouring of Atemoztli (January); the alms-giving of Tecuililhuitl (July); the bird of Quecholli (November) when Cortes first came to Tenochtitlan and when the migrating birds flock to the highland lakes; and the mummy of Micailhuitl (August), the feast of the dead, when the Mexica decided on surrender, and when the soul journeying beyond death is offered four seeds of comfort (maize, bean, two types of squash) by the domestic companion Turkey shown in Laud (p.22) and Féjérváry (pp.15–16). The Tlaxcala Calendar gives its own version of these 18 images (fig.5), in a wheel design which complements that of the 52-year Round.

Present in both Laud and Féjérváry, the nocturnal Eleven of the year have received little recognition as a ritual set and need introduction. Bearing axes (*tepoztli*), adepts of the maguey and pulque, and adorned with crescent moons, they relate thematically to the pioneer house-builders in the *Popol Vuh*

158 Quarterly feasts of the year: Tlacaxipehualiztli – Etzalqualiztli – Ochpaniztli – Panquetzaliztli. Tlapa Annals 2 verso

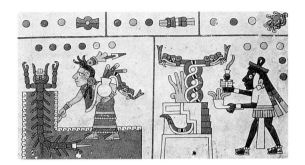

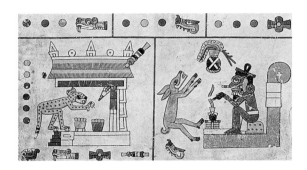

who, drunk on pulque, rose into the night sky to become the Pleiades, and first signposted the winding zodiac road of the year. The maguey, which possesses its own fermenting agents, matures over 11 years (also the sunspot cycle) and 11 is the number of days in the epact of the moon, whose phases affect the amount of liquid carried in the maguey. As 'the place of the axe' surrounded by 11 hill shrines and 11 tributary subjects, Tepoztlan is home of Tepoztecatl (fig.159), president of 11 axe bearers from towns along the Chichinautzin–Popocatepetl ridge, who include the maguey and pulque goddess

159 Tepoztecatl. Magliabechiano Codex

Mayauel and her consort Patecatl, expert in herbs. (The Florentine Codex Book 10 supplies the names of those who drank pulque with Tepoztecatl at the foaming mouth of the volcano Chichinautzin, the Olympus of Tamoanchan and Mesoamerica.) The astronomical nature of the Eleven is further confirmed by the fact that, as in Maya hieroglyphic texts, they preside over formulae relevant to the synodic and sidereal cycles of the sun, the moon and the wasp-star Venus. This link is epitomised in the Cempoala murals, where the sun, the moon and Venus, the brightest bodies in the sky, are numerically correlated and where the elevenfold hallmark of the zodiac is inset into the moon. In both Cospi (verso pp.1–11) and Féjérváry (pp.5–15), under the aegis

160 Elevens: first of the eleven figures above stellar 'stingers' and three rows of elevens (two bars and a dot, 5+5 I 1). Féjérváry p.5

of the 11 zodiac figures, these formulae are in turn calculated in units whose optimal number-base itself is 11 (fig.160); and in Borbonicus (p.28) the ring of dancers who become stars in the Feast Xocotl Uetzi number 11, as they do in the Primeros Memoriales (f.251v.). As axe-bearing pioneers, the Eleven also appear in Laud (pp.39–44), in upper and lower sequences, and prefigure totals of conquests, garrisons and subjects listed in such historical sources as Mendoza (fig.161), the Tlaxcala Lienzo, the Cuauhquechollan Round Map (which shows Popocatepetl), the census of the 'axe town' Cuauhtepoztlan (Tepetlaoztoc), Tochpan Lienzo 1 and the great stone *cuauhxicalli* of emperor Tizoc now on display in the Museo Nacional de Antropología. As if to affirm the link with the night sky, Laud like Mendoza begins its 'upper' sequence with a star glyph.

Much of the detail given in the Zodiac chapter in Cospi, Laud and Féjérváry admittedly remains obscure, yet the identity of the Eleven as such is rein-forced by the pattern of their occurrence. The sequence in Laud ends in what could conceivably be two pairs of Era dates and in Féjérváry it is intricately inset into that of the 18 feasts of the year.

In the terms of Mesoamerican tribute, the yearly seasons are to commodity

161 Eleven plus eleven garrisons. Within Basin (left and lower margin): Citlaltepec (star), Tzonpanco (skull rack), Xaltocan (sand spider), Acalhuacan (boat), Coatitlan (snake), Huizachtitlan (*huizache* plant), Coatlayauhcan (snake), Acolnahuac (water, elbow, speech), Popotlan (straw) Iztaccalco (white as salt pan, house), Chalco Atenco (jade, water, lips). Beyond Basin (right): Cuauhtochco (tree rabbit), Huaxac/Oaxaca (*guaje* plant, nose), Zozolan (old cloth), Tetenanco (stone fort), Izteyocan (obsidian, stone), Poctepec (smoke hill), Oztoma (cave, hand), Atlan (water), Tetzapotitlan (stone *zapote*), Atzacan (sluice), Xoconochco (cactus fruit). Mendoza ff.17v–18

tribute items what the *tonalamatl* is to labour and human activity. Defined by the movements of the sun and the night sky, the year relates to quantities and types of item 'offered' or due over its 18 feasts, as well as the less obvious periodicities of planets contemplated by the 11 pulque drinkers. By contrast, as the measure of the nine moons that separate conception from birth, the *tonalamatl* relates to human gestation, body and skill, and by extension the construction of society, its mores and callings. As such, the opposition between the two types of service and value is neatly confirmed by the Féjérváry screenfold, whose sides are respectively devoted to one and then the other. Moreover, in this, and in the title-page map they share, Féjérváry exactly anticipates the Mendoza Codex, which deals first with the conquest and levying of tribute items, and then with the birth, growth and duties of the citizens of Tenochtitlan (Appendix 1a and 1c).

Cosmic maps

As a rule, the ritual texts have been regarded as mantic literature, a means for predicting fates and deciding propitious moments in the endlessly recurring cycles of time identified with the *tonalamatl* and the year; and this was

undoubtedly one of their functions. As a consequence, however, these books do not divorce or separate themselves from the material history and geography. On the contrary, they embed in their archetypal discourse references to specific events and places, of just the kind found in the annals genre. The logical counterpart to the ritualising tendency in annals such as those of

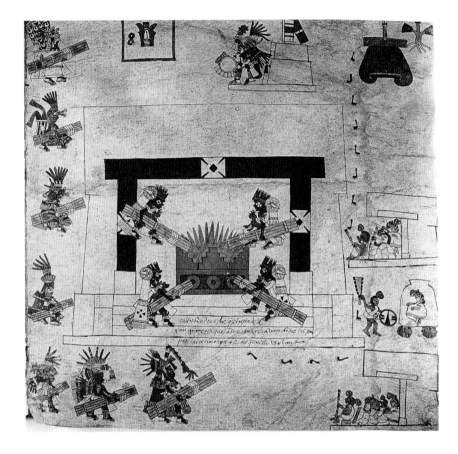

162 The kindling of 2 Reed 1507; fire brought from Huizachtepec (upper right). Borbonicus p.34

Tepexic or Teozacoalco, the historicism latent in the ritual genre is most pronounced in the Feasts chapter, and in the cosmic maps which characterise Féjérváry and the texts from the Upper Papaloapan.

As part of the seasonal experience of a particular year, one or other of the feasts may readily become a memento of it, like, for example, the feast Quecholli in the year 1 Reed (1519) – the moment of Cortes's appearance seared into Mexica memory. In its Feasts chapter, Borbonicus similarly identifies the winter solstice Panquetzaliztli with the last Mexica kindling, performed at Huizachtepec in the year 2 Reed (1507); in its square marker, this year name in fact forms part of a subsidiary count of years which runs through the chapter as a whole (fig.162).[8] So unambiguous is the historicity of this 'cyclic' chapter that it recalls straightforward *xiuhtlapoualli* accounts of the same event. Because of its clarity, this Borbonicus example is critical for

making the more general case for the historicity of the ritual texts, suggesting that they demand a more comprehensive literary reading, that goes beyond the insistent Western binary opposition between diachronic and synchronic time, historical narrative and ritual cycle.

In the Chichimec tradition, the Feasts chapter in the Borgia screenfold closely parallels the Cuauhtinchan Annals, in its account of how the fore-fathers were initiated after emerging from Chicomoztoc. As Nowotny has shown, the correspondence between the two texts is so close, notably in the images of the succour given by the beasts of the wild, that there can be little

163 Coixtlahuaca Map: fifths of the tonalamatl and a quincunx of place signs (after von den Steinen)

doubt that, again, the ritual chapter is alluding to a particular historical experience. In the Coixtlahuaca and Upper Papaloapan area, historical allusions have already been noted in the Hazards and Amazons chapters of Cuicatlan and Laud (fig.93); for his part, Alfonso Caso revealed yet another parallel of this kind in the Cuicatlan screenfold, in the final page which comprises a cosmic map based on the place glyphs found in annals from Tepexic and the Mixteca (fig.82). Moreover, through the matching pattern of *tonalamatl* Signs, this map alludes to the names of their celebrated rulers, for example [2] Dog (x) of Tepexic, and Lady [1] Eagle (xv) of Nexapa. Other examples of multilayered maps of this sort are Aubin Ms 20, here referred to as the Coixtlahuaca Map, and the title page of Féjérváry.

Formally the Coixtlahuaca Map is a quincunx, a central circle between pairs of lesser areas above and below (fig.163). Each area is correlated with a 52-day

fifth of the *tonalamatl*, and in each fifth stands a pair of Cihuateteo and Tonaleque, the female and male Workers who occupy the fifth position in the set of Thirteen Heroes and who here celebrate military triumph. Yet at the same time it can be read as a map of the Coixtlahuaca area.

The text once displayed its town of provenance at its centre, but the toponym in question is now mostly obliterated. It can be reconstructed thanks to remaining traces and with the help of a copy made before the damage was done. It shows the snake (*coa-*) adorned with star-eyes (*-ix-*) stretched out as on a plain (*tla-huaca*), exactly the image given in Mendoza. Moreover, through its jaws and other details, the snake acquires the feathered-caiman aspect that characterises Coixtlahuaca in texts from the surrounding valley, not least in the Federal Emblem shared with Ihuitlan, Tlahuixtlahuaca (Selden Roll) and other towns. As we noted, with its strategic significance, Coixtlahuaca is widely acknowledged in texts from the Cholula Plain to the north and the Mixteca to the south.

From its large central circle, Coixtlahuaca dominates pairs of towns above and below, registers which correspond to the northern and southern regions commanded by the town from its position near the continental divide.[10] The upper towns feature suns to the right or east and mountains to the left or west, while the lower towns both lie on rivers. The mountains to the northwest denote Tepexic, with its characteristic cliff and cleft, and the inset black chequer that denotes its twin settlement Tlil-tepexic; as in the conjoint glyph in the Tepexic Annals (fig.83), we also see the 'old people' suffix of Huehue-tlan and the maguey of the Tentzon ridge. To the northeast the sun glyph is set in a blood-red field, serried rows of flint knives and images of day-time stars and Venus as the 'stinging' planet. The knives are possibly mementos of the *tzitzimine* who, as stars monstrously revealed in daytime, descend to excoriate during the solar eclipse, which is caused by 'stings' from Venus: together, these indicate Teotlillan, the town of divine or solar darkness to the northeast. Below to the southeast (lower right) we see the bones of the dead (*mic*) that denote the 'underworld' Mictlan, shown as Coixtlahuaca's tributary in Mendoza (p.43) and revered as the ancestral shrine Mictlantongo in the annals of Xaltepec, Tilantongo and other Mixtec centres. Then completing the set, to the southwest (lower left) lies Nexapa, the ash of whose name (*nex-tli*) is produced by a volcano rising from under the water: along the chevron road to it there is an image of Eight Deer complete with his nickname Jaguar Claw, the Mixtec ruler who met a superior power in Coixtlahuaca's Four Jaguar and whose hill is here shot through with arrows.

At this second level of reading then, the ritual design commemorates the actual domain of Papaloapan, a setting out of landmarks that mediate between the ancient Popolocan settlement and Coixtlahuaca's particular career as a political power, in alliance with Tepexic. For, as we saw earlier (p.80), while at Mictlan(tongo), Teotlillan and Nexapa the impulse of Coix-tlahuaca's victory is shown by warpath chevrons that lead in past temples

ablaze and pierced by arrows, at Tepexic the warpath runs out from, not into, the town, and a decapitated pair of Jaguar and Eagle warriors suggest a match that led to an alliance. In all, within its quincunx Coixtlahuaca rests on a support system of four bastions in the upper and lower landscape.

This geo-historical dimension of the Coixlahuaca Map is echoed in quincunxes in later documents that quite specifically coordinate battles and conquests. A clear-cut example comes in the Tlaxcala Lienzo (fig.31), in the scene which shows Tenochtitlan under siege in the summer of 1521: after an arduous series of 11 battles, at this key moment we switch to a view in plan that is based on the quincunx. Surrounded by its lake and defended by four war canoes, the Great Pyramid of the Mexica capital is threatened strategically from four corners, by towns already in the possession of the Tlaxcalan–Spanish allies, after the campaigns of the previous months. Tecpatepec and Xochimilco face each other above, as do Coyoacan and Tlacopan below, controlling the causeways that linked Tenochtitlan to the mainland. The battles that had been waged at these four places are shown by the usual arrow of conquest, and by the severed heads and trunks, arms and legs of the defeated. Affirming the prior victories in theme and number as well as space, within the fixed areas of the quincunx design, these anatomical units, part of a ritual foursome, cross-match each other arithmetically, as do the four groups of visitors; themselves subdivided as ten shield-bearing Tlaxcalans and five mounted Spaniards, the 15 victors anticipate the encounter with Tenochtitlan, marking already the 15 defenders in the war canoes. In other words, this historical text from Tlaxcala draws conversely on the quincunx model for its ritual potential and its complex logic of fives. It does so, however, inverting the victory whose impulse comes here from without, not within. Hence it better urges its argument that the support which Tenochtitlan had relied upon, in its quincunx of towns, was now militarily denied, leaving the centre itself open to defeat.

Not only does the Coixtlahuaca Map, as a ritual text, invoke history in this way. In so doing, it further contrives to appeal to the model of the world ages superbly represented on the Sunstone of Tenochtitlan, likewise a quincunx in which our Era Four Ollin, at the centre, is surrounded by and emerges from the four Suns of creation. Each of these Suns has its *tonalamatl* name and ends in a characteristic disaster, and following the traditional sequence of Flood, Eclipse, Volcanic Rain and Hurricane, we may find indisputable echoes of each in the Coixtlahuaca text in the same configuration, moving from lower right to upper right and then lower left to upper left, as the Cuauhtitlan Annals transcription tells us to (f.2) (figs 140, 163).

The river beside Mictlan's pyramid, where fish-hearts swim, is shown rising up the steps at its edge, recalling the Flood that ended the age 4 Water, when vertebrate life reverted to the fish swimming in it. Above, the daytime stars and serried flint-knives that oppress the sun of Teotlillan invoke the solar Eclipse of 4 Jaguar, when the *tzitzimine* and jaguars descended with their

murderous knives (one such is also featured in the Sunstone). Then, in the other river, the rising volcanic ash of Nexapa is just what was precipitated by the fire-rain of 4 Rain, and it is approached by one of saurians that characterised that world age. Above, affixed to the edge of Tepexic's cliffs howling wind intimates the hurricane of 4 Wind, which is also shown in the same image on the Sunstone. Finally, at the centre, the good flat earth of Coixtlahuaca matches the visage of the Earth Lord Tlaltecutli, our whole terrestrial space.

In sum, just as the comparison with the Tlaxcala Lienzo sharpens the political–military message of the Coixtlahuaca Map, so comparison with the Sunstone brings out its geological depths in details such as the wind-scouring of Tepexic's cliffs which would otherwise be inexplicable or superfluous.[11] Through the paradigm of the quincunx itself, siege and mountain pillars, we move from imperial surface down into the earth's crust, a vaster claim in time and space.

Like the Coixtlahuaca Map, the end page of Laud and the title page of Féjérváry fully belong to the ritual genre, yet they too appeal to the history of particular areas and to an underlying cosmic scheme. In Laud, the page is dominated by the sun, midway between the east and west horizons, each of which has a pair of year-bearer Signs; from below Mictlantecutli exhales darkness, causing an eclipse, while from above an eagle sips its blood. This is of course a ritual scene, yet one which evokes the Eclipse which ended the first world age, the sequel to the Flood of Tlaloc shown on the previous page (fig.148). At the same time, the main elements in it correspond to a pattern of toponyms familiar in Upper Papaloapan texts, again offering the possibility of multiple reading (Table 5D). In these terms, the Eclipse may be construed as the determinant of the glyph for Teotillan, the place of divine darkness, in which therefore the text possibly originated.

Perhaps the New World's most celebrated page, the cosmic map at the start of Féjérváry is best described as a quatrefoil, four out-folding lobes or quarters, to each of which is allotted a 65-day quarter of the *tonalamatl* (fig.164). Symmetrically arranged in the centre and four quarters we see the nine Night Lords and four of the Quecholli, while another four Quecholli attach to the Signs which appear at the diagonals between the quarters. In all, another typically ritual design.

The further levels of significance legible in the Féjérváry title page are best understood in the first instance through a comparison with the title page of the Mendoza Codex, which uses the same overall design in order to map the tribute empire of a particular place, Tenochtitlan. The Mendoza page (fig.51), it will be recalled, celebrates the founding of that city, making its plan prefigure that of the future empire. Point for point, Féjérváry confirms the ritual dimensions of this political project.

On the Féjérváry title page, within the same quatrefoil design, we find the same interplay between plan and profile. Towards the central city emblem or

area, here a plaza placed between a stepped pyramid and a temple platform, flow four diagonal streams, of blood rather than water, separating four quarters that sustain plant growth, now trees rather than rushes and reeds, and which are occupied by nine figures, here the midwives' Night Lords rather

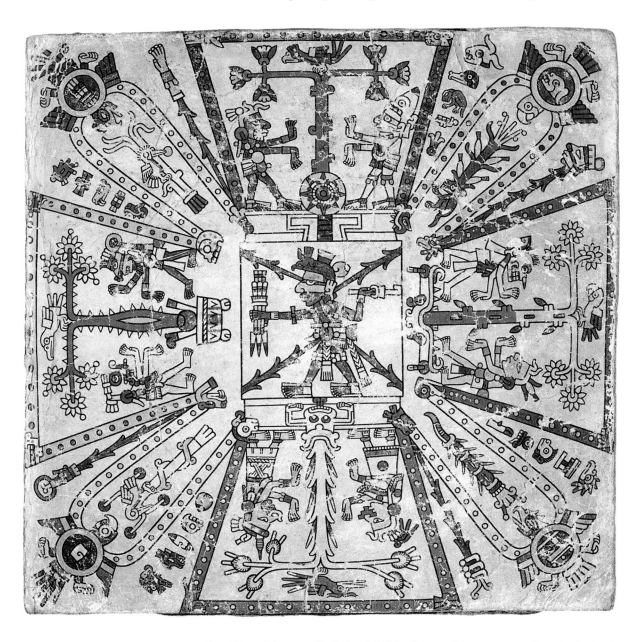

164 Title-page map. Féjérváry p.1

than Tenoch's council of nine. Within the set of four quarters there is the same emphasis on the east–west horizons and the time axis between, though here, inverting the Mendoza scheme, east is placed above (a sun rising over pyramid steps) and west below (a crescent moon hanging from a temple platform).

The preference for the east–west axis as such is stated in Mendoza by an elongation of these quarters, and in Féjérváry by the fact that these same quarters are continuous with the central plaza while those to the sides are not. (This finesse, incidentally, also makes it quite inaccurate to refer to the Féjérváry design, as some have done, as a 'cross'.)

The dominant element in the Féjérváry quarters is the set of four trees, in flora the equivalent of Mendoza's rushes and reeds. Standing one per quarter and each a different variety, these trees are surmounted by representatives of the Thirteen Quecholli: Quetzal (east), Parrot (south), Humming-bird (west), and Hawk (north). The direct relevance of this imagery to tribute is confirmed in the Tribute Trees chapter and the matching commentary in the Tudela Codex, while certain alphabetic texts, in Nahuatl and Maya, explicitly decode the birds as collectors and feeders on provincial produce.

Besides, the Quecholli in Féjérváry display an exact numerical correspondence with the actual totals of towns listed as sources of tribute in Mendoza. Each of them perched on its tree has its unvarying number-value, so that the four can be simultaneously read as arithmetic: Quetzal, 12, to the east: Hawk, 3, to the north: Humming-bird, 1, to the west; plus Parrot, 13, to the south. The total is clearly 29, just the lunar cipher that is evident in accounts of the four quarters given in the annals from Tepexic and Teozacoalco, as in the Tribute Tree chapter itself.[12] In Mendoza, this cipher is not actually stated on the title page; but it is spelt out as the sum of the tribute head towns allotted to the four provincial quarters around Tenochtitlan. After the nine metropolitan head towns come Atotonilco and the west with seven, Tlachco and the south with seven, Chalco and the road east to Xoconochco with seven, and finally Cuauhtochco and the north with eight, making 29 in all (fig.20).

Through the symbolic visual language of the Quecholli, the Féjérváry map adheres then to a pattern proper to tribute: perched on their trees the Quecholli symbolise the 'input' from each of their quarters. The fact that both Féjérváry and Mendoza respect this cipher here confirms that ritual–astronomical logic applies to a text unquestionably devoted to the tribute and economic system of a known city Tenochtitlan (Mendoza), while conversely it brings out the material underpinning of what otherwise might be considered a purely mantic or ritual text (Féjérváry). In similar fashion, even the year dates of Tenoch's that frame the Mendoza map find their equivalent in the four year Signs at the end of the diagonals in Féjérváry: for by virtue of being literally borne on the backs of another four Quecholli, these Signs acquire the coefficient Numbers which enable them to be read as dates, respectively, Parrot (13) Rabbit and Quetzal (12) Reed to the east, Macaw (11) Flint and 5 (Eagle) House to the west. How these dates might correlate with the Christian calendar remains an open question, since we are ignorant of the time-depth and lack the '1 Reed = AD1519' equation stated in Mendoza. The main point is that such dates could exist at all, as counterparts to those in Mendoza, adding material history to the material geography already deci-

phered in the Féjérváry map. In short, they are an added token of how ritual texts may be implicated in the basically historical business of levying tribute.

In the Féjérváry quarters each of the trees is flanked by a pair of the Night Lords, in an arrangement whereby the first of their number Xiuhtecutli Fire Lord stands alone in the central plaza, that is one, plus four pairs. Other arrangements of these nine include having three in one quarter and pairs in the rest, that is three, plus three pairs, as in Mendoza and Laud (Night Lords chapter), and for that matter Tochpan Lienzo 1, the Itzcuintepec Map, the Coatlan Map and other overtly geo-historical texts. Here in Féjérváry the nine spiral out from the centre, tracing gestation along the retrograde path of the lunar phases, and opening out the four directions to six by double-reading north and south as above and below, a convention found likewise in the Coixtlahuaca and Laud Maps, the Tepexic Annals and Maya astronomical tables, as well as the very architecture of Mesoamerica.[13] Shod males and females are placed to east and west, unshod males to south, also the nadir of maize and bones, and to north, also the zenith of mountain and thunder rain. Between these pairs of figures, this gestation theme is developed in two sets of emblems placed at the diagonals: one concerns human anatomy, the head, hand, leg, and trunk which severed serve as the source of the blood streams; the other

165 Four roots and stems:
a) binary root, trunk and leaves, silent bird b) triple-root, spiral vine, bird c) snake root, thorny trunk, stamen-antennae d) mammal leg root, maize plant. Féjérváry p.1

(fig.165), a more complex model of growth which culminates in the maize plant, the human substance and analogue according to the *Popol Vuh*. In Mendoza, this concern is echoed in the name glyphs of the council of nine, which between them hint at a double human anatomy, banners of jaguar and eagle above, head, trunk and leg between, sandal and severed bird's head below.

As a quatrefoil, the Féjérváry map closely anticipates that in Mendoza, and here we have far from exhausted the possible comparisons between the two. Moreover, as a title page it introduces a text whose overall structure and logic remarkably foreshadow that of Mendoza, its respective screenfold sides being dedicated first to the conquest and organization of yearly commodity tribute, and then to the labour tribute of the *tonalamatl*. There are even exact coincidences of detail, for example in the 11 armed figures or garrisons who guard the empire, the rites proper to the *pochteca* who carried the goods, and all that concerns Birth, Marriage, Martial Arts, and Behaviour among citizens, Mendoza serving here as the key to its more enigmatic predecessor.

STATING THE CASE

Many post-Cortesian texts written in native script were originally produced as evidence in legal disputes, and in the cause of self-defence more generally. As a result, some bear the marks, in format and style, of having been aimed at the organs of Spanish colonial power, specifically the courts of the Real Audiencia. For all that, the corpus as a whole offers a wealth of historical insights of its own while directly continuing the pre-Cortesian script tradition.

The two major examples of this kind of text are the Mendoza Codex and the Tlaxcala Lienzo, each of which was aimed at the highest known authority, the monarch himself. Each lays out comprehensive evidence, in the interests of a particular group. Written by scribes in Tenochtitlan over a decade after the military defeat, the Mendoza Codex was forwarded to Spain by the first viceroy Antonio de Mendoza. Its first objective was to defend the former Mexica capital as the proper centre of New Spain, and to this end it presents an attractive account of the old centralised economic system, both its tribute geography and the discipline of its citizens and workers. No-one doubted that by then much had changed, with the havoc wrought by the encomenderos against whom the text is directed (see p.32), the introduction of herd animals, the priority on mining precious metals, the use of water-wheels, new modes of transport and the opening of transoceanic ports. Yet, as we have seen, the text named after Mendoza contrives to vindicate Tenochtitlan's centrality almost entirely in traditional terms, emphasizing past harmony as if it were recuperable or sustainable. In this, it very closely resembles Guaman Poma's *Chronicle of Good Government*, the famous letter sent to the Spanish monarch from America's other great economic empire, the Inca Tahuantinsuyu.

In stating their case, Tenochtitlan's rivals the Tlaxcalans had begun with the modest business of reckoning how much it had cost them to feed and work for the Spanish. This statement is made in impeccably native terms in the Tizatlan Codex. Only later did they go on to advance their claim to being Christian conquistadors in their own right, in the documents that were addressed to the monarch, that is the Lienzo and the Codex. In the process, we witness a growing loss of interest in native precedent, both historically and formally, for example in the blurring and suppression of name glyphs, and in the appeal to European perspective. Most striking is the fate of the sacred

mountain Matlalcueye-Malinche, which initially stood at the centre of the Tlaxcala quincunx, a geographical and ideological guarantee for the four headtowns; in the Codex it is simply removed and, uprooted, the headtowns appear serially on successive pages.

Lesser in scope though not in ingenuity, a whole number of other documents make their cases in relation to one or more of the arms of colonial power within New Spain: the conquistador–encomendero, the Church and the Crown. Indeed, from the native side, some texts are primarily concerned to establish the limits between each, something the Spanish themselves were far from clear about, for example in relation to former tribute subjects who might belong to encomendero or Crown, or both, or neither. Moreover, as Marquis, Cortes had to be defined as a special kind of encomendero, a fact which resulted in a flurry of texts that denounce his land-grabbing in the Cuernavaca area where he built his palace.[1]

Texts about encomenderos written by those unfortunate enough to have fallen into their power typically testify to insistent greed and cruelty. Indeed, before the Second Audiencia of 1530, these masters of estates were scarcely bound by any legal constraint in making their demands. Their cruelty extended to brutal beatings at Tenochtitlan, burning alive at Tepetlaoztoc and savaging by dogs at Coyoacan (figs 11, 24). After the first excesses, their demands for tribute were sometimes countered by attempts to establish contractual relations, as is shown in a finely drawn document from Huiztilopochco (today Churubusco in Mexico City) that dates to 1554. Complaints repeatedly made against Cortes and other encomenderos are that

166 Huitznahuac temple, with tribute due. Mendoza f.19

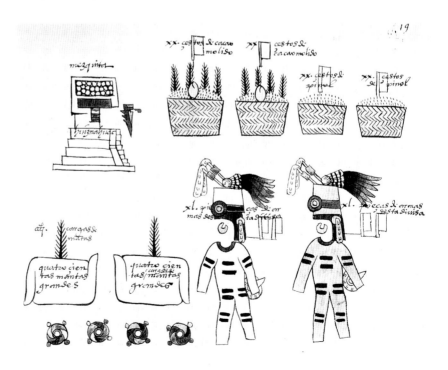

by habitual absence they allowed free rein to agents who behaved even worse than they did; and that as nascent capitalists they demanded materials which, being locally unavailable, their subjects could obtain only by selling their own scarce wares and supplies.

Documents relating to the Church also denounce greed and cruelty, behaviour much at odds with the Christian message, as it was when Malintzin and Cortes themselves eliminated native leaders at Coyoacan under the pretext of wishing to convert them to the new faith. It is not that the native people rejected out of hand the idea of paying tribute to priests: Mendoza suggests a pre-Cortesian antecedent in the special category of supplies given to the temple at Huitznahuac (f.19) (fig.166). Rather, from their point of view, much of the burden imposed on them by this authority seemed hypocritical and often covert, insofar as no account was taken of the expenses incurred in such pious duties as providing the paraphernalia for mass or feeding the choir (texts from Texupan and Otlazpan, and Yanhuitlan in the Mixteca, are excellent sources on this) (fig.167). For their part, the inhabitants of Teotihuacan and Acolman carefully recorded their reasons for throwing out the Augustinians, recently arrived as replacements for the Franciscans, in 1557; they objected chiefly to being used as slave labour in the building of a convent. At the same time, the Church's mission was effectively furthered, most often under duress, by documents prepared for the Inquisition as evidence of

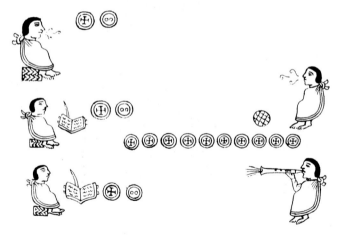

167 Choir expenses: singers, scribes and instrumentalist. Otlazpan Codex p.4

heresy.[2] Like the Tlaxcala Codex, these focus on the rites of the old religion, for instance, severing a bird's head as the mummified corpse is consigned to the earth's maw.

As for the Crown itself, most documents were addressed to it as the supreme arbitrating body, with its various 'branches' or areas of specialisation. As such, its authority was seen to have pre-Cortesian roots, especially in documents that refer to land disputes. The authors of the exquisite Cozcatzin Codex, one the Ixhuatepec group, invoked emperor Itzcoatl's verdict of 1439 when '133 years later' they argued their claim to lands just north of Tenochti-

168 Abuses: Spaniards shut workers in walled garden and in textile factory. Osuna Codex

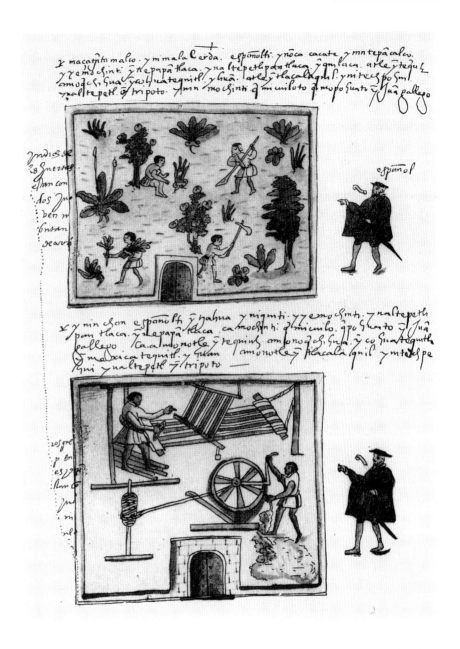

tlan. In similar vein, the Tlacotepec codices of 1565 from just south of Toluca note continuity between the Mexica and the Spanish crown in the image of a Spaniard just arrived in Tenochtitlan in 1519, while the years elapsed since that date are ingeniously double read as the fence around the disputed lands, in the style of the Nepopoalco Maps.

Beside judging matters relevant to others, the Crown in principle could receive complaints about itself, with respect to the behaviour of its local appointees. Investigations by officials sent directly from Spain, notably Valderrama in 1565, revealed quite a range of abuse in the technical sense of

'*agravio*' or going beyond one's official powers, such as ignoring debts (for which a host of native-paper invoices exists), intercepting tribute, embezzlement, seizing native land and even homes outright, and forced labour in field and factory (fig.168).[3] Coercion came in the form of physical assault, imprisonment, the stocks, and pressgangs that took people off to fight in Florida and other distant parts. As the Tepotzotlan Codex and several other texts make clear, there was in any case a flaw in the system from the start, insofar as judges and Crown officials investigating the crimes of others were expected to claim their expenses direct from the party they found guilty. The corruption encouraged by this arrangement involved not just Spaniards but Indians as well. For members of the native aristocracy were likewise appointed to serve the Real Audiencia as judges, and in doing so generally showed little solidarity with their former *macehuales* or subjects. The two social classes, always distinguished by dress, are even classified differently in the Huexotzinco census. It should be noted that those aristocrats who chose not to collaborate in this way were generally reduced to the condition of *macehuales* themselves.

In this body of post-Cortesian evidence we find internal differences of emphasis arising from such factors as region, class, and degrees of faith. Yet overall a clear difference emerges between native and imported ideas of law, and ways of presenting a case. This can be better appreciated through examining more closely the three United Kingdom texts which represent the causes of Tenochtitlan, Tepetlaoztoc and Tepotzotlan.

The Tenochtitlan Model

In making its case about the harmony of native economics, the Mendoza Codex follows a traditional sequence of exposition, as we have seen. The title-page map leads into the reigns of the nine emperors under whom Tenochtitlan's tribute empire was assembled, with its garrisons, 11 in the Highland Basin and 11 beyond, and is 9 plus 29 tribute districts at the centre and the four quarters (figs 20, 161). The final section deals with the life and labour of the citizens, according to topics which for the most part are familiar from earlier sources, such as Birth, Marriage, Judges, Martial Arts and Behaviour (figs 150, 153).

In echoing pre-Cortesian models, this last section strongly sustains the notion of reciprocity between the sexes, and between the classes of nobles and *macehuales*. Yet it perhaps places extra emphasis on education and employment, with their punishments and rewards, as a means of social control (figs 169–72); and it points quite precisely to respect for profession and rank, and to the construction and repair work on buildings, roads and bridges which comes under the rubric of 'public service' (fig.173). This would all have seemed most apt to Spanish and native administrators then endeavouring to restore and rebuild Tenochtitlan. The major concession made to surrounding reality in this last section, however, is to have suppressed the *tonalamatl* as the time-mechanism proper to labour tribute, though the Birth sequence repro-

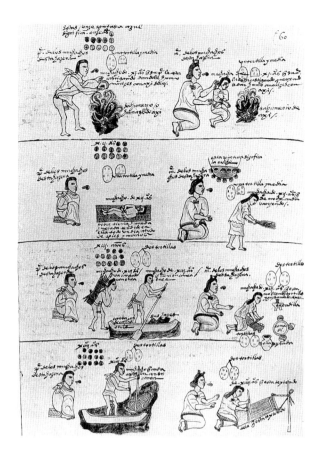

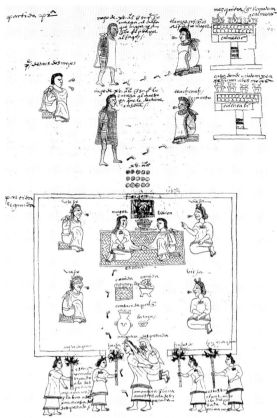

169 Tasks and rations for children aged 11 to 14. Punishments include exposure to chilli-pepper smoke (both boy and girl at age 11), sleeping on cold earth (boy at 12), sweeping (girl at 12), while tasks include ferrying and fishing (boy at 13 and 14), grinding with the *metate* and weaving (girl at 13 and 14). Rations rise from one and a half to two tortillas. Mendoza f.60

170 Life at 15: School for the male, either the priestly *calmecac* or the military *cuicacali*; marriage for the female. Mendoza f.61

duces exactly the four lots of 20 days found in the equivalent Féjérváry chapter. This was perhaps in recognition of the *tonalamatl's* pagan intellectual power, which was already being fiercely denounced by the Christian missionaries. As a result, these pages acquire a strangely denuded look, which has even led some scholars to declare them a mere afterthought.

By contrast, the commodity tribute section, transcribed from the earlier Matrícula de tributos, continues to appeal to the year cycles by which this side of the economy was governed. As well as actual signs for the equinoctial feasts Ochpaniztli and Tlacaxipehualiztli, we find the old convention of implicit frequency, whereby each category of tribute listed is understood to be due over a particular period, such as maize and beans at the yearly harvest, woven goods at the equinoxes, metals quarterly, and so on.

Most important, like the Féjérváry screenfold before it, the Mendoza text continues to distinguish formally and in principle between the two modes of tribute, commodity and labour, as do most texts produced in subsequent decades: in the end, native insistence actually brought about a corresponding adjustment in colonial law. In its layout, the Huitzilopochco contract of 1554 (fig.174) succinctly adheres still to these norms, of implicit frequency and types of tribute. Daily items or 'comida' appear to the right (two bundles of

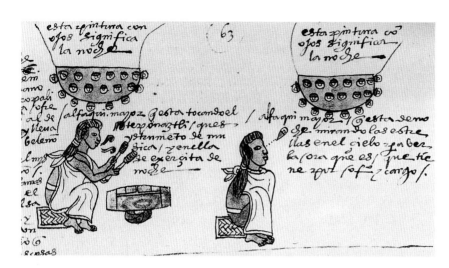

171 Music and astronomy at school. Mendoza f.63

172 Military strategy: planning an attack to avenge the murder of Mexica *pochteca*. Mendoza f.67

173 Public works: the road and bridge department. Mendoza f.64

174 Huitzilopochco Contract

firewood and two of fodder, plus a turkey), longer-term items to the left (50 pesos quarterly, 200 scoops of maize yearly); the presence of a canoe confirms that the tribute will be not just produced, but delivered, in this case by water to a the riverbank (*atenco*) by the encomendero's house.

Throughout, Mendoza draws strongly on the logic of native script, in layout and in detail, in specifying the sources and types of commodity tribute, as well as styles and instruments of labour (the glosses were added only later). From its nine plus 29 districts, Tenochtitlan is shown to receive clothing and uniforms, skins, live birds, shells, reams of paper, lengths of smooth and rough wood, salt cakes, gold bars, feathers, firewood, cane shafts, hods of lime, cacao beans, cotton, chilli peppers, bushels of cereals 3 metres high and finished inside with plaster, bowls of cacao powder and of gold dust, pans of paint and of turquoise fragments, jade necklaces, jars of 'liquidambar', pots of honey and syrup, rubber balls, baskets of pinole and copal, bags of cochineal and of down, bowls and plates and other crockery, wickerwork seats and chairs, cigar holders, masks, bells, diadems and many more materials and products. Often exquisite in themselves, these items are all arranged by origin and category, quantified by the usual vigesimal number signs (fig.175), and qualified where necessary by size, colour and texture. The commonest containers – hod, bowl and jar – could of themselves denote a measure of the item they most often contained: lime, cacao and honey. Alternatively, as a measure the container can have glyphs of more than one product attached to it.

175 Signs for numbers:
a) 20 banner (*pantli*) b) 400 hair (*tzontli*) c) 8000 pouch (*xiquipilli*)

As an example we may take the page devoted to the 'painted-head hill', Tepecuacuilco, the second head town in the southern tribute quarter and still visible on modern maps of Guerrero, along with most of its 13 subjects (Mendoza f.39) (fig.176). Reading from top left we have first the half-yearly category of woven goods, defined by the *tilmatli*, the blanket-cape with knotted ends, which could be plain, striped or ornate, and of thicknesses equivalent to finger tips. In serving as a glyph for clothing in general, the *tilmatli* could be infixed with such subsidiary items as the *huipil* (blouse) or *maxtlatl* (breeches). Below are the luxurious feather and gold uniforms of the Eagle and Jaguar warriors, and their superb matching shields. Next comes the yearly category of harvested food, here bushels of white maize and black beans, and of the two flours *chia* and *huauhtli*, to which are added copal incense (refined in baskets, unrefined in grains), and bound jars of honey (binding with stripes indicates syrup). Finally, reading back up the page to the right, we see jade necklaces, wooden bowls and copper axe-heads, in the quarterly category of metals and manufactured products.

In pre-Cortesian literature, Mendoza's representation of tribute on the grand scale is anticipated not just in the ritual chapters but in ceremonial scenes of fire kindling in the annals. Moreover, besides supplies of such commodity items as Tepecuacuilco's *tilmatli*, copal, honey and cacao, we see there evidence of the labour tribute detailed in the last section of Mendoza. In

176 Opposite: Tepecuacuilco tribute district. Mendoza f.39

the Tepexic Annals (p.35) (fig.177), over the span of a year before the kindling held in the eastern quarter, rough coloured stone is fetched from the quarry, literally walking in on feet, and once cut is used to build pyramids, stairways and platforms. These annals also show the tools needed for this work, as does Mendoza, when noting the basic equipment of planter's stick and *tameme's* or carrier's tumpline; elsewhere we find such additions as the mason's stone hammer, the carpenter's axe and the plasterer's float (fig.178).

As the provenance of tribute in Mendoza, Tepecuacuilco and its subjects are celebrated through their place glyphs, which in themselves embody whole systems of native taxonomy and thought. In practical terms it should also be remembered that these glyphs have an advantage over alphabetic script, in that they may be read simultaneously in more than one local language. As a category of sign, place glyphs generally go on playing a major role in post-Cortesian texts, even when most other forms of native expression have vanished. Such is the case of the Tamazolco Map (fig.78) which dates to as late as 1616 and yet still uses glyphs to represent the toad (*tamazolin*) of Santa Barbara Tamazolco and the river bend (*a-col*) of Santa Ana Acolco, in an amphibian-plus-water pair of glyphs which long predates the pair of churches erected above. The intensity of this loyalty is brought out in the accompanying Nahuatl glosses which, amongst statistics of land measurements and prices, record the songs about the trees that were planted there at the time, to

177 Kindling in the eastern quarter; commodity tribute (right) includes boxes of copal pods, jars of honey, tools, *maguey* products, *cacao*. The conjoint place signs, right to left on lower margin include the white tree of Apoala, the eclipsed sun of Teotlillan and the blood-sipping eagle town. Tepexic Annals p.35

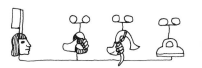

178 Bill for work done by 20 men (*macehuali*), 2 masons or stone-breakers (*tezozonqui*), 2 carpenters or wood-splitters (*cuauhxinqui*), and 2 plasterers (*tlaquilqui*) armed with float or polisher. Osuna Codex

further the memory of place. Yet more striking is the case of the Landbooks, notably the Calacoayan example, where pre-Cortesian place signs continue to signify as late as the nineteenth century (figs 192–4; Appendix 2e).[4]

The estate of Tepetlaoztoc

Exactly comparable to Mendoza in length, the Tepetlaoztoc Codex likewise takes the old order of things as its premise. It soon passes on, however, to devote most of its length to denouncing the abuse and exploitation that began with Cortes. It amounts to the full statement of a case originally put to the Real Audiencia in New Spain and later presented to the monarch himself, which nominally at least achieved some legal redress, such as the exile of offending parties, indemnity, and reductions in tribute or tax. The argument is laid out and developed with great clarity, evidence being provided for every statement.[5] Drawn with full regard for pre-Cortesian norms, the wealth of detail in the text implies that its authors had recourse to a well-tended archive of records in native script.

Of the text's two parts, the first deals with the pre-Cortesian settlement (figs 66–9). After the journey from Seven Caves, the land in and around Tepetlaoztoc is settled, part of the larger Chichimec story told from another angle in the Xolotl Maps of neighbouring Texcoco. Then Cocopin and Tlilpotonqui appear with their subject towns, and the line of rulers is traced from the early twelfth-century pioneers Huey Tonatiuh and Ocotochtli to the sixteenth-century Tlilpotonqui and his nephew Don Luis Tejeda. The tribute received by the ruler is duly recorded, along with that received by the 20 nobles of the polity. In noting the change in the ruler's dress in 1431, from skins to Cocopin's cotton clothes, the text alludes to how Tepetlaoztoc made its peace with Texcoco, Cocopin marrying Nezahualcoyotl's daughter; in fact, this happened only after the wars of resistance led by Ocotochtli, a notion expressed in the ferocious cave-maw of the town's glyph. In showing the powers and limits of the nobles, through glyphs for commodity and labour tribute and its source in 60 places, it brings out both the equity of the arrangement and the fact that it reciprocally involved nobles and *macehuales*. That Tepetlaoztoc's nobles remained loyal to their polity after Cortes, in marked contrast to their fellow aristocrats in other places, is specifically noted on a later page (ff.40v–41).

The ensuing narrative in the second part plunges us into a very different world, that controlled by the Spanish encomenderos and their agents (fig.179). In destroying the very source of the wealth and well-being they so violently desired, Cortes and his associates (1523–8) were succeeded by the durable Gonzalo de Salazar (1528–51), reputed to have been the first Christian born in Granada, after the war against Islam which had originally inspired the encomienda system. Under them, tribute items are exacted in extortionate quantities and kinds, and labour means slavery.

The traditional format of tribute accounts can no longer contain the huge

la quenta de la gente — *tlepotonqui* — *Diego de ocampo*

179 Tlilpotonqui and Ocampo, diamond marker for start of yearly tribute. Tepetlaoztoc f.9v

consignments of precious objects that were seized: textiles, jewels and metals, gold necklaces, bracelets and pendants, two elevenfold series of plumed sceptres (*penachos*), mirrors, caskets, ceremonial shields, all exquisitely worked using the lost-wax process and other techniques beyond the knowledge and expertise of Europeans. Similarly, far exceeding the traditional male and female glyphs for carrying (*tameme*) and cooking (*metate* or grindstone) (fig.180), labour was demanded for the extraction of gold in distant mines, including footwear and all logistic support along the way, and for transporting Salazar plus masses of goods to Veracruz when he left for Spain for six years, and to Jalisco, the western outpost and bishopric also named in the Tlaxcala Codex (figs 36, 181). Known to be hazardous for the *tameme*, as the same Tlaxcala text confirms, the journey down to Veracruz caused many deaths (fig.30). The construction of sizeable houses and other buildings (fig.182) not just locally but further afield, in Tenochtitlan, Acozpan and Cozcacuauhco, involved labour and materials, plus the costs of finding food and a sleeping place. A watermill built at Cozcacuauhco near Santa Fe Acaxochic right to the other side of Tenochtitlan (fig.183), used the powerful rivers that flow down from Ajusco to grind grain; another, nearer to Tepetlaoztoc,

180 *Metate* and *tameme*, emblems of the female grinder of maize and the male carrier. Tepetlaoztoc

182 Watermill. Tepetlaoztoc f.42v

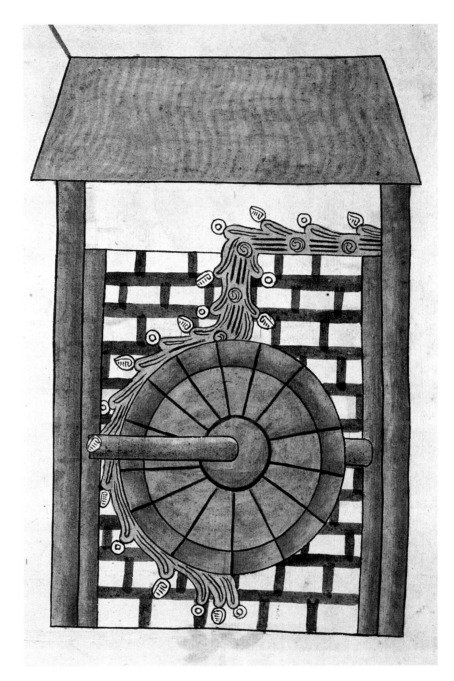

181 Xalixco (Jalisco): *xal-li* (sand), *ix-tli* (eye), *co-matl* (pot). Tepetlaoztoc f.32v

a b

183 Cozcacuauhco: (necklace eagle): a) Tlatelolco Map: b) Tepetlaoztoc f.41v

appears to have been designed for treating wool. Both testify on the page to the proto-capitalist spirit of the encomenderos. Their subjects also found themselves obliged to sell coarse maguey lace and other items in order to provide materials for the new factories, as well as locally unavailable fish and frogs for consumption on Christian holy days.

Intercalated with the statistical evidence, and the passage of years identi-

fied here by diamond markers, are scenes of amazing brutality. Cortes's agent Anton burns alive four nobles whose hands are bound (f.9) (fig.11); Salazar kicks and thumps people insensible (f.27v), as does Luis de Vaca (f.15v), one of the agents who took over during Salazar's long absences (App.1d). Salazar also banished Tlilpotonqui to watch sheep for 80 days, having failed to get the

latter's wife to sleep with him (fig.186). Over his 23 years of power (far fewer of physical presence), Salazar was accused of no less than 220 murders; his henchman Vaca, of 173 (f.40). Before them, at the start of things, the population fell from 30,608 (f.9) to 27,765 (f.11v) between the encomenderos Ocampo and Díaz de Aux, that is, by 10 per cent in a single year.

184 Spanish names and titles transcribed phonetically:
a) Ocampo, from *cac-tli* (sandal), *po-ca* (smoke) b), c) *fator*, from the bean tokens of *patolli* d) *dotor* [doctor], from *tototl* (bird). Tepetlaoztoc

Just because of the story they tell – of greed, violent yet abstract possession, and crazed individualism – the pages of this Tepetlaoztoc Codex appear all the finer, as formal representation. Their craftsmanship is analogous to that which they portray, in the dazzling ceremonial shield with its Xochiquetzal or butterfly design (f.8) (fig.187), or the elevenfold sets of *penachos* which in their design integrate glyphs for Tepetlaoztoc, Tenochtitlan and other places (ff.19v–20v, 25v–26v) (fig.188). Located on the east bank, Tepetlaoztoc like Chiautla belonged in matters of script to what has been called the Texcoco school, which also includes texts authored by its own wards. The Vergara visit of 1543 (cf. ff.35v–36) prompted a series of statements from Cuauhtepoztlan and other wards on the subject of land; they used a whole repertoire of glyphs to denote soil type, and reckon area by two methods of calculation neither of which was properly understood by the Spanish dispossessors.[6] A similar precision and attention to detail characterise the codex of Tepetlaoztoc itself, notably in the tabular summaries of tribute rendered over four periods between 1528 and 1553 (ff.46v–72). Opening as spreads, as in a screenfold, these pages make maximum use of layout and of the right-to-left arrangement of native glyphs.

In a manner likewise typical of the Texcoco school, the text easily extends into phoneticism in registering the names of places and people. In toponyms representing the subjects of the 20 nobles, a pot (*comatl*) stands for -*co*-, an eye (*ix-tli*) for -*ix*-, flour (*chia*) for -*chi*-, much smoke (*popoca*) for -*po*-, and so on. The practice is taken to the extreme in the noting of Spanish names and titles; hence a sandal (*cactli*) provides the -*ca*- in both Ocampo and Vaca, while

'factor' is derived from the board game *patolli* just as 'doctor' is from the bird *totol* (f, r and d, absent in Nahuatl, can only be approximated) (fig.184).[7] In western theory, phoneticism is supposed to have been a great breakthrough for humankind: established already two millennia ago in Mesoamerica, in the Olmec–Zoque inscriptions, it is used sparingly here. Its necessarily reductive effect on the visual image is clearly resisted in the case of the names of major towns, such as Acaxochic, Acozpan or Tepetlaoztoc itself, and of native dignitaries who appeal rather to the power of the sun Huey Tonatiuh, or the Quecholli Humming-bird (*Huitzilhuitl*), Hawk (*Uactli*), and Eared Owl (*Tecolotl*).

Tepotzotlan faces a united front

The recently-discovered *amate* codex named after the 'hunch-back' town Tepotzotlan (figs 29, 191), which lies north of Tenochtitlan, was actually authored by the scribes of three other places, all close by, which the Crown had assigned to Tepotzotlan as tributaries. They are Xoloc (San Mateo), Cuauhtlapan (Santiago) and Tepoxaco (San Francisco). In the early 1550s they complained to the Real Audencia about Tepotzotlan's excessive demands, which are detailed in the Codex (Tepotzotlan 1). The case was judged by Francisco Maldonado, a noble from Chiconautla and a descendant of Nezahualcoyotl's, who sided with his fellow aristocrats in Tepotzotlan and, adding insult to injury, threatened and physically abused the three tributary communities. These *agravios* of Maldonado's are noted on a copy of the original codex, here referred to as Tepotzotlan 2, where we see him seated in his judge's chair near the local governor Don Luis of Tepotzotlan, flanked by an open-mawed trio of snake, puma and ocelot said to typify their behaviour (fig.185).[8]

 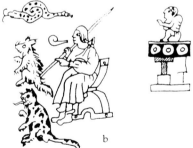

185 a) Xoloc and Cuauhtlapan b) Judge Francisco Maldonado sitting before the hunchback of Tepotzotlan, his threats shown as three dangerous beasts. Tepotzotlan Codex 2

a b

As a ruler, Don Luis descended from a certain Quinatzin (ruled 1460), whose origins are traced back to Xolotl himself in the Techialoyan Landbook of Tepotzotlan. The Cuauhtitlan Annals, however, state that his ancestry was far shorter and depended on Cuauhtitlan, being validated through the marriage of Don Luis's mother as late as 1536. This is important because in its 1395 set of quarters the same Cuauhtitlan source accords Cuauhtlapan and Tepoxaco exactly the same status as Tepotzotlan (f.29), saying moreover that

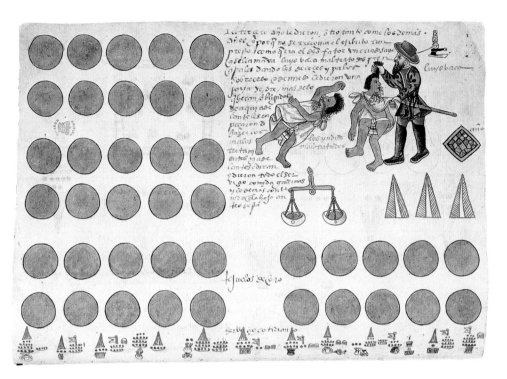

186 Salazar and Tlilpotonqui. Top picture, top right: Salazar's henchman Vaca. Lower picture, bottom left: Tlilpotonqui, wife and the sheep he was sent to tend. Tepetlaoztoc ff.15v–16

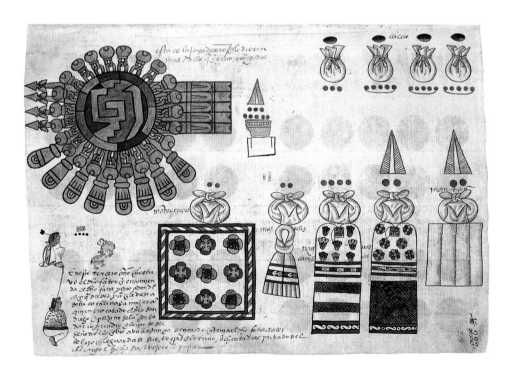

187 'Butterfly' shield.
Tepetlaoztoc ff.8

188 Penachos with
glyphs for Tepetlaoztoc
and other places.
Tepetlaoztoc ff.19v

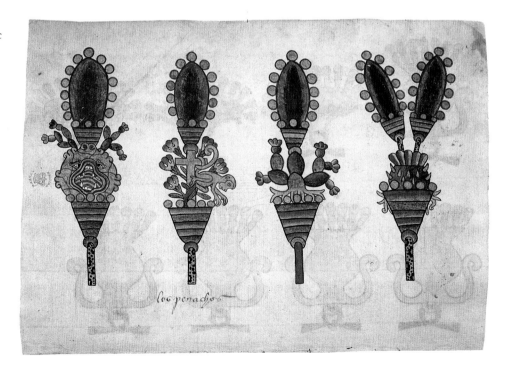

Xoloc and Cuauhtlapan each had a palace and royal *tlaxilacalli* from notably early dates, at Miccacalco and Tianquizçolco (ff.8–9). As for Tepoxaco, its rank as a tributary to Tenochtitlan equalled that of Tepotzotlan, a tributary to Tlacopan, the Tepanec member of the Triple Alliance. The Church made Tepotzotlan the scene of a mission even at the time when the Spaniards were expelled from Tenochtitlan in 1520 (see fig.29) and later endowed it with a fabulous convent: it seems, then, the Crown also elevated it, over towns which had been at the very least its peers in the tribute hierarchy.

A perfectly proportioned and executed text on native paper, Tepotzotlan 1 is divided into ten columns and five horizontal registers, the lower two registers each being double. The uppermost register, reading left to right, depicts the *tlaxilacalli* or wards of Xoloc (1), which are four and include the charnel house Miccacalco (2); Cuauhtlapan (5), which are also four and include the 'old market' Tianquizçolco (6) and the 'house entrance' Calacoayan (8); and lastly Tepoxaco (9), which are only two, the other one being the communal field of ?Coamilco (10). The two broader registers below depict tribute they rendered, at a 90 degree angle. First comes the daily *comida* of maize and turkeys, cacao and chilli peppers, basketed eggs and tortillas, bundles of firewood and saltcakes. Then, listed only under the first two wards of each of the three places, come the less frequent payments of pesos (turned back through 90 degrees), two types of pottery made from the local clay, small and large woven *petate* mats, further tortillas and turkeys, and a hog which had to be fed; and finally labour, a serving woman with her *metate*, and a *tameme* carrier with a note of his inadequate wage. Quantities of items are shown by the usual signs and include the possibility of incompletion (for example, 10 as half a flag –*pantli* or 20), while infixes denote quality and type of item and in turn display a subsidiary numeracy (for example, sticks of firewood in a bundle).[9] The pesos are tied to cloth at a ratio of 3:1. Certain of these items are depicted on a document dating from an earlier stage of the case, which was prepared jointly by Cuauhtlapan and Tepoxaco.

a b c d

189 Place glyphs: a) Xoloc b) Tianquizçolco c) Tepoxaco d) Coamilco. Tepotzotlan Codex 1

In Tepotzotlan 2, Europeanised and on European paper, the layout becomes that of a ledger. Vertically aligned to the left, place glyphs are retained only for the titular wards of Xoloc, Cuauhtlapan and Tepoxaco (this last is now erased) (fig.185). What goes is the visually united front or band of place glyphs, which defends the idea of communality against the divisive tendencies of Spanish law, by identifying place with its constituent parts rather than just one titular ward (in Tepotzotlan 1, only slight extra size had

been given to Xoloc and Cuauhtlapan). Also by highlighting their own ward structure in Tepotzotlan 1, the three tributaries had shown that they had the same municipal status as their supposed superior. Tepotzotlan 2 lists the *comida* vertically too, but when it comes to the further payments the assignment from source becomes an assignment to receiver, now in pesos only, in a detached space. What goes is the paired-*tlaxilacalli* convention whereby currency tribute pertains to the titular ward just as manufactured items and labour pertain to their counterparts, in the royal wards Miccacalco and Tianquizçolco, and Coamilco.

Such is the ingenuity of Tepotzotlan 1 that the upper band of place glyphs may at one level be seen and read as the actual landscape near Tepotzotlan, with east to the top as in the Xolotl Maps, that is with northern Xoloc to the left, southern Tepoxaco to the right, and central Cuauhtlapan in between. Xoloc is represented by Xolotl's fierce-looking canine head atop a hill

190 Calacoayan, the 'entrance':
a) Tepotzotlan Codex 1
b) Calacoayan Landbook f.2v

(fig.189a). Well defined in profile and known as La Columna in Spanish, this hill in fact lies between Xoloc and Tepotzotlan, being claimed by each under the respective concept names of canine and hunchback. Invoking the Chichimec texts which show Xolotl emerging triumphantly from the north (figs 61, 63), Xoloc here uses an idea of landscape effectively to advance its own priority against the 'hunchback' version of Tepotzotlan, which nonetheless had recourse to Xolotl itself in its Landbook. Cuauhtlapan appears as a tree (*cuauhitl*) on a river (*-apan*), its actual position, Tepotzotlan depending downstream on the river's generous waters (today dammed in a reservoir). The leaves of the tree have a 'wild' look said to be characteristic of its western location in the Florentine Codex (Book 11, chapter 1). Tepoxaco is the place of the stone sponge (*te-poxa-*), the type of rock found in the hill on which the town stands; dots in stone plus a plume of smoke indicate its porosity and its volcanic origin. Mendoza uses the same glyph when assigning the place to Cuauhtitlan (fig.115).

This geographical and historical reading of tribute source glyphs is not even a possibility in Tepotzotlan 2. Here, the native towns are literally abstracted from their environment and put into a column that parallels the tribute items, within what has become a standardised European ledger. For good measure, Xoloc loses its hill, too, being reduced to just a dog's head.

In the row of ten place glyphs in Tepotzotlan 1, the pairing principle at work within the 4+4+2 wards also can be seen to alternate the natural with the built, interweaving, as it were, the notion of a united front of 5 intercalated

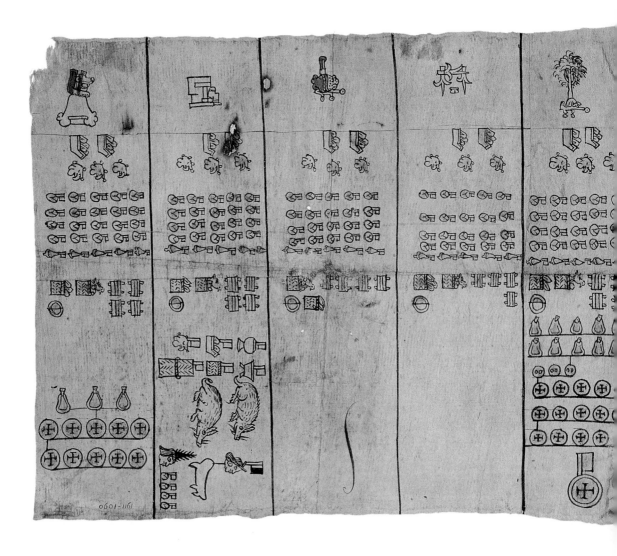

191 Tepotzotlan Codex 1

with 5. For while odd numbers feature hill (1) porous rock (3, 9), and rivers (5, 7), even numbers feature houses (2, 8), altar shrine (4), market-place (6) and squared field (10). In other words, over the tenfold sequence, each of the river and unworked ground glyphs precedes a construct, following a pre-Cortesian logic visible, for example, in the set of masonic forms included in the Borgia Behaviour chapter.

Moreover, the two of the four even-numbered built toponyms which appear in plan rather than profile – the 'old market' Tianquizçolco (6) and the perfectly formed fields of Coamilco (10) – show a complex internal logic that reflects the very structure of the page and the text, with its five registers and ten columns. At its centre, within the standard circular design for market, Tianquizçolco has five small circles (fig.189b): these evoke the round stones to which slaves or work-hands were tied, the digits of the working hand, the

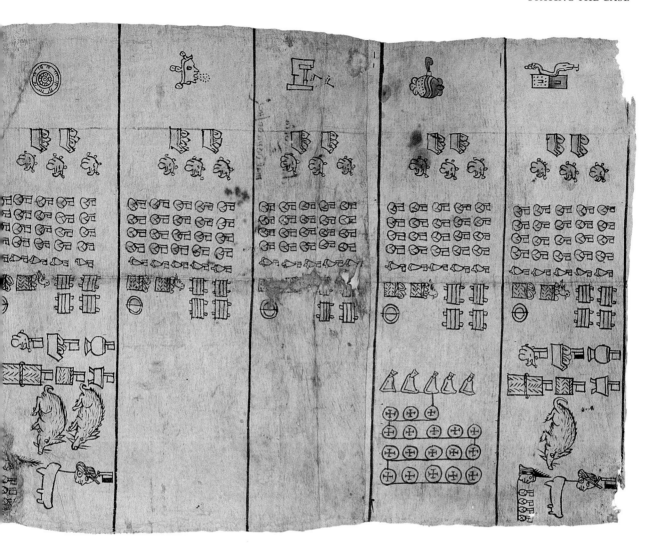

male and female workers who are fifth in the set of Thirteen Heroes, and in time the five-day frequency with which markets were held before the seven-day Judeo-Christian week took over. On the outer circle, small markers are drawn in eight lots, irregularly to reflect the 'old age' of Tianquizçolco, so that the total count is eight lots of three, plus one, 25 in all, the square of the central five small circles. Echoing similar calculations in the Feasts chapter in Féjérváry (note the 5×5×5×5 on p.15), this touch aptly reminds us of the market as the focus of arithmetic and exchange, of supply and demand, more equitable and more ancient than the tribute practices imposed after Cortes.

The other place glyph in the plan (fig.189d), the tenth and last, is a pair of rectangular fields or *milpas*, surmounted by the snake that denotes community work. The first field contains ten dots in two sets of five which each turn through 90 degrees; the second field is empty. The actual proportions of the

fields, length and breadth, correspond to that stated by the dots on the corresponding sides, that is 4:3, a fine example of the native principle of calculating field area, *tlahualmatli*, so highly developed in the Tepetlaoztoc texts. What is more, when measured these stated proportions of the fields exactly match those of the frames in which the place glyphs are set, and which are defined by the columns and registers drawn on to the page. As a result, the pair of fields turns out to be a spatial model for the two halves of the text, a literal image of the kind also found in the pre-Cortesian texts.

So far, the ten toponyms have been read first as viewed landscape and then as municipal wards. Going closer in, there proves to be yet another level of reading, the logic of which is quite basic, in the sense that it refers primarily to the very ground on which the places rest. This level of reality is likewise a concern of the Tepetlaoztoc texts which refine those calculations of field area with minute accounts of soil type, for which a whole repertoire of signs exist, such as pierced stone for clay, or patterns of dots to show sandiness, friability, or porosity. In the Coixtlahuaca Map and other ritual texts, this convention is developed arithmetically, dots signifying units, notably in the 'sigma' logic whereby a number equals the sum of all those numbers up to and including itself (for example $5 = 1+2+3+4+5 = 15$, the case of the eagle which is 5 of the Quecholli and 15 in the Twenty Signs).[10]

In Tepotzotlan 1, the ground or soil dots in the third, seventh and ninth place glyphs have the same total, 15, the sigma equivalent of 5 (fig.189c); added together to make 45, they become the sigma equivalent of 9. The only other soil dots are the 10 of the final field – again itself a sigma equivalent (of 4) – which added on make a grand total of 55, the sigma equivalent of 10, the number of wards in the first place. Certainly beyond the bounds of the random or coincident, this complete consistency indicates at the basic level the ten tributaries' cumulative strength, while reminding us that to produce regularly soil needs human intelligence.

Treating this native text from the Tepotzotlan area in such detail is possible because so much can be known, from the Archivo file, about the context from which it emerged, and because of its limited subject and size. In layout, logic and detail it draws deeply on native script, picturing landscape, intimating history and calculating value in successive readings yet all within a single statement. Its sophistication as a piece of legal evidence goes quite beyond anything expected or even recognisable in a western court.

COMMENTARIES

KEY TO ENTRY HEADINGS

Title (with screenfolds, name only). Location; *HMAI* number and, where different, title. Material and format; number of leaves or pages, with dimensions. Genre and type of text; provenance or focus (town and state, or area); date or period. Select references.

Aubin Codex. BM Add. MSS 31219; *HMAI* 13. European paper; 79ff., 15 × 11 cm. Annals; Tenochtitlan–Mexico; 1608. Vollmer 1981.
See figs 14, 16, 18, 19, 47, 48, 50, 51, 52, 56, 58, 67, 192

Despite its late date and tiny pages, the Aubin Codex gives a comprehensive native account of the Mexica or Aztecs, extending from AD 1168 to 1596 (plus an addendum to 1608). The Mexica are first seen setting off from Aztlan, on the long journey to the highland Basin of Mexico. In the early fourteenth century they announce their leader as Tenoch, at an inaugural date 2 House (AD 1325), the same as that on the title page of the Mendoza Codex. At this stage, however, they still live as uneasy neighbours of more settled polities on the lake shore. In the year 1 Reed (1311) they come into conflict with king Tezozomoc of Azca-potzalco, leader of the Tepanecs whom they would displace a century later upon forming the Triple Alliance, and shortly afterwards in 2 Reed (1351) they suffer a humil-iating defeat at Tepanec hands at 'Grasshopper Hill' or Chapultepec, a major water source; their dispersal is indi-cated by footprints set around the club and shield of war. In driving them from Chapultepec the Tepanec were assisted by Coxcox and the old-established inhabitants of Colhuacan. Having worked as mere mercenaries for Coxcox, in his war against the Xochimilca, the Mexica had tried to hold their 2 Reed fire-kindling ceremony on Chapultepec, which was seen as effrontery and added reason for driving them off.

In the year 1 Reed (1363) they finally have revealed to them the sacred site of the stone cactus (*te-noch-*) on which they are destined to build their capital, Tenochtitlan, setting themselves on the course to empire. The triumphant succession of emperors and conquests is brought to an abrupt halt in the fateful year 1 Reed (1519) (f.41v), when the Spaniards arrive in their ships at Chalchicueyecan (Veracruz); invited to Tenochtitlan, they kill their host Moctezuma, whose mummy bundle is shown. Thereafter, the foreign imposition becomes steadily more visible in new weapons, diseases, style of dress and architecture and the cult objects of religion, the concluding years being dominated by church building and other Christian activities.

Bodley. BO; *HMAI* 31. Skin screenfold; 23 + 23pp., 26 × 29 cm. Annals; Tilantongo and allied Mixteca towns, Oaxaca; pre-contact. Caso 1960, 1977–9; Pagden 1972.
See fig.111

The two sides of this screenfold, the reverse being yet more complex than the obverse, present a wealth of information about the dynasties of the Mixteca, from the seventh century up to the Spanish invasion. Like Zouche it concen-trates on the central towns of Tilantongo and Teozacoalco. Unlike Zouche, however, and more in line with Selden, it has no hesitation in celebrating the aristocratic birth from the tree at Apoala. Prior to the appearance of Eight Deer, the landmarks of the Mixtec realm are set up, with Tepexic far to the north. Certain of the places from which ancestral lines spring on the reverse have still to be identified.

In this text, the boustrophedon reading convention acquires a special elegance and complexity, up and down five horizontal registers over pairs of double pages.

Cochineal Treatise. Relación de lo que toca a la Grana cochinilla. BM Add. MSS 13964 (part); *HMAI* 128, Gómez de Cervantes. European paper, 4ff., 29.8 × 21.5 cm. Manual; Oaxaca; *c.*1599. Dahlgren de Jordan 1963; Gómez de Cervantes 1944.
See fig.9; Appendix 2a

Tenuous though its link with the native tradition is, this

small and colourful treatise on cultivating cochineal appeals to local conventions in depicting architecture, dress, hair-style. An item paid as tribute by Oaxaca to Tenochtitlan, cochineal red (*grana cochinilla*) became a major Mexican export under Spanish rule. It is made from tiny beetles that feed on the nopal cactus, here called *semilla* or seed, which in Nahuatl are *noch-eztli* or cactus blood, whence the name of the Oaxacan town Nochistlan. The process of cultivation followed a yearly cycle, shown in 12 scenes which involve pruning, propagation, culling excess beetles, propping up sagging branches, knowing good insects from bad and weeding. The final page lists insects and other pests with their Nahuatl names. Scene 5 in the series of the monthly 12 shows beetles being gathered by women who have their hair in Mexica fashion and who wear *huipils* dyed red with cochineal; in the background a native house can be seen. The caption runs: 'Here the ripe and ready beetles are taken in August, September and October, the main harvest of the year' (*Aquí se coje la semilla que está ya madura y de sazón para agosto, septiembre y octubre aunque todo el año ay cosecha pero la principal es en estos meses*).

Egerton. BM Egerton MS 2895. *HMAI* 279, Sánchez Solis. Skin screenfold, 16+16pp., 21.5×27.7cm. Annals; ?Acatlan or Tehuacan, s.Puebla; 16th C. Burland 1965; Johnson 1991; König 1979; Rivas Castro 1994; Smith & Parmenter 1991.
See fig.119

Prominent among the many place names that attach to the ancestral couples depicted in this text is that of the 'jewel town', read as *yoco yoxi ndixaa* in the Mixtec gloss (it appears on pages 16, 20, 23–4). This is the former Mixtec name of Acatlan, 'reed-town' in Nahuatl, situated in southern Puebla, which some believe to be the provenance of text. Others have pointed to the 'wild beast' town Tehuacan. We begin with a dynastic emergence (p.1) reminiscent of the Mixtec annals from the northern towns of Nochistlan and Huamelulpan. It is followed (pp.2–4) by a procession of priestly figures, male and female, whose bodies are blackened. They lead towards the 26 royal couples who fill the rest of the text and who are politically related to the Mixtec heartland of Tilantongo and Teozacoalco. The glosses, in part illegible, are all in the Mixtec language.

Féjérváry. Merseyside Museum, Liverpool; *HMAI* 118. Skin screenfold; 22+22pp., 16.2×17.2cm. Ritual; ?Xiuhtecuhtlan, Puebla; pre-contact. Brotherston 1976,

1992; Burland 1950, 1971; Gibson & Wright 1988; León-Portilla 1985; Nowotny 1961.
See figs 134, 147, 149, 154–7, 160, 164; Appendix 1a

With Laud, Féjérváry is the most ingenious and consummately executed of the texts in the ritual genre. The design of the title-page is a magnificent map, a quatrefoil consisting of four quarters, with intervening diagonals, each of which is correlated with a quarter of the 260-unit *tonalamatl*. Within this frame stand the nine Night Lords of the midwives and human gestation. At the centre the Fire Lord, the first of their number, bears sense emblems on his head (bird's eye for sight, copal incense for smell, jaguar ear for touch, hand by ear for hearing); the other eight appear in the quarters, standing in pairs either side of the four trees. East appears above and west below, forming a broad path that passes through the central plaza. To the sides of this path, south (right) and north (left) also denote the underworld of the Death God and the upper regions of the Rain God. The birds that perch on the trees, like those flying in at the corners with year Signs on their backs, are known in ritual as Quecholli; here, as collectors and feeders on provincial produce, they encode calendric and economic information. The four Quecholli atop the trees symbolise the 'input' from each of their quarters, a reading supported by the fact that this title-page map is a clear model for that in the Mendoza Codex. At the same time, other details, such as the four plants and growth emblems at the diagonals which culminate in maize, recall the deeper cosmogony of world ages.

From here we pass to the Night Lords in their guise as conquerors (pp.2–4), and then to a long chapter that deals with offerings and tribute placed beneath the 11 armed figures of the zodiac (pp.5–14), followed by emblems of the yearly feasts (pp.15–22). In the feast of the dead in August, the domestic companions Turkey and Dog wait to accompany the soul on its journey into the other world, just as they do in the corresponding chapter in Laud.

Divided into two registers, the reverse includes chapters devoted to Birth, Behaviour, Travel (of the traders or *pochteca*), Hazards of the road, Martial Arts and Maize planting (the maize is anthropomorphic since humankind was made in its image, as the *Popol Vuh* confirms. The nativity scene in the Birth chapter is memorable, while the repeated appearance of the travelling *pochteca* has led to the association of this text with trading centres east of the highland Basin. The Behaviour chapter concentrates poetically on a few multivalent symbols, such as the Signs Jaguar and Snake.

Huitznahuac Capulli. BM ex Christy Collection (reference by Burland in Ethnological Document 1386); *HMAI* 146. European paper. Genealogy; Central Mexico. Around 1600. Burland 1957.

Burland describes this text as 'a single page with heads and numerals, probably seventeenth century' The *HMAI* entry reads: 'Late style, simple genealogy of about 40 persons in eight generations. The Nahuatl gloss mentions Acolman, Tlacopan, and Tlaqualtzinco. Huitznahuac is a common designation of wards or barrios in the Valley of Mexico and perhaps elsewhere as well.'

Itzcuintepec Codex. BM Egerton MSS 2897; *HMAI* 161. Eleven native paper fragments that form five subtexts, 1 (1), 2 (2, 4), 3 (3, 5, 6, 8, 9, 10), 4 (7r & v) and 5 (11); 41×44 cm (1, 2, 4), *c.*119×80 cm (3), & 44×22 cm (5). Map (1), annals (2) and genealogies (3–5). Itzcuintepec, n.Puebla. Burland 1948, 1960; Haley et al. 1994; Nicholson 1966
See figs 100, 103–5

This complex and probably incomplete collection of sub-texts begins with an overall index and Map; at the centre, the twin towns of Itzcuintepec and Tenanitec are surrounded by nine dependencies. Of these, several occur together with Itzcuintepec and Tenanitec in the Tochpan Lienzos, at appropriate positions, notably the hill of Quetzalcoatlan or Ecatlan (Puebla) and the stone of Tetzapotitlan (east, top), the hand of Tamapachco (northwest, lower left) and the water of Atlan (southwest, lower right).

Next, the Annals consist of two fragments which may once have been laterally joined. Taking further the dual statement of the Map, they each repeat year dates down their right margins, show ancestors enthroned on wicker-work *icpalli*, and make their twin beginnings. In one, Itzcuintepec with its patriarch Six Tooth is juxtaposed with the places of the crescent moon, very likely Metztitlan to the west, and the rattle-snake of Xiuhcoac, a neighbouring tribute centre in Mendoza; the year date is 5 Flint which repeats at least seven times, each time measuring the 52-year calendar span or 'year binding' (*xiuhmolpilli*), here confirmed by a tied-rope period-marker. In similar fashion, the other series of years repeats 13 Flint at least three times, and here we see the Chichimec ancestor Sun above Six Eagle and other forebears linked here and later at the place of Tenanitec's subject Teximalpa. As in the Map, the steps of the pyramid at Itzcuintepec are saw-toothed, just as those at Tenanitec are square-edged.

For their part, the Genealogies – 3, 4, 5 – are radial, showing descent by plaited or simple cords. The largest has a narrow upper and broad lower register which restate yet again the dual relationship between Itzcuintepec and Tenanitec (here, above and below). Xiuhcoac and Metztitlan reappear with Itzcuintepec; below, as in the Tochpan Lienzos, Tenanitec lies beside the place of the frog (?Cahuac). On a smaller scale the two other Genealogies give similar details of succession, at the place of the open-maw cave attributed to Tenanitec in the opening Map, and at an unnamed locality.

Itzcuintepec Roll. BM Egerton MSS 2896; *HMAI* 161. Native paper strip, 41×249 cm. Annals; Itzcuintepec, n.Puebla. 16th C. Burland 1948.
See figs 101–2; Appendix 2b

Only recently shown to be a complete text, the Itzcuintepec Roll gives a grand account of Chichimec history. Materially, as in scope and conception, it fully deserves comparison with other native-paper scrolls in the Chichimec tradition, such as the Selden (Tlahuixtlahuaca) Roll and the Huamantla Codex.

Moving vertically from top to bottom, the story begins, like the year count and the footprint trail, on the upper edge, now in part destroyed and illegible, which Nahuatl Gloss 1 (see Appendix 2b) identifies with the Chichimec birthplace Chicomoztoc, and which leads past places noted in Tochpan Lienzo 1 towards the Gulf Coast (shown upper right). Along the way, there appear the ancestors Tonatiuh (Sun) and then the black-faced Ahuizotl, his small companion Tzitziquiltzin, One Rabbit plus companion at Tenanitec (stone enclosure), and Four Eagle. Spewing the blackness that puts the sun in eclipse, Ahuizotl extends his arm behind him like the tail of the *ahuizotl* beast of his name. Power is then ceremonially transferred by Four Eagle to another Tonatiuh, who begins a genealogy that turns into a road. At Itzcuintepec, this road is joined by another that leads up from the enclosure where four black-faced archers with 'captor' top knots engage in a shooting match, one reminiscent of contests depicted in the Selden Roll and the Cuauhtinchan Annals. Observing them are two figures granted the privilege of sitting on wickerwork thrones (*icpalli*). Finally, from the house of lineage, *quatzontecpan* as Gloss 1 names it, seen frontally and surmounted by the cross of the Santísima Concepción (Gloss 2), several ancestral threads descend to the bottom edge. The fact that the cross was added in a later hand suggests a sixteenth-century date.

Few if any of the place signs in the text can be made to

correspond to the 50 places listed in Gloss 3 (several of which repeat); some of them reappear, however, in the Itzcuintepec Codex and the Metlatoyuca Map.

Laud. Bodleian Library, Oxford; *HMAI* 185. Skin screenfold, 22+24pp., 15.7×16.5cm. Ritual; ?Teotlillan, n.Oaxaca; pre-contact. Brotherston 1992; Burland 1966; Lewis 1995; Nowotny 1961.
See figs 93, 143, 148, 151, 152; Appendix 1b

Like Féjérváry, Laud is a ritual text whose title-page map combines ceremony with geography. The last rather than the first page of the text, it shows an eclipsed sun suspended between the east and west horizons, a blood-sipping eagle above and the skeletal lord of hell below. Through comparison with the Selden Roll and other Upper Papaloapan texts, where these elements are set into a definite landscape centred on Coixtlahuaca and Cuicatlan, the text may be surmised to have come from Teotlillan, the place of eclipse included in the Tochtepec district in the Mendoza Codex. Formally, Laud resembles Féjérváry in page size and squarish shape, chaptering, reading direction (right to left), style and the use of Olmec style 'bar-and-dot' numbers.

The text opens with the Birth chapter (pp.1–8), which presents two versions of impregnation and parturition, one 'bad' and one 'good'. The 'bad' sequence is dominated by Mictlantecutli, the skeletal lord of the underworld and fifth of the Night Lords, whose power, necessary for the formation of good bones and blood, can be deadly in excess. In the 'good' sequence, this power is tempered by that of Weaving Woman, seventh of the Night Lords, who holds the thread of life and carries a spindle in her hair.

The remaining chapters of the obverse deal with Couples, the four Amazons who appear to be invoked in the Selden Roll, Burial, an enigmatic pair of journeys past buildings and mountains (the first of which is made under the stars of the night sky), and finally the feasts of the year (pp.21–2), where as in Féjérváry (pp.15–6) the domesticated Turkey and Dog accompany the travelling soul. The reverse opens with another enigmatic chapter of notionally 32 scenes which opens and closes with the Signs of the lower and upper jaw (Tooth XII and Skull VI) and which hence invokes the total of teeth these jaws contain, i.e. 16+16 or 32 (five dots at the start specify the interval between Sign VI and Sign XII and so enable the chapter to be read as an unending cycle). Next the nine Night Lords (pp.31–8) appear under glorious awnings reminiscent of the equivalent chapter in the Cuicatlan screenfold (pp.1–3):

the precious child or nascent sun – number three among the Night Lords – rides a spectacular blue jaguar, which is also legible as a caiman whose tail becomes a flower-bearing tree where the humming bird feeds. In all, Laud is distinguished by its precision of line, its visual puns and its play with spatial and numerical logic, which it takes to degrees unknown in other extant manuscripts.

Mendoza Codex. Bodleian Library, Oxford; *HMAI* 196. European paper, 71ff., 32.7×22.9cm. Tribute; Tenochtitlan–Mexico; *c*.1541–2. Barlow 1949; Berdan & Anawalt 1992; Clark 1938; Escalona 1989; Mohar Betancourt 1988.
See figs 20, 51, 54, 55, 115, 150, 153, 161, 166, 169–73, 176; Appendix 1c

Modelled on the four quarter map found in Féjérváry, though with west rather than east to the top, the title page of Mendoza centres on an imposing image of Tenochtitlan, as the place (*-tlan*) where an eagle perches on a stone cactus (*te-noch-*). Around it spread the quarters of the city and of the future empire, in the quatrefoil pattern.

Below are the first events in the story of empire, the conquests of Colhuacan and Tenayuca, towns which had dominated the southeastern and northwestern sides of the lake now encroached upon by Tenochtitlan and which in profile can be seen standing as if in the landscape to the south and north of the capital. Around the edge of the page run the year dates of Tenoch's reign, when Tenochtitlan was founded and conducted its first fire kindling, here attached to the year 2 Reed (1351). It begins in 2 House (1325) and ends in 13 Reed (1375) – a house and a reed arrow are also placed respectively in the west and east quarters – and runs on subsequent pages through the reigns of nine Mexica emperors, from the first year of Acamapichtli's reign 1 Flint (1376) to Moctezuma II's encounter with Cortes in 1 Reed (1519).

As a title page, this map prefigures the text as a whole. After the 9 imperial reigns, garrisons are set up, 11 in the Highland Basin and 11 beyond, which secure the delivery of commodity tribute over the feasts of the year and in carefully specified quantities, according to the scheme of a metropolitan area surrounded by its four quarters. The final part is devoted to the life of Tenochtitlan's citizens and their labour tribute: as in the ritual screenfolds (though now without the *tonalamatl*), we see chapters on Birth, Behaviour, Martial Arts, Travel of the *pochteca* and Hazards of the road. Just as the commodity tribute is anticipated on the title page in the map of the four quarters, so this labour

tribute is anticipated by the nine figures set into them, whose names in combination suggest a double anatomy, banner above and sandal below. In all this, structurally and in detail, Mendoza shows a particular affinity with Féjérváry.

Metlatoyuca Lienzo. BM Add. MSS 30, 088; *HMAI* 199. Cotton lienzo, 180×105 cm. Annals, genealogy and map; Metlatoyuca, n.Puebla; post-contact. Breton 1920; Brotherston 1982; Guzmán 1939; Haley et al. 1994; Herrera 1994.
See fig.99

Within a firm geographical frame of ten landmarks, this large text includes a dozen further places and lists seven genealogies. Of the genealogies, five run to no more than six or so generations; a sixth, identified with the ball-court Tlachco above, runs to 13 generations while winding across and up the page the seventh and main list reaches a total of no less than 26. The accompanying year count specifies the biologically apt sum of 763 years, calculated in native numerals from the seventh-century Chichimec calendar base to just before Cortes. Tonatiuh, the ancestor from Chicomoztoc, is shown feeding into the ancestral line at an early stage.

Being basically a map, the text may be meaningfully oriented, thanks mainly to the four rivers which, rising from their separate sources, flow together towards the bottom edge. In the region in question, the direction of the flow can only be north, up through the valley of Pantepec (whose sign appears to be present) towards the main Tochpan system. In this reading, the Mexica tribute centre Atlan (river place) lies northeast, just as Molanco (black ball) lies northwest in the tribute district of Xiuhcoac, and Tototepec (bird hill) and Tlachco (the I-shaped ball-court) lie respectively southwest and south – all appropriate directions.

This puts what must be Tecpantepec (palace hill) at the centre, between the vanished Tlemaco (brazier; east) and Patoltetitlan (*patolli* board-game, due west). As locatives in Tecpantepec's genealogy, we see Molanco's neighbour Ichcatlan (cotton place), in addition to further examples of places that appear in the Itzcuintepec texts, such as Tamapachco and Ecatlan.

As well as places, people and ancestral time depth, the Metlatoyuca Map shares with the Itzcuintepec texts certain stylistic traits, such as abnormally squat human figures, and semantic distinctions between plain and saw-tooth pyramid steps, *icpalli* and lesser seats, types of head attire (band, top knot, crown, crown with plume) and of ances-

tral links (thick and thin cords, dotted lines and footprint trails).

Selden. Bodleian Library, Oxford: *HMAI* 283. Skin screenfold, 20pp. *c.*27.5×27.5 cm. Annals; Xaltepec, Oaxaca. 1556–60. Caso 1964, 1977–9.
See figs 116, 121

Remarkably uncluttered, the narrative in this screenfold is read from bottom to top over 20 pages, passing through four registers on each page. Recalling the tree birth of the Mixtecs, it tells the royal story of Xaltepec, which stretches over four dynasties right up to 1556. Near the start we encounter Ten Reed (pp.3–5), who founded the first dynasty there in 9 House (AD 917) and whose ancestors were tree-born, or came from Coixtlahuaca (the jurisdiction in which Xaltepec is placed in the Mendoza Codex). Also prominent is Lady Six Monkey of the second dynasty (pp.6–7). After her brothers were slaughtered, she sought to ensure her rights to succession and appealed for help to her fellow matriarch, the formidable Lady Nine Tooth of neighbouring Mictlan. Especially vivid is the account of her relationship with Eleven Wind, over the years 6 Reed to 13 Rabbit (AD 1031–38). Together they make offerings, dance, bathe and finally marry. Upon Eleven Wind's death in 9 Reed (1047), Xaltepec was invaded by Eight Deer of Tilantongo, whose biography is told in Zouche and who makes only a brief appearance here (p.9).

Selden Roll. Bodleian Library, Oxford; *HMAI* 284, Selden Roll. Native paper strip. 38×350 cm. Annals; ?Tlahuixtlahuaca, w.Oaxaca; post-contact. Burland 1955; Caso 1977–9; Parmenter 1982.
See figs 84–6, 88–92, 142

The Selden Roll begins in the sky, the abode of the dynastic patron deity Nine Wind Quetzalcoatl and the couple One Deer, and descends through bands of stars to the Chichimec heartland Chicomoztoc or Seven Caves, whence the black-faced ancestor Tecpatzin emerges. Reading now horizontally from left to right, we proceed at length towards a fire kindling via two routes, upper and lower, that are marked by footprints, and encounter the leader Two Dog. The lower route passes the hills of ocelot, eagle and macaw, all traversed by arrows, and the river of the deer-woman, landmarks found in other Chichimec texts.

As the climax of the story, the kindling is accompanied by acrobatic and other events and is set above a huge composite place name which combines the snake of Coixtlahuaca, the feathers of Ihuitlan, and the knot of

Tlapiltepec, all settlements in the Coixtlahuaca Valley on the Upper Papaloapan: the dominant element is the head of Tlahuixtlahuaca, the likely provenance of the text. To the right, the copious scroll that rises from the seated figure's mouth is thought to signify Cuicatlan, the place of the singer, that lies on the southeastern branch of the same Papaloapan river system. The year is given as 10 House and marks the start of Chichimec ascendancy in that region. From this centre, four chevron paths of war, two to the left and two to the right, lead out to the traditional landmarks of Papaloapan, of which the two to the right (east), Teotlillan and Mictlan, are readily decipherable.

Giving an account of Chichimec rise to power in and around Coixtlahuaca, the Selden Roll appeals to remote celestial origins and places the Toltec patron Nine Wind at the very start of historical time. Only from this grand beginning do we descend to Chicomoztoc and the Chichimec epic of less remote years.

Tamazolco Map. BM Add. MSS 22070(c), formerly AGN Tierras vol.145, exp.7; *HMAI* 298. Native paper, 50×77 cm. Property plans; Santa Barbara Tamasolco, Tlaxcala; 1616. Reyes 1993.
See fig.78; Appendix 2c

Near the centre, a tree stands between two imposing churches, Santa Barbara to the left and Santa Ana to the right. Together, in profile, they dominate a plan of roads, water-courses, houses (*tecpan*), lands (*tlalli*) and an inn (*tecali techialoyan*). Locations are identified by native signs, such as the toad (*tamazolin*) of Tamazolco (lower centre) and the water loop (*a-tl*, *coltic*) of Acolco (lower right), and by numerous glosses in Nahuatl (see Appendix 2c). These include lyrical invocations of the central tree as well as more prosaic details concerning the scribes who authored the titles to these lands, the conquistador Diego Muñoz, father of the Tlaxcalan historian of the same name, and Antonio de Mendoza, the first viceroy. Also mentioned is Francisca Maxixcatzin. As the Tlaxcala Codex shows (scene 3), Maxixcatzin, one of the four Tlaxcalan principals, had his palace in Ocotelulco, the head town to which Tamazolco belonged. In style and approach, this text recalls the Techialoyan Landbooks.

Tepetlaoztoc Codex. BM Add. MSS 13964 (part); *HMAI* 181, Kingsborough. European paper, 72ff., 29.8×21.5 cm. Legal evidence; Tepetlaoztoc, Basin of Mexico; 1555-6. Gibson 1964; Robertson 1959; Seler 1961; Valle 1989, 1992. See figs 11, 65-9, 174, 179-84, 186-8; Appendix 1d

Drawn with the clarity and minute detail characteristic of the Texcoco school, this document stems from Tepetlaoztoc, on the east bank of the highland lake. It begins by placing Tepetlaoztoc in that landscape in an opening pair of maps, both oriented to the east. The first alludes to moments in the Chichimec migration from Chicomoztoc, the second concentrates more on Tepetlaoztoc's position, near the 'butterfly' town Papalotlan and the river of that name. Its own place sign is legible as a mountain cave (-*oztoc*) or maw, in rocky terrain which in that precise area impedes communication between Texcoco and the Teotihuacan Valley.

This geographical introduction has its historical sequel, an account of the Chichimecs who had settled that part of the Basin of Mexico 'four hundred and forty years' ago. First come the five wild ancestors from Chicomoztoc, headed by Tonatiuh (left) and Ocotochtli (right), dressed in skins and carrying bows and arrows, and then the four more genteel cotton-clothed representatives imposed by Nezahualcoyotl and the Xolotl dynasts of Texcoco, in their triumphal year 4 Reed (1431). The leader of the Texcoco faction, Cocopin, is suitably enthroned; in the annals of nearby Chiautla, he is shown being introduced to Tepetlaoztoc in 1431; this Chiautla source also measures his actual reign from 1 House (1441) to his death in 10 House (1489). After a short interregnum under his widow Iztacxochitl ('white flower', a daughter of Nezahualcoyotl), he was succeeded in 6 Rabbit (1498) by the six-year-old Diego Tlilpotonqui, in whose reign Cortes arrived and whose name glyph includes the element black (*tlil-*).

Particular attention is paid to the economy and tribute practices of pre-Hispanic times. The text here draws on a rich visual vocabulary that typifies the five or more texts which belong to the Tepetlaoztoc subgroup, in the detailing of such matters as social hierarchy, demography, land ownership, field area and soil type.

From here we move to a vivid and meticulous record of the havoc wrought by Cortes and the line of overlords who succeeded him, year after year. Adapted now to the phonetics of Spanish, name glyphs continue to be used while the year period is indicated by a diamond marker. The huge quantities of goods seized by the invaders are specified, by means of vigesimally-based numerals, as is the dire fate that befell those who refused to comply. Cortes is charged with having ordered his servant Anton to burn a group of four such recalcitrants alive; the encomendero Salazar is seen brutally beating and kicking the local inhabitants. The catalogue of precious items taken is

dazzling: a shield that invokes a metamorphosis of butterfly and human, obsidian mirrors, a box with emeralds, and above all gold *penachos* featuring in the finest detail the place sign Tepetlaoztoc, exotic butterflies, and a lizard catching a fly. In addition to all this come seemingly endless supplies of maize and other food. Labour and its products are also shown, in a subsection where the heavy stones of watermills and other European structures built for the Spaniards over the years wholly dominate the page.

Tepotzotlan Codex. Ulster Museum, Belfast; *HMAI –*, AGN copy 322. Native paper, 40×110 cm. Legal evidence; Tepotzotlan, Basin of Mexico; 1555–6. Brotherston & Gallegos 1988; Brotherston 1993.
See fig.191

Evidence in a dispute between the principals of Tepotzotlan and three neighbouring towns which the Spanish had placed under its jurisdiction, this single-sheet text falls into ten columns. These detail the goods paid to Tepotzotlan by its three subjects and their wards: Xoloc (dog head; four wards), Cuauhtlapan (tree and river; four wards) and Tepoxaco (volcanic stone; two wards). In the horizontal register, the columns distinguish between daily food supply and less frequent transactions; and through the 90 degree angle they distinguish between commodity items (turkeys, firewood, pottery etc.) and labour, female and male. Quantities of items are shown by the usual numerals, which allow for incompletion, while as in Mendoza infixes denote quality and type of item and subsidiary numeracy.

The signs of the places that supplied these goods form a row along the top of the ten columns. Indicating type of terrain and soil, they state a logic of their own, not just as sets of wards (4+4+2) but as a series that alternates the natural with the made, interweaving as it were the notion of a united front (5+5): while odd numbers feature hill and river, even numbers feature house and altar shrine. Two of the even-numbered made toponyms appear in plan as opposed to profile – the 'old market' Tianquizçolco (sixth) and the perfectly formed fields of Coamilco (tenth) – and make numerical statements of their own, which relate to the five-day frequency of native markets and to the proportions of the text itself.

Succinctly conveying all these data, the row of toponyms running north–south from Xoloc (left) to Coamilco (right) contrives at the same time to profile the local landscape. Moreover, in profiling landscape in this way, the toponyms that begin here with Xoloc or hill of Xolotl encode the history of that Chichimec leader who, in establishing the political order of this whole area in the eleventh century, preferred Xoloc, Cuauhtlapan and Tepoxaco to the object of their complaint, Tepotzotlan. In all these details and within its frame, the extreme sophistication of this page as a legal and literary statement is further confirmed by negative definition, when it is compared with the Europeanised copy of that was made of it, Tepotzotlan Codex 2, whose format is reduced simply to that of a ledger.

Tlaxcala Calendar. Glasgow University Library, Hunterian Collection 242 (part); *HMAI –*, later versions 388C, Veytia Calendar Wheel no.2. European paper, 2 sheets, *c*.38×38 cm. Calendar; Tlaxcala; 1570–80. Acuña 1984; Brotherston & Gallegos 1990; Reyes 1993.
See fig.5; Appendix 2d

Dedicated to the 52-year cycle and the 18 feasts celebrated over the course of each year, this calendar takes the form of two wheels. The first correlates the Twenty Signs of the *tonalamatl*, at the centre, with the 52 years of the *xiuhmolpilli*, at the circumference, showing how four of the Signs (House, Rabbit, Reed, Flint) combine with the Thirteen Numbers to produce 52 year names. These are further correlated with the Christian calendar, from 1 Reed (1519), when Cortes arrived (the gloss reads: 'llegada de Cortés'), to 13 Rabbit (1570).

The wheel on the other sheet shows the eighteen 20-day feasts of the year from Atemoztli (January, top right) to Quecholli, apparently with one error (Panquetzaliztli, the winter solstice feast in December, is placed after Ochpaniztli, September, rather than after Quecholli, November). Though late in style, the feast emblems evoke the old beliefs and customs, such as the 'quickening' of the infant in Izcalli (February), the commemoration of the dead in Miccailhuitl (August), the clean sweep of the broom in Ochpaniztli at the autumn equinox and the Quecholli hunt of migrant birds as they descend on the highland lakes in November (the bird, *quechol*, is traversed by an arrow). The five dots (top) complete the 365 days of the year.

In Muñoz Camargo's *Historia de Tlaxcala* (1580), into which it is inserted, this dual calendar is said to belong to the treatise *Calendario índico* by Francisco de Navas, which is quoted at some length on the preceding folios (167r–177v) and which explicitly states that the second sheet is the work of Mocallio (Antonio de Guevara), from Ocotelulco and native governor of Tlaxcala 1583–4. Among the many calendar wheels included in histories during the Spanish colonial period, these two have the distinction of being the earliest.

Tlaxcala Codex. Glasgow University Library, Hunterian Collection 242 (part); *HMAI* –, other versions 350–2. European paper, 164 pages, 29×21 cm. Bound with Diego Muñoz Camargo, *Historia de Tlaxcala*, ff.236r–317r. Legal evidence; Tlaxcala; pre-1580. Acuña 1984; Brotherston & Gallegos 1990.
See figs 2, 32–8; Appendix 1e

The first evidence of what became this extensive Codex can be found in a modest and elegant native-paper text from Tizatlan, now in Texas, which over four pages depicts the Spaniards arriving in Tlaxcala and the tribute given to them, each of these two concepts being developed over two pages. The logic is perfect and the function was no doubt to alert the Spaniards, supposed allies, to debts they were not paying: a native statement of account not unlike those found in the Tepetlaoztoc and Tepotzotlan texts.

Subsequently, this statement was incorporated into the famous Lienzo of Tlaxcala, of which several versions exist, as scenes 4 to 7. Starting out from the four head towns, Quiyahuiztlan, Tepeticpac, Ocotelulco and Tizatlan, the far grander Lienzo celebrates the heroism of the Tlaxcalans and their Spanish allies in subduing first the empire of Tenochtitlan, taken after the siege of 1521, and then territories beyond, west to Jalisco and the 'setting sun' of California, and east to the sacred Maya lake Atitlan in Guatemala.

Taking the story one stage further again, the Tlaxcala Codex expands the initial scenes in Tlaxcala, and extends the narrative of conquests from 87 to 121 scenes. The Codex also inserts an adulatory section (scenes 21–26) designed to win over the Spanish monarch: the text was in fact taken to Europe by the Tlaxcalans in their mission to contest a case of privilege in Madrid in 1585.

By far the most extensive in this series of Tlaxcalan texts, the Codex presents much information not available elsewhere, not least, the 42 further conquests not included in the Lienzo. These feature, for example, the 'wild beast' of Tehuantepec; the 'snake enclosure' of Coatzacoalcos; the 'rainbow river' of Cozumalhuapan, an ancient site on the Pacific Coast of Guatemala; the 'necklace' of Cozcatlan, now a suburb of San Salvador; and easternmost, the 'smoking water' of Atlpopocayan, which 'is in the volcanoes of Masaya', a shrine in Nicaragua. The final depiction of the seven-gated city of Cibola or Zuni is also quite unparalleled, as is the synopsis of whole Mesoamerican provinces to the east and west.

In the much expanded opening section, we are shown the Franciscan mission and the brutal punishment inflicted by the Christians, burning and the gallows, for such sins as gaming (at *patolli*) and apostasy. Also clearly shown are Spaniards participating in pagan rites, clutching the bodies of decapitated quails. Above all, it is here that we have the vivid scene of conflagration, of priestly paraphernalia and piles of native books.

Zouche. BM Add. MSS 39671; *HMAI* 240, Nuttall. Skin screenfold, 46+46pp., *c.*19×23.5 cm. Annals; Teozacoalco, w. Oaxaca; pre-contact. Anders & Troike 1987; Brotherston 1975; Clark 1912; Jansen 1992; Miller 1975.
See figs 109, 110, 112–14, 122–32

The screenfold has a different text on each of its sides, which in principle could be separately paginated. The obverse deals with the grander history of the Mixteca area, leading into a succession of dynasties that starts in the eighth century AD and extends over at least six centuries. The reverse, on the other hand, concentrates just on the story of Eight Deer, from the year of his father's first marriage (6 Flint – AD 992) to the last year of his official bachelorhood and the eve of his fortieth birthday (12 Rabbit – 1050).

The stately progress of years on the obverse gathers momentum as we approach the founding of the first local dynasties in and near Tilantongo (p.23). This epochal event is set against a multiple background of migration, economic change and military strife. We see the institution of progressively more complex forms and agencies of tribute (pp.1–2), a recurrent rivalry with people identified with striped coloured stone (pp.3–5, 20–22), and the grand confluence of three traditions stemming from the snow volcanoes of the west, the turtle river of the centre and a bleeding sun flanked by the Lords One and Seven Death. To commemorate the setting up of the temple of Quetzalcoatl, coloured sand is brought in, hallowed and laid in ceremonial patterns, and a roofed ball-court is constructed (p.15). Next comes the intricate matriarchal story of a long line of women who all bear the name Three Flint, the birth of successive daughters and granddaughters being a main motif (p.16).

High points in the biography of Eight Deer, on the reverse, include his childhood prowess on the battlefield, his regime of prayer and fasting as a young man, and his homage in 6 Reed (1031) to the Lady of Mictlan in the company of the future matriarch Six Monkey (pp.42–44). Thereafter he is revealed as an increasingly bloodthirsty conqueror: he displaces his older half-brother, seeks recognition from Four Jaguar, lord of Coixtlahuaca (pp.52–53), demands homage from 100 lords summoned from 29 towns

and the four directions of Tilantongo–Mictlan (pp.55–68), and performs the climatic fire kindling of 9 Reed (1047) (p.76). Especially vivid are the pages which depict the murder carried out with a concealed weapon in the sauna (p.81), and a pair of water-borne attacks, one at night that is successful (p.75), the other by day that is a disaster (p.80).

Landbooks (Techialoyan)

Calacoayan. BM Add. MS 43795, ff.15–22. A 1802 copy on European paper of an 8-folio text which is also partly preserved in the 3-folio amatl paper Landbook in the Sutro Collection, San Francisco, *HMAI* 710 [Santa María Calacohuayan]. 8 folios, double-level (BM ff.1–3=Sutro ff.3, 1, 2). Unpublished. Barlow & McAfee 1946; Gómez de Orozco 1948; Noguez 1993: 72–6.

Chalco Atenco. BM Add. MS 17038. *HMAI* 716. 10 folios, double-level, 8pp Nahuatl only. 47.5×25 cm. Unpublished.

Huixoapan. BM Add. MS 22070(a) (b). *HMAI* 717 [San Pablo Huyxoapan; Azcapotzalco]. 4 folios, double-level, 2 folios Nahuatl only. 46×24 cm & 46×22 cm. Second of three fragments, *HMAI* 702–717–735, of an incomplete text. Published in Gates 1935.

Tepotzotlan. John Rylands Library, Manchester. *HMAI* 722. 6 folios, Nahuatl only. 27.3×21.5 cm. Third of three fragments, *HMAI* 718–714–722, of a complete text. Transcribed in Robertson 1960. Mönnich 1985.

Mexican MS 2. John Rylands Library, Manchester. *HMAI* 204 [Fisher]. 4 folios, double-level, 2 folios Nahuatl only (ff.1r & 2v are blank). 25.5×16.5 cm. Unpublished. Lemoine V. 1960.

Other references: Barlow 1948; Béligand 1993; Galarza 1982; Harvey 1993; Lockhart 1992; Noguez 1992; Robertson 1959: 190–5; 1975; Wood 1989.
See figs 62, 108, 190, 192–4; Appendix 2e

Surviving Landbooks number over fifty and have as their objective the defence of communal lands. Their alternative name 'Techialoyan' derives from a place in the State of Mexico (which means 'inn'), the source of an exemplary text. Usually made of coarse native paper folios, sewn in European fashion, they combine single- or double-level illustrations with an alphabetic text, written in a large unlovely hand in which the letters remain separate. Their language is Nahuatl, often the intermediary between Span-

ish and locally spoken Otomi or Matlatzinca. Geographically, they cluster around Azcapotzalco, capital of the former Tepanec domain, and the provenance of an especially fine Techialoyan text.

The history they record begins with the arrival of Xolotl and the Chichimecs, who here typically bear obsidian tipped swords, and the founding of the dynasty of Tezozomoc. Then comes the accommodation with Tenochtitlan and its emperors (Itzcoatl, Moctezuma I) after the Triple Alliance of 1428, when Tlacopan/ Tacuba replaced Azcapotzalco as the Tepanec capital; and after that, the accommodation with the Spanish, their religion and legal system, and the often cited viceroy Mendoza. Tlacopan is seen stoutly defending its traditional right to be a judicial centre in the Osuna Codex (document 6). In representing geography, the Landbooks are notable for continuing to use glyphs for place names, and for types of building, terrain, soil and water. In all, these are precisely the qualities of the Landbook genre which have been most ignored by those scholars who have wished to characterise them as 'fraudulent', on the grounds that they sometimes attempt, as 'titles', to appear older and more authoritative than they really are. As Galarza has said, whatever its scholarly merits (and they appear to be few) such a view implies stag-

192 Mexican MS 2 f.2

193 Tetitlan, Hueycalco,
Tequizquinahuac, Teocaltitlan.
Calacoayan Landbook ff.5v–6

194 Amelco (*ameyali*, spring),
maguey, four houses and village
lands (*altepetlali*), church of
'our dear father San Pablo'
(*totlazotatzin xan papolo*).
Huixoapan Landbook ff.8v–9

195 The Ten
Commandments.
Catechism f.8

gering insensitivity to what indigenous Mexicans have actually been forced to suffer for nearly five centuries.

Submitted as legal evidence in the court at Tacuba or Tlacopan as late as 1802, the Calacoayan Landbook was brought to light only in 1994. It defends local lands against the designs of a certain Sebastian Melchor Villegas. Copied for these purposes on to European paper, it refers to its original (' el mapa original', f.7) and even notes the burn marks on it (ff.5v–6, 7v–8). By the same token, it translates

Nahuatl into Spanish (*mecatl*, a land measure, becomes *cordel*) and no longer employs the rounded Landbook handwriting. Yet the order of its folios is more reliable than that of the native-paper Sutro fragment and its style of drawing is no less native. In stating its case, it refers back to agreements made with the Crown in [15]50 and goes on specifically to represent the Otomi quarter of Calacoayan, 'la parcialidad de los otomies' known as Santa María (Maria's image on f.1v has attracted the attention of

Guadalupe enthusiasts), and leaves aside the references to San Martín Calacoayan that are present in the Sutro fragment; some years previously, San Martín had argued its own land case, as a 1772 map in the AGN shows (Catálogo no.1470). Several of the places named in the text can be found today northwest of Azcapotzalco and Satélite, among them Atenco, Tequizquinahuac, the 'Palma' of Tezoloapan, Tizapan, Chiluca and the two quarters of Calacoayan itself.

In the Landbook corpus, the Calacoayan text has an unusually fine array of place glyphs, including the 'house entrance' of its own name (another version of this name corresponds to the eighth ward in the Tepotzotlan Codex, fig.190), the 'deer' of Mazatlan, the pagan 'temple' of Teocaltitlan (fig.193), and so on (see Appendix 2e). Its glyphs also finely distinguish water and land use and register as many as six types of roof construction which differ according to area and language-culture. Acolnahuacatzin and the other sword-bearing founder figures it names, again glyphically (Appendix 2e), occur separately and without glyphs in the Azcapotzalco and Huixquilucan books; here they embody historical continuity and the particular links that bound Tenochtitlan to Tlacopan/Tacuba, Azcapotzalco's successor and the court at which this text was presented in 1802.

From the town which served as the last of the eleven garrisons kept by the Mexica in the Basin (fig.161), the Chalco Atenco Landbook includes one of the only three native *ilhuitl* dates found in the corpus (the 'month' Tlacaxipehualiztli of 1537). As a provenance, Chalco Atenco is notable for lying some way to the east and south of the Tepanec domain from which the Landbooks chiefly stem. By contrast, as its alternative title suggests, the finely-drawn and coloured Huixoapan fragment comes from the very heart of Landbook territory, from a district close to Azcapotzalco itself (fig.194). From the same area as the Codex now in Belfast, north-northwest of Azcapotzalco, the Landbook of Tepotzotlan invokes the same geographical arena and history. In the fragment of the Tepotzotlan Landbook that is now in Paris, the dynastic or family tree sprouts literally from the ancestor's navel (fig.108), as it does in the Azcapotzalco prototype.

Not included in the Landbook section of the *HMAI* Census, the Mexican Ms 2 (fig.192) nonetheless corresponds to the type, as Gómez de Orozco foresaw. It is on coarse *amatl* paper and has the usual format, sewn binding, style of drawing and handwriting, records in Nahuatl the detailed geography of a place and the history of its

'caciques', and served as legal evidence before the Real Audiencia. It was probably brought from Mexico by Agustin Fis[c]her just before the emperor Maximilian was shot in 1867. Letters of that year pertaining to the matter are published by Lemoine (who however confuses this text with the quite separate Vischer Lienzo in Basel). The letters record the invaluable opinion of Maximilian's Nahuatl-speaking aide Faustino Chimalpopoca, that while these pages (*fojas*) are of the landbook type they lack a public 'declaration' and therefore may be considered the notes (*apuntes*) of a draft manuscript.

Catechism (Testerian Manuscript)

BM Egerton MS 2898; *HMAI* 813 [copies 801 802].
European paper, 15 bound double folios (double leaf missing between ff.7–8 & 23–4), 24×16.5 cm. Galarza 1992; Galarza & Monod Becquelin 1980; Glass 1975a.
See fig.195
Named after the sixteenth century Franciscan friar Jacobo de Testera, these texts were developed in order to convey doctrine and the Catechism. Entitling itself *Doctrina cristiana* and self-dating to August ?1614, the British Museum example is unusually brilliant in colour and vigour of design; it is also unusual in working with the Nahuatl language, rather than Otomi or Mazahua (the Testerian norm), and in invoking images from the old script tradition. It has two kinds of chapter, those with (ff.1–7) and those without (ff.8–) an internal numbering sequence.

Generally, Testerian manuscripts are considered to have only the remotest links with native script, and then at just the phonetic level. That is, they make flexible use of signs and affixes in order to suggest sounds, in rebus fashion, for example, showing a hand (*ma-itl*) to indicate the optative in phrases such as '*ma yn chihua*' ('do this'), a practice which undoubtedly has native antecedents. A more significant link with the old tradition involves set images and reading order, which are found in abundance in *Doctrina cristiana*. Hell appears as an earth maw whose saurian teeth are marked *tlan*; heaven is literally portrayed 'within the sky' (*ilhuicatitic*). In the Ten Commandments sequence (fig.195; Appendix 2f) worship is read as flower-offering (1), while parents sit with traditional dignity when receiving honour (4). Recalling the snake image of the pre-Cortesian gossip (fig.155), the false witness exudes scorpion poison when pointing an accusing finger at a couple 'under the blanket' (8), just as the coveting of wives (9) recalls older images of straying spouses (fig.144).

CHAPTER NOTES

Chapter 1

1 On New World scripts and texts, see Boone & Mignolo 1994, Brotherston 1979, 1992; and on those of Mesoamerica, Galarza 1988, León-Portilla 1969, Martínez Marín 1989.

2 These are meticulously listed in the *HMAI* Census, and are also found in collections in Italy, France, Austria and Mexico. Throughout, for details of editions of texts cited, see section A of the Bibliography. The criteria for distinguishing classics of the pre-Cortesian tradition include material (native paper, skin), format (non European binding or pagination), adherence to standard genres (annals, rituals), and style.

3 Wolf (1950), who, however, uses work by Swadesh that some now dispute; Stuart 1993. cf. note 10 to chapter 6.

4 On this, Schultze Jena's essay of the 1930s (translated in Furst 1986) is fundamental; see chapter 7.

5 Edmonson (1988) brings together a great range of evidence for the development of the Mesoamerican year calendar, and touches on the Tepexic correlation proposed for that town and Coixtlahuaca in Brotherston 1982. The Tilantongo correlation cited throughout is that proposed by the Mexican scholar Alfonso Caso; it has not gone unchallenged, though a better one has yet to be generally agreed. See Aveni & Brotherston 1983.

6 The sheer mechanics of these complex and demanding texts, chapter by chapter, are discussed in chapter 7. The names and *HMAI* Census numbers of the nine surviving examples are: Aubin Ms 20 (14), Aubin Tonalamatl (15), Borbonicus (32), Borgia (33), Cospi (79), Féjérváry (118), Laud (185), Porfirio Díaz (255), Vaticanus (384).

7 On the cosmogony and world-ages of Mesoamerica, see Brotherston 1992: chapter 9, and the editions of the *Popol Vuh* by Edmonson (1971) and Tedlock (1985).

8 The Behaviour chapter is legible thanks to the explanations in Mendoza (ff.70–1), and the exhortations to Nahuatl youth known as 'Huehuetlatolli' (León-Portilla 1988). See chapters 7 and 8.

9 The Chalco Atenco book is a unique exception to this geographical rule; on continuity in the Landbooks, see the Commentaries (pp.185–8). On the general question of 'titles' and other post-Hispanic genres, James Lockhart has kindly offered advice and information.

10 See Gibson (1988) for details of the purchase for Liverpool of this text, also known as the Féjérváry-Mayer Codex. Zouche is also known as the Nuttall Codex, after Zelia Nuttall, who published a facsimile and commentary early this century. At her house in Coyoacan, Mexico City, she was host in the 1920s to English-speaking visitors, not least D.H. Lawrence, and is thought to be the model for Mrs Norris in *The Plumed Serpent* (1926). The copy of Martín de la Cruz's Libellus de medicinalibus indorum herbis (*HMAI* 85), which is kept in the Royal Library at Windsor Castle, turns out to be partial and of minor interest, despite its early seventeenth-century date (see Francesco Solinas, 'Il primo erbario azteco e la copia romana di Cassiano dal Pozzo', in F. Haskell et al. (eds), *Il Museo Cartaceo di Cassiano dal Pozzo*, (Milan, Olivetti, 1989) pp.77–83.

11 Acuña 1984; cf. Brotherston & Gallegos 1990.

12 The AGN copy of this text (Tierras 2719, exp.8) was detected by us thanks to its partial publication in *Códices indígenas* 1933 (Brotherston & Gallegos 1988); the AGN file details are not given in the *HMAI* Census, where it is wrongly dated to 1552 (1555–7 would be more accurate). The original was accessioned in 1911, having been in Belfast since 1857. The Calacoayan Landbook is incorporated into ff.15–22 of the British Library Additional Manuscript 43795, a source which is mentioned in the *Bibliography of HMAI* vol.15 (British Museum 1967, Catalogue of Additions to the manuscripts, 1931–1935), in relation, however, only to a quite separate and far less interesting text from Tepetlaoztoc (f.8), a late map which shows the road to Otumba and a muddy degenerate place glyph for Cuauhyocan (thicket of trees). Further details of the Calacoayan Landbook, not least its relationship to the previously known text of that name, are given in the Commentaries, as are details of the unusual draft Landbook from a still unknown locality which is now in Manchester (Mexican Ms 2; fig.194).

13 A major impediment to this task was the fact that all 14 fragments were encased in thick glass until early 1992, when they were prepared for the exhibition and could at last be minutely examined. Worm-holes and ink guidelines reveal that the three fragments of the Itzcuintepec Roll (A, B, C) form a 249×41 cm strip while the regularly spaced water stains along both edges suggest that this strip was once rolled up. As for the Itzcuintepec Codex, Cottie Burland (1948) foresaw that six of the fragments (nos. 3, 5, 6, 8, 9, 10, these last two having been deceptively trimmed to a variant rectangular shape) form a single large genealogy.

14 Dibble 1980; Melgarejo Vivanco 1970. The Itzcuintepec and Metlatoyuca texts, whose common fund of place signs is discussed in chapter 4 and the Commentaries, were all acquired in the same post-Independence period,

ostensibly in and near Metlatoyuca, in northernmost Puebla; this general area, northeast of Mexico City, is also indicated by their respective subtitles, which refer to Tulancingo and Huachinango. Following evidence supplied by Robert Barlow, Burland (1957) subsequently came to accept the northern Puebla location. Despite this accumulated evidence, yet another provenance, Oaxaca, has recently been proposed on clearly insufficient grounds (Haley et al. 1994).

15 The bird of Tototepec, Hidalgo, identified as a turkey or *toto-tl* in the Metlatoyuca Lienzo by its blue headcrest, has been read as the troupial of Zacualtipan (Breton 1920, located in Gerhard 1972:184), and the quail of Zoltepec (Guzmán 1939, unlocated). The four-stone glyph of Tenanitec appears in the Tochpan Lienzos, to the northwest of Itzcuintepec, as in Itzcuintepec Codex 1. In the Xolotl Maps, exactly the same four-stone glyph occupies the northeast corner and is transcribed by Ixtlilxochitl as Tenamitec, or Tenanitec (Dibble 1980:27; Gerhard 1972 improbably identifies it with Zacatlan, further to the south and denoted by a quite separate glyph in the same Xolotl Maps). At the end of a major road in the Tochpan Lienzos, Metlatoyuca is denoted by a *metlatl* (*metate*) or grindstone (cf. figs 97, 180). Among other places and emblems common to these maps and the Itzcuintepec and Metlatoyuca texts we find Four Rabbit and Cahuac, the place of the frog.

Chapter 2

1 Barlow 1980:70–71; responses to the invasion are treated more generally in León-Portilla 1962; Brotherston 1979: chapters 2 and 3.

2 Gibson (1964) remains the best overall account of Spanish colonial administration.

3 Mentioned and illustrated in the Florentine Codex Book 12, a major account and the source of quotations not otherwise specified below.

4 In the *Cantares* manuscript, there is a great concentration of interest in the invasion in Songs 66 to 69 (ff.54–62v). Songs 66 and 67, 'Tlaxcaltecayotl' and 'Ycuic Nezahualpilli', deal sarcastically with Cortes's Tlaxcalan and Texcocan allies; Songs 68 and 69, 'Atequilizcuicatl'

(Water-pouring song) and 'Xopancuicatl' (Tree-growth song) deal more with Tenochtitlan's own tradition as a lake city, as Bierhorst's recent edition well brings out.

5 Brotherston 1979:38.

6 Incorporated in the *Cantares mexicanos* (Song 68) and echoed in the Priests' Speech, the extreme courtesy of Moctezuma's welcome to Cortes did little to counteract the claim he thought the visitor was a god.

7 Exactly this idea of gestation underlies Song 66 in *Cantares mexicanos*.

8 The choice of this moment is the more notable in the Rios Annals since elsewhere in the same text an alternative name is used for the feast Miccailhuitl.

9 Motelchiuh is celebrated as a fighter in the *Cantares mexicanos* (Song 66, lines 17–18); as a ruler he appears in Aubin in the year 9 Reed (1527). Mendoza actually arrived in November 1535.

10 León-Portilla 1986; Brotherston 1979:63–9.

11 These quarters correspond to the actual geography of the tribute towns and were largely separated from one another by independent polities. The Mixteca lay between south and east, Teotitlan and Tlaxcala between east and north, and Metztitlan between north and west, while completing the circle the ex-enclave of Coatlan, heir to Xochicalco, continued to separate west from south even after becoming an extension of the metropolitan district of Cuauhnahuac. In addition, the metropolitan area was separated from the east by the enclave of Tochimilco whose borders with both Huaxtepec and Chalco are shown in the Oyametepec Map and in the Ocopetlayuca *RG*. Fundamental as it has been in scholarship, Barlow's map of 1949 fails to register the logic of this scheme and Chalco's role as the governor of the eastern quarter is obscured by the misplacing of Huaxtepec's subject Tepoztlan. These flaws have been only partly remedied in the Berdan and Anawalt edition of Mendoza (1992). In the Mendoza text itself, the definition of the quarters is confirmed by subtle literary means, also used in the native-paper antecedent of Mendoza (Matrícula de tributos, Berdan & Durand-Forest 1980). First, the shift from the metropolis to the

quarters is highlighted at Atotonilco el Grande (f.30), the only head town name that repeats; and then changes in format reflect the shifts between the quarters, a deliberate bunching up of districts at the end of the west and south quarters (ff.35, 40), that is, the placing of more than one head town per page, which is the norm. The end of the eastern quarter is indicated by a different frequency of payments and sheer distance (f.47). Perceiving these patterns is critical to understanding the literature and politics of the Mexica and Mesoamerica more widely.

12 Thomas 1993:530.

13 These arguments are set out more fully in Brotherston 1994a.

14 Not to be confused with the western Tlaxcalan head town of the same name; Ixtlilxochitl 1977–9, 1:267–8 refers this town to the Atlantic Coast Anahuac.

15 *Cantares mexicanos*, Song 66, stanza 2.

16 In *Cantares mexicanos*, Song 68, her act echoes that of Moctezuma who had offered the city's water to Cortes only to end up his victim, torn between courtesy and the need for self-assertion. For Moctezuma pictured literally as puppet, controlled by strings held by Cortes, see fig.22.

17 Brotherston 1979:37.

18 On these Tlaxcalan texts, see the excellent study by Reyes 1993. See also Brotherston & Gallegos 1990; Martínez 1990; Stone 1984. Comparable in size and sheer geographical scope, the Cuauhquechollan Lienzo also registers in detail the process of collaboration with Cortes and gives unique details of Tlaxcalans making use of steel swords. The theme of early baptism is developed with reference to Cortes's supposed ally Tepoztecatzin in the Cuauhtlantzinco Map (Starr 1898).

19 These included Tecamachalco and Tepexic. A citadel now shown to date from at least the Classic Period, the latter once had the highest stone-brick walls in Mesoamerica, built in a style reminiscent of such Chichimec-related sites as Chicomoztoc–La Quemada and Pénjamo. Politically, Tepexic retained great power under the Mexica, and when the Tlaxcalans and Cortes threatened to invade, its ruler Moctezuma Mazatzin had the authority to bargain with them in the

name of Tehuacan, Cozcatlan, Teotitlan and the Upper Papaloapan region generally. At the confluence of Nahuatl, Chocho and Mixtec languages, it is still a focus of native devotion and its annals preserve the longest native count of years known in the Fourth World (see p.126).

20 The subgroups to the east and west are matched above by warriors who face in corresponding directions. Cuauhtemallan (Guatemala) is shown by a tree (*cuauhitl*) rather than the eagle (*cuauhtli*) depicted elsewhere in the text, a preference also seen in Aubin under the year 1527, and which corresponds better with the local Maya name *Qui-che*, 'wood people'.

21 A remarkable and quite uninspected set of stone stelae and inscriptions from this eastern extreme of Mesoamerica was sent in 1850 by E.G. Squier to the Smithsonian Institution in Washington DC, where they are now, and illustrated in part by him in his volume *Nicaragua* (New York, 1852); work by Jeffrey L. Gould on Nicaraguan Indian communities in this century reveals a strong continuity with this archaeological precedent at precisely the locations named in the Tlaxcala Codex ('La raza rebelde: las luchas de la comunidad indígena de Subtiava', *Revista de Historia de Costa Rica*, 1990:69–117). Motolinía's *Memorias* (1971:391) highlights New Mexico as an extreme in the other direction in the section 'Relación postrera a Cibola'.

Chapter 3

1 On the rise of the Mexica, see Seler 1904, 1923; Conrad & Demarest 1984; Brotherston 1974. Accounts of the Mexica generally include Broda et al. 1987; Clendinnen 1991; Davies 1973.

2 These respective positions are well summarised in Boone (1991); Boone has also usefully charted discrepant Mexica dates. Among the many factors that speak in favour of Mexica arrival from elsewhere is Chimalpahin's report (Séptima Relación) that unlike more seasoned inhabitants of the Basin they were astounded by a minor eruption of Popocatepetl in the year 1 Reed (1363).

3 Robertson (1959) and others have said that Boturini is post-Cortesian because of the impressionistic 'European' manner in which the scribe drew the leaves of the

tree Tamoanchan. Their claim is contradicted by the fact that trees in firmly pre-Cortesian texts, such as Zouche p.76, have equally impressionistic leaves (fig.128).

4 Brotherston 1979:201,.

5 Brotherston 1992:139–42.

6 In the same world-age series, an earthquake occurs at Tepetzinco, later a Mexica shrine like Pantitlan.

7 For Barlow (1980:xxv), these two places are diagnostic of three main routes followed by the Mexica from Aztlan; of these, type 1 mentions both (Aztlan Annals, Aubin), type 2 mentions only Coatlicamac (Azcatitlan, Mexicanus), and type 3 mentions neither (Rios and Telleriano manuscripts, Florentine Codex, Durán). His placing of them towards the Gulf Coast echoes the fact that the glyphs for Oxitipan and other places in the Aztlan Map can be found in Mendoza's northern quarter.

8 The Cuauhtitlan Annals account of the Ichcuinanme is referred to in Vollmer's edition of Aubin (1981:142).

9 The gravity of this moment may explain why Tzonpanco is the only place glyph to be found in the four quarters of Mendoza's title-page map, apart from Tenochtitlan itself.

10 It is of course the case, however, that no absolute line can be drawn here or in native histories generally between the 'proper' name of a place and its symbolism, in this case the imminent birth of Tenochtitlan.

11 By mentioning them both, Aubin makes clear that, though close to each other, Coatlicamac and Coatepec are two separate places; even so, Boone (1991) makes no distinction between them. On Coatlicamac in Barlow's fine categorisations of the Mexica route see note 7 above.

12 Garibay 1958; Brotherston 1974.

13 West is placed to the top in such other cases as the Tlatelolco Map, the Tochpan Lienzos, and the quatrefoil in the Madrid Codex (p.75). The Mexica punned their name with that of the moon (*meztli*) which first appears in the west.

14 Most of these nine appear in the Azcatitlan Annals (p.24), but in 1 Flint (1376), and as the king-makers of Acamapichtli. The latter is paired with

Tezozomoc, the Tepanec ruler of Azcapotzalco whose line began in 1 Reed (1311), according to Aubin. This pairing indicates Tepanec affinities in the Azcatitlan account, as does Tenoch's nopal cactus lineage tree, a model for that shown in Azcapotzalco's Landbook (Noguez 1993).

Chapter 4

1 The eighteenth-century Mexican historian Francisco Javier Clavigero pointed to La Quemada, Zacatecas, as a probable Chicomoztoc (*Storia antica del Messico*, Cesena, 1780–81), following a tradition which goes back to native sources as Pomar suggests when he says that the Texcocan Chichimec were excellent archers who came from Zacatecas (Acuña 1982–88, 8:48). Coliuhcan, a separate location from Colhuacan in the Tlaxcala Lienzo, has been favoured by Wigberto Jiménez Moreno and others.

2 Chicomoztoc is invoked specifically as the womb or stomach in the Nahuatl cures collected in Hernando Ruiz de Alarcón's *Treatise on the Heathen Superstitions* [1629], ed. J.R. Andrews & Ross Hassig (Norman: University of Oklahoma Press, 1984); as orifices of a reptilian body it appears in the Laud Feasts chapter (fig.59).

3 These ancestor names are listed in the *Historia Tolteca Chichimeca* or Cuauhtinchan Annals (Kirchhoff et al. 1989: para.223), a key source which sees Chichimec history from the perspective of the Cholula Plain. Mixcoatl appears in the Cuauhtitlan Annals (Velázquez 1945), Nopal and Xolotl in the Xolotl Maps (Dibble 1980); others are noted below.

4 In the Cuauhtinchan Annals, the Chichimec sing in Otomi upon emerging from Chicomoztoc; the modern Conchero movement, known to have originated in the Querétaro area in the nineteenth century, has characterised itself as both Chichimec and Otomi. Both groups appear skin-clad in the Cempoala *RG* Map, though this source does not distinguish between the speech of each.

5 Other main arenas entered by the Chichimec noted in the Cuauhtitlan Annals and other sources include the Purepecha territory of Michoacan (see also chapters 3 and 4 of the *Relación de Michoacan* in Miranda, 1988), Teotitlan,

Totonacapan (see the *RGs* of Tetela,
Xonotla and neighbouring areas in Acuña
1982–88, 5:388–95, 412), and Guatemala
(see Chimalpahin in Rendón 1965:26).

6 Dibble 1980:20; compare the frog of the
'abandoned house' of ill fortune in the
Florentine Codex Book 5, f.10r.

7 See Chimalpahin in Rendón 1965:145.

8 The flight and life generally of prince
Nezahualcoyotl, who on many counts
resembles Bonnie Prince Charlie, are dealt
with in overwhelming detail in the last
two of the ten Xolotl Maps (Dibble 1980).
The saw-tooth crown and skin marking in
Tohueyo's name glyph are explicitly
identified with the Gulf Coast in the
Florentine Codex (fig.64) and indeed
appear in texts from that area
(Itzcuintepec, Metlatoyuca) and elsewhere
are related to the passage through it, en
route to Coixtlahuaca (Selden Roll,
Ihuitlan Lienzo, Tequixtepec Lienzo) and
the Mixteca (Teozacoalco Annals).

9 Yacanex is equated with the ruler
Tohueyo by Valle (1991), who keenly
analyses the difference between 'hill' and
'plain' Chichimecs in the Basin, yet makes
no reference to Ocotochtli's appearance in
this context in the Xolotl Maps. See also
notes 5 and 7 to chapter 7.

10 See Reyes 1977; this source usefully
proposes that the intrusive map in the
Cuauhtinchan Annals be called
Cuauhtinchan Map 5. The Cuauhtinchan
Annals are edited by Kirchhoff et al. (1989)
and the no less significant Cuauhtinchan
Maps by Yoneda (1981). On the Cholula
Maps, see Bittmann Simons 1968; the
Cuauhtla Map, which extends the
Cuauhtinchan account of migration to
Nonohualco and Tzoncoliuhcan
(Zongólica), shows seven caves on its
north horizon (this text was discussed at
the II Simposio Códices y Documentos
sobre Mexico, Taxco, June 1994, by Ma
Teresa Sepúlveda y Herrera).

11 Recently excavated, Cantona can now
be recognised as a sizeable city that was
built entirely on a lava flow; it has a
remarkable pattern of streets and no less
than 24 ball-courts, a Mesoamerican
record. It is almost contiguous with
Tepeyahualco and may well be referred to
in the smoking-lava signs attached to that
place glyph in Cuauhtinchan Map 1. This
source is remarkable for the beauty of its
place glyphs, which represents through

negative painting in Teotihuacan style the
cords of the 'net' town Matlatlan (fig.75).
Cuauhtinchan Map 5 places the Eagle and
Jaguar mountains of the Chichimec
migration near Matlatlan.

12 Nowotny 1961:34–5. Francisco Rivas
drew my attention to the *chi-a* element in
the Seven Caves scene.

13 Acuña 1982–88, 4; Aguilera 1986a; see
also Gibson 1967. For the Tamazolco
glosses, see Appendix 2c.

14 The Roll and other Coixtlahuaca Valley
texts have been decisively illuminated by
Caso (1954, 1958, 1961, 1977–79),
Parmenter (1982, 1993) and König (1984);
Cuicatlan and Quiotepec texts are studied
in Hunt (1972). Johnson (1994) offers
further detailed readings of the
Tlapiltepec Lienzo; the Nativitas Lienzo
was copied in Tizaltepec by Dahlgren
(1966). The Papaloapan boundary marks,
which also include Tepexic to the
northwest and Nexapa to the southwest,
were recognised as a set by Alfonso Caso
(1977–79) and Karl Nowotny (1961), and
are geographically located in Brotherston
(1992: Map 3). Reasons for seeing
northwestern Tepexic as a focus and
provenance for Vindobonensis obverse are
set out in Brotherston (1985) and pp.106–7.
Jansen, Byland and others Mixtequistas
have preferred to read Teotlillan's
bleeding or eclipsed sun as Achiotla,
despite the fact that this town lies to the
west, far from the northeastern position
consistently specified in the Coixtlahuaca
Lienzos and Maps. Possibly from the
northeastern boundary mark Teotlillan,
Laud resembles the Porfirio Díaz
screenfold, definitely from Cuicatlan, in its
depiction of the Night Lords, for example,
and the tree awnings under which they sit;
and it echoes the Tequixtepec Lienzo of
Coixtlahuaca in showing one of those
lords actually riding on a jaguar
(Parmenter 1982). As for Féjérváry, similar
to Laud in style, it has now been
interpreted as a work relating to the
pochteca or merchants, whose great centre
was Tochtepec, just a little downstream
from Teotlillan (León-Portilla 1985), an
area preferred by Eduard Seler nearly a
century ago (cited in Burland 1957). At the
same time, the central figure of its title-
page map, Xiuhtecutli, could perhaps
suggest the Xiuhtecutlan placed east of
Tlaxcala and just north of Cofre de Perote
in Xolotl Map 1.

15 The Nahuatl epic of Tepoztecatl, the
hero who made his eastern part of
Morelos safe from the devouring monster
of Xochicalco, ever hungry for tribute, is
published by Pablo González Casanova,
Estudios de lingüística y filología náhua
(UNAM, 1977); stelae from the site
depicting open-mouthed monsters are
thought to allude to this event.

16 Moreover, Tlahuixtlahuaca has a
special link with the conqueror featured
prominently in the Roll, Seven Death, and
together these facts suggest that town as
its provenance. Caso (1958) pointed out
the close parallels between the Baranda
Roll and the Coixtlahuaca corpus; its
unusual type of year marker is also found
in the Tulancingo Lienzo (Parmenter
1993:23) and in inscriptions from just west
of Miltepec, reported by Seler (1915:135;
see figs 6, 60).

17 Nowotny 1961:264; Brotherston
1992:84–6; 1994c. Caso ingeniously reveals
how in Porfirio Díaz the four subjects are
identified with patron names logically
arranged according to direction, age and
gender: to the west, ancient Two Dog of
Tepexic and Lady One Eagle of Nexapa; to
the east, skeletal One Death Sun of
Teotlillan and Lady Nine Tooth of Mictlan
(which leaves the women to the south and
the men to the north).

18 Ihuitlan Lienzo B1; the monkey figure
appears in F6. See Johnson (1994a) on the
geography of the roads that lead out from
the subsequent kindling, especially the
'castillos' on the northwestern road to
Tepexic.

19 Muñoz Camargo, among others, uses
the term Cuextlachichimeca; carnivals in
the same Huaxtec region today feature
local 'Chichimecs'.

20 Ixtlilxochitl 1975–77, 2:15.

21 Cuautitlan Annals f.1. For the 'four
Chichimec conquerors' see the *RG* of
Tetela in Acuña 1982–88, 5:412; this 1580
source also confirms that the Totonacs had
arrived out of the east 'more than 763
years ago'; cf. note 27.

22 Melgarejo Vivanco brings out this
capacity for resistance in his edition of the
Lienzos (1970), especially in the time of
Maximilian when the Itzcuintepec and
Metlatoyuca texts were taken from the
region.

23 Soledad González (1994) has shown

the key role of the *ahuizote* or *granicero* in shamanist ceremonies held still in Xalatlaco and the State of Mexico; the name is also that of the eighth Mexica emperor. This beast is black and its tail is said to have a hand at the end, with which it pulls its victims under water (Florentine Codex Book 2: chapter 4); Ahuizotl's long tail-like arm in the Itzcuintepec Roll suggests this feature.

24 The place name Teximalpa is noted in the *Breve vocabulario de nombres nahoas usados en el departamento de Tuzpan, Veracruz*, published by Maximilian's Nahuatl expert Faustino Chimalpopoca (reprinted Mexico 1947); it fits the axe-cutting glyph perfectly.

25 In the annals, Nicholson (1966) is in error in not reading the tied rope as a 52-year period marker; cf. the ropes shown in the Mexica kindling year 2 Reed in figs 12, 46.

26 The ludo-like design of the *patolli* gaming-board is quite distinctive in both texts and must correspond to the Patoltetitlan listed for the area by the Cuauhtitlan Annals (f.65), the equivalent of Patoltetipan in Motolinía's list (1971:394) and of the Patoltecoya that exists north of Huachinango today. Pantepec: like the Xolotl Maps and other Texcocan texts, the Metlatoyuca Lienzo uses a crest device to indicate the quantity 20, which elsewhere is the flag *pantli*, sometimes adorned with a crest or feathers as in Aubin. Hence this same crest set into the large toponym beside the main river in this map just possibly indicates the place Pantepec, and the river of that name whose course corresponds exactly to the description of it quoted in Breton (1920).

27 See Prem 1972; Brotherston, 'The Year 3113 BC and the Fifth Sun of Mesoamerica', in Aveni & Brotherston 1983:167–220. Described and deciphered for the first time as a direct result of preparations for the 1992 exhibition, the Itzcuintepec Roll gloss is highly significant in confirming the notion of the seventh-century Chichimec calendar base. It begins: 'Ancestral palace; two four hundreds plus three score years ago there emerged the Chichimec lords.' (See Appendix 2d). The 763 years in the Lienzo, which have the round marker also found in the Tepechpan Annals and in

Féjérváry, are said to be Spanish colonial coins (pesos) by Herrera (1994), despite the fact that the context is firmly pre-Cortesian. The early date of Chichimec intrusion in western Mexico (see note 5) is confirmed archaeologically.

Chapter 5

1 Jansen (1992) and Stokes (1994) make clear that these births are from trees that exist and thrive in the larger landscape of rivers and mountains. For umbilical trees at Palenque and Tepotzotlan, see Brotherston 1979:217.

2 These links are especially eloquent in the case of the elaborately carved bones from Monte Alban, which read like pages from the Mixtec annals (Jansen 1992a:117).

3 Lady Six Monkey's mother and Eight Deer's grandmother were cousins, granddaughters of Eight Wind. The skull or mummy glyphs that denote the 'dead-land' Mictlan, also known as Mictlantongo, have been referred by Jansen (1982, 1992) to the shrine of Chalcatongo, further west, and a great focus of reverence still today. A pioneering study of the different perspectives of these texts was made by Clark (1912); see also Caso's encyclopaedic work (1977–78), Smith (1973) and Stokes (1994). Byland (1994) and others have recently made detailed surveys of the central territory that lies between Tilantongo, Xaltepec and Teozacoalco and attempt to correlate its features with place signs in the annals. Here, in noting place names generally we prefer Nahuatl to Mixtec, since as an ancient lingua franca the former has a more stable orthography and has provided the names in most common use today.

4 The Zapotecs have a long script tradition of their own, which in its later stages, notably in the Guevea Lienzos, overlaps with that of the Mixtecs (Marcus 1992; Jansen 1992). On Mixtec links with the Cuicatec area, see Geist 1990. On the Mixteca generally, see Dahlgren's classic study (1966).

5 The miniature copper axes of Tututepec, used by the Toltecs as trading currency ('cierta moneda de cobre'), are mentioned by Ixtlilxochitl (1975–77, 1:283) and have been traced archaeologically to South America (Dorothy Hosler et al., *Axe Monies and their Relatives, Studies in Pre-*

Columbian Art and Archaeology 30, Washington, DC: Dumbarton Oaks, 1990).

6 See respectively Brotherston 1985 (Tepexic); Nowotny 1975, Smith 1979 (Nochistlan); König 1984, Rivas 1994 (Tehuacan); Smith & Parmenter 1991 (Huamelulpan).

7 Possible references to Eight Deer's military defeat and death south of Coixtlahuaca can be seen in that position in the Coixtlahuaca Map (see p.147); the name as such appears in the feast of the dead in the Laud Feasts chapter p.22.

8 Of the four quarters legible in this long listing: east includes the Xipe dynasty of Zaachila, Xaltepec, Tamazola, and the archaeological site Nuu Yuchi (Mogote del Cacique); north shows the pair with saw-tooth crowns, Eight Lizard and Eight Flint, who appear in Coixtlahuaca texts (Ihuitlan Lienzo, Tlahuixtlahuaca Roll, Tequixtepec Lienzo), Miltepec, and possibly Cholula with footprints of a 'fleeing' animal (normally 'stairs' in Mixtec); the heavily-armed south with its Toltec links has Nine Wind and the cacao identified with Tututepec in previous pages of the biography. In all, this makes $11+9+3+6=29$ towns, the same total for the four quarters as in Mendoza, Tepexic etc.; see note 12 to chapter 7. The Tututepec Annals invoke Eight Deer's quarters quite specifically through the model of the four-directional trees. The story from the other side of the western boundary is told in the Tlapa Annals (Vega 1991).

9 Consuming pulque leads to literal downfall in the Tepexic Annals p.28 (Jansen 1992a), and is a theme taken up in the Drinkers chapter of the ritual screenfolds.

Chapter 6

1 *Cantares mexicanos*, Song 69. Standard works in English on the Toltec tradition that relate to Tula Hidalgo are Davies 1977, 1980.

2 Florentine Codex Book 3, chapter 3.

3 By Fox Fabrics of San Francisco, in just the colour range named in the Florentine Codex.

4 Davies 1980:7; Bierhorst has argued cogently for the overall coherence of this two-part poem about Tula and Quetzalcoatl (1974:17–97).

5 To the east Zacanco is the eastern terminus of Quetzalcoatl One Reed's exodus from the highlands, while Nonohualco and Chiuhnauhtla are placed in the same general area by the Maya books of Yucatan (Bierhorst 1985; Barrera Vásquez & Rendón 1963). Most of the western glyphs are, of course, in the Cuextlan texts (those of Tochpan, Itzcuintepec, Metlatoyuca), which is what gives them such importance in this context; of the others, Tezcatepec is in the Rios migration (AD 1233), Tlecuaztepec in the Cempoala *RG* (Acuña 1982–88, 6), Cuetlaxtla in Mendoza and Cozcatlan in the Ihuitlan Lienzo and Cuauhtinchan Map 1. Tecolotlan is known for the length of its archaeological record.

6 Rojas, in Acuña 1982–88, 5:128. The Toltecs' long stay in Tollantzinco is confirmed in the Florentine Codex, as is the time sequence which places ancient Tula before Seven Caves and highland Tula (Book 8, chapter 5; Book 10, chapter 29).

7 Acuña 1982–88, 6:78; instead of seeing that it refers to the original Gulf Coast town, Acuña dismisses the statement that the highland town was founded by those who came 'from Cempoala' as merely tautological. In the same source, the plasterer's float in the place glyph Tlaquilpan is taken as emblematic of age-old Toltec building skills (fig.178).

8 Marcus 1992:394–400.

9 Davies 1977:140ff.

10 Stuart 1993; Wolf 1959:36; Piña Chan 1989; see also note 21 to chapter 4.

11 Kelley 1976:96–7.

12 The world-age allusions present in the Mexica and Chichimec migration stories (Azcatitlan Annals, Cuauhtitlan Annals, the names Four Wind and Four Ollin in the Tlahuixtlahuaca Roll) likewise precede the earliest Toltec story in Rios and in the Cholula Map (giants, Toltecs, Xolotl etc.; Bittman Simons 1968). The dating of these sequences is discussed in Brotherston (1982, 1985). While Huey Tullan/Tullan Tlapallan is placed in the same world-age context by Ixtlilxochitl, his (quite understandable) fear of appearing heretical led him to include America in the then orthodox Biblical history of the world by inserting a note on how the Toltecs sailed from the Old World.

13 For a fuller discussion, see Brotherston 1992:119–27. Robertson (1778, 2:474–8) was among the first to detect material history in the Tepexic Annals, aptly comparing it to Mendoza in its concern with tribute.

14 Evidence from the Cozcatlan cave puts maize agriculture back to near 3000 BC in this area; towns and ceramics appear five hundred years later (Piña Chan 1969).

15 Further examples of Era dating include Mexicanus p.9, Zouche p.76, Rios, the Sunstone, the Tlapiltepec Lienzo (the four 'millennial' boulders prior to Chicomoztoc decoded by the Mixtec scholar Castellanos), Legend of the Suns, Chimalpahin's *Relaciones* and *Memorial breve*, the Pinturas Ms, and the AD 2088 date in the Chilam Balam Book of Tizimin, which falls exactly 5200 years after 3113 BC; cf. notes 12 and 13 above. In the Zouche example, the date 9 Reed (1047) marks 4/5 of the era, the 52×80 years indicated in the accompanying 'nauh ollin' design (fig.128).

Chapter 7

1 Earle & Snow 1985; Furst 1986. Tepeyolotli, also a special kind of volcanic rock soft on the outside and hard at the core, continues to be invoked in mountains today by shamans in Xalatlaco (González 1994). Numerically, the 9×29 count of night and moons is adjusted to the 260 total through the doubling up of the last two *yoallitecutin*, as the tables in Cospi and Tonalamatl Aubin make quite clear (cf. Reyes 1992:65).

2 For example, in the place name Tonala in the Ihuitlan Lienzo G8. Variant Quecholli names in later texts are noted by Gilonne (1977) and Riese (1986).

3 Since they are thought to sing to attract rain, frogs and lizards are offered in effigy today in the caves of the owners of water, for example in San Andrés de la Cal, a ward of Tepoztlan Morelos.

4 In his catalogue of the chapters in the ritual books, Nowotny (1961) performed the indispensable task of identifying them as such, in the formal terms of their metrics or use of the *tonalamatl* sets of Signs and Numbers. Hesitant about their 'themes', he nonetheless established several, thanks in part to Juan de Córdova's sixteenth century *Arte de la*

lengua zapoteca and to Leonard Schultze Jena's accounts of ritual practices and customs still current in Mexico and Central America. Details of topic chapters are given in Brotherston (1992:67–73); the Martial Arts *tlacuache* is seen in Féjérváry and corresponds to the warrior order mentioned in the Chilam Balam Book of Tizimin (López Austin 1990:19–20).

5 Relevant details of current natal lore are given in Fink 1989, while the coded language of the cures in the *Ritual of the Bacabs* matches images of conception as the 'carving of the face', and of placenta burial in the maw of the earth beast (Roys 1965: xiv, 58). The *cuauhcalli* cage or prison seen in Laud was illustrated and explained by Friar Diego Durán (1967, 2:200, 222). The idea that the boney lords of the underworld are deadly and yet life enhancing, the oppressors and yet the grandfathers of the Twins in the *Popol Vuh*, is developed by Brotherston (1994). Baquedano (1994) refers to the significance of the hummingbird and of plaited and non-plaited umbilical cords; see also Carmichael 1992. A very different and more gruesome reading of this chapter is made by Cecelia Klein (1991), one out of line with the obviously natal imagery elsewhere firmly identified by, among others, Tibón (1981), and in Launey's account of 'grossesse' (1979).

6 Florentine Codex Book 8, especially chapters 10, 14 and 17; for the Huehuetlatolli, known to have been transcribed from native-script sources, see León-Portilla 1988, Burkhart 1989.

7 Treasure casket: *petlacalli*, also a stronghold of knowledge in the Priests' Speech of 1524 (Brotherston 1979:65); the perception of the jaguar as an idle thief (see below) corresponds to rain forest philosophy (Brotherston 1992:261–2, 306). *Maquizcoatl*: thoroughly defined in relation to gossip in Molina's dictionary (*maquizcoatl chiquimoli*), the bestiary in the Florentine Codex ('. . . llaman los chismeros por el nombre desta culebra, que dicen que tienen dos lenguas y dos cabezas'; Book 11, chapter 5) and the texts of Sahagún's informants ('Así también se llama al que entre la gente, al que en medio de la gente anda metiendo discordias, al que acarrea habladurías de la gente: serpiente de pulsera o maquizcoatl. Porque es como si para los dos lados

hablara, por los dos lados tuviera labios, como cosa escandalosa, portentosa, espantosa o de agüero tetzauitl'; quoted by Reyes (1992) with reference to the *maquizcoatl* image in Borbonicus p.14). Thirsty deer: a deer-headed figure is one of the nine heavy drinkers of pulque who came to no good in the Tepexic Annals (p.28); deer antlers recently found with pulque artefacts in burials in the 'maguey hill' Metepec near Toluca (Raúl & Guizzela Aranda, personal communication) further underline the link (antlers also appear on a pulque pot in Laud p.38). Snake-like penis: *coatl*, cf. fig.144. Under the blanket: *tilmatitlan*, like the couples shown in Borgia pp.48–52. The Nahuatl phrases that refer to field work are taken from Librado Silva's autobiography (*ECN* 18:18).

8 Not only that, the year sequence is actually glossed showing that the missing pages at the end of the chapter must somehow have alluded to the arrival of Cortes in 1 Reed (1519). Similarly, glosses in the ritual trecena chapter in Rios double read certain of the 13×20 days as years, for example over 1 Rabbit we see 1558.

9 Caso 1977–79, 2:234, 338, with reference to Two Dog (x) of Tepexic and Lady One Eagle (xv) of Nexapa; for Nowotny's historical reading, see note 12 to chapter 4.

10 On north and south as up and down, see León-Portilla 1987:185–205; Brotherston 1992:372–3. The inverse may have held true for the highland Basin at certain periods.

11 Exactly this order of multiple reading occurs with maps made today in the Anasazi dry-painting tradition of New Mexico. Especially telling are the examples of the Emergence quincunx, where five mountains again denote both actual geography and the world ages; and the Red Mountain quatrefoil, which traces human gestation and development from fire in the centre through four pairs in the quarters, as in the case of the Féjérváry quatrefoil discussed below (Brotherston 1992:90–102). In a paper given at the II Simposio Códices y Documentos sobre Mexico (Taxco, June 1994), Meredith Paxton showed how the quatrefoil in the Codex Madrid p.75 likewise demands multiple reading, even at the calendric level.

12 Over the given order east, west, north, south, we find the lunar total of 29 reached through place glyphs in Mendoza (ff.30–55) 7 7 8 7, Tepexic Annals (pp.35–48) 7 5 12 5, Tepetlan Codex, 8 7 8 6, Teozacoalco Annals (pp.56–68) 11 3 9 6; and through Quecholli in Borgia (pp.49–52) 12 5 8 4, Laud (pp.31–8) 12 1 3 13, Féjérváry (p.1) 12 1 3 13, Tequixtepec Lienzo 10 5 6 8.

13 See note 10 above. In appealing to this convention, both the Coixtlahuaca Map and Féjérváry likewise represent an even more recondite notion of numeracy which is basic below and modified above. Hence, starting lowermost in the Map, in each emergent row or stratum of Nexapa's volcano a unit is added, so that in a sigma count, four equals the combined units of the rows to have emerged altogether, i.e. ten $(1+2+3+4=10)$. Contrasting with this lower or base logic, quite a different celestial order of calculation is made above at Tepexic, in dots written on maguey paper. Here, modifying a model of twice seven by three, units are so arranged as to present a formula that correlates the moon and Mercury, in a fashion that relates to the ritual zodiac chapter and the eleven who drink pulque, the product of maguey. In Féjérváry, the embedded or subsidiary numeracy is biological and botanical rather than geological and is manifest in the pair of flowering trees to the south and north. The pale southern or lower tree doubles the triple three leaf-petals (i.e. twice $3\times3\times3=54$); the hued northern or upper tree modifies this in the name of calendrics, reducing the 54 to the 52 year-leaves of the Round (i.e. twice $3\times3\times3$ less $2=52$ leaves). Put another way, in both cases the relentless base arithmetic of the under- and lower world, with its squares and cubes and sigma numbers, is adapted to the more idiosyncratic phases of the sky.

Chapter 8

1 Gathered in *Códices indígenas de algunos pueblos del Marquesado del Valle de Oaxaca* (1933, 1983), to which Tepotzotlan 2 (see below) is an addendum. For details of the various texts referred to below, see under the relevant town name in section A of the Bibliography. For Guaman Poma, see Brotherston 1979: chapter 2.

2 The native-paper manuscript known as 'Las joyas de Martín Ocelotl' is an example; it comes from Tlatelolco and dates from about 1540 (AGN Ramo Inquisición 37, exp.4; *HMAI* 176).

3 Various texts from Tenochtitlan, Tlatelolco Tlacopan and Tula Hidalgo relating to this visit are gathered under the title of Osuna Codex (*HMAI* 243). An extensive collection of invoices drawn up on native paper and entirely in native script comes from Mizquiahuala (*HMAI* 216–221).

4 The continuing presence of place signs in these Landbooks (Calacoayan, Azcapotzalco, Cempoala, Coacalco, amongst others) is a principal argument against those who downplay their native properties: see p.185. For the tree song in the Tamazolco text, see Appendix 2d:21.

5 This account of the Tepetlaoztoc text owes a great deal to Perla Valle's careful and acute analysis (1992). Berger (1994) supplies useful data on population.

6 The term 'Tepetlaoztoc Group' is used by Nicholson (1973); Williams (1980) and Harvey (1984) discuss soil types and numeracy. The field area calculations involve the use of 90 degree angle value, of the kind evident in Féjérváry pp.5–22 and similarly used to convert units of 1 into units of 20 in Maya Initial Series dates.

7 The *chi* in Chichimec is denoted by a scoop of the flour *chia*, as it is in the Xolotl and the Cuauhtinchan Maps, where it denotes Chichimec speech (Dibble 1980:50; cf. fig.76).

8 Much of the discussion of these texts was anticipated in Brotherston & Gallegos (1988) and Brotherston (1993), q.v. for more detail.

9 The exact count of firesticks has economic and political resonance in the Cuauhtitlan Annals (f.47), and in the *Relación de Michoacan* (Miranda 1988:229). Selling cloth is shown in the Tepetlaoztoc Codex to be a preferred way of acquiring locally non-produceable items, such as pesos.

10 The glyph for Nepopoalco, the 'counting' town in Mendoza (f.25), shows a sigma count of $1+2+3$. For the classic case of the Coixtlahuaca Map, see note 13 to chapter 7.

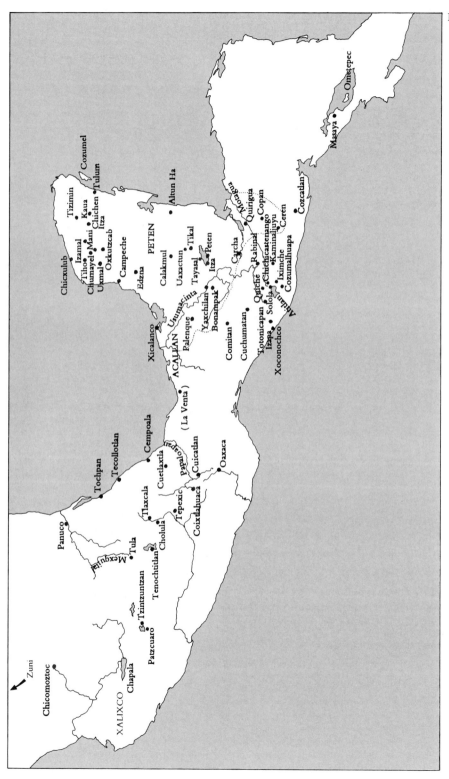

Map 1 Mesoamerica

Map 2 Tenochtitlan's
domain

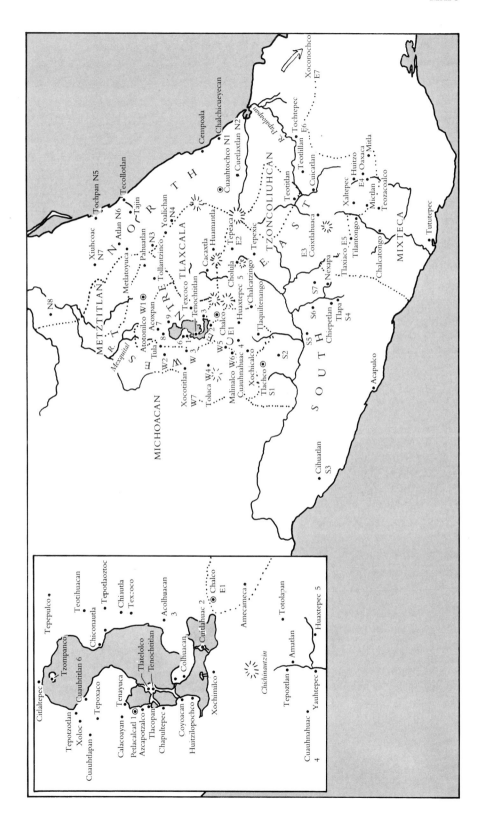

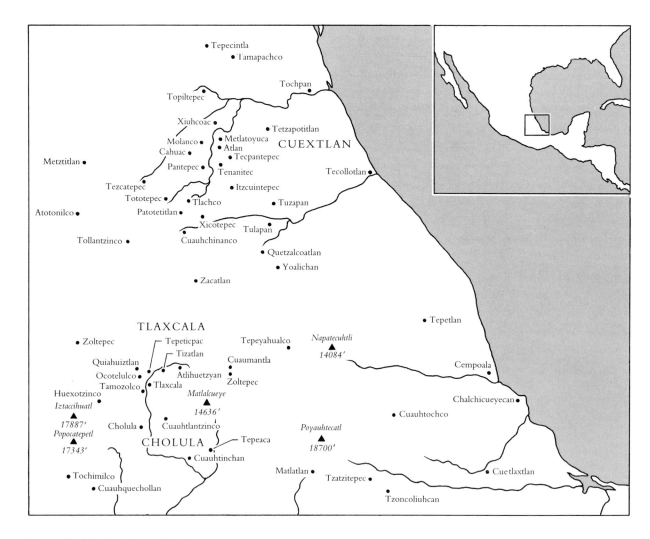

• Tepecintla
 • Tamapachco
 Tochpan •
 Topiltepec •
 Xiuhcoac •
 • Tetzapotitlan
 Molanco • • Metlatoyuca
 Cahuac • • Atlan CUEXTLAN
 • Tecpantepec
 Pantepec •
Metztitlan • • Tenanitec
 Tecollotlan •
 Tezcatepec •
 Tototepec • • Itzcuintepec
Atotonilco • • Tlachco • Tuzapan
 Patotetitlan •
 • Xicotepec • Tulapan
Tollantzinco • • Cuauhchinanco
 • Quetzalcoatlan
 • Yoalichan
 • Zacatlan

 TLAXCALA • Tepetlan
 • Zoltepec • Tepeticpac • Tepeyahualco *Napatecuhtli*
 ▲
 Quiahuiztlan • • Tizatlan • Cuaumantla *14084'*
 Ocotelulco • • Atlihuetzyan Cempoala •
 Tamozolco • • Tlaxcala • Zoltepec
Huexotzinco • *Matlalcueye* Chalchicueyecan •
 Iztaccihuatl ▲
 ▲ *14636'* • Cuauhtochco
 17887' • Cholula • Cuauhtlantzinco *Poyauhtecatl*
 Popocatepetl ▲
 ▲ CHOLULA • Tepeaca *18700'*
 17343' • Cuauhtinchan
 • Tochimilco Matlatlan • • Tzatzitepec • Cuetlaxtlan
 • Cuauhquechollan • Tzoncoliuhcan

Map 3 Cholula, Tlaxcala and Cuextlan

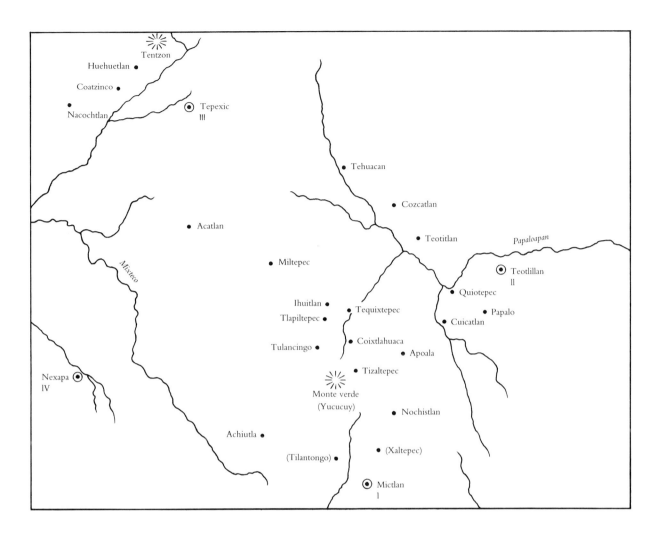

Map 4 Coixtlahuaca and surroundings

APPENDICES

APPENDIX 1

Layout of texts

Note: Original folio numbers; new numbers were added when the text was incorporated into the Kingsborough Codex (ff.1–72 = ff.203–74).

Note: Page numbering follows Acuña 1982–88, 4, who omits numbers for blank pages following pp.15, 16, 21, 28, 31, 142, 155, 156.
Pages 5–27 and 115–156 are not present in the Lienzo of Tlaxcala

APPENDIX 2

Transcriptions and translations of Nahuatl glosses

a) Cochineal Treatise: pests (p.7)

NAME		GLYPH
nextequili (nextecuil)	ash worm	grub
tenchicol	chatterer	bird head
nopaloquili (nopalocuil)	cactus worm	grub
zacapochin	grass comber	spider
nopaloquequeyachin	cactus . . .	grub
chichian	bitter one	beetle
ixquimilinqui	false cochineal	red beetle
tzotzon	hair	weed
hahayote	?brown one	red beetle

b) Itzcuintepec Roll, gloss 1 (fig.101)

quatzo[n]tecpa[n]
o[n] tzo[n] xiuitl ypa[n] ye poual xiuitl
yyeliz tlatoque chichimeca tzitziquiltzin auizotl
chicomoz[t]oque
yxquich cauitlo monemitiqu . . . ia
motlitlapostequiui otlalmaceiuque
ypa[n] aca xiuitl yyeliz tlatoque

ancestral palace
two four hundreds plus three score years ago
there emerged the Chichimec lords Little One and Ahuizotl at
 Chicomoztoc
all that time they lived
they broke ground, deserved the land
in the year Reed the lords emerged

c) Tamazolco Map (fig.78)

1 *Ytepanco doña Francisca Maxixcatzin.*
2 *Ynic patlahuac hepohuali yhuan matlactli nehuitzantli.*
3 *Ytepanco don Lasaro Pazquez.*
4 *Diego Cotztotolontzin.*
5 *Atlixca Martintzin.*
6 *San no huel huatl ytepanco don Lazaro Pazquez.*
7 *Mateo Quauhtli.*
8 *Maxoxotlan.*
9 *Estepan Quauhtli.*
10 *Yn omochiuh titoloz lones 11 mani metztli de setiembre de 1547 [1647 ?] años pintorres ichan Mateo . . . tzi Mateo Quauhtli Diego Pasques don Leonarto Xicotencateuhtli s . . . ano quichiuhque i Santa Barpara pintoltin.*
11 *Juan Pauhtista.*
12 *Tecali techialoyan.*
13 *Tecaxtli.*
14 *Ytepanco doña Francisca Maxixcatzin ynic huecapan centzontli ihuan matlacpohual yhuan caxtoli oce nehuitzantli tlamate . . . mela . . hua.*
15 *Ytlal Petru Teomani.*
16 *Calcuitlapan ytlal Juan Martin.*
17 *Gobernador don Diego Monoz 4 alcaldes Pedro de Albino Francisco Ramírez Diego [?] don Bartazal Melchior te Soto yc . . . xa.*
18 *Elena Tozcuepontzin.*
19 *Oquito in Mateo Quauhtzatzic axcan nicmomaquilía yn totlazonantzin Tepitzin tlalzintli macemicac ypan manis in taltepetzin = oquinanquili yn Petru Deomani oquilhui nocniuhtzine cenca quali in tiquitoa ma iuhqui mochiua aic sapa polihuis in totlatol ic nican tictlalia yn a armas itlauz.*
20 *Elena Tozcuepontzin.*
21 *Juan Vernave oquilhui in iciuatzin nocnitzin matictonaltica yn toconetzin matictocacan yn ahuehuetl tolnamicoca mochiuaz.*
22 *Ypan in xihuitl yn motlali altepetl Santa Barpara de 1547 años ynic opa huala tohueitlatocatzi birei don Antonio de Mentoza.*
23 *Ynic omotlali altepetl Santa Ana zan . . . huehue cuicatl ay comacaco izque ynic nian Santa Barpara huehuetque yntoca Petru Deomani Mateo Quauhtzatzi oquito ma iuhqui mochiua maceccan quichihuacan inteopan in ipilhuantzitzinuan Santa Ana.*
24 *Don Diego te Soto escribano de Tlaxcala.*
25 *Niman oquitoque huehuetque maceccan tichihuacan todeopan in techmopialia Santa Ana ca nel todeopan in techmopialia Santa*

Ana ca nel itlalcohualtzin quicohuilique in ipilhuantzitzinhua in tlale itoca Juan Matheo in ipatiuh tlali 8 pesos 12 tomines oquiceli imatica in tlale ipan xihuitl 1616 años 10 de mayo.
26 *Yn oquitlalique altepetl huehuetque yntoca Antonio Citlaltzin Juan Nicolás, Diego Mixcouatl Vernave Quauhtliztac Xohuachin Quauhtli zan Eni. yn oquitlalique altepetl Santa Ana.*
27 *Tamazolco.*
28 *Ameali catqui quimitiaia San Francisco ypilhuantzitzinhuan.*
29 *Acoli tlama.*
30 *Acolco.*

(After Reyes 1993)

1 Boundary of dona Francisca Maxixcatzin.
2 Width here is 70 cubits.
3 Boundary of don Lazaro Vazquez.
6 Also the boundary of don Lazaro Vazquez.
10 The titles were drawn up Monday 11th September 1547 in the house of the scribes Mateo . . ., Mateo Quauhtli, Diego Vazquez and don Leonardo Xicotencatl . . . it was done by the scribes of Santa Barbara.
12 The manor house and inn (*techialoyan*).
13 Tecaxtli (stone box; place glyph).
14 The boundary of dona Francisca Maxixcatzin is 616 cubits long.
15 Land of Pedro Teomani.
16 Behind the houses is the land of Juan Martin.
19 Mateo Quauhtzatzic said: I now give to our dear mother a little land, on it our town will stand for ever.
Pedro Teomani answered and said: Oh brother of mine, what you say is good, may it be so, so that our word shall never be lost we place here our arms, our insignia.
21 Juan Bernabe said to his wife: Sister of mine, let us give soul to our offspring, let us plant the willows that shall be our memory.
22 In this year 1547 the town of Santa Barbara was founded when our great governor, the Viceroy don Antonio de Mendoza, arrived for the second time.
23 The town of Santa Ana was founded . . . the old songs were presented by the old men who came from here Santa Barbara, Pedro Teomani and Mateo Quauhtzatzi by name. They said: May it be so, may the sons of Santa Ana build their own temple.
25 Then the old men said: Let us make our own temple to Santa Ana who protects us. In truth the land was bought by her sons, they bought it from the owner of the land Juan Mateo by name; the price of the land was eight pesos and twelve tomines, the owner of the land received them in his hands on the tenth of May of the year 1616.
26 The old men who founded the town, Antonio Citlaltzin, Juan Nicolas, Diego Mixcouatl, Bernabe Quauhtliztac and Joaquin Quauhtli by name; they were the ones who founded the town of Santa Ana.
27 Tamazolco (the place of the toad; place glyph).
28 The source of the water which the sons of San Francisco drank.
29 It extends to Acolco.

30 Acolco (where the water turns; place glyph).

Note: 4, 5, 7, 8, 9, 11, 17, 18, 20, 24 are personal names and Spanish titles: *alcalde* – mayor; *escribano* – scribe; *gobernador* – governor. Orthographically t and d are interchangeable, and b and v may become p. 'Cubit' is used as an approximate term for the *nehuitzantli* or Spanish *braza* (one and three-quarter yards)

d) Tlaxcala Calendar: the eighteen 20-day feasts (*ilhuitl*) of the year (fig.5)

NAME		GLYPH
1 Atemoztli	water comes down	water falls from pyramid
2 Tititl	tightening	wooden rods stitched in cloth
3 Izcalli	quickening	child held high and shouted at
4 Xilomaniztli	new maize offering	cob of new maize
5 Cohuailhuitl	common (coa) wealth	snake (coa) and rich adornments
6 Tozçotzintli	lesser vigil (tozoa)	feather of yellow parrot (*toztli*)
7 Hueytozçoztli	greater vigil	idem, larger
8 Toxcatl	hazard?	(Tezcatlipoca)
9 Etzalqualliztli	cake eating	man eating cakes
10 Tecuilhuitzintli	lesser lord's feast	lord with labret and hat
11 Hueytecuilhuitl	greater lord's feast	idem, larger
12 Micaylhuitzintli	lesser death feast	skull and crossbones
13 Hueymicaylhuitl	greater death feast	idem, larger
14 Ochpaniztli	road sweeping	broom
15 Panquetzaliztli	upright banner	upright banner
16 Pachtzintli	lesser tree moss	clump of tree moss
17 Hueypachtli	greater tree moss	idem, larger
18 Quecholli	flier	bird shot by arrow
[nemontemi	useless days]	five dots

Note: Read clockwise from top left, January to December. The 4th and 5th *ilhuitl* are Tlaxcalan versions of the Mexica Atlacahualo and Tlacaxipehualiztli. The 15th *ilhuitl* should be the 18th, and the 16th, 17th and 18th should be the 15th, 16th and 17th.

e) Calacoayan Landbook (ff.1–8 = ff.15–22 of BM Add. Ms. 43795) (fig.192)

PLACE NAME		GLYPH	FOLIO
Atenco	water's edge	two rivers	4
Ayotepec	turtle hill	?vestige of turtle shell	4v
Calacoayan	house entrance	half open door	2v
Caltzalan	between the houses	long house	3
Hueycalco	big house	several houses	5v
Mazatlan	deer place	male and female deer	3v

?Milocuauhtla	?	beast	5
Tecuantitlan	carnivore place	beast with spots	8
Teocaltitlan	temple place	temple (without cross)	6
Tepechpan	stone base	stone base	6v
Tepeticpac	on the stones	stones	4v
Tepeteytzintla	?<*iztli*, obsidian	?black obsidian blades	3
Tequizquinahuac	near saltpetre	(banded field)	6
Tetitlan	stone place	stones	5v
Tezoloapan	?<*tezoyatl*, palm	palm tree	8v
Tomaiz . . quititlan			5v
Tototlamanco	bird area	four birds	7
Tlamalacachiuhian	rounded place	oval enclosure	5v
Tzacuyocan	?<*coyolli*, bell	bell on branch	5
Yecactepec	nose (*yacac*) hill	face profile in hill	8v

PERSONAL NAME			
Acolmiztli	Acolhua feline	cat ears	7v
Acolnahuacatzin	Acolhua speaker		7v
Totoquihuatzin	bird-like	wings	7v

	Tepanec link	*Mexica link*	
Acolnahuacatzin	Tezozomoc's son in law	ally of Huitzilhuitl	
Acolmiztli	[ruled in Tlatelolco]	ally of Itzcoatl	
Totoquihuatzin	Tezozomoc's grandson	ally of Moctezuma I	

f) Catechism (Testerian Ms) f.7: from the Ten Commandments (fig.195)

LINE 1

ynic centetl ticmotlatlacotiliz yn totecuio Dios
 yhuan ticmomahuiztiliz yn ipan quallachihualli
The first thou shalt love our lord God
 and thou shalt honour him through good works

ynic ontetl amo tictlapictetlahuaz yn intocatzin Dios
 amo ticahuilquixtiz
The second thou shalt not profane God's precious name
 thou shalt not demean it

LINE 2

 tlacamatiz toquinmahuiztiliz
[The fourth] thou shalt honour them [thy parents]

ynic macuiltetl ayac momac miquiz
The fifth no-one shall kill

ynic chiquacentetl amo . . . to . .
The sixth thou shalt not [fornicate]

LINE 3
[chi]cuetetl amo ti . . .
The eighth thou shalt not [bear false witness]

ynic chiucnauhtetl amo tiqueintezihuailtenamic
The ninth thou shalt not covet thy neighbour's wife

Note: The sequence is Roman and puts together as the 1st Commandment what elsewhere are the 1st and 2nd, and separates as the 9th and 10th what elsewhere is the 10th.

Table 1: The Night Lords

(Cospi; after Seler)

KEY

1 Xiuhtecutli (fire lord)
2 Itztli (obsidian)
3 Piltzintecutli (precious lord)
4 Cinteotl (maize god)
5 Mictlantecutli (dead land lord)
6 Chalchiuhtlicue (jade skirt)
7 Tlazoteotl (lust goddess)
8 Tepeyolotli (hill heart)
9 Tlaloc (rain god)

Table 2: The Thirteen Quecholli

(Borgia; after Seler)

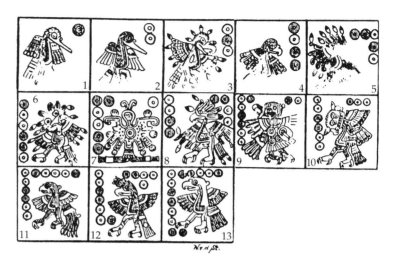

KEY

1	Huiztilin	(humming-bird)
2	Quetzalhuitzilin	(green humming-bird)
3	Huactli	(hawk)
4	Zolin	(quail)
5	Cuauhtli	(eagle)
6	Chicuatli	(screech owl)
7	Papalotl	(butterfly)
8	Tlotli	(hawk eagle)
9	Huexolotl	(turkey)
10	Tecolotl	(owl)
11	Alotl	(macaw)
12	Quetzal	(quetzal)
13	Toznene	(parrot)

The corresponding Thirteen Heroes are

1	Xiuhtecutli	(fire lord)
2	Tlaltecutli	(earth lord)
3	Chalchiuhtlicue	(jade skirt)
4	Tonatiuh	(sun)
5	Tonaleque	(workers)
6	Mictlantecutli	(hell lord)
7	Tonacatecutli	(flesh lord)
8	Tlaloc	(rain god)
9	Quetzalcoatl	
10	Tezcatlipoca	(mirror smoke)
11	Yoaltecutli	(night lord)
12	Tlahuizcalpantecutli	(dawn house lord)
13	Ometecutli	(dual lord)

Table 3: The Twenty Signs

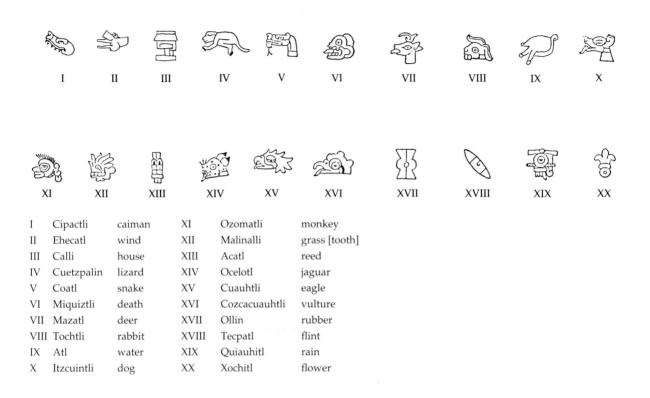

I	Cipactli	caiman
II	Ehecatl	wind
III	Calli	house
IV	Cuetzpalin	lizard
V	Coatl	snake
VI	Miquiztli	death
VII	Mazatl	deer
VIII	Tochtli	rabbit
IX	Atl	water
X	Itzcuintli	dog

XI	Ozomatli	monkey
XII	Malinalli	grass [tooth]
XIII	Acatl	reed
XIV	Ocelotl	jaguar
XV	Cuauhtli	eagle
XVI	Cozcacuauhtli	vulture
XVII	Ollin	rubber
XVIII	Tecpatl	flint
XIX	Quiauhitl	rain
XX	Xochitl	flower

The 52-year cycle runs by Series, of which Series III is the commonest

1 III 2 VIII 3 XIII 4 XVIII 5 III 6 VIII 7 XIII 8 XVIII 9 III 10 VIII 11 XIII 12 XVIII 13 III

1 VIII 2 XIII 3 XVIII 4 III 5 VIII 6 XIII 7 XVIII 8 III 9 VIII 10 XIII 11 XVIII 12 III 13 VIII

1 XIII 2 XVIII 3 III 4 VIII 5 XIII 6 XVIII 7 III 8 VIII 9 XIII 10 XVIII 11 III 12 VIII 13 XIII

1 XVIII 2 III 3 VIII 4 XIII 5 XVIII 6 III 7 VIII 8 XIII 9 XVIII 10 III 11 VIII 12 XIII 13 XVIII

Table 4: The nine ritual books

			OBVERSE			REVERSE
Borbonicus[a]	40ff	>	pp.1–40] [...
Tonalamatl Aubin [a]	20ff	<	pp.1–20] [...
Borgia[b]	39ff	<	pp.1–38] [<	pp.39–76
Vaticanus[c]	49ff	>	pp.1–48] [<	pp.49–96
Cospi	20ff	>	pp.1–13...] [<	pp.1–11...
Féjérváry	23ff	<	pp.1–22] [<	pp.23–44
Laud[d]	24ff	<	pp.1–22] [<	pp.23–46
Cuicatlan[d]	21ff	<	pp.1–10...] [...
Coixtlahuaca Map	1f		p.1] [...

Symbols: >, < = reading direction;

[a] End pages are now missing.

[b] Pages 29–46, a single chapter, form the middle section of the text read in part
 from top to bottom. Covers now missing.

[c] Repetition of chapters between the two sides of the screenfold (Twenty Signs,
 Burial) suggests that they represent two texts.

[d] Nowotny (1961), in line with most scholars, keeps to the old pagination, which
corresponds to a reversed reading order.

All are of skin except Borbonicus, which is of paper.

Table 5: Upper Papaloapan texts

A. ROUTES FROM SEVEN CAVES

Seven Caves

	Coixtlahuaca Lienzo 1	Tlapiltepec Lienzo	Tequixtepec Lienzo 1	Miltepec Roll	Tlahuixtlahuaca Roll	Tequixtepec Lienzo 2
Routes	1, 2 south and west	2, 3	2, 3	2, 3	3, 4	4 north and east

KEY

1 highland Tula

2 quetzal and jade rivers (fig.79a); Matlatlan (fig.75)

3 macaw, jaguar and eagle mountains (fig.79b)

4 star river (fig.8+)

B GLYPHS FOR COIXTLAHUACA (FEDERAL EMBLEM) AND THE 'SINGER' PLACE CUICATLAN

Tlapiltepec Lienzo Tlahuixtlahuaca Roll Miltepec Roll

Tequixtepec Lienzo Coixtlahuaca Lienzo 1 Mendoza Tepexic Annals Teozacoalco Annals Monte Alban

C CROSS REFERENCE BETWEEN THE LIENZOS

	Tlapiltepec Lienzo	Coixtlahuaca Lienzo 1	Ihuitlan Lienzo	Tequixtepec Lienzo 1
a				
b				
c		[damaged]		
d				

KEY

a Tlapiltepec, knot hill
b Coixtlahuaca, snake plain
c Ihuitlan, feather place
d Tequixtepec, shell hill

Table 5: Continued

D THE FOUR OUTPOSTS

Source	Mictlan I	Teotlillan II	Tepexic III	Nexapa IV	IV (bis)
a Coixtlahuaca Map					
b Selden Roll					
c Tlapiltepec Lienzo					
d Tequixtepec Lienzo					
e Cuicatlan (p.10)					
f Gómez de Orozco Fragment					
g Laud (p.46)					
h Tepexic Annals	(p.39)	(p.36)	(p.32)		(p.36)
i Mendoza	(f.43)	(f.46)	(f.42)		

Table 6: Cuextlan place glyphs

A MEXICA TOWNS

	Mendoza Codex	Tochpan Lienzos	Itzcuintepec Roll and Codex	Metlatoyuca Lienzo
a				
b				
c				
d				
e				
f				
g				
h				

KEY
a Atlan, water
b Molanco, rubber ball
c Pantepec, flag or the number 20
d Tlaltizapan, chalk earth
e Tamapachco, hand plus shell
f Tetzapotitlan, stone zapote
g Xiuhcoac, fire snake
h Ichcatlan, cotton

Table 6: Continued

B OTHER TOWNS

	Tochpan Lienzos	Itzcuintepec Roll and Codex
a		
b		
c		
d		
e		

KEY

a Matlacomeitlan, 13

b Quetzalcoatlan

c Tepecintla, dried maize hill

d Topiltepec, frond hill

e Tulapan, rushes

BIBLIOGRAPHY

A Native texts

[] Number in censuses in Glass 1975, 1975a; Robertson 1975
* UK text described in the Commentaries
S Screenfold of skin or paper (genre and provenance also noted)

Aubin Annals*
Aubin Ms 20: see Coixtlahuaca Map
Aubin Tonalamatl [15]. S, ritual, Tlaxcala. Aguilera 1981
Azcapotzalco Landbook [715; García Granados]. Noguez 1993
Azcatitlan Annals [20]. Barlow 1949a
Aztlan Annals [34; Boturini Codex]. S, annals, Tenochtitlan. Corona Núñez 1964–7, Vol.2
Aztlan Map [290; Mapa Sigüenza]. Glass 1964, Pl.16; Boone 1991

Baranda Roll [24]. Caso 1958
Becker [27]. S, annals, Tututepec. Echániz 1944
Becker II & Fragment [28, 29]. S, annals, Nochistlan. Nowotny 1975; Smith 1979
Bodley*
Borbonicus [32]. S, ritual, Tenochtitlan. Reyes 1992
Borgia [33]. S, ritual, ?Cholula. Nowotny 1976; Diaz & Rodgers 1993
Boturini: see Aztlan Annals

Calacoayan Landbook*
Cempoala RG Map. Acuña 1982–8
Chalco Atenco Landbook*
Chiautla Annals [84; Codex en Cruz]. Dibble 1981
Chiepetlan Codex [–]. Galarza 1972
Cholula Maps [57]. Glass 1964, Pl.12
Cholula RG Map. Acuña 1982–8
Coatepec Lienzo [251; Filadelfia]. Caso 1989
Coatlan Map [–]. Hirth 1988
Cochineal Treatise*
Coixtlahuaca Lienzos 1–3 [71, 70, 195]; Seler II; Ixtlan; Meixueiro König 1984; Glass 1964, Pl.123; Glass 1975, Pl.49

Coixtlahuaca Map [14; Aubin Ms 20]. Pre-Cortesian page, ritual, Coixtlahuaca. Nowotny 1961, Pl.51; Brotherston 1992 Pl.11
Colombino [72]. S, annals, Tututepec. Caso & Smith 1966
Cospi [79]. S, ritual, ?Cholula area. Nowotny 1968
Coyoacan Codex [9]. Manuscrito del Aperreamiento. Brotherston 1979:37
Cozcatzin Codex [83]. Boban 1891, Vol.1, Pl.41–5
Cuauhquechollan Lienzo [89]. Glass 1964, Pl.44–45
Cuauhtepoztlan Codex [11; Santa María Asunción Codex]. Williams 1980; Harvey in Closs 1985
Cuauhtinchan Annals [359; Historia tolteca–chichimeca]. Kirchhoff et al. 1989
Cuauhtinchan Maps [94–7]. Bittmann 1968; Yoneda 1981
Cuauhtla Map [–]. Sepúlveda in ch.4, note 10
Cuauhtlantzinco Map [101]. Starr 1898; Glass 1964, Pl.110
Cuicatlan: see Porfirio Díaz

Dehesa [112]. S, annals, ?Acatzinco. Chavero 1892

Egerton*
Entrada [351]. Gurria Lacroix 1966

Féjérváry*
Florentine Codex [274]. Dibble & Anderson 1950–69; Sahagún 1988

Gómez de Orozco Fragment [129]. S, annals, Coixtlahuaca area. Caso 1954
Guevea Lienzos [130]. Glass 1964, Pl.1–2

Heye Lienzo [134]. Von Hagen 1944
Huamantla Roll [135]. Aguilera 1986
Huexotzinco Codex [139], Prem 1974
Huichapan Annals [142]. Alvarado Guinchard 1976
Huitzilopochco Contract [145]. Brotherston 1979
Huitzilopochtli: see Rios; Telleriano
Huixoapan Landbook*

Ihuitlan Lienzo [157]. Caso 1961; Parmenter 1982
Itzcuintepec Codex*
Itzcuintepec Roll*

Kingsborough: see Tepetlaoztoc; Cochineal Treatise

Laud*
Libellus de medicinalibus indorum herbis [85]. Facsimile FCE Mexico 1991

Madrid Codex [187]. Lee 1985
Magliabechiano Codex [188]. Boone 1983
Matrícula de tributos [368]. Mohar 1990; Berdan & Durand-Forest 1992
Mendoza Codex*
Metlatoyuca Lienzo*
Mexican Manuscript No.2, Landbook*
Mexicanus Codex [207]. Menguin 1952
Miltepec Roll: see Baranda
Moctezuma Codex [223]. Glass 1964, Pl.27

Nepopoalco Maps [46; Maps of Chichimec History]. Glass 1975; Prem 1972; Brotherston 1982
Nochistlan: see Becker II & Fragment
Nuttall: see Zouche

Osuna [243]. Chávez Orozco 1947
Otlazpan Codex [193; Mariano Rios]. Leander 1967
Oyametepec Lienzo: see Tochimilco Lienzo

Porfirio Díaz [255]. S, ritual (pp.1–10) & annals (remaining pages), Cuicatlan. Chavero 1892
Primeros memoriales [271]. Sahagún 1993

Quinatzin Codex [263]. Robertson 1959; Vaillant 1965

Rios [270; Vaticanus A]. Anders 1979

Selden*
Selden Roll*
Sigüenza: copy of Aztlan Map, q.v.

Tamazolco Map*
Tecamachalco Map [300; Vischer 1]. Burland 1960
Telleriano [308]. Corona Núñez 1964–7, Vol.1

Teozacoalco Annals: see Zouche

Teozacoalco *RG* Map. Acuña 1982–8

Teotihuacan–Acolman Codex [315]. Glass 1964

Tepechpan Annals [317]. Noguez 1978

Tepeticpac Lienzo [–]. Aguilera 1986a

Tepetlan Codex [320]. Kutscher 1963; Glass 1975, Pl.59

Tepetlaoztoc Codex*

Tepexic Annals: obverse of Vienna, q.v.

Tepotzotlan Codex 1*

Tepotzotlan Codex 2 [322]. AGN Catálogo 1979–80, no.1799; *Codices indígenas* 1933

Tepotzotlan Landbook*

Tepoxaco Codex [–]. AGN Catálogo 1979–80, no.1798

Tepoztlan Ms: see Magliabechiano

Tequixtepec Lienzos 1–2 [433–434]. Parmenter 1982

Texupan [289; Sierra]. N. León ed. Mexico 1933

Tilantongo Annals: see Bodley

Tizaltepec Lienzo [232; Nativitas]. Glass 1975, Pl.48

Tizatlan Codex [352; Texas Fragment]. Reyes 1993; Brotherston 1994a

Tlacotepec Codex [336]. Boban 1891 vol.1, Pl.32

Tlahuixtlahuaca Roll: see Selden Roll

Tlapa Annals [21–22; Azoyu Codex]. S, annals, Tlapa. Vega 1991

Tlapiltepec Lienzo. Caso 1961; Parmenter 1982; Johnson 1994

Tlaquiltenango Codex [343]. Glass 1964, Pl.22

Tlatelolco Annals [344]. Barlow 1980

Tlatelolco Map [280]; Santa Cruz, Mapa de 1550. Aguilera & León-Portilla 1986

Tlaxcala Calendar*

Tlaxcala Codex*

Tlaxcala Lienzo [350]. Chavero 1892

Tochimilco Lienzo [245; Oyametepec]. Unpublished; displayed in the Casa del Alfeñique, Puebla

Tochpan Lienzos 1–3 [373–378:1 = 373; 2 = 375, 374, 376; 3 = 377–8]. Melgarejo Vivanco 1970

Tudela Codex [229]. Facsimile, Madrid 1980

Tulancingo Lienzo [–]. Parmenter 1993

Tututepec Annals: see Becker, Colombino

Vaticanus B [364]. S, ritual, ?Cholula area. Anders 1972

Vienna [395]. S, annals, Tepexic. Adelhofer 1963; Jansen 1982; 1992a

Xalapa *RG* Map. Acuña 1982–8

Xaltepec Annals: see Selden

Xochitepec Annals: see Moctezuma Codex

Xolotl Maps 1–10. Dibble 1980

Yanhuitlan [415]. Glass 1964, Pl.99

Zouche*

For alphabetic texts, see as follows:

Cakchiquel Annals (ed. A.Recinos et al, Norman 1953); *Cantares mexicanos* (Garibay 1964–8; Bierhorst 1985); Chilam Balam Books (Barrera Vásquez & Rendón 1963; Edmonson 1982–Tizimin; Roys 1933–Chumayel); Cuauhtitlan Annals (Velázquez 1945; Bierhorst 1992); Huehuetlatolli (Burkhart 1989: León-Portilla 1988); Legend of the Suns (Velázquez 1945; Bierhorst 1992); Matichu Chronicle – in Chilam Balam Books; Pinturas Ms (Garibay 1979); Priests' Speech (Brotherston 1979; León-Portilla 1986); *Popol Vuh* (Edmonson 1971; Tedlock 1985); *Relaciones geográficas* (Acuña 1982–88, 3 Teozacoalco, 4 Tlaxcala, 5 Cholula, Tetela, 6 Cempoala, Tepoztlan, 7 Ocopetlayuca, 8 Texcoco); *Ritual of the Bacabs* (Roys 1965); Sacred Hymns (Garibay 1958); histories by Chimalpahin (Rendón 1965); Castillo (ed. F.Paso y Troncoso, Biblioteca nauatl 5 [1908]); Muñoz Camargo (=Tlaxcala RG); Pomar (=Texcoco RG); Tezozomoc (ed. A.León, UNAM 1949)

B Institutional holdings

Belfast, Ulster Museum
Tepotzotlan Codex

Glasgow, University Library
Tlaxcala Calendar, Hunterian Collection 242
Tlaxcala Codex, Hunterian Collection 242

Liverpool, Merseyside Museum
Féjérváry, No.12014M

London, British Museum
Aubin Codex, Add. Mss 31219
Cochineal Treatise, Add. Mss. 13964
Egerton, Egerton Ms 2895
Huitznahuac Capulli, reference in Ethnological Document 1386
Itzcuintepec Codex, Egerton Ms 2897
Itzcuintepec Roll, Egerton Ms 2896
Metlatoyuca Lienzo, Add. Mss. 30088
Tamazolco Map, Add. Mss. 22070(c)
Tepetlaoztoc Codex, Add. Mss. 13964
Tepetlaoztoc and Tacuba property

plans, Add. Mss. 43795
Zouche Nuttall, Add. Mss. 39671
Tlapiltepec Lienzo, Add. Mss. 38845. Copy (original is unpublished)
Landbooks (Techialoyan) of Calacoayan, Chalco Atenco and Huixoapan, Add. Mss. 43795, 17038 & 22070 (a) (b)
Catechism (Testerian), Egerton Ms 2898

Manchester, John Rylands Library
Landbooks (Techialoyan) of Tepotzotlan and of unknown locality (draft version only), Mexican Mss.1 & 2

Oxford, Bodleian Library
Bodley, 2858
Laud, 546
Mendoza, 3134
Selden, 3135
Selden Roll, 3207

Windsor, Royal Library of Windsor Castle
Martín de la Cruz, Libellus de medicinalibus indorum herbis. Copy.

C Secondary Sources

Acuña, Rene (ed.). 1982–88. *Relaciones geográficas del siglo XVI*. 10 vols. 1 Guatemala, 2–3 Antequera, 4–5 Tlaxcala, 6–8 Mexico, 9 Michoacan, 10 Nueva Galicia. Mexico: UNAM

1984. *Diego Muñoz Camargo, Descripción de la cuidad y provincia de Tlaxcala*. Mexico: UNAM

1989. *Códice Baranda*. Mexico: Toledo

Adelhofer, Otto (ed.). 1963. *Codex Vindobonensis Mexicanus I*. Graz: ADEVA

Aguilera, Carmen (ed.). 1981. *Tonalamatl Aubin*. Tlaxcala: ITC

1986. *Códice de Huamantla*. Tlaxcala: ITC

1986a. *Lienzos y Códice de Tepeticpac*. Tlaxcala: ITC

Aguilera, Carmen & Miguel León-Portilla (eds.). 1986. *Mapa de México y sus contornos hacia 1550*. Mexico: Celanese

Alcina Franch, José. 1992. *Códices Mexicanos*. Madrid: Mapfro

Alvarado Guinchard, Mañuel. 1976. *El códice de Huichapan*. Mexico: INAH

Alvarado Peralta, Felipe. 1993. *La Historia de Amatlan de Quetzalcoatl*. Mexico: Centro Ce Acatl

Anders, Ferdinand & Nancy Troike. 1987. *Codex Zouche–Nuttall*. Graz: ADEVA

Anders, Ferdinand & Maarten Jansen. 1988. *Schrift und Buch im alten Mexiko*. Graz: ADEVA

Archivo General de la Nación. 1979–80. *Catálogo de ilustraciones*. 6 vols. Mexico: AGN

Aveni, Anthony & Gordon Brotherston (eds.). 1983. *Calendars in Mesoamerica and Peru*. Oxford: BAR

Baquedano, Elizabeth. 1994. 'Vida y muerte en el Códice Laud'. Paper presented at II Simposio Códices y Documentos sobre México, Taxco, June 1994

Barlow, Robert. 1948. 'The Techialoyan Codices: Codex N', *Tlalocan* 2 (4):382–3
1949. *The Extent of the Empire of the Culhua Mexica*. Berkeley: University of California Press
1949a. 'El Códice Azcatitlan', *Journal de la Société des Américanistes* 38:101–35
1980. *Los Anales de Tlatelolco*. Mexico: Porrúa

Barlow, Robert & B. McAfee. 1946. 'The Techialoyan Codices: Codex K', *Tlalocan* 2 (2):184–5

Barrera Vásquez, Alfredo & Silvia Rendón. 1963. *El libro de los libros de Chilam Balam*. Mexico: FCE

Baudot, Georges & T. Todorov. 1983. *Récits aztèques de la conquête*. Paris Seuil

Béligand, Nadine. 1993. *Códice de San Antonio Techialoyan*. Toluca: Colegio Mexiquense

Berdan, Frances & J. Durand-Forest (eds.). 1980. *Matrícula de tributos*. Graz: ADEVA

Berdan, Frances & Patricia Rieff Anawalt (eds.). 1992. *Codex Mendoza*. 4 vols. Berkeley: University of California Press

Berger, Ute. 1994. 'Some notes on the Codex Kingsborough'. In Vega (Ed.) 1994:255–272

Bierhorst, John, 1974. *Four Masterworks of American Indian Literature*. New York: Farrar, Straus and Giroux
1985. *Cantares mexicanos. Songs of the Aztecs*. 2 vols. Stanford University Press

1992. *History and Mythology of the Aztecs. The Codex Chimalpopoca*. Tucson: Arizona University Press

Bittman Simons, Bente. 1968. *Los Mapas de Cuauhtinchan y la Historia Tolteca–Chichimeca*. Mexico: UNAM

Boban, Eugène. 1891. *Documents pour servir à l'histoire du Méxique*. Paris: Ernest Leroux

Boone, Elizabeth. 1983. *The Codex Magliabechiano*. Berkeley: University of California Press
1991. 'Migration histories and ritual performance'. In David Carrasco (ed.), *To Change Place: Aztec Ceremonial Landscapes*, pp.121–151. Niwot: University Press of Colorado

Boone, Elizabeth Hill & Walter D. Mignolo (eds.). 1994. *Writing without Words. Alternative Literacies in Mesoamerica and the Andes*. Durham: Duke University Press

Breton, A.C. 1920. 'An ancient Mexican picture-map', *Man* 20:17–20; 143–4

Broda, Johanna, David Carrasco & Eduardo Matos Moctezuma. 1987. *The Great Temple of Tenochtitlan – Center and Periphery in the Aztec World*. Berkeley: University of California Press

Brotherston, Gordon. 1974. 'Huitzilopochtli and what was made of him'. In Norman Hammond (ed.), *Mesoamerican Archaeology: New Approaches*, pp.155–166. London: Duckworth; Austin: University of Texas Press
1975. 'Sacred sand in Mexican picture-writing', *Estudios de Cultura Náhuatl*, 9:302–9
1976. 'Mesoamerican description of space. II: Signs for direction', *Ibero-Amerikanisches Archiv* (Berlin) 2:39–62
1979. *Image of the New World*. London and New York: Thames and Hudson
1982. *A Key to the Mesoamerican Reckoning of Time*. London: British Museum Occasional Paper 38
1985. 'The Sign Tepexic in its textual landscape', *Ibero-Amerikanisches Archiv* (Berlin) 11:209–51
1992. *Book of the Fourth World. Reading the Native Americas through their Literature*. London and New York: Cambridge University Press

1992a. *Mexican Painted Books*. Colchester: University of Essex
1993. 'The Tepotzotlan Codices and tribute in literature in Mesoamerica'. In J. Durand Forest & M. Eisinger (eds.), *The Symbolism in the Plastic and Pictorial Representations of Ancient Mexico* pp.102–122. Bonn: Universitäts Verlag
1994. 'Huesos de muerte, huesos de vida', *Cuicuilco* (Mexico) 1 (nueva epoca): 85–98. Expanded version in E. Baquedano (ed.), *La muerte en Mesoamerica: significación, imágenes y rituales funerarios*. Mexico: UNAM
1994a. 'La Malintzin de los códices, *Espacios: Cultura y sociedad* (Puebla) 19: 85–99. Expanded version in Margo Glantz (ed.), *La Malinche: sus padres y sus hijos*. Mexico: UNAM pp.13–30
1995. 'Los cerros Tlaloc: su representación en los códices'. In Beatriz Albores (ed.), *Cosmovisión y meteología indígenas de Mesoamerica*. Toluca: Colegio Mexiquense
1995a. 'Los cuatro sujetos del Papaloapan Superior: su disposición textual'. In C. Vega (ed.), *Códices y documentos sobre México. II Simposio*. Mexico: INAH

Brotherston, Gordon & Ana Gallegos. 1988. 'The newly-discovered Tepotzotlan Codex: a first account'. In N. Saunders & O. de Montmollin (eds.), *Recent Studies in Pre-Columbian Archaeology*, pp. 205–227. Oxford: BAR
1990. 'El Lienzo de Tlaxcala y el manuscrito de Glasgow', *Estudios de Cultura Náhuatl* 20:117–40

Bullock, William. 1824. *Six Months' Residence and Travels in Mexico*. 2 vols. + atlas. Paris
1824a. *A Description of the Unique Exhibition called Ancient Mexico collected on the Spot*. London

Burkhart, Louise M. 1989. *The Slippery Earth: Nahua-Christian Moral Dialogue in Sixteenth-century Mexico*. Tucson: University of Arizona Press

Burland, Cottie. 1948. *A short note on the MSS Egerton 2896 and 2897*. Unpublished ms
1950. *The Four Directions of Time*. Santa Fe: Wheelwright Museum
1955 (ed.). *The Selden Roll*. Berlin: Mann

1957. 'Ancient Mexican documents in Great Britain', *Man* 85: 76–7

1960. 'The map as a vehicle of Mexican history', *Imago Mundi* (Den Haag) 15:11–18

1965 (ed.). *Codex Egerton 2895*. Graz: ADEVA

1966 (ed.). *Codex Laud*. Graz: ADEVA

1971 (ed.). *Codex Féjérváry–Mayer*. Graz: ADEVA

Byland, Bruce E. 1994. 'Places in the Mixtec historical codices: The archaeology of Mixtec history'. Paper presented at II Simposio Códices y Documentos sobre México, Taxco, June 1994

Carmichael, Elizabeth. 1991. *The Skeleton at the Feast*. London: British Museum Press

Caso, Alfonso. 1954. *Interpretación del Códice Gómez de Orozco*. Mexico: Talleres de Impresión de Estampillas y Valores

1958. *Comentario al Códice Baranda*. In Acuña 1989

1960. *Interpretation of the Codex Bodley 2858*. Mexico: Sociedad Mexicana de Antropología

1961. 'Los lienzos mixtecos de Ihuitlan y Antonio de León', in *Homenaje a P.Martínez del Rio*, Mexico, pp.237–74

1964. *Interpretación del Códice Selden*. Mexico: Sociedad Mexicana de Antropología

1967. *Los calendarios prehispánicos*. Mexico: UNAM

1977–9. *Reyes y reinos de la Mixteca*. 2 vols. Mexico: FCE

1989. *De la arqueología a la antropología*. Mexico: UNAM

Caso, Alfonso & Mary Elizabeth Smith. 1966. *Interpretación del Códice Colombino*. Mexico: Sociedad Mexicana de Antropología

Catálogo de illustraciones. 1980. Archivo General de la Nación. vol.4. Mexico

Chavero, Alfredo (ed.). 1892. *Antigüedades mexicanas publicadas por la Junta Colombina de Mexico*. 2 vols. Mexico: Secretaría de Fomento

Chávez Orozco, Luis (ed.). 1947. *Códice Osuna*. Mexico: Instituto Indigenista Interamericano

Clark, John Cooper. 1912. *The Story of Eight Deer*. London: Taylor and Francis

1938 (ed.). *Codex Mendoza*. 3 vols. London: Waterlow and Sons

Clendinnen, Inga. 1991. *Aztecs*. Cambridge University Press

Closs, Michael P. (ed.). 1985. *Native American Mathematics*. Austin: University of Texas Press

Códices indígenas. 1933. *Códices indígenas . . . del marquesado del Valle*. Mexico: AGN

Conrad, Geoffrey W. & Arthur A. Demarest. 1984. *Religion and Empire. The Dynamics of Aztec and Inca Expansionism*. New York: Cambridge University Press

Corona Núñez, José. 1964–7. *Antigüedades de Mexico, basadas en la recopilación de Lord Kingsborough*. 4 vols. Mexico: Secretaría de Hacienda y Crédito Público

Cuauhtinchan Annals: see Kirchhoff

Cuauhtitlan Annals: see Velázquez

Dahlgren de Jordan, Barbro. 1963. *La grana o cochinilla*. Mexico: Robredo

1966. *La Mixteca. Su cultura e historia prehispánicas*. Mexico: UNAM

Davies, Nigel. 1973. *The Aztecs: A History*. New York: Putnam

1977. *The Toltecs until the Fall of Tula*. Norman: University of Oklahoma Press

1980. *The Toltec Heritage*. Norman: University of Oklahoma Press

Diaz, Gisèle & Alan Rodgers. 1993. *The Codex Borgia. Color Restoration of an Ancient Mexican Manuscript*. New York: Dover

Dibble, Charles (ed.). 1980. *Códice Xolotl*. 2 vols. Mexico: UNAM

1981. *Codex en Cruz*. Salt Lake City: University of Utah Press

Dibble, Charles & A.J.O. Anderson. 1950–69. *Florentine Codex*. Salt Lake City: University of Utah Press

Durán, Fray Diego. 1980. *Ritos y fiestas de los antiguos mexicanos* [1576–78], ed. César Macazaga Ordoño. Mexico: Editorial Innovación

Earle, Duncan & D. Snow. 1985. 'The origin of the 260-day calendar: the gestation hypothesis reconsidered in the light of its use among the Quiche Maya'. In V.M. Fields (ed.), *Fifth Palenque Round Table*, pp.241–4. San Francisco: Pre-Columbian Art Research Institute

Echáñiz, G.M. 1944. *Códice Becker*. Mexico: Librería Echaniz

Edmonson, Munro. 1971. *The Book of Counsel: the Popol Vuh of the Quiche Maya of Guatemala*. New Orleans: Tulane Universtiy Press

1982. *The Ancient Future of the Itza*. Austin: University of Texas Press

1988. *The Book of the Year*. Salt Lake City: University of Utah Press

Escalona, Enrique. 1989. *Tlacuilo*. Mexico: UNAM

Fink, Ann E. 1989. 'A Mopan Maya view of human existence'. In D. McCaskill (ed.), *Amerindian Cosmology*, pp.399–414. Edinburgh: Cosmos

Furst, Peter. 1986. 'Human biology and the origin of the 260-day Sacred Almanac: the contribution of Leonard Schultze Jena (1874–1955)'. In G. Gossen (ed.), *Meaning and Symbol in the Closed Community*. Albany: State University of New York

Galarza, Joaquín. 1974. *Lienzos de Chiepetlan (Guerrero)*. Mexico: Mission Archéologique et Ethnologique Française au Méxique

1988. *Estudios de escritura indígena tradicional Azteca–Náhuatl*. Mexico: AGN

1982. *Codex Zempoala*. Lille: Université de Lille

1990. *Amatl, amoxtli: el papel, el libro*. Mexico: Tava

1992. *Códices testerianos. Catecismos indígenas*. Mexico: Tava

Galarza, Joaquín & A. Monod Becquelin. 1980. *Doctrina cristiana . . . de Pater Noster*. Paris: Société de Ethnographie

Garibay, Angel Maria. 1940. *Poesía indígena de la Altiplanicie*. Mexico: UNAM

1953–4. *Historia de la literatura náhuatl*. 2 vols. Mexico: Porrúa

1958. *Veinte himnos sacros de los nahuas*. Mexico: UNAM

1964–8. *Poesía náhuatl*. 3 vols. Mexico: UNAM

1979. *Teogonía e historia de los mexicanos. Tres opúsculos del siglo XVI*. Mexico: Porrúa

Gates, William. 1935. *The Azcapotzalco Maguey Manuscript in Facsimile*. Baltimore: The Maya Society

Geist, Ingrid. 1990. *Reflexiones acerca de las prácticas rituales en San Andrés*

Teotilalpan, Estado de Oaxaca. Un ensayo de antropología filosófica. Mexico: INAH/ENAH Tesis profesional

Gerhard, Peter. 1972. *A Guide to the Historical Geography of New Spain.* Cambridge University Press

Gibson, Charles. 1964. *Aztecs under Spanish Rule.* Stanford University Press
1967. *Tlaxcala in the Sixteenth Century.* Stanford Univerisity Press

Gibson, Charles & John B. Glass. 1975. 'A census of Middle American prose manuscripts in the native historical Tradition', *HMAI* 15:322–400

Gibson, Margaret & Susan M. Wright. 1988. *Joseph Mayer of Liverpool 1803–1886.* London: Society of Antiquitaries

Gilonne, Michel. 1977. 'L'Avifaune dans le Codex Borbonicus'. *Actas del XLII Congreso Internacional de Americanistas.* Paris: 29–42

Gingerich, William. 1986. 'Quetzalcoatl and the Agon of Time'. In G. Brotherston (ed.), *Voices of the First America.* Santa Barbara: New Scholar

Glass, John B. 1964. *Catálogo de la colección de códices.* Mexico: Museo Nacional de Antropología
1975. 'A census of native Middle American pictorial manuscripts', *HMAI* 14:81–250
1975a. 'A census of Middle American Testerian manuscripts', *HMAI* 14:281–96

Gómez de Cervantes, Gonzalo. 1944. *La vida económica y social de Nueva España al finalizar el siglo XVI* [1599]. Mexico: Robredo

Gómez de Orozco, Federico. 1948. 'La pintura indoeuropea de los códices techialoyan', *Anales del Instituto de Investigaciones Estéticas* 4, 16:57–68

González Montes, Soledad. 1994. 'Pensamiento y ritual de los ahuizotes de Xalatlaco, en el Valle de Toluca'. Paper presented at the Simposio Graniceros, Colegio Mexiquense, Toluca, April 1994

Graulich, Michel. 1987. *Mythes et rites du Méxique ancien préhispanique.* Brussels: Académie Royale de Belgique

Gruzinski, Serge. 1992. *Painting the Conquest. The Mexican Indians and the European Renaissance.* Paris: Flammarion

Gurria Lacroix, Jorge. 1966. *Códice Entrada de los españoles en Tlaxcala.* Mexico: UNAM

Guzmán, Eulalia. 1939. 'The art of map-making among the Ancient Mexicans', *Imago Mundi* (Den Haag) 3:1–6

Hagen, Victor W. von. 1944. *The Aztec and Maya Papermakers.* New York: J. J. Augustin

Haley, Harold B. et al. 1994. 'Los lienzos de Metlatoyuca e Itzcuintepec: su procedencia e interrelaciones'. In Vega (ed.) 1994:145–60

Harvey, H.R. (ed.). 1991. *Land and Politics in the Valley of Mexico. A Two-Thousand Year Perspective.* Albuquerque: University of New Mexico Press
1993 (ed.). *Códice techialoyan Huixquiluca.* Toluca: Colegio Mexiquense

Harvey, H.R. & Hanns J. Prem (eds.). 1984. *Explorations in Ethnohistory: Indians of Central Mexico in the Sixteenth Century.* Albuquerque: University of New Mexico Press

Hassig, Ross. 1988. *Aztec Warfare. Imperial Expansion and Political Control.* Norman: University of Oklahoma Press

Herrera, Carmen. 1994. 'Tiempo y espacio en el Lienzo de Metlatoyuca'. Paper presented at II Simposio Códices y Documentos sobre México, Taxco, June 1994

Hirth, Kenneth. 1988. *Tiempo y asentamiento en Xochicalco.* Mexico: UNAM

Hunt, Eva. 1972. 'Irrigation and the socio-political organization of Cuicatec Cacicazgos'. In F. Johnson & R. MacNeish (eds.), *The Prehistory of the Tehuacan Valley,* Vol.4. Austin: University of Texas Press

Ixtlilxochitl, Fernando de Alva. 1975–7. *Obras históricas,* ed. Edmundo O'Gorman. 2 vols. Mexico: UNAM

Jaecklein, Klaus. 1978. *Los popolocas de Tepexi.* Wiesbaden

Jansen, Maarten E.R.G.N. 1982. *Huisi Tacu. Estudio interpretativo de un libro mixteco antiguo Codex Vindobensis Mexicanus I.* 2 vols. Amsterdam: Centro de Estudios Latinoamericanos y del Caribe
1992. *Crónica mixteca* [Zouche–Nuttall]. Mexico: FCE
1992a. *Origen e historia de los reyes mixtecos* [Vienna]. Mexico: FCE

Jiménez Moreno, Wigberto. 1988. 'Tula y los toltecas según las fuentes históricas'. In Torre Villar et al (eds.) 1988:17–22

Johnson, Nicholas. 1994. 'Las líneas desvanecidas en el Lienzo de Tlapiltepec: una red de pruebas'. In C. Vega (ed.) 1994:117–44
1994a. 'The route from the Mixteca Alta into Southern Puebla on the Lienzo of Tlapiltepec'. Paper presented at II Simposio Códices y Documentos sobre México, Taxco, June 1994

Kelley, David H. 1976. *Deciphering the Maya Script.* Austin: University of Texas Press

Kingsborough, Lord [Edward King]. 1831–48. *Antiquities of Mexico.* 9 vols. London

Kirchhoff, Paul, Lina Odena Güemes & Luis Reyes García (eds.). 1989. *Historia tolteca-chichimeca.* Mexico: FCE

Klein, Cecelia. 1991. 'Snares and entrails. Mesoamerican symbols of sin and punishment', *RES* 19/20:81–104

König, Viola. 1979. *Inhaltliche Analyse und Interpretation von Codex Egerton.* Hamburg: Museum für Völkerkunde
1984. 'Der Lienzo Seler II und seine Stellung innerhalb der Coixtlahuaca Gruppe', *Baessler Archiv* 32:229–320

Kutscher, Gerdt. 1963. 'Mapa de San Antonio Tepetlan. Postkolumbische Bilddokumente aus Mexiko', *Baessler Archiv* 11:227–300

Kutscher, Gerdt, Günter Vollmer & Gordon Brotherston. 1987. *Aesop in Mexico.* Berlin: Mann

Launey, Michel. 1979–80. *Introduction à la langue et à la littérature aztèques.* 2 vols. Paris: L'Harmattan

Lawrence, David Herbert. 1983. *The Plumed Serpent* [1926], ed. Ronald G. Walker. Harmondsworth: Penguin

Leander, Birgitta. 1967. *Códice de Otlazpan.* Mexico: INAH

Lee, Thomas. 1985. *Los códices mayas.* Tuxtla Gutiérrez: UNACH

Lemoine, V., Ernesto. 1960. 'Notas para la historia del Códice Fisher', *Boletín del Centro de Investigaciones Antropológicas de México* 10:3–5

León-Portilla, Miguel. 1962. *The Broken Spears*. Boston: Beacon Press
1969. *Pre-Columbian Literatures of Mexico*. Norman: University of Oklahoma Press
1985. *Tonalamatl de los pochteca (Códice Féjérváry)*. Mexico: Celanese
1986. *Coloquios y doctrina cristiana. Los diálogos de 1524 según el texto de Fray Bernardino de Sahagún y sus colaboradores indígenas*. Mexico: UNAM
1987. *Time and Reality in the Thought of the Maya*, 2nd enlarged edn. Norman: University of Oklahoma Press
1988. *Huehuetlahtolli: testimonios de la antigua palabra*. Mexico: Comisión Nacional Conmemorativa del V Centenario del Encuentro de Dos Mundos

Lewis, Laura. 1995. *The Laud Codex*. PhD Dissertation, University of Essex

Lockhart, James. 1992. *The Nahuas after the Conquest*. Stanford University Press

López Austin, Alfredo. 1985. 'El texto Sahaguntino sobre los méxicas', *Anales de Antropología* (UNAM) 22: 287–336
1990. *Los mitos del tlacuache. Caminos de la mitología mesoamericana*. Mexico: Alianza

Maldonado Jiménez, Druzo. 1990. *Cuauhnahuac y Huaxtepec (Tlalhuicas y Xochimilcas en el Morelos Prehispánico)*. Mexico: UNAM

Marcus, Joyce. 1992. *Mesoamerican Writing Systems. Propaganda, Myth, and History in Four Ancient Civilizations*. Princeton University Press

Martínez, Andrea. 1990. 'Las pinturas del Manuscrito de Glasgow y el Lienzo de Tlaxcala', *Estudios de Cultura Náhuatl* 20:141–62

Martínez Marín, M. (ed.). 1961. *El Códice Laud*. Mexico: INAH
1989. *Primer Coloquio de documentos pictográficos de tradición náhuatl*. Mexico: UNAM

Melgarejo Vivanco, José Luis. 1970. *Códices de Tierras. Los lienzos de Tuxpan*. Mexico: Petróleos Mexicanos

Menguin, Ernst. 1952. 'Commentaire de Codex Mexicanus', *Journal de la Société des Americanistes* 41:387–498 plus Album

Miller, Arthur G. 1975 (ed.). *The Codex Nuttall*. New York: Dover

Miranda, Francisco de (ed.). 1988. *Fray Jerónimo de Alcalá: Relación de Michoacan*. Mexico: SEP

Mohar Betancourt, Luz María. 1990. *La escritura en el México antiguo: la Matrícula de Tributos y el Códice Mendoza*. 2 vols. Mexico: Plaza y Valdés

Monjarás Ruiz, Jesus. 1987. *Mitos cosmogónicos del México indígena*. Mexico: INAH

Mönnich, Anneliese. 1985. 'Zwei Techialoyan-Fragmente', *Indiana* (Berlin) 10:221–35

Motilinía. 1971. *Memoriales o Libro de las cosas de la Nueva España*, ed. Edmundo O'Gorman. Mexico: UNAM

Nicholson, H.B. 1966. 'The significance of the "looped cord" year symbol in Pre-Hispanic Mexico', *Estudios de Cultura Náhuatl* 6:135–47
1973. 'Phoneticism in the late Pre-Hispanic Central Mexican writing system'. In E. Benson (ed.), *Mesoamerican Writing Systems*. Washington, DC: Dumbarton Oaks

Noguez, Xavier (ed.). 1978. *Tira de Tepechpan*. Toluca: Biblioteca Enciclopédica del Estado de México
1992 (ed.). *Códice techialoyan García Granados*. Toluca: Colegio Mexiquense
1993. *Documentos guadalupanos. Un estudio sobre las fuentes de información tempranas en torno a las mariofanías en el Tepeyac*. Mexico: FCE

Nowotny, Karl. 1961. *Tlacuilolli. Die mexikanischen Bilderhandschriften, Stil und Inhalt*. Berlin: Mann
1968 (ed.). *Codex Cospi*. Graz: ADEVA
1975. *El fragmento de Nochistlan*. Hamburg: Museum für Völkerkunde
1976. (ed.). *Codex Borgia*. Graz: ADEVA

Nuttall, Zelia (ed.). 1902. *Codex Nuttall*. Cambridge: Peabody Museum

Pagden, A.R. 1972. *Mexican Pictorial Manuscripts*. Oxford: Bodleian Library

Paredes Martínez, Carlos Salvador. 1991. *La región de Atlixco, Huaquechula y Tochimilco. Sociedad y la agricultura en el siglo XVI*. Mexico: FCE

Parmenter, Ross. 1982. *Four Lienzos of the Coixtlahuaca Valley*. Washington DC: Dumbarton Oaks
1993. *The Lienzo de Tulancingo, Oaxaca. An Introductory Study of a Ninth Painted Sheet from the Coixtlahuaca Valley*. Philadelphia: American Philosophical Society (Transactions vol.83)

Paso y Troncoso, Francisco del. 1912. *Memorial de los indios de Tepetlaoztoc*. Madrid: Hauser u. Menet [XVIII ICA]

Piña Chan, Roman. 1977. *Quetzalcoatl Serpiente emplumada*. Mexico: FCE
1989. *The Olmec: Mother Culture of Mesoamerica*, ed. Laura Laurencich Minelli. New York: Rizzoli

Powell, Philip W. 1952. *The Northwest Advance of New Spain*. Berkeley: University of California Press

Prem, Hanns. 1972. 'The Map of Chichimec history identified', *Actas XL International Congress of Americanists, Genoa*, pp.447–52
1974 (ed) Matrícula de Huexotzingo ADEVA

Rendón, Silvia (ed.). 1965. *Chimalpahin: Relaciónes originales de Chalco Amaquemecan*. Mexico: FCE

Reyes García, Luis. 1977. *Cuauhtinchan vom 12. bis zum 16. Jahrhundert. Entstehung und Entwicklung einer vorspanischen Herrschaft*. Wiesbaden: Franz Steiner
1992. *El libro del ciuacoatl [Borbonicus]*. Mexico: FCE
1993. *La escritura pictográfica en Tlaxcala*. Tlaxcala: UAT

Riese, Berthold. 1986. *Ethnographische Dokumente aus Neu-Spanien im Umfeld der Codex Magliabechiano Gruppe*. Stuttgart: Steiner

Rivas Castro, Francisco. 1994. 'Acatlan, Piaztla, Chila de las Flores y Chila de la Sal. Cuatro señoríos de la Mixteca Baja', *Mirada Antropológica* (Puebla) 1:4–16

Robertson, Donald. 1959. *Mexican Manuscript Painting of the Early Colonial Period*. New Haven: Yale University Press
1960. 'The Techialoyan Codex of

Tepotzotlan', *Bulletin of the John Rylands Library* 43:109–30

1975. 'Techialoyan manuscripts and paintings, with a catalog', *HMAI* 14:253–80

Robertson, Martha Barton. 1991. *Mexican Indian Manuscript Painting: A Catalog.* New Orleans: Tulane University

Robertson, William. 1778. *A History of America*, revised edn. 2 vols. Edinburgh

Roys, Ralph L. 1965. *Ritual of the Bacabs.* Norman: University of Oklahoma Press

1933. *The Book of Chilam Balam of Chumayel.* Washington: Smithsonian

Ruiz de Alarcón, Hernando. 1984. *Tratado de supersticiones* [1629] ed. J. Richard Andrews & Ross Hassig. Norman: University of Oklahoma Press

Sahagún, Bernardino de. 1988. *Historia general de las cosas de Nueva España.* 2 vols. [Codice Florentino] Mexico: Conoculta

1993. *Primeros Memoriales* [Photographed by F. Anders]. Norman: University of Oklahoma Press

Schele, Linda & David Freidel. 1990. *A Forest of Kings. The Untold Story of the Ancient Maya.* New York: Morrow

Seler, Eduard. 1961. 'Aus dem Berichte über die achtzehnte Tagung des Internationalen Amerikanisten-kongresses in London' [1915]. In *Gesammelte Abhandlungen*, Vol.5, pp.152–169. Graz: ADEVA

Sisson, E.B. 1983. 'Recent work on the Borgia group'. *Current Anthropology* 24:653–6

Smith, Mary Elizabeth. 1973. *Picture Writing from Ancient Southern Mexico. Mixtec Place Signs and Maps.* Norman: University of Oklahoma Press

1979. 'Codex Becker II: A manuscript from the Mixteca Baja?', *Archiv für Völkerkunde* (Vienna) 33:29–43

Smith, Mary Elizabeth & Ross Parmenter. 1991. *The Codex Tulane.* New Orleans: Tulane University Press

Solinas, Francesco. 1989. 'Il primo erbario azteco e la copia romana di Cassiano dal Pozzo', in F. Haskell et al. (eds), *Quaderni Puteano I: Il Museo Cartaceo di*

Cassiano dal Pozzo, pp.77–83. Milan: Olivetti

Starr, Frederick. 1898. *The Mapa de Cuauhtlantzinco.* University of Chicago Press

Stokes, Philip. 1994. *The Origins of the Mixtec Lords as Given in Their Own Histories.* PhD Dissertation, University of Essex

Stone, Andrea. 1984. 'A fragment version of the Lienzo of Tlaxcala', *Huntington Art Gallery Newsletter*, Fall: 6–8

Stuart, George. 1993. 'New Light on the Olmec'. *National Geographic Magazine*, November

Tedlock, Denis. 1985. *Popol Vuh. The Definitive Edition of the Mayan Book of the Dawn of Life and the Glories of Gods and Kings.* New York: Simon & Schuster

Thomas, Hugh. 1993. *The Conquest of Mexico.* London: Hutchinson

Tibón, Gutierre. 1981. *La triade prenatal: cordón, placenta, amnios. Supervivencia de la magia paleolítica.* Mexico: FCE

Torre Villar, Ernesto de la, et al (eds.). 1988. *Arqueología e Historia Guanajuatense.* León: Colegio del Bajío

Valle, Perla. 1989. 'Un registro contable indígena del siglo XVI'. In Martínez Marín 1989:231–44

1991. 'Yacanex, Caudillo de arco y flecha', *Homenaje al Dr J.C. Oliver*, pp.432–43. Mexico: UNAM

1992 (ed.). *Memorial de los indios de Tepetlaoztoc o Códice Kingsborough.* Mexico: INAH

Vega, Constanza (ed.). 1991. *Códice Azoyu 1. El reino de Tlachinollan.* Mexico: FCE

1994. *Códices y documentos sobre Mexico.* Papers presented at I Simposio Códices y Documentos sobre México. Mexico: INAH

Velázquez, Primo Feliciano (ed.). 1945. *Códice Chimalpopoca: Anales de Cuauhtitlan y Leyenda de los soles.* Mexico: UNAM

Vollmer, Günter (ed.). 1981. *Geschichte der Azteken. Der Codex Aubin und verwandte Dokumente.* Berlin: Mann

Williams, Barbara. 1980. 'Pictorial representation of soils in the valley of Mexico', *Geoscience and Man* 21:51–62

Wolf, Eric. 1959. *Sons of the Shaking Earth.* University of Chicago Press

Wood, Stephanie. 1989. 'Don Diego García de Mendoza Moctezuma: a Techialoyan Mastermind?', *Estudios de Cultura Náhuatl* 19:245–68

Wright, David. 1994. *Conquistadores otomíes en la guerra chichimeca. Documentos de Querétaro.* Queretaro: Gobierno del Estado

Yoneda, Keiko. 1981. *Los mapas de Cuauhtinchan y la historia cartográfica prehispánica.* Mexico: AGN

Zantwijk, Rudolf. 1985. *The Aztec Arrangement.* Norman: University of Oklahoma Press

INDEX

223